mark galer philip andrews

Focal Press An imprint of Elsevier Linacre House, Jordan Hill, Oxford OX2 8DP 30 Corporate Drive, Burlington, MA 01803

First published 2004 Reprinted 2005 (twice)

Copyright © 2004, Mark Galer. All rights reserved

The right of Mark Galer to be identified as the author of this work has been asserted in accordance with the Copyright, Designs and Patents Act 1988

No part of this publication may be reproduced in any material form (including photocopying or storing in any medium by electronic means and whether or not transiently or incidentally to some other use of this publication) without the written permission of the copyright holder except in accordance with the provisions of the Copyright, Designs and Patents Act 1988 or under the terms of a licence issued by the Copyright Licensing Agency Ltd, 90 Tottenham Court Road, London, England W1T 4LP. Applications for the copyright holder's written permission to reproduce any part of this publication should be addressed to the publisher

Permissions may be sought directly from Elsevier's Science & Technology Rights Department in Oxford, UK: phone: (+44) 1865 843830, fax: (+44) 1865 853333, e-mail: permissions@elsevier.co.uk. You may also complete your request on-line via the Elsevier homepage (http://www.elsevier.com), by selecting 'Customer Support' and then 'Obtaining Permissions'

British Library Cataloguing in Publication Data

A catalogue record for this book is available from the British Library

Library of Congress Cataloguing in Publication Data

A catalogue record for this book is available from the Library of Congress

ISBN 0 240 51951 5

For information on all Focal Press publications visit our website at www.focalpress.com

Working together to grow libraries in developing countries

www.elsevier.com | www.bookaid.org | www.sabre.org

ELSEVIER

BOOK AID

Sabre Foundation

Printed and bound in Italy

Acknowledgements

To our families:

Dorothy, Matthew and Teagan and Karen, Adrian and Ellena

for their love, support and understanding.

Picture credits

Paul Allister; Catherine Dorsen; Zarah Ellis; Tamas Elliot; Samantha Everton, Shaun Guest; Orien Harvey; Guy Israeli, Itti Karuson; Anitra Keogh; MiAe Jeong; Seok-Jin Lee; Benedikt Partenheimer; Raphael Ruz; Fabio Sarraff; Michael Wennrich; Amber Williams; Stuart Wilson.

Also our thanks go to www.ablestock.com for supporting this venture with the supply of various tutorial images.

All other images and illustrations by the authors.

Introduction	×
Acquisition of skills	x
Application of skills	x
A structured learning approach	xi
The skills	xi
Web site	xi
Research and resources	xi
Essential information	xii
The Digital Darkroom	
Digital setup	2
Monitor settings	. 3
Desktop alias or shortcut	5
Managing your photos	6
Getting started with Photoshop	7
Settings and preferences	10
Opening images	12
Navigation and viewing modes	13
Rulers and guides	17
Storage for digital photographs	18
Keyboard shortcuts	20
Mouse or graphics tablet?	22
Mac or PC?	22
Digital Basics	25
Introduction	26
File size	27
Modes and channels	28
Bit depth	29
Hue, saturation and brightness	30
Color paragraphics	31
Color perception	32
File formats Lossy and lossless compression	34 37
Resolution	40
Capture, image and output resolutions	41
Calculating file size and scanning resolution	43
Image size	45
Resampling	46

module Contents

foundation module >>

Capture and Enhance	51
Introduction	52
Image capture	52
Image adjustment	54
Correcting a weak histogram	56
Image size	57
Optimizing quality	59
Save	61
Capturing in RAW	63
Digital Printing	67
Printing to an inkjet printer	68
Monitor calibration and working color space	69
RGB and CMYK	70
Profiles	70
Preflight checklist	71
Soft proofing	72
Print preview	73
Printer settings	74
Output levels	74
Creating a 'ringaround'	75
Analysis of the test print	76
Creating a 'preview master'	77
Printing overview	77
Printing using a professional laboratory	78
Printing monochromes	80

advanced skills >>

Layers and Channels	83
Introduction	84
Layers overview	85
Layer types	89
Channels	92
Adjustment layers	94
Layer masks	95
Working with layers and masks	96
Layer Blends	107
Introduction	108
The 'Darken' group	110
The 'Lighten' group	112
The 'Overlay' group	114
Blend modes for tinting and toning	116
Luminosity	118
Difference and Exclusion	119
Creating a simple blend	120
Advanced blending techniques	123
Selections	129
Introduction	130
Selection tools overview	130
Modifying your selections	132
Saving and loading selections	134
Feather and anti-alias	135
Defringe and Matting	136
The 'Magic Wand'	137
Quick Mask	139
Color Range	141
Channel masking	143
Extract filter	145

Advanced Retouching Introduction	165 166
16-bit image editing	167
Target values – using the eyedroppers	169
Controlling tones using the Shadow/Highlight feature	170
Dust and scratches	172
The History Brush technique	174
Correcting perspective	175
Capturing high contrast scenes	196
Special Effects	201
Layer comps	202
Gradient maps	209
Cast shadows	216
Posterization	220
Cross process effect	225
Lith printing – the digital way	227
Digital Diffusion	230
Split toning	236
Selective toning	238
Creating digital depth of field effects	241
Lens Blur DOF effects	244
Digital Polaroid transfer effect	246
Filters	251
	252
Filtering in Photoshop	
New for Photoshop CS – The Filter Gallery	253
Fade Filter command	254
Improving filter performance	254
Installing and using third party filters	255 255
Filtering a shape or text (vector) layer	255 255
Filters 101	265
Filter DIY	200

graphics, web & workflow >>

Graphics	269
Introduction	270
Working with typography	270
Vector graphics	275
Creating a simple vector logo	277
Layer styles	281
Creating an animated graphic for the web	284
Combined use of filters and styles	287
Images for the Web	293
Introduction	294
ImageReady	295
Image resolution and the web	296
Web page construction	301
Slice the image canvas	304
Save for Web command	305
Creating the rollovers	306
Preview and save web pages	307

Automated Features	309
Customizing your frequently used commands	310
Keyboard shortcuts	310
Actions	311
Editing an action	313
Actions and Batch commands	314
Contact Sheet	315
Picture Package	316
Photomerge	317
PDF presentation	318
Web Photo Gallery	319
Glossary	327
Keyboard shortcuts	337
Web links	339

Introduction

Photoshop has helped revolutionize how photographers capture, edit and prepare their images for viewing. Most of what we now see in print has been edited and prepared using the Adobe software. The image editing process extends from basic retouching and sizing of images, to the highly manipulated and preconceived photographic montages that are commonly used by the advertising industry. This book is intended for photographers and designers who wish to use the 'digital darkroom' rather than the traditional darkroom for creative photographic illustration. The information, activities and assignments contained in this book provide the essential skills necessary for competent and creative image editing. The subject guides offer a comprehensive and highly structured learning approach, giving comprehensive support to guide Photoshop users through each editing process. An emphasis on useful (essential) practical advice and activities maximizes the opportunities for creative image production.

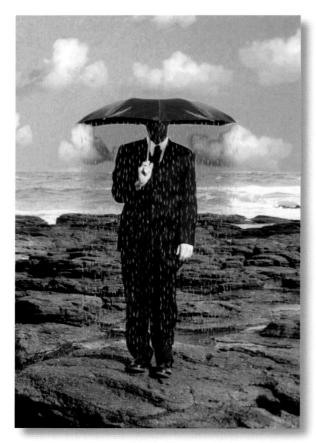

Anitra Keogh

Acquisition of skills

The first section of this book is a foundation module designed to help the user establish an effective working environment and act as a guide for successful navigation through the image editing process from capture to print. Emphasis is placed on the essential techniques and skills whilst the terminology is kept as simple as possible using only those terms in common usage.

Application of skills

The subsequent modules extend and build on the basic skills to provide the user with the essential techniques to enable creative and skilful image editing. The guides explore creative applications including advanced retouching, photomontage, vector graphics, special effects and preparing images for the web. Creative practical tasks, using a fully illustrated and simple step-by-step approach, are undertaken in each of the guides to allow the user to explore the creative possibilities and potential for each of the skills being offered.

The study guides contained in this book offer a structured learning approach and an independent learning resource that will give the user a framework for the techniques of digital imaging as well as the essential skills for personal creativity and communication.

The skills

To acquire the essential skills to communicate effectively and creatively takes time and motivation. Those skills should be practised repeatedly so that they become practical working knowledge rather than just basic understanding. Become familiar with the skills introduced in one study guide and apply them to each of the following guides wherever appropriate.

The web site associated with this book has images available for download

Web site

A dedicated web site has been set up where it is possible to download images required to complete the activities within the study guides. The address for the Internet web site is:

www.photoshopessentialskills.com

Research and resources

You will only realise your full creative potential by looking at a variety of images from different sources. Artists and designers find inspiration in many different ways, but most find that they are influenced by other work they have seen and admired.

The basic equipment required to complete this course is access to a computer with Adobe Photoshop version 8 (versions 6 and 7 would suffice for most of the activities contained in the book). The photographic and design industries predominantly use Apple Macintosh computers but many people choose IBM compatible PCs as a more cost effective alternative. When Photoshop is open there are minor differences in the interface, but all of the features and tools are identical. It is possible to use this book with either IBM compatible PCs or Apple Macintosh computers.

Storage

DAOMSOLOMA <<

Due to the large file sizes involved with digital imaging it is advisable that you have a high capacity, removable storage device attached to the computer or use a CD writer to archive your images. Avoid bringing magnetic disks such as Zip disks into close contact with other magnetic devices such as can be found in mobile phones and portable music players - or even the speakers attached to your computer.

Commands

Computer commands which allow the user to modify digital files can be accessed via menus and submenus. The commands used in the study guides are listed as a hierarchy, with the main menu indicated first and the submenu or command second, e.g. Main menu > Command or Submenu > Command. For example, the command for opening the Image Size dialog box would be indicated as follows: Edit > Image Adjustments > Image Size.

Keyboard shortcuts

Many commands that can be accessed via the menus and submenus can also be accessed via keyboard 'shortcuts'. A shortcut is the action of pressing two or more keys on the keyboard to carry out a command (rather than clicking a command or option in a menu). Shortcuts speed up digital image processing enormously and it is worth learning the examples given in the study guides. If in doubt use the menu (the shortcut will be indicated next to the command) until you become more familiar with the key combinations. See pages 20 and 21 in 'The Digital Darkroom' for a list of the most frequently used shortcuts.

Note > The keyboard shortcuts indicate both the Mac and PC equivalents.

Example: The shortcut for pasting objects and text in most applications uses the key combination Command/Ctrl + V. The Macintosh requires the Command key (next to the spacebar) and the V key to be pressed in sequence whilst a PC requires the Control key (Ctrl) and the V key to be pressed.

essential skills >>>

the digital darkroom

hop photoshop photoshop photoshop photoshop phot

essential skills

- Set up the computer, monitor and software preferences for effective digital image editing.
- Create an effective image file management system.
- Gain familiarity with the Photoshop interface.
- Review Photoshop's basic tools and commands for navigating images on screen.

Digital setup

Photoshop is the professional's choice for digital image editing. Photoshop affords precise control over images that are destined to be viewed on screen and in print. In order to maximize this control it is necessary to spend some time setting up the software and hardware involved in the imaging process in order to create a predictable and efficient workflow.

This chapter will act as a preflight checklist so that the user can create the best possible working environment for creative digital image editing. The degree of sophistication that Photoshop offers can appear daunting for the novice digital image-maker, but the time required setting up the software and hardware in the initial stages will pay huge dividends in the amount of time saved and the quality of the images produced.

Commands and shortcuts

This chapter will guide you to select various options from a list of menus on your computer. If a command or dialog box is to be found in a submenu which in turn is to be found in a main menu it will appear as follows: 'Main menu > Submenu > Command'. Many of the commands can be executed by pressing one or more of the keyboard keys (known as 'keyboard shortcuts').

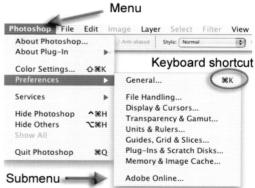

Keyboards: Mac and PC keyboards have different layouts. The 'Alt' key on a PC is the 'Option' key on a Mac. The functions assigned to the 'Control' key on a PC are assigned to the 'Command' key on a Mac (the key next to the spacebar with the apple on it). When the text lists a keyboard command such as 'Ctrl/\mathbb{\mathbb{H}} Command + Spacebar' the PC user will press the Control key and the spacebar whilst the Mac user is directed to press only the Command key together with the spacebar.

Monitor settings

Resolution and colors

Set the monitor resolution to '1024 \times 768' pixels or greater and the monitor colors to 'Millions'. If the 'Refresh Rate' is too low the monitor will appear to flicker. The best monitors will enable a high resolution with a flicker-free or stable image. It is possible to use a monitor resolution of 800×600 but the size of the palettes, and the lack of a 'palette well' in which to store these palettes, results in a lack of 'screen real estate' or monitor space in which to display the image you are working on.

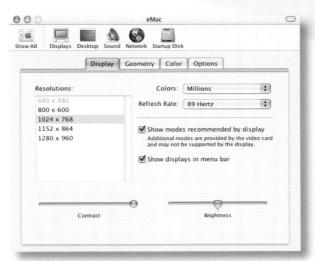

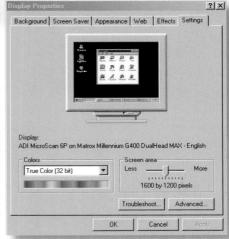

Color temperature - selecting a white point

The default 'color temperature' of a new monitor is most likely to be too bright and too blue for digital printing purposes (9300). Reset the 'Target White Point' (sometimes referred to as 'Hardware White Point' or 'Color Temperature') of your monitor to 'D65' or '6500', which is equivalent to daylight (the same light you will use to view your prints). Setting the white point is part of the 'calibration' process that ensures color accuracy and consistency.

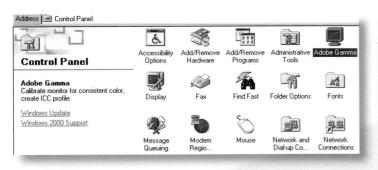

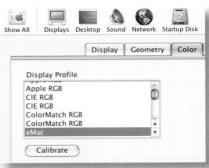

Calibration

Full monitor calibration is not recommended until a new monitor has had time to 'bed in' or 'settle down'. You should, however, select an appropriate color temperature for the monitor from the start. This can be adjusted using either the software 'Adobe Gamma' or 'Monitor Calibrator'.

Once a new monitor has had time to 'bed in' you should complete a full monitor calibration. Switch on the monitor and allow the image to stabilize for at least half an hour. Then set the brightness, contrast, gamma and color temperature of the monitor using calibration software. This will ensure that the appearance of an image on your screen will be the same on any other calibrated screen. Monitor calibration will also ensure that your prints will appear very similar to your screen image.

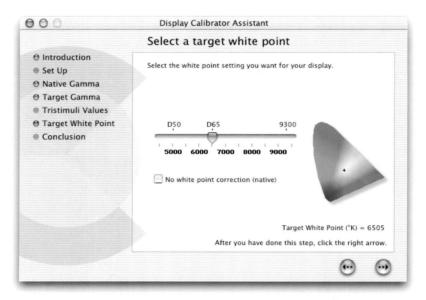

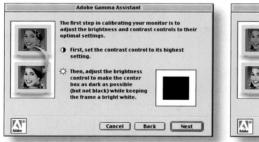

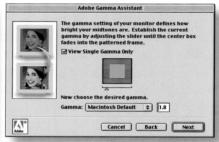

When using an older Macintosh operating system (OS9) or Windows open the software 'Adobe Gamma' (found in the 'control panel' or 'control panels' on a PC and Mac). Alternatively go to 'System Preferences > Displays > Color > Calibrate' when using Macintosh OSX. This will launch the monitor calibrator software. Choose '6500' as the 'Target White Point' or the 'Hardware White Point' and 'Adjusted White Point' if using Adobe Gamma. The software will also guide the user to set the contrast, brightness and 'gamma' of the monitor. On completion of the calibration process you must save the newly calibrated monitor settings by giving it a profile name. It is advised that when you name this profile you include the date that you carried out the calibration. It is usual to check the calibration of a monitor every 6 months.

Note > When you choose 6500 as your target white point your monitor will initially appear dull and a little yellow compared to what you are used to seeing.

Although images of tropical beaches and sunsets may look pretty relaxing, splashing them on your screen when editing digital images is not recommended. Any colors we see on the monitor – including the richly saturated colors of our desktop picture – will influence our subjective analysis of color, and our resulting image editing. It is therefore highly recommended to replace the desktop picture with a solid tone of gray. When using Mac OSX select desktop from the System Preferences.

Note > If you do not have a solid gray image in your 'Desktop Pictures' folder you can create one using the image editing software.

Desktop alias or shortcut

Create an alias or shortcut for Photoshop so that it is guick to launch from the desktop, Apple menu or 'Dock'. Open the Photoshop folder in the applications folder to locate the Photoshop application icon. Select the Photoshop application icon and right click in the destination you wish to create the shortcut. When using a Mac drag the application icon into the 'Dock' in OSX to automatically create an alias. To create an alias anywhere else on a Macintosh (such as the 'Apple Menu Items' in the 'System Folder' on OS9) simply hold down the command and option keys as you move the Photoshop icon. Dragging images onto the Photoshop alias/shortcut will automatically open them in the software.

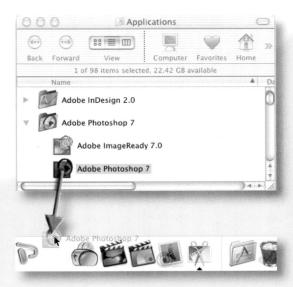

Managing your photos

There are many software applications available (such as 'Photoshop Album' or 'iPhoto') to help catalog and index image files so they are quick to access, edit, output and archive.

Searching for an image file that is over a year old with a file name you can only begin to guess at is a task best avoided. The software enables 'Keywords' or 'Tags' to be assigned to the image so that a year down the track you can search for your images by date, name or content to simplify the task. Subsets of images can be displayed based on your search criteria. Some packages even provide the option of locating your images via a calendar display where the pictures are collated based on the date they were taken.

For the Mac OSX user it is advised that all images are stored in the 'Pictures' folder associated with each 'User'. For those readers with Windows machines it is good advice to save your pictures in

the 'My Pictures' folder. These folders are often set as the default images folder by the indexing or browser programs. Storing your pictures here will mean that the program will automatically retrieve, index and display images newly added to your system.

Many of the software packages available allow you to assign an image editing program in the preferences so that the image opens in this software when double-clicked. If you are provided with this option select Photoshop as your default image editing program.

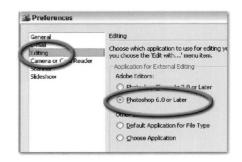

Photo for Macintosh

Getting started with Photoshop

The interface of Photoshop is highly organized and presents the user with an effective interface offering maximum control over the process of image editing. If all of the information and control relating to a single image were on display there would be no room left on a standard monitor for the image itself. Most of the features of the editing software therefore are hidden from view but can be quickly accessed once the user starts to understand how the software is organized. The Photoshop interface consists of the:

- Main menu
- Toolbox
- Options bar
- Image window
- Palettes
- Palette well

Note > Adobe Photoshop is available for both the Macintosh and Windows platforms. The interface for each system is very similar, with the only differences being the result of the underlying operating system of each computer. Once inside the program items like the menu structure and palette design are exactly the same irrespective of the computer platform you are working with. In practical terms the main difference between the two systems is that Windows and Macintosh use different key stroke combinations for shortcuts and most Macintosh systems use a single button mouse.

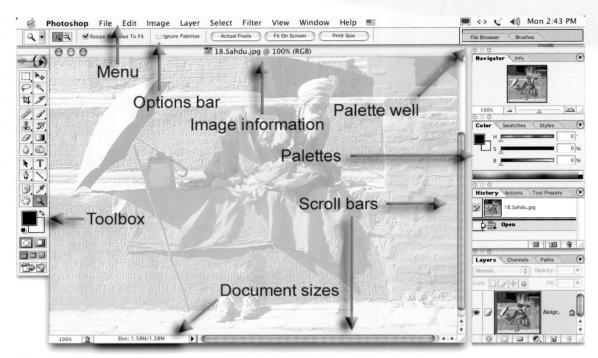

The main menu

The main menu gives you access to the main commands. The menu is subdivided into main categories. Clicking on each menu category gives you access to the commands in this section. A command may have a submenu for selecting different options or for launching various 'dialog boxes'. Many of the commands can be accessed without using the menu at all by simply pressing a key combination on the keyboard called a 'shortcut'.

The toolbox

To select a tool to work on your image you simply click on it in the toolbox. If you leave your mouse cursor over the tool Photoshop will indicate the name of the tool and the keyboard shortcut to access the tool. Some of the tools are stacked in groups of tools. A small black arrow in the bottom right corner of the tool indicates additional tools are stacked behind. To access any of the tools in this stack hold the mouse clicker down on the uppermost tool for a second.

The Options bar

The 'Options' bar gives you access to the controls or specifications that affect the behavior of the tool selected. The options available vary as different tools are selected.

The image window

The file name, magnification, color mode and document size are all indicated by the image window. If the image is larger than the open window the scroll bars can control the section of the image that is visible.

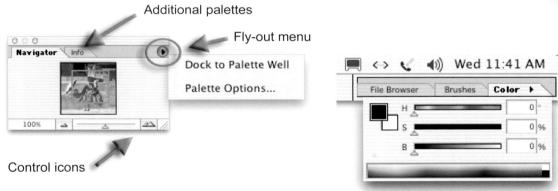

The palettes

The palettes provide essential information and control over the image editing process. They can be arranged in stacks and moved around the screen. Icons at the base of each palette provide access to frequently used commands whilst additional options are available from the palette flyout menu. Double-clicking the palette tabs or title bars will collapse the palettes to save additional screen real estate. Pressing the 'Tab' key will temporarily hide the palettes. If you want to open a palette that has been closed it can be launched from the 'Window' menu.

Note > Pressing the 'Tab' key will hide the palettes and toolbox from view. Pressing the Tab key again returns the palettes and toolbox. Holding down the Shift key whilst pressing the Tab key will hide all the palettes but keep the toolbox on the screen.

The palette well

Palettes can be dragged to the 'palette well' so that maximum screen space is available for the image window. Clicking on a tab in the palette will temporarily open the palette. Clicking away from the palette will automatically collapse the palette back into the well.

Settings and preferences

Before you start working with an image in Photoshop it is important to select the 'Color Settings' and 'Preferences' in Photoshop. This will not only optimize Photoshop for your individual computer but also ensure that you optimize images to meet the requirements of your intended output device (monitor or print). These settings are accessed through either the 'Photoshop' menu or 'Edit' menu from the main menu at the top of the screen.

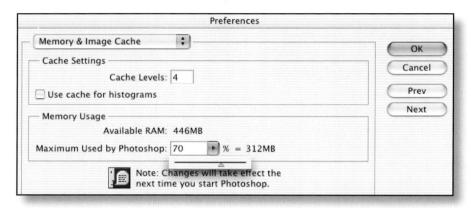

Memory (the need for speed)

If you have a plentiful supply of RAM (256 RAM or greater) you have to give permission for Photoshop to tap into these RAM reserves to a greater or lesser extent when using OS9 or OSX. Seventy-five percent of the available RAM will automatically be assigned to Photoshop when using a PC. The best advice is to close all non-essential software when you are using Photoshop and allocate more RAM from the 'Memory & Image Cache' preferences (70% is a good starting point).

Image cache

The Image cache setting controls the speed of the screen redraw (how long it takes an image to reappear on the screen after an adjustment is made). If you are working with very high-resolution images and you notice the redraw is very slow you can increase the redraw speed by raising the image cache setting (it can be raised from the default setting of 4 up to 8 depending on the speed required). The drawback of raising this setting is that the redraw is less accurate on screen images that are not displayed at 100%.

Macintosh OS9: If you are using an older version of Photoshop on Macintosh OS9 you will need to allocate more memory. In order to allocate this additional memory you must select the application icon in the application folder and then go to 'File > Get Info > Memory'. You cannot allocate the total amount of RAM you have installed to either Photoshop as the operating system requires a proportion of this RAM. If RAM is not plentiful you will also need to switch the operating system's 'Virtual Memory' on (go to 'Control Panels > Memory > Virtual Memory'). Choose a figure that is greater than the installed amount of RAM (256M or greater is recommended).

Scratch disks

As well as using RAM, Photoshop also requires a plentiful amount of free memory on the hard drive to use as its 'scratch disk' (a secondary memory resource). To avoid memory problems when using Photoshop it is best to avoid eating into the last gigabyte of your hard drive space. As soon as you see the space dwindling it should be the signal for you to backup your work or consider the installation of a second hard drive. If you have a second hard drive installed you can select this as your 'Second Scratch Disk' by going to 'Preferences > Plug-ins and Scratch Disks'.

Note > If you are intending to work on a very large image file it is recommended that the scratch disk and image file location are using separate drives.

Efficient use of memory

When you have set up your memory specifications you can check how efficiently Photoshop is working as you are editing an image. Clicking to the right of the document size information (at the base of the image window) will reveal that additional information is available. Choosing the 'Scratch Sizes' option will display how much RAM and how much memory from the scratch disk are being used to process the image.

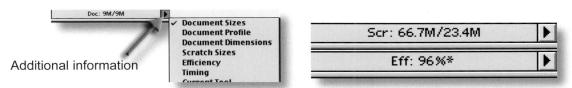

Choosing efficiency will display whether Photoshop is using the scratch disk to perform the image editing tasks. Values less than 100 % indicate that if more RAM were made available to Photoshop the operations would be faster. Simply closing software that is not being used can often increase efficiency, or closing additional images that have been opened but are not required for the editing process.

Photoshop's 'Color Settings'

If you were launching Photoshop for the first time you may have already been invited to choose a 'Color Setting' that you would like to use as your default working space. The most appropriate color setting for image-makers who wish to output to print is Adobe RGB (1998). If Photoshop has already been launched this can be changed in the RGB drop-down menu by going to the 'Color Settings' command, found in the 'Photoshop' or 'Edit' menu.

Default settings

It is possible to reset all of the software preferences to their default settings at the time of opening. Press and hold Alt + Control + Shift (Windows) or Option + Command + Shift (Mac OS) as the software is launching. A screen prompt will invite you to delete the current settings. This is useful when using a shared computer so that each tool behaves as you would expect it to. Return the working space to its default setting when the application is already open by going to 'Window > Workspace > Reset Palette Locations'.

Page Setup

Select the paper size and orientation (vertical or horizontal) by going to File > Page Setup. When you have chosen the paper size you can quickly gain an idea of how large your image will be printed by holding down the Alt/Option key and clicking on the document size at the base of the image window. The window that springs open shows the relationship between the paper and the image (represented by a rectangle with a large cross).

Note > A shaded area around the edge of the paper indicates the portion of the paper that cannot be printed (older style printers).

Opening images

Double-clicking an image on the desktop should automatically open the file into image editing software. If the file does not open into the image editing software you can launch it by going to the 'File > Open' menu in the software program. If you prefer your Adobe software to handle all of your image files you should select it as the default image editing software in your system preferences. In OSX click once to select a file that would normally be opened in software other than Adobe, e.g. QuickTime. Then select 'Get Info' from the 'File' menu of the 'Operating System' menu. Choose the Adobe software program in the 'Open With' submenu. Then select the 'Change All' button for all future documents of a similar format and file type to be opened by Adobe automatically.

The fastest way to open a file from your picture library is to use the 'File Browser' from the Window menu. Multiple files can be selected by successively dragging them into the preview window.

Navigation and viewing modes

When viewing a high-resolution image suitable for printing it is usual to zoom in to check the image quality and gain more control over the editing process. There are numerous ways to move around an image and each user has their preferred methods to speed up the navigation process.

The Navigator palette

The Navigator palette is simple and effective to use. You can use it to both zoom in and out of the image and move quickly to new locations within the enlarged image. The rectangle that appears in the image shows the area visible inside the image window. This rectangle can be dragged to a new location within the image. Using the slider directly underneath the preview window or clicking on the icons either side of the slider controls magnification. It is also possible to type in a specific magnification and then press the enter/return key.

The 'Zoom' and 'Hand' tools

These tools offer some advantages over the Navigator palette. They can be selected from within the toolbox or can be accessed via keyboard shortcuts. Clicking on the image with the zoom tool selected zooms into the image around the point that was clicked. The Zoom tool options can be selected from the Options bar beneath the main menu. Dragging the Zoom tool over an area of the image zooms into that area with just the one action (there is no need to click repeatedly).

When you are zoomed into an area you can move the view with the 'Hand' tool. Dragging the image with the Hand tool selected moves the image within the image window (a little like using the scroll bars). The real advantage of these tools is that they can be selected via shortcuts. The spacebar temporarily accesses the Hand tool no matter what other tool is selected at the time (no need to return the cursor to the toolbox). The Zoom tool can be accessed by pressing the Control/Command + Spacebar to zoom in or the Alt/Option + Spacebar to zoom out.

Note > When you are making image adjustments and a dialog box is open, the keyboard shortcuts are the only way of accessing the zoom and move features.

Additional shortcuts

Going to the View menu in the main menu will reveal the keyboard shortcuts for zooming in and out. You will also find the more useful shortcuts for 'Fit on Screen' and 'Actual Pixels' (100 % magnification). These very useful commands can also be accessed via the toolbox by either double-clicking on the Hand tool (Fit on Screen) or double-clicking the zoom tool (Actual Pixels) in the toolbox itself.

Screen modes

The screen can begin to look very cluttered when several applications or windows are open at the same time. A quick way to simplify the view is to switch to 'Full Screen Mode with Menu Bar'.

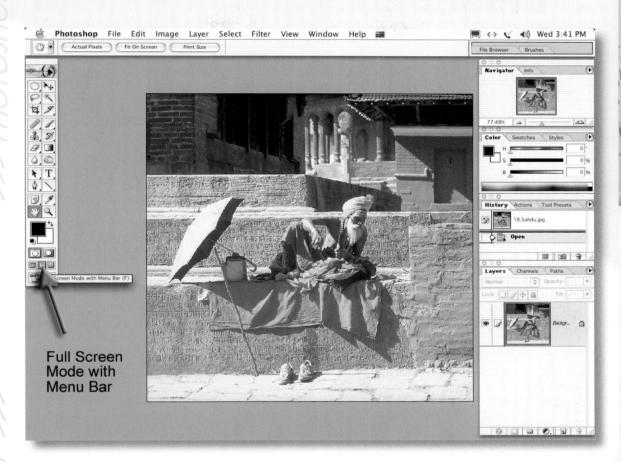

Press the icon located in the toolbox or press the letter 'F' on the keyboard to access the 'Full Screen Mode'. This will temporarily hide all other windows. The open image will be centered on the screen and surrounded with a neutral tone of gray. Continuing to press the F key will cycle through the screen modes and return you to the 'Normal View'.

Note > The screen can be further simplified by pressing the 'Tab' key. This hides the palettes and toolbox from view. Pressing the Tab key again returns the palettes and toolbox. Holding down the Shift key whilst pressing the Tab key will hide all the palettes but keep the toolbox on the screen.

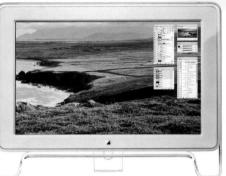

Side-by-side screens

For the ultimate in workspace luxury some professionals use specially configured video cards to drive two screens that are placed side by side. In this setup Photoshop's tools and palettes can be spread over both monitors and the mouse moves freely from one screen to the other.

Tidy screen tips

No matter what size screen you have, or even if you have two side by side, it always seems that there is never enough space to arrange the various palettes and images needed for editing work. Here are a few tips that will help you make the most out of the 'screen property' that you do have.

Docking – Docking is a feature that allows several palettes or dialogue boxes to be positioned together in the one space. Photoshop provides the option to dock all open palettes in a special docking well provided for this purpose in the options bar at the top of the screen. Alternatively several palettes can be docked together in one palette group.

Roll ups – Photoshop allows users to roll up large palettes so that the details of the box are hidden behind a thinner heading bar. This way the full box is rolled out only when needed.

Resizing the work window – If you have a small screen then it is still possible to work on fine detail within an image by zooming in to the precise area that you wish to work. For this reason it is worth learning the keyboard shortcuts for 'zooming in' and 'out'. This function is a little like viewing your enlargement under a focus scope.

Save your workspace – Once you are satisfied with your workspace arranging, save your setup by selecting Window > Workspace > Save Workspace. Now whenever you want to revert to this way of organizing your screen you can selected your setup from the Window > Workspace submenu.

📖 \leftrightarrow 📞 📢) Wed 10:28 AM

(P)

0 -

(1)

4 4

3, 3

800

000

Photoshop File Edit Image Layer

It is possible to have the same image open in two windows. This allows the user to zoom in to work on detail in one window and see the overall impact of these changes without having to constantly zoom in and out. Any changes made in one window will automatically appear in the other window.

Select Filter View Window Help

Workspace

File Browser

✓ Options

✓ Navigator

Swatches Styles # History

> Actions Tool Presets

Channels
Paths

Brushes

Character Paragraph

Info

✓ Color

20.Flowers.jpg @ 200% (F

Cascade

Bring All to Front

√ 20.Flowers.jpg @ 200% (RGB)

20.Flowers.jpg @ 33.3% (RGB)

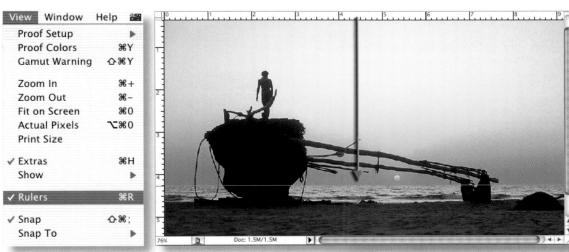

Rulers and guides

Guides can help you to align horizontals and verticals within the image area. Select 'Rulers' from the 'View' menu and then click on either the horizontal or vertical ruler and drag the guide into the image area. Guides can be temporarily hidden from view by selecting 'Extras' from the 'View' menu. Drag a guide back to the ruler using the Move tool to delete it or remove all the guides by selecting 'Clear Guides' from the 'View' menu.

Storage for digital photographs

It didn't take much time before digital photographers realized that high quality pictures use a lot of storage space. Very quickly manufacturers became aware of the need for big capacity portable storage solutions for archiving and transporting large picture files. A few systems have come and gone but the range of devices that we now have are bigger, faster and cheaper than ever before.

Zip disk

>>> PHOTOSHOP CS

The Zip revolution started in 1995 when lomega first released the 100MB removable cartridge and drive. Featuring a disk not much bigger than the old 1.4MB floppy disk, this storage option quickly became the media of choice with photographers and graphic designers worldwide. The latest incarnation of the drive is not only smaller than its predecessor but the new cartridge is now capable of storing 750MB of your precious pictures. What's more the new drive can still read and write the old cartridges. Unlike most CD-based storage Zip drives work in a very similar way to your hard drive allowing files to be read, written and overwritten with ease.

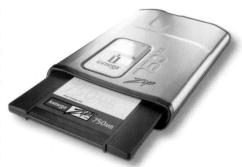

CD-ROM

The CD is a stable and familiar format that is used universally for storing massive amounts of data cheaply. As recent as six years ago CD readers were an expensive add-on to your computer system. Now writers, and sometimes even rewriters

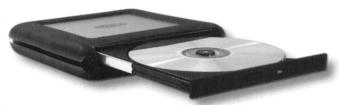

are thrown in as part of system package deals. The CD has become the floppy of the new millennium and unlike the Zip storage option the majority of all current computers have a CD drive.

Drives and media are available in two formats. 'Write once, read many' or Worm drives (CD-R) are the cheapest option and allow the user to write data to a disk which can then be read as often as required. Once a portion of the disk is used it cannot be overwritten.

The advanced version of this system (CD-RW) allows the disk to be rewritten many times. In this way it is similar to a hard drive; however, the writing times are much longer. Most drives can read, write and rewrite all in one unit.

Portable hard drive

A new category in portable storage is the range of portable digital hard drives available for photographers. These devices operate with mains or battery power and usually contain a media slot that accepts one or more of the memory cards used in digital cameras. The most well known of these devices is the Nixvue Vista.

Designed to be used on the road, pictures are transferred from your camera's memory card to the device, freeing up space and allowing you to continue shooting. Back at the desktop the images are downloaded to your computer via a fast cable setup such as Firewire or USB 2.0.

External hard drives

With the ever increasing need for storage and the desire of many users to be able to move their image archives from one machine to another, companies like lomega are developing more and more sophisticated external hard drive options. Their latest offerings include capacities from 20 to 200GB and the choice of Firewire or USB 2.0 connection. When connected these devices act like another drive in your machine.

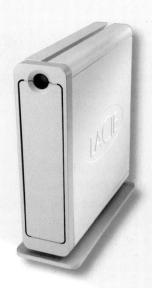

DVD

DVD is fast becoming the storage medium of choice for the professional image-maker. Capable of storing between 4.7 and a staggering 9.4 GB of picture files DVD is perfect for archiving and sharing the vast amount of information that is collected daily as part of a professional photographic practice. The technology comes in variety of formats with different manufacturing companies supporting

specific formats. This lack of a common or universal format initially reduced the attractiveness of this storage option, but now the best DVD drives can read and write more than one disk type making these models the best option when looking for a DVD storage solution. As drive and disk prices continue to fall this technology is set to replace the CD as the digital photographer's main storage medium.

USB mini drives

Also called Flash or pen drives, this is a comparatively new option in the portable storage market. These tiny devices plug directly into the USB port of your computer or laptop. Once recognized by your system they can be used just like any other drive in your computer. The fast transfer speed and 'hotswappable' capabilities of the USB 2.0 connection mean that large files are quickly saved and can be

transferred to other machines by disconnecting the drive from one computer and then plugging into another. The drives have no moving parts and are available in various sizes ranging from 64MB to 1 GB.

Action	Keyboard Shortcut	
Navigate and view		
Fit image on screen	Double-click Hand tool in palette	
View image at 100%	Double-click Zoom tool in palette	
Zoom tool (magnify)	∺/Ctrl + Spacebar	
Zoom tool (reduce)	℃ /Alt 第/Ctrl	
Full/standard screen mode	F	
Show/hide rulers	₩/Ctrl + R	
Show/hide guides	₩/Ctrl + ;	
Hide palettes	Tab key	
File commands		
Open	₩/Ctrl + O	
Close	₩/Ctrl + W	
Save	₩/Ctrl + S	
Save As	公 兆/Ctrl + S	
Undo/Redo	器/Ctrl + Z	
Step Backward	√/Alt 器/Ctrl + Z	
Selections		
Add to selection	Hold 企 key and select again	
Subtract from selection	Hold ℃ /Alt key and select again	
Сору	₩/Ctrl + C	
Cut	₩/Ctrl + C	
Paste	₩/Ctrl + V	
Paste Into	器/Ctrl ☆ + V	
Free Transform	₩/Ctrl + T	
Distort image in free transform	Hold ₩ key + move handle	
Feather	%/Ctrl ℃/Alt + D	
Select All	₩/Ctrl + A	
Deselect	₩/Ctrl + D	
Inverse selection	೫/Ctrl + I	
Edit in Quick Mask Mode	Q	

Pa	IF	111	n	a
ıa		ıu		2

Set default foreground D and background colors

Switch between foreground X and background color

Enlarge brush size (with Paint tool selected)]
Reduce brush size (with Paint tool selected) [

Change opacity of brush in 10% increments (with Paint tool selected)

Color adjustments

Levels $\Re/\text{Ctrl} + L$ Curves $\Re/\text{Ctrl} + M$ Group or clip layer $\Re/\text{Ctrl} + G$

Press number keys 0 - 9

Select next adjustment point in curves Ctrl + Tab

Layers and channels

Change opacity of active layer in 10% Press number keys 0 – 9

increments

Crop

Enter crop Return key

Cancel crop Esc key

Constrain proportions of crop marquee Hold ☆ key

Turn off magnetic guides when cropping Hold √Alt ☆ keys + Drag handle

Much of the time spent working on digital images will be via the mouse or graphics tablet stylus. These devices are electronic extensions of your hand allowing you to manipulate your images in virtual space. The question of whether to use a mouse or stylus is a personal one. The stylus does, however, provide pressure sensitive options not available with a mouse-only system. Wacom, the company foremost in the production of graphics tablets for digital imaging use, has recently produced a cordless mouse and stylus combination that allows the user to select either pointer device at will.

Mac or PC?

Photoshop was originally written as a Macintoshonly application back in 1990 and became available for PC with the release of version 2.5. Photoshop now happily works out of either platform. Most commercial image-makers, who have to deal with the printing industry are still using Apple Macintosh computers. Macs dominate the industry but they are not necessarily any better than PCs at image-making tasks. Commercial image-makers tend to purchase them because their colleagues within the industry are using them. It is really just a communication issue. Macs and PCs can talk to each other if required, e.g. Photoshop operating on either platform can open the same image file. The bottom line, however, is that small, but annoying, communication issues can

often arise when files are passed 'between' the two platforms. Image-makers who are thinking of choosing the PC platform need to think carefully how, if at all, these communication issues will impact upon them. The biggest communication problem that exists to date is that an image file on a Macintosh formatted disk cannot be accessed easily, or at all, by a PC user.

Use-by date

When choosing a computer for commercial digital imaging it is worth noting that most systems are usually past their use-by date before three years have expired. This may continue to be the case although the whole issue of speed is largely becoming academic for stills image editing. The days of waiting for extended periods whilst Photoshop completed a command are largely over, even using an entry-level computer. The issue of speed, however, is still very much of an issue for creators of DVD (digital video) where disk write speeds are still slow and file sizes are measured in gigabytes instead of megabytes.

digital basics

photoshop photoshop

Sam Everton

hop photoshop photoshop photoshop photoshop photoshop

essential skills

hop

- ~ Gain a working knowledge of digital image structure.
- ~ Understand file size, bit depth, image modes, channels, file format and resolution.
- ~ Understand color theory and color perception.

Introduction

The term 'digital photography' is used to describe images that have been captured by digital cameras or existing photographs that have been scanned to create digital image data. The term also describes the processing of digital image data on computers and the output of 'hard copies' or digital prints (on paper or plastic) from this data.

Digital photography is now revolutionizing not only the process of photography but also the way we view photography as a visual communications medium. This new photographic medium affords the individual greater scope for creative expression, image enhancement and manipulation.

Digital foundations

This guide is intended only to lay the foundations of practical digital knowledge. The individual may find it beneficial to supplement this information with additional guides specific to the equipment and computer programs being used. The information supplied by these additional guides, although valuable, may quickly become redundant as new equipment and computer programs are released frequently in this period of digital evolution.

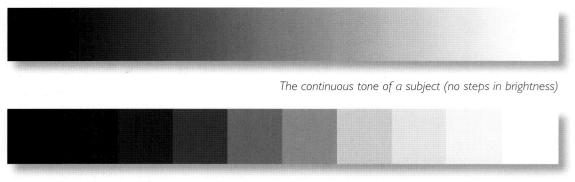

Ten pixels each with a different tone or level used to describe the above

Pixels and levels

A digital image is one in which the image is constructed from 'pixels' (picture elements) instead of silver halide grains. Pixels are square and positioned in rows horizontally and vertically to form a grid. Each pixel in the grid is the same size and is uniform in color and brightness, i.e. the tone does not vary from one side of the pixel to the other.

In the illustration above 10 pixels, each with a different tone, are used to describe the 'continuous tone' above it. Each different tone is called a 'level' and assigned a numerical value, e.g. 0 to 9. In a typical digital image there are 256 different levels or separate tones to create a smooth transition from dark to light. If the pixels are sufficiently small when printed out the viewer of the image cannot see the steps in tone thereby giving the illusion of continuous tone.

File size

Digital images are usually created using a large amount of information or data. This data is required to record the subtle variations in color and/or tone of the original image or subject. The simple binary language of computers and the visual complexities of a photographic image lead to large 'file sizes'. This data can require large amounts of computer memory to display, print or store the image. The text file for this book can comfortably fit onto a floppy disk whereas only a small portion of the cover image may be stored on a similar floppy disk.

Units of memory 8 bits =

1024 bytes=1 kilobyte1024 kilobytes=1 megabyte1024 megabytes=1 gigabyte

Storage capacity of disks

Floppy disk = 1.4 megabytes

Zip disk = 100 or 250 megabytes CD = 600 - 700 megabytes

1 byte

Jaz drive = 1 gigabyte

Bits, bytes, kilobytes and megabytes

There are 1024 bytes in a 'kilobyte' (KB) and 1024 kilobytes is a 'megabyte' (MB). The 'digital file' of the image that is used on the cover of a glossy magazine is likely to exceed 20MB. That is a lot of information to produce one color image in print. Fortunately files can be 'compressed' (reduced in memory size) for storage and it is possible to fit a large image file onto a floppy disk. Storing large files on floppy disks, although possible, is not practical. Removable hard drives (such as the inexpensive 'Zip' drive made by lomega™ and the newer 'USB' or 'Flash' drives) are commonly used for storing and transferring large image files conveniently and quickly.

ACTIVITY 1

Find one digital image file and identify its file size when the image is closed. Open the same digital image using image editing software and identify its file size when open (go to the 'document sizes' underneath the image window or choose 'Image Size' from the 'Image' menu). It is common for the file size to be larger when the image is open. If this is the case with the image you have opened, image compression is taking place prior to the file being closed.

Modes and channels

The color and tonal information of pixels within a digital image can be described using a number of different 'modes', e.g. a black and white image can be captured in 'bitmap' mode or 'grayscale' mode. In a bitmap image each pixel within the grid is either black or white (no shades of gray). This mode is suitable for scanning line drawings or text. For images that need to be rendered as continuous tone the grayscale mode is used.

Grayscale

SO HOTOSHOP CS

Black and white (continuous tone) photographs are captured or scanned in what is called 'grayscale'. Each pixel of a grayscale image is assigned one of 256 tones or levels from black to white. These 256 levels allow a smooth gradation between light and shade simulating the continuous tone that is achieved with conventional silver-based photography. A grayscale image is sometimes referred to as an '8-bit image' (see 'Bit depth').

RGB channels		R	G	В
	Red:	255	0	0
	Green:	0	255	0
7	Blue:	0	0	255
0	Cyan:	0	255	255
	Magenta:	255	0	255
0	Yellow:	255	255	0
O	Black:	0	0	0
()	White:	255	255	255
0	Mid gray	127	127	127

RGB

A 'full color' image can be assembled from the three primary colors of light: red, green and blue or 'RGB'. All the colors of the visible spectrum can be created by varying the relative amounts of red, green and blue light. The information for each of the three primary colors in the RGB image is separated into 'channels'. Each channel in an RGB image is usually divided into 256 levels. An RGB color image with 256 levels per channel has the ability to assign any one of 16.7 million different colors to a single pixel (256 × 256 × 256). Color images are usually captured or scanned in the RGB 'color mode' and these colors are the same colors used to view the images on a computer monitor. A color pixel can be described by the levels of red, green and blue, e.g. a red pixel may have values of Red 255, Green 0 and Blue 0; a yellow pixel may have values of Red 255, Green 255 and Blue 0 (mixing red and green light creates yellow); and a gray pixel may have values of Red 127, Green 127 and Blue 127.

Note > 'CMYK' is the color mode used in the printing industry and uses the colors Cyan, Magenta, Yellow and black. RGB images should only be converted to CMYK after acquiring specifications from your print service provider.

Each pixel of an 8-bit image is described in one of a possible 256 tones or colors. Each pixel of a 24-bit image is described in one of a possible 16.7 million tones or colors. The higher the 'bit **depth**' of the image the greater the color or tonal quality. An 8-bit image (8 bits of data per pixel) is usually sufficient to produce a good quality black and white image, reproducing most of its tonal variations, whilst a 24-bit image (8 bits × 3 channels) is usually required to produce a good quality color print from a three channel RGB digital file. Images with a higher bit depth require more data or memory to be stored in the image file. Grayscale images are a third of the size of RGB images (same pixel dimensions and print size, but a third of the information or data).

RGB image, 256 levels per channel (24-bit)

256 levels (8-bit)

Scanning and editing at bit depths exceeding 8 bits per channel

Most scanners now in use scan with a bit depth of 32 bits or more. Although they are capable of discerning between more than 16.7 million colors (therefore increasing the color fidelity of the file) most only pass on 24 bits of the data collected to the editing software. Higher quality scanners are able to scan and export files at 16 bits per channel (48-bit). Some digital cameras are also able to export files in 'RAW' format in bit depths higher than 8 bits per channel. In Photoshop it is possible to edit an image using 16 bits per channel or 8 bits per channel. The file size of the 16-bit per channel image is double that of an 8-bit per channel file of the same pixel dimensions. Image editing in this mode is used by professionals for high quality retouching. When extensive tonal or color corrections are required it is recommended to work in 16 bits per channel whenever possible. It is, however, important to note that not all file formats support 16 bits per channel.

Hue, saturation and brightness

It is essential when describing and analyzing color in the digital domain to use the appropriate terminology. The terminology most frequently used belongs to that of human perception. Every color can be described by its hue, saturation and brightness (HSB). These terms are used to describe the three fundamental characteristics of color.

Hue – the name of the color, e.g. red, orange or blue. All colors can be assigned a location and a number (a degree between 0 and 360) on the standard color wheel.

Saturation – the purity or strength of a color, e.g. if red is mixed with gray it is still red, but less saturated. All colors and tones can be assigned a saturation value from 0% saturated (gray) to 100% saturated (fully saturated). Saturation increases as the color moves from the center to the edge on the standard color wheel.

Brightness – the relative lightness or darkness of the color. All colors and tones can be assigned a brightness value between 0% (black) and 100% (white).

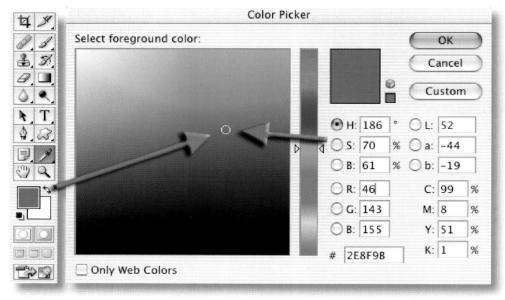

The 'foreground swatch' and 'Color Picker'

Creating and sampling color

Different colors can be created by mixing the 'primary colors' (red, green and blue) in varying proportions and intensity. When two primary colors are mixed they create a 'secondary color' (cyan, magenta or yellow). The primary (RGB) and secondary (CMY) colors are complementary colors. Two primary colors combined create a secondary color and two secondary colors combined create a primary.

Color in a digital image can be sampled by selecting the eyedropper tool in the tools palette. Move the tool over the color to be sampled and click the mouse. The color will appear in the foreground swatch in the tools palette and the foreground swatch in the color palette. Clicking on the foreground swatch in the tools palette will bring up the full color information in the 'Color Picker'.

Color and light

Additive color

The additive primary colors of light are Red, Green and Blue or RGB. Mixing any two of these primary colors creates one of the three secondary colors Magenta, Cyan or Yellow.

Note > Mixing all three primary colors of light in equal proportions creates white light.

Subtractive color

The three subtractive secondary colors of light are Cyan, Magenta and Yellow or CMY. Mixing any two of these secondary colors creates one of the three primary colors Red, Green or Blue. Mixing all three secondary colors of light in equal proportions creates black or an absence of light.

ACTIVITY 2

Open the files RGB.jpg and CMYK.jpg from the supporting web site and look at the channels to see how they were created using Photoshop. Use the information palette to measure the color values.

Hue, saturation and brightness

Although most of the digital images are captured in RGB it is sometimes a difficult or awkward color model for some aspects of color editing. Photoshop allows the color information of a digital image to be edited using the HSB model.

Hue, saturation and brightness or HSB is an alternative model for image editing which allows the user to edit either the hue, saturation or brightness independently of the other two.

ACTIVITY 3

Open the image Hue.jpg, Saturation.jpg and Brightness.jpg. Use the Color Picker to analyze the color values of each bar.

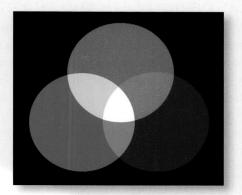

RGB - additive color

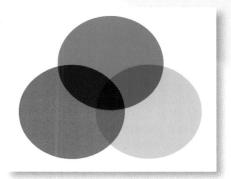

CMY - subtractive color

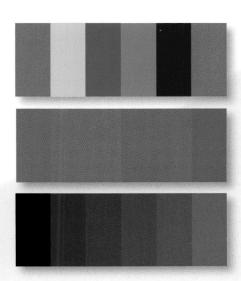

HSB - hue, saturation and brightness

Color perception

Our perception of color changes and is dependent on many factors. We perceive color differently when viewing conditions change. Depending on the tones that surround the tone we are assessing, we may see it darker or lighter. Our perception of a particular hue is also dependent on both the lighting conditions and the colors or tones that are adjacent to the color we are assessing.

ACTIVITY 4

Evaluate the tones and colors in the image opposite. Describe the gray squares at the top of the image in terms of tonality. Describe the red bars at the bottom of the image in terms of hue, saturation and brightness.

Color gamut

Color gamut varies, depending on the quality of paper and colorants used (inks, toners and dyes, etc.). Printed images have a smaller color gamut than transparency film or monitors and this needs to be considered when printing. In the image opposite the out of gamut colors are masked by a gray tone. These colors are not able to be printed using the default Photoshop CMYK inks.

Color management issues

The issue of obtaining consistent color – from original, to its display on a monitor, through to its reproduction in print – is considerable. The variety of devices and materials used to capture, display and reproduce color in print all have a profound effect on the end result.

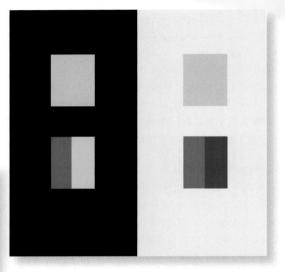

Color perception

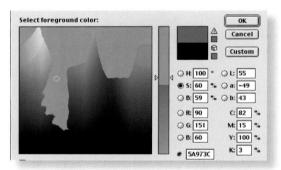

Out of gamut colors

Color management ensures consistent colors

ACTIVITY 5

1. Set the palettes in Photoshop to their default setting. Go to 'Window > Workspace > Reset Palette Locations'. Open a color digital image file.

2. Double-click the Hand tool in the tools palette to resize the image to fit the monitor.

- 3. Click on the '**Zoom tool**' in the tools palette to select the tool (double-clicking the Zoom tool in the tools palette will set the image at 100% magnification).
- 4. Click on an area within the image window containing detail that you wish to magnify.

Keep clicking to increase the magnification (note the current magnification both in the title bar of the image window and in the bottom left-hand corner of the image window.

At a magnification of 400% you should be able to see the pixel structure of the image. Increase the magnification to 1200% (to decrease the magnification you should click the image with the Zoom tool whilst holding down the Option/ Alt key on the keyboard).

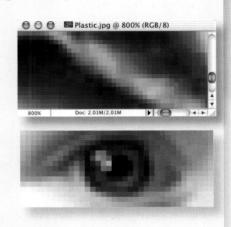

5. Click on the hand in the tools palette and then drag inside the image window to move the image to an area of interest (pixel variety).

- 6. Click on the eyedropper in the tools palette to access the information about a single pixel.
- 7. Click on different colored pixels within your magnified image.
- 8. View the color information in the color palette (note how the color of the selected pixel is also displayed in the foreground swatch in the tools palette).

9. The color information is displayed as numerical values in the red, green and blue channels. These values can be altered either by moving the sliders underneath the ramps or by typing a new value into the box beside the ramp.

Drag the sliders or type in different numbers to create your own colors.

File formats

When an image is captured by a camera or scanning device it has to be 'saved' or memorized in a 'file format'. If the binary information is seen as the communication, the file format can be likened to the language or vehicle for this communication. The information can only be read and understood if the software recognizes the format. Images can be stored in numerous different formats. The three dominant formats in most common usage are:

- JPEG (.jpg) Joint Photographic Experts Group
- TIFF (.tif) Tagged Image File Format
- Photoshop (.psd) Photoshop Document

JPEG (Joint Photographic Experts Group) – Industry standard for compressing continuous tone photographic images destined for the World Wide Web (www) or for storage when space is limited. JPEG compression uses a 'lossy compression' (image data and quality are sacrificed for smaller file sizes when the image files are closed). The user is able to control the amount of compression. A high level of compression leads to a lower quality image and a smaller file size. A low level of compression results in a higher quality image but a larger file size. It is recommended that you only use the JPEG file format after you have completed your image editing.

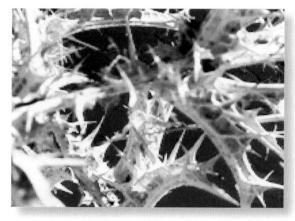

A close-up detail of an image file that has been compressed using maximum image quality in the JPEG options box

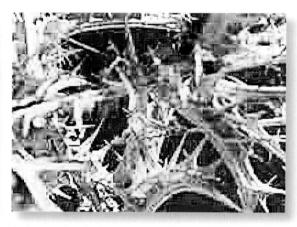

A close-up detail of an image file that has been compressed using low image quality in the JPEG options box. Notice the artifacts that appear as blocks

TIFF (**Tagged Image File Format**) – Industry standard for images destined for publishing (magazines and books, etc.). TIFF uses a 'lossless' compression (no loss of image data or quality) called '**LZW compression**'. Although preserving the quality of the image, LZW compression is only capable of compressing images a small amount.

PSD (Photoshop Document) – A default format used by the most popular image processing software. An image that is composed of 'layers' may be saved as a Photoshop document. A Photoshop document is usually kept as the master file from which all other files are produced depending on the requirements of the output device.

(1)	Format	Compression	Color modes	Layers	Transparency	Uses
at	Photoshop	No	RGB, CMYK, Grayscale, Indexed color	Yes	Yes	DTP, photography, graphic design
Ë	JPEG	Yes	RGB, CMYK, Grayscale	No	No	Internet
	JPEG2000	Yes	RGB, CMYK, Grayscale	No	No	Internet
.0	GIF	Yes	Indexed color	No	Yes	Internet
4	SVG	No	RGB	No	No	DTP, Internet, graphic design
<u>U</u>	TIFF	Yes	RGB, CMYK, Grayscale	Yes	No	DTP, photography, graphic design
	PNG	Yes	RGB, Grayscale	No	Yes	Internet
	EPS	Yes	RGB, CMYK, Grayscale	No	No	DTP, publishing, graphic design

In addition to these file types, Photoshop is capable of saving pictures in a range of other specialized formats. The most commonly used alternatives to the top three are listed below:

GIF (Graphics Interchange Format) – This format is used for logos and images with a small number of colors and is very popular with web professionals. It is capable of storing up to 256 colors, animation and areas of transparency. Not generally used for photographic images.

PNG (Portable Network Graphics) – A comparatively new web graphics format that has a lot of great features that will see it used more and more on web sites the world over. Like TIFF and GIF the format uses a lossless compression algorithm that ensures what you put in is what you get out. It also supports partial transparency (unlike GIF's transparency off/on system) and color depths up to 64 bit. Add to this the built-in color and gamma correction features and you start to see why this format will be used more often. The only drawback is that it works with browsers that are version 4 or newer. As time goes on this will become less of a problem and you should see PNG emerge as a major file format.

EPS (Encapsulated PostScript) – Originally designed for complex desktop publishing work, it is still the format of choice for page layout professionals. Not generally used for storing of photographic images but worth knowing about.

JPEG2000 – The original JPEG format is over a decade old and despite its continued popularity it is beginning to show its age. Since August 1998 a group of dedicated imaging professionals (the Digital Imaging Group – DIG) have been developing a new version of the format. Dubbed JPEG2000, it provides 20% better compression, less image degradation than JPEG, full color management profile support and the ability to save the file with no compression at all. With its eyes firmly fixed on the ever increasing demand for transmittable high quality images JPEG 2000 will undoubtedly become the default standard for web and press work. Photoshop CS is the first version of the program to include JPEG2000 as a standard file format.

SVG (Scalable Vector Graphics) – Unlike the two most popular web formats today, JPEG and GIF, SVG is a vector-based file format. In addition to faster download speeds, SVG also contains many other benefits such as high-resolution printing, high-performance zooming and panning inside of graphics and animation. This format will challenge the current dominant position of GIF as the premier format for flat graphic images on the web.

TOP TIPS for cross platform saving

Many work and education environments contain a mix of Windows and Macintosh machines. Though both systems are far better at reading each other's files than they used to be, there are still occasions when you will have trouble when sharing files between the two platforms. Use these tips to ensure that work that you save is available for use in both environments.

- 1. Make sure that you always append your file names. This means add the three letter abbreviation of the file format you are using after the name. So if you were saving a file named 'Image1' as a TIFF the saved file would be 'Image1.tif', a JPEG version would be 'Image1.jpg' and a Photoshop file would be 'Image1.psd'. Macintosh Photoshop users can force the program to 'Always Append' by selecting this option in the 'Saving Files' section of preferences.
- 2. Save TIFF files in the IBM version. When saving TIFF files you are prompted to choose which platform you prefer to work with, choose IBM if you want to share files. Macintosh machines can generally read IBM (Windows) TIFFs, but the same is not true the other way around.
- 3. Macintosh users save images to be shared on Windows formatted disks. If you are sharing images on a portable storage disk such as a Zip drive always use media that are formatted for Windows. Macintosh drives can usually read the Windows disks but Windows machines can't read the Macintosh versions.
- 4. Try to keep file names to eight characters or less. Older Windows machines and some web servers

have difficulty reading file names longer than eight characters. So just in case you happen to be trying to share with a cantankerous old machine get into the habit of using short names...and always appended of course.

Lossy and Lossless compression

Imaging files are huge. This is especially noticeable when you compare them with other digital files such as those used for word processing. A text document that is 100 pages long can easily be less than 1% the size of file that contains a single 10 × 8 inch digital photograph. With files this large it soon became obvious to the industry that some form of compression was needed to help alleviate the need for us photographers to be continuously buying bigger and bigger hard drives.

What has emerged over the last few years is two different ways to compress pictures. Each enables you to squeeze large image files into smaller spaces but one system does this with no loss of picture quality – *lossless* compression – whereas the other enables greater space savings with the price of losing some of your image's detail – *lossy* compression.

What is compression?

All digital picture files store information about the color, brightness and position of the pixels that make up the image. Compression systems reorder and rationalize the way in which this information is stored. The result is a file that is optimized and therefore reduced in size. Large space savings can be made by identifying patterns of color, texture and brightness within images and storing these patterns once, and then simply referencing them for the rest of the image. This pattern recognition and file optimization is known as compression.

The compression and decompression process, or CODEC, contains three stages.

- 1. The original image is compressed using an algorithm to optimize the file.
- 2. This version of the file becomes the one that is stored on your hard drive or web site.
- 3. The compressed file is decompressed ready for viewing or editing.

If the decompressed file is exactly the same as the original after decompression, then the process is called 'lossless'. If some image information is lost along the way then it is said to be 'lossy'. Lossless systems typically can reduce files to about 60% of their original size, whereas lossy compression can reduce images to less than 1%.

There is no doubt that if you want to save space and maintain the absolute quality of the image then the only choice is the lossless system. A good example of this would be photographers, or illustrators, archiving original pictures. The integrity of the image in this circumstance is more important than the extra space it takes to store it.

On the other hand (no matter how much it goes against the grain) sometimes the circumstances dictate the need for smaller file sizes even if some image quality is lost along the way. Initially you might think that any system that degrades my image is not worth using, and in most circumstances, I would have to agree with you. But sometimes the image quality and the file size have to be balanced. In the case of images on the web they need to be incredibly small so that they can be transmitted quickly over slow telephone lines. Here some loss in quality is preferable to images that take 4 or 5 minutes to appear on the page. This said, I always store images in a lossless format on my own computer and only use a lossy format when it is absolutely crucial to do so.

Unlike other imaging packages Photoshop CS provides a range of compression options when saving your pictures in the TIFF format

Balancing compression and image quality

One of the by-products of the tiny files produced using lossy compression systems is the inclusion of image artifacts or errors in the compressed file. These errors are a direct result of the lossy compression process and their appearance becomes more apparent as file sizes become smaller. One of the key tasks of any image-maker who regularly needs to compress their files is to judge what level of compression produces an acceptable level of artifacts whilst maintaining usable file sizes. Photoshop CS provides two visual tools to aid in this process. Both provide previews of how the picture will look after compression plus a prediction of its reduced file size. The 'Save for Web' option has quickly become a favorite with desktop compressors everywhere. When Adobe initially included support for the JPEG format in its flagship image editing software

the process was based around a simple dialog with a slider used to determine the amount of compression applied to the image file. The 'Save for Web' option а much clearer and more visual approach and provides live previews of the compressed file giving the user the chance to balance file size and image quality with all

the artifact 'cards clearly on the table'. In addition to JPEG, GIF and PNG files can be saved using the Save for Web feature as well.

New for CS is the option to save your picture in the JPEG2000 format. The option is accessed not as you would expect in the Save for Web feature, but rather via the File > Save As dialog. Selecting JPEG2000 as your file type displays the JPEG2000 dialog which includes a post-compression preview, compression amount control and a files size prediction. Adobe has also made use of the extra features built into the JPEG2000 algorithm to provide a 'lossless' option.

JPEG2000

The last couple of years has seen a lot of development work in the area of image compression. In the year 2000 the specifications for a new version of JPEG were released with the first commercial programs using this technology hitting the market a few months later. The revision, called JPEG2000, uses wavelet technology to produce smaller and sharper files than traditional JPEG. The standard also includes options to use different compression settings and color depths on selections within the image itself. It is also possible to save images in a lossless form. CS is the first Photoshop version with the ability to save pictures as a JPEG2000 file built in.

	Format	Compression amount	Original file size	Compressed file size	Lossy/ Lossless
pressic Ints	JPEG	Minimum		0.14MB	Lossy
	JPEG	Maximum		2.86MB	Lossy
	JPEG2000	Minimum		0.07MB	Lossy
	JPEG2000	Maximum	20.0MB (PSD file)	2.54MB	Lossy
	JPEG2000			5.40MB	Lossless
	TIFF	LZW		10.30MB	Lossless
25	TIFF	Zip		10.10MB	Lossless
ŃΕ	TIFF	None		27.30MB	Lossless
つ の 📗	PSD			20.00MB	Lossless

How lossy is lossy?

The term lossy means that some of the image's quality is lost in the compression process. The amount and type of compression used determines the look of the end result. Standard JPEG and JPEG2000 display different types of 'artifacts' or areas where compression is apparent. The level of acceptable artifacts and practical file sizes will depend on the required outcome for the picture.

To help ensure that you have the best balance of file size and image quality make sure that you:

- Use the Save for Web and Save As > JPEG2000 features as these both contain a postcompression preview option.
- Always examine the compressed image at a magnification of 100% or greater so that unacceptable artifacts will be obvious.

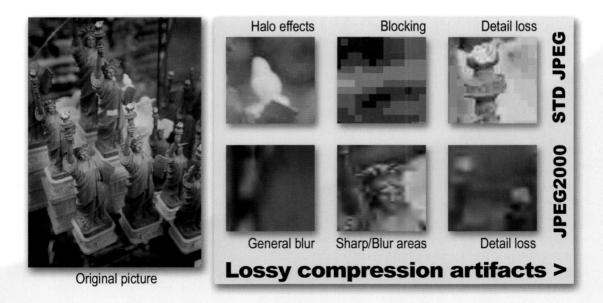

Resolution

Resolution is perhaps the most important and the most confusing subject in digital imaging. It is important because it is linked to quality. It is confusing because the term '**resolution**' is used to describe at what quality the image is captured, displayed or output through various devices.

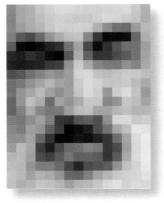

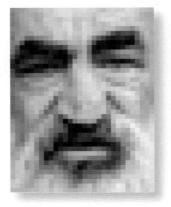

10 pixels per inch

20 pixels per inch

40 pixels per inch

Resolution determines image quality and size

Increasing the total number of pixels in an image at the scanning or capture stage increases both the quality of the image and its file size. It is '**resolution**' that determines how large or small the pixels appear in the final printed image. The greater the resolution the smaller the pixels, and the greater the apparent sharpness of the image. Resolution is stated in '**pixels per inch**' or '**ppi**'.

Note > With the USA dominating digital photography, measurements in inches rather than centimeters are commonly used - 1 inch equals exactly 2.54 centimeters.

The images to the right have the same pixel dimensions (300 × 300) but different resolutions. The large image has a resolution half that of the small one. A digital image can be made to appear bigger or smaller without changing the total number of pixels, e.g. a small print or a big poster. This is because a pixel has no fixed size. The pixel size, and therefore the resulting document size, is determined by the resolution assigned to the image by the capture device or image editing software. Increasing the resolution of a digital image decreases the size of the pixels and therefore the output size of the file.

Note > When talking about the 'size' of a digital image it is important to clarify whether it is the pixel dimensions or the document size (measured in inches or centimeters) that are being referred to.

PSSENTIA SKIIS >>>

Capture, image and output resolutions

We can talk about scanning resolution, image resolution, monitor resolution and printer resolution. They are all different, but they all come into play when handling a single digital image that is to be printed. In a simple task of scanning a 4×6 inch postcard-sized original with the aim of producing a high quality 8×12 inch digital enlargement, various resolutions can be quoted as we move through the chain of processes involved in creating a digital print.

35mm film - scanned at 1800dpi

Print – scanned at 400dpi

Digital file

Pixel dimensions: 1600 × 2400 RGB file size: 11 megabytes Grayscale file size: 3.67 megabytes

Adjustment in Photoshop
Go to 'Image > Image Size'
Change resolution to **220ppi**Change print size to 7 × 10.5 inches

Note > Retain pixel dimensions.

Output

Image printed on A4/US letter paper* at 720dpi (image resolution 220ppi).

* Coated paper recommended.

Example: A 4×6 inch print is scanned at 400dpi and displayed at 72dpi on a medium resolution monitor. Using image editing software the image resolution is changed to 220ppi (the pixel dimensions remain the same). The image is then printed using an inkjet printer with a printer resolution of 720dpi. The different resolutions associated with this chain of events are:

- Scanning resolution
- Display resolution
- Image resolution
- Output device resolution.

Dpi and ppi

If manufacturers of software and hardware were to agree that dots were round and pixels were square it might help users differentiate between the various resolutions that are often quoted. If this was the case the resolution of a digital image file would always be quoted in 'pixels per inch', but this is not the case.

At the scanning stage some manufacturers use the term dpi instead of 'ppi'. When scanning, 'ppi' and 'dpi' are essentially the same and the terms are interchangeable, e.g. if you scan at 300dpi you get an image that is 300ppi.

When working in Photoshop image resolution is always stated in ppi. You will usually only encounter dpi again when discussing the monitor or printer resolution. The resolutions used to capture, display or print the image are usually different to the image resolution itself.

Note > Just in case you thought this differentiation between ppi and dpi is entirely logical – it isn't. The industry uses the two terms to describe resolution, 'pixels per inch' (ppi) and 'dots per inch' (dpi), indiscriminately. Sometimes even the manufacturers of the software and hardware can't make up their mind which of the two they should be using, e.g. Adobe refer to image resolution as ppi in Photoshop and dpi in InDesign...such is the non standardized nomenclature that remains in digital imaging.

File size and resolution

When we use the measurement 'ppi' or 'pixels per inch' we are referring to a linear inch, not a square inch (ignore the surface area and look at the length).

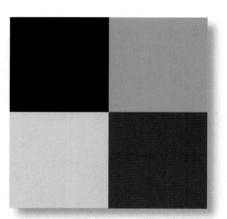

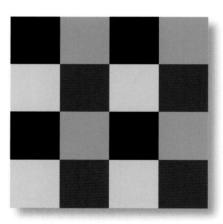

File size is directly linked to the **total** number of pixels covering the entire surface area of the digital image. Doubling the image output dimensions or image resolution quadruples the total number of pixels and the associated file size in kilobytes or megabytes.

Note > Handling files with excessive pixel dimensions for your output needs will slow down every stage of your digital image process including scanning, saving, opening, editing and printing. Extra pixels above and beyond what your output device needs will not lead to extra quality. Quality is limited or 'capped' by the capability of the output device.

Calculating file size and scanning resolution

Scanning resolution is rarely the same as the resolution you require to print out your image. If you are going to create a print larger than the original you are scanning, the scanning resolution will be greater than the output resolution, e.g. a 35mm negative will have to be scanned in excess of 1200ppi if a 150ppi A4 color print is required. If the print you require is smaller than the original the scanning resolution will be smaller than the output resolution.

The smaller the original the higher the scanning resolution.

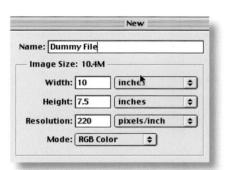

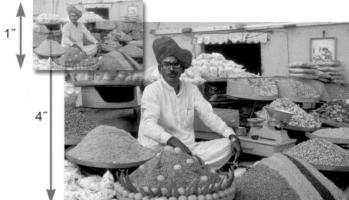

Magnification x output resolution = scanning resolution scanning resolution = 4 x 300ppi = 1200ppi

To calculate the correct file size and scanning resolution for the job in hand you can:

- 1. Go to 'File > New' in Photoshop, type in the document size, resolution and mode you require and then make a note of the number of megabytes you require from the scanning process. Then adjust the scanning resolution until the required number of megabytes is captured.
- 2. Multiply the magnification factor (original size to output size) by the output resolution (as dictated by the output device) to find the scanning resolution (not so difficult as it sounds!).

Size & mode	Optimum res 72ppi low quality	olution red 150ppi medium	200ppi	output de 300ppi high quality	vice
A3 RGB	2.86MB	12.44MB	22.20MB	49.80MB	size
A3 Grayscale	1.98MB	4.14MB	7.40MB	16.60MB	
A4 RGB	1.43MB	6.22MB	11.10MB	24.90MB	<u>e</u>
A4 Grayscale	0.49MB	2.07MB	3.70MB	8.30MB	
A5 RGB	0.73MB	3.11MB	5.52MB	12.50MB	
A5 Grayscale	0.24MB	1.04MB	1.84MB	4.24MB	

Megapixels and megabytes

Six megapixel digital cameras are currently the affordable 'end' of professional digital capture. The image resolution produced by these digital cameras is not directly comparable to 35mm film capture but the images produced can satisfy most of the requirements associated with professional 35mm image capture.

Six megapixel cameras capture images with pixel dimensions of around 3000 × 2000 (6 million pixels or 6 'Megapixels'). The resulting file sizes of around 17MB are suitable for commercial print quality (300ppi) to illustrate a single page in a magazine. Digital capture is now an affordable reality for most professional photographers.

Useful specifications to remember

- Typical high-resolution monitor: 1024 × 768 pixels
- Typical full-page magazine illustration: 3000 × 2000 (6 million pixels)
- High-resolution monitor: 96ppi
- High quality inkjet print: 200ppi
- Magazine quality printing requirements: 300ppi
- Full-screen image: 2.25MB (1024 × 768)
- Postcard-sized inkjet print: 2.75MB
- A4 inkjet print: 10MB
- Full-page magazine image at commercial resolution: 20MB

Note > Remember to double the above file sizes if capturing in 16-bit per channel mode.

A 20MB file will usually suffice if you are not sure of the intended use of the digital file. Twenty megabytes is enough to create an A3 inkjet print or a full-page magazine illustration. Thirty-five millimeter film scanned with a scanning resolution of **2300** will produce a 20.3MB file (2173 pixels × 3260 pixels).

AOHSOLOHO <<<

Image size

Before retouching and enhancement can take place the '**image size**' must be adjusted for the intended output (scanning resolution will probably require changing to output resolution). Choose Image > Image Size. This will ensure that optimum image quality and computer operating speed are achieved. Image size is described in three ways:

- Pixel dimensions (the number of pixels determines the file size in terms of kilobytes).
- Print size (output dimensions in inches or centimeters).
- Resolution (measured in pixels per inch or ppi).

If one is altered it will affect or impact on one or both of the others, e.g. increasing the print size must either lower the resolution or increase the pixel dimensions and file size. The image size is usually changed for the following reasons:

- Resolution is changed to match the requirements of the print output device.
- Print output dimensions are changed to match display requirements.

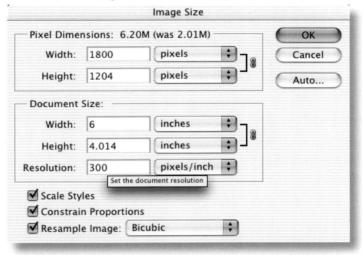

'Resample Image' and 'Bicubic' options selected. Interpolation will lead to increased pixel dimensions and file size

Image size options

When changing an image's size a decision can be made to retain the proportions of the image and/or the pixel dimensions. These are controlled by the following:

- If 'Constrain Proportions' is selected the proportional dimensions between image width and image height are linked. If either one is altered the other is adjusted automatically and proportionally. If this is not selected the width or height can be adjusted independently of the other and may lead to a distorted image.
- If 'Resample Image' is selected adjusting the dimensions or resolution of the image will allow the file size to be increased or decreased to accommodate the changes. Pixels are either removed or added. If deselected the print size and resolution are linked. Changing width, height or resolution will change the other two. Pixel dimensions and file size remain constant.

Resampling

An image is 'resampled' when its pixel dimensions (and resulting file size) are changed. It is possible to change the output size or resolution without affecting the pixel dimensions (see 'Resolution'). Resampling usually takes place when the pixel dimensions of the original capture or scan do not precisely match the requirements for output (size and resolution).

Downsampling decreases the number of pixels and information is deleted from the image. Increasing the total number of pixels or resampling up requires 'interpolation' (new pixel information is added based on color values of the existing pixels).

Effects of excessive resampling

Excessive resampling up can result in poor image quality. The image will start to appear blurry and out of focus. Avoid the need for resampling up by capturing at a high enough resolution or limiting output size. Applying the '**Unsharp Mask**' filter to an image that has been resampled up can help sharpen a blurry image.

Resample only when there is no other option

The thinking behind such a statement is sound. The best results are obtained when you only use the pixels contained in the original captured or scanned image. But what about the situations when you need to have a bigger picture irrespective of the consequences. When faced with this problem those 'non-professional' shooters amongst us have been happily upscaling their images using the Resample option in the Image Size feature in Photoshop, whilst those of us who obviously know better have been running around with small, but beautifully produced, prints.

Interpolation

Well it seems that in recent years a small revolution in refinement has been happening in the area of interpolation technologies. The algorithms and processes used to apply them have been continuously increasing in quality until now they are at such a point that the old adages such as

Sensor dimension/output resolution = maximum print size

don't always apply. Using either software or hardware versions of the latest algorithms it is now possible to take comparatively small files and produce truly large prints of good quality.

Resampling techniques

Bicubic – All resampling techniques in Photoshop use the best interpolation settings of Bicubic, Bicubic Sharper, or Bicubic Smoother in conjunction with the Image > Image Size feature. The standard approach uses a 4 × 4 sampling scheme of the original pixels as a way of generating new image data. With the Resample and Constrain Properties options selected, the new picture dimensions are entered into the 'width' and 'height' areas of the dialog. Clicking OK will then increase the number of pixels in the original.

Use the Unsharp Mask after resampling rather than before and restrict the amount of resampling that is performed on a single image. If the software allows the user to crop, resize and rotate the image at the same time, this function should be utilized whenever possible.

Bicubic via LAB – In this technique the mode of the picture is changed from RGB to LAB first using the Image > Mode > Lab command. The two color channels (A and B) are then hidden in the channels palette and the bicubic interpolation is applied to just the lightness (L) channel. The color channels are then switched back on. The theory behind this approach is that by only interpolating the lightness channel the enlarged image will suffer less deterioration overall.

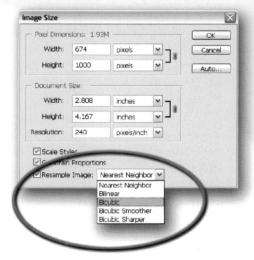

Stair interpolation – There is a growing school of thought that states that increasing the size of an image by several smaller steps will produce a sharper more detailed result than making the upscale enlargement in a single jump. Most professionals who use this approach increase the size of their images by 10% each time until they reach the desired pixel dimensions.

The advances in the algorithms and procedures used to create large images have dramatically improved over the last few years. I still cringe saying it, but it is now possible to break the 'I must never interpolate my images rule' in order to produce more print area for the pixels I have available.

Resampling guidelines:

When resampling keep in mind the following guidelines for ensuring the best results:

- 1. Images captured with the correct number of pixels for the required print job will always produce better results than those that have been interpolated.
- 2. The softening effect that results from high levels of interpolation is less noticeable in general, landscape or portrait images and more apparent in images with sharp edged elements.
- 3. The more detail and pixels in the original file the better the interpolated results will be.
- 4. A well-exposed sharply focused original file that is saved in a lossless format such as TIFF is the best candidate image for upsizing.

What is interpolation anyway?

Interpolation is a process by which extra pixels are generated in a low resolution image so that it can be printed at a larger size than its original dimensions would normally allow. Interpolation, or as it is sometimes called, upsizing, can be implemented via software products such as the Image Size > Resample option in Photoshop or by using the resize options in the printer's hardware.

Both approaches work by sampling a group of pixels (a 4×4 matrix in case of bicubic interpolation) and using this information together with a special algorithm as a basis for generating the values for newly created pixels that will be added to the image. The sophistication of the algorithm and the size of the sampling set determine the quality of the interpolated results.

Printer-based resampling

An alternative approach to using Photoshop to resample your picture is to make use of the 'scaling' options in your printer driver dialog. Most desktop and high-end laboratory digital printers are capable of the interpolation necessary to produce big prints.

When outsourcing to a professional printer the file is kept to its original pixel dimensions and the

resolution is reduced so that the print size will equal the required print dimensions. The digital printer is then instructed to interpolate the file as it was printing to its optimum resolution of the machine. On the desktop a similar process is used with the digital photographer selecting a scale value in the print driver dialog that is greater than 100%.

Letting the output device perform the interpolation of the image has the following advantages – the process does not require the photographer to change the original file in any way and it removes an extra processing step from the file preparation process.

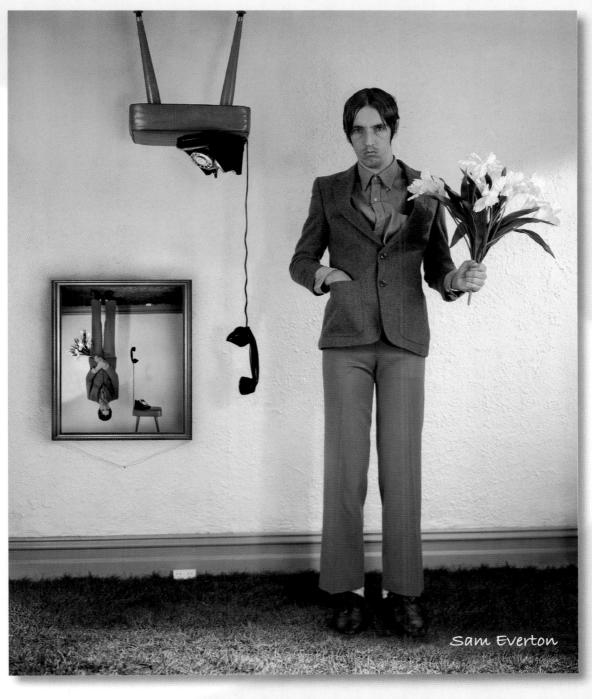

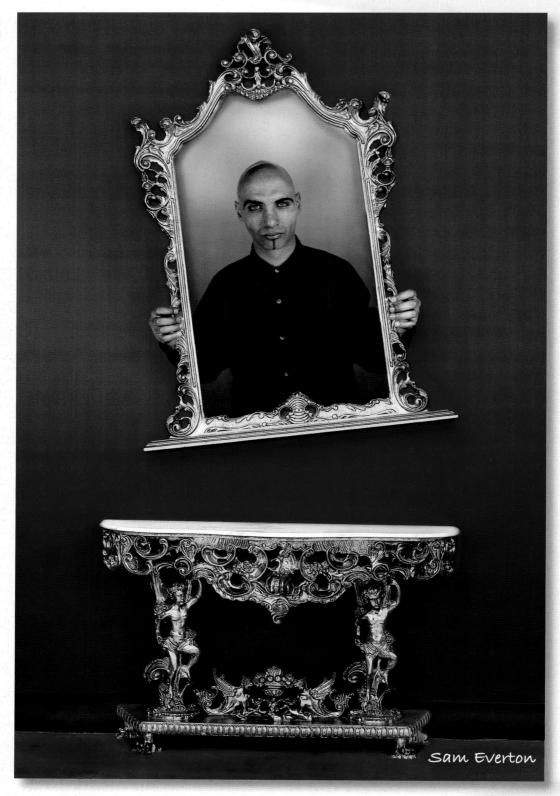

capture and enhance photoshop photo

nop photoshop photoshop photoshop photoshop photoshop

essential skills

- Capture high quality digital images for image editing.
- Gain control over the color, tonality and sharpness of a digital image.
- Duplicate, optimize and save image files for print and for web.

SO HOMSOLLOHIN <<<

Introduction

This chapter will take you through the complete digital process from capture to output. It is intended as an introduction to provide the user with an overview for creating successful digital images.

Choose an image with full detail in the shadows and highlights

Image capture

Step I – Choosing an image

Select or create a softly lit color portrait image (diffused sunlight or window lighting would be ideal). The image selected should have detail in both the highlights and shadows and should have a range of colors and tones. An image with high contrast and missing detail in the highlights or shadows is not suitable for testing the effectiveness of the capture or output device.

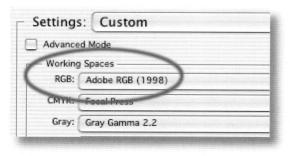

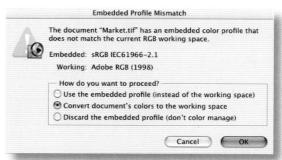

Step 2 – Adjusting the Color Settings

Set the working space to 'Full color management' or 'Adobe RGB (1998)' in the 'Color Settings' of your Adobe software.

Profile warnings: When you encounter a profile alert using Photoshop, select 'Convert document's colors to the working space' or 'Assign working RGB' and then click 'OK'.

Step 3 - Importing the image

Import the image into the computer using either of the following two options.

Digital camera

Images for this activity can be transferred directly to the computer from a digital camera. The image size should not be smaller than 2.75MB and if using the JPEG file format to capture images you should choose the high or maximum quality setting whenever possible.

0.0

Scanning device

Ensure the media to be scanned is free from dust and grease marks. Gloss photographic paper offers the best surface for flatbed scanning. A 6 inch × 4 inch print would be suitable for this activity. The scanning device can usually be accessed directly through the Adobe software. This is achieved by going to 'File > Import' and selecting the scanning software from the submenu.

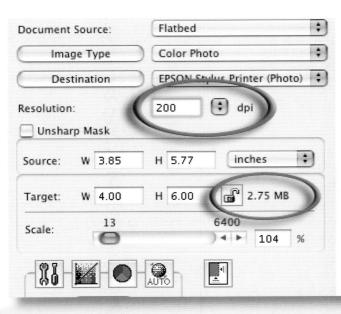

Set the scanning specifications and check the file size

Scanning specifications

40HS0L0Hd <<<

If you are using a scanner to convert your image to a digital file use the following options:

- Select the correct setting for scanning film or print.
- Select 'Preview' to view the image you are about to scan.
- Select the scanning area by dragging a rectangular marquee around your image area.
- · Deselect any Unsharp Mask/Sharpen options.
- Select a scanning resolution of 200dpi to create a digital image with a file size of approximately 2.75M for 24-bit scanning (check the file size in the scanning software after you have selected the scanning area and before scanning). Always scan with a little extra memory/pixels rather than a little less.
- Select 'Scan' and wait for the image to open in the image editing software.

Note > Increase the scanning resolution to 300dpi for print enlargements up to 6×8 inches and 400dpi for full A4 sized prints.

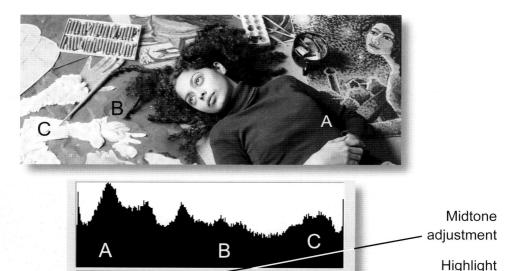

adjustment

Shadow adjustment

Image adjustment

Step 4 - Adjusting the tonality and color

When the image is opened in the editing software for the first time it is important to check how the capture device has handled or interpreted the tonality and color of the subject or original image. Press the 'Control' key (PC) or 'Command' key (Mac) and the letter 'L' on your keyboard to open the 'Levels' dialog box. The 'histogram' displayed in the Levels dialog box shows the brightness range of your image. The sliders beneath the histogram can be used to modify the shadow, midtone (gamma) and highlight tones or levels.

Note > You should attempt to modify the brightness, contrast and color balance at the capture stage to obtain the best possible histogram before editing begins in the software.

Adjusting the levels to control tonality

A good histogram (a broad tonal range with full detail in the shadows and highlights) will extend all the way from the slider on the left to the slider on the right. The histogram below indicates missing information in the highlights (on the right) and a small amount of 'clipping' or loss of information in the shadows (on the left).

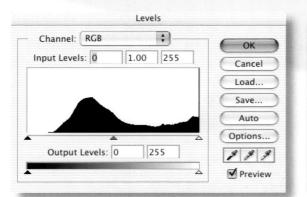

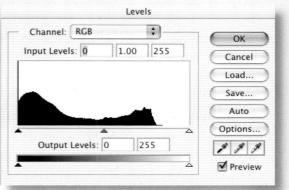

Histograms indicating image is either too light or too dark

Brightness

If the digital file is too light a tall peak will be seen to rise on the right side (level 255) of the histogram. If the digital file is too dark a tall peak will be seen to rise on the left side (level 0) of the histogram.

Solution: Decrease or increase the exposure/brightness in the capture device.

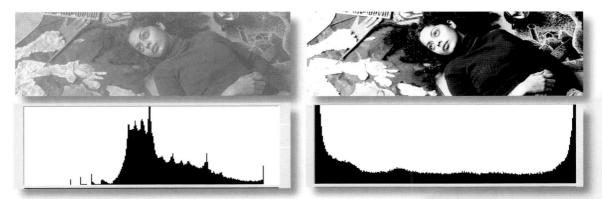

Histograms indicating image either has too much contrast or not enough

Contrast

If the contrast is too low the histogram will not extend to meet the sliders at either end. If the contrast is too high a tall peak will be evident at both extremes of the histogram.

Solution: Increase or decrease the contrast of the light source used to light the subject or the contrast setting of the scanning device. Using diffused lighting rather than direct sunlight or using fill-flash and/or reflectors will ensure that you start with an image with full detail.

Correcting a weak histogram

The final histogram should show that pixels have been allocated to most if not all of the 256 levels. If the histogram indicates large gaps between the ends of the histogram and the sliders (indicating a low contrast scan) the subject or original image should be recaptured.

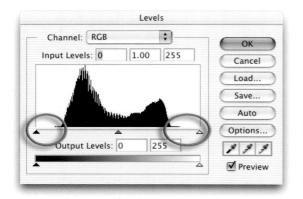

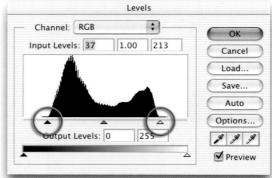

Small gaps can, however, be corrected by dragging the sliders to the start of the tonal information. Note how the sliders have been moved beyond the short thin horizontal line at the either end of the histogram. These low levels of pixel data are not representative of the broader areas of shadows and highlights within the image and can usually be clipped (moved to 0 or 255).

Moving the 'gamma' slider can modify the brightness of the midtones. If you select a Red, Green or Blue channel (from the channels pull-down menu) prior to moving the gamma slider you can remove a color cast present in the image. For those unfamiliar with color correction the command 'Variations' gives a quick and easy solution to the problem. After correcting the tonal range using the sliders click 'OK' in the top right-hand corner of the levels dialog box.

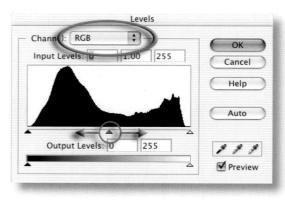

Note > Variations is not available for Photoshop users working in 16 bits per channel mode.

Color

Neutral tones in the image should appear desaturated on the monitor. If a color cast is present try to remove it at the time of capture or scanning if possible.

Solution: Control color casts by using either the white balance on the camera (digital) or an 80A or 80B color conversion filter when using tungsten light with daylight film. Use the available color controls on the scanning device to correct the color cast and/or saturation.

Using 'Variations' to adjust color

To access 'Variations' go to 'Image > Adjustments > Variations'. Use the 'Adjust Color Intensity' or 'Fine/Coarse' slider to increase or decrease the color differences between the images presented, then simply click on any thumbnail that looks better than the original.

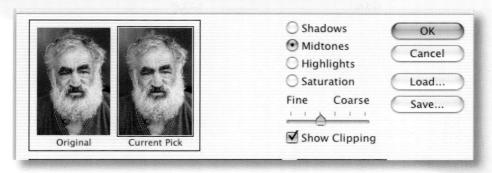

The color adjustments are automatically applied when you click 'OK'. To avoid 'clipping' the tonality of the image it is advisable to keep the 'Midtones' radio button checked when removing color casts. Save the adjusted image with a different name to the original. This will ensure that you have a master image that you can return to if you later feel that you would have done things a little differently.

Image size

Step 5 - Crop

Select the crop icon in the toolbox and enter the following cropping dimensions in the Options bar: $4 \text{ in } \times 6 \text{ in } \otimes 200 \text{ppi}$ (this will result in a file size of exactly 2.75MB). Drag the cropping marquee over the image area and press the return/enter key to crop the image. Move the mouse cursor inside the cropping marquee to move the marquee or click and drag a corner handle to adjust the size.

Note > Entering the letters 'in' after each measurement overrides the default unit measurements (which may be set to pixels or centimeters). Resolution is uniformly set to pixels/inch (ppi) and rarely pixels/cm.

Perfecting the crop

If the image is crooked you can rotate the cropping marquee by moving the mouse cursor to a position just outside a corner handle of the cropping marquee. A curved arrow should appear allowing you to drag the image straight.

Click and drag the corner handle to extend the image window to check if there are any remaining border pixels that are not part of the image. Press the 'return/enter' key on the keyboard to complete the cropping action. Alternatively press the 'esc' key on the keyboard to cancel the crop.

Note > The marquee tool is programmed to snap to the edges of the document as if they were magnetized. This can make it difficult to remove a narrow border of unwanted pixels. To overcome this problem you will need to go to the 'View' menu and switch off the 'Snap To' option.

Optimizing quality

Step 6 - Clean

The primary tools for removing dust and scratches are the 'Clone Stamp Tool' and the 'Healing Brush Tool' (Photoshop 7 and 8 only). The Clone Stamp is able to paint with pixels selected or 'sampled' from another part of the image. The Healing Brush is a sophisticated version of the Clone Stamp tool that not only paints with the sampled pixels but then 'sucks in' the color and tonal characteristics of the pixels surrounding the damage. The following procedures should be taken when working with either the Healing Brush or Clone Stamp tool.

- Zoom in to get a close look at the damage that needs to be repaired.
- Choose an appropriate soft edged brush from the brushes palette that just covers the width of the dust or scratch to be repaired.
- Select a sampling point by pressing the Option/Alt key and then clicking on an undamaged area of the image that is similar in tone and color to the damaged area.
- Move the mouse cursor to the area of damage.
- Click and drag the tool over the area to paint with the sampled pixels to conceal the damaged area (a cross hair marks the sampling point and will move as you paint).
- · Save the image file before proceeding to the next stage.

Note > Deselect 'Aligned' if you want to return to the initial sampling point each time you start to paint. If a large area is to be repaired with the Clone Stamp tool it is advisable to take samples from a number of different points with a reduced opacity brush to prevent the repairs becoming obvious.

Step 7 - Sharpen

Sharpnening the image is the last step of the editing process. Many images benefit from some sharpening even if they were photographed and scanned with sharp focus. The 'Unsharp Mask' filter is used to sharpen the edges and corrects any blurring introduced during the digital process. The Unsharp Mask increases sharpness by emphasizing the edges where different tones meet.

The Unsharp Mask works by increasing the contrast at the edges. The pixels along the edge on the lighter side are made lighter and the pixels along the edge on the darker side are made darker. Before you use the Unsharp Mask go to 'View > Actual Pixels' to adjust the screen view to 100%. To access the Unsharp Mask go to 'Filter > Sharpen > Unsharp Mask'. Start with an average setting of 100% for 'Amount', a 1 pixel 'Radius' and a 'Threshold' of 3. The effects of the Unsharp Mask filter are more noticeable on-screen than in print. For final evaluation always check the final print and adjust if necessary by returning to the saved version from the previous stage. The three sliders control:

Amount – this controls how much darker or lighter the pixels are adjusted. Eighty to 180% is normal.

Radius – controls the width of the adjustment occurring at the edges. There is usually no need to exceed 1 pixel if the image is to be printed no larger than A4/US letter. A rule of thumb is to divide the image resolution by 200 to determine the radius amount, e.g. 200ppi ÷ 200 = 1.00.

Threshold – controls where the effect takes place. A zero threshold affects all pixels whereas a high threshold affects only edges with a high tonal difference. The threshold is usually kept very low (0 to 2) for images from digital cameras and medium or large format film. The threshold is usually set at 3 for images from 35mm. Threshold is increased to avoid accentuating noise, especially in skin tones.

Save

Step 8 - Save, duplicate, resize and save again

Go to the 'File' menu and select 'Save As'. Name the file, select 'TIFF' or 'Photoshop' as the file format and the destination 'Where' the file is being saved. Check the 'Embed Color Profile' box and click 'Save'

Important > Always keep a back-up of your work on a remote storage device if possible.

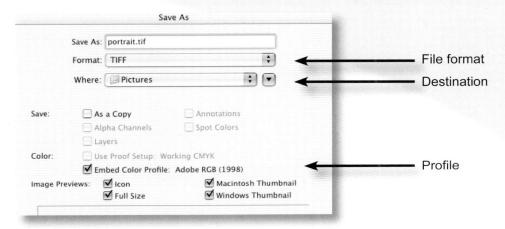

Duplicate your file by going to 'Image > Duplicate Image' command. Rename the file and select OK. Go to 'Image > Image Size'. Check the 'Constrain Proportions' and 'Resample Image' boxes. Type in 600 pixels in the 'Height' box. Anything larger may not fully display in the browser window of a monitor set to 1024 × 768 pixels without the viewer having to use the scroll or navigation bars.

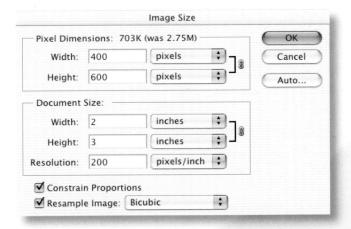

An alternative to using this image resizing approach is to use the Crop tool. Typing in the dimensions 400px and 600px, dragging the crop marquee over the image and then committing the crop will also resize the image quickly and effectively.

Note > Internet browsers do not respect the resolution and document size assigned to the image by image editing software – image size is dictated by the resolution of the individual viewer's monitor. Two images that have the same pixel dimensions but different resolutions will appear the same size when displayed in a web browser. A typical image resolution that is suitable for viewing on a monitor is often stated as being 72ppi but actual monitor resolutions vary enormously.

JPEG format

Set the image size on screen to 100% (this is the size of the image as it will appear in a web browser on a monitor of the same resolution). Go to 'File' menu and select 'Save As'. Select JPEG from the Format menu. Label the file with a short name with no gaps or punctuation marks (use an underscore if you have to separate two words) and finally ensure the file carries the extension .jpg (e.g. portrait_one.jpg). Click 'OK' and select a compression/quality setting from the 'JPEG Options' dialog box. With the Preview box checked you can check to see if there is excessive or minimal loss of quality at different compression/quality settings in the main image window.

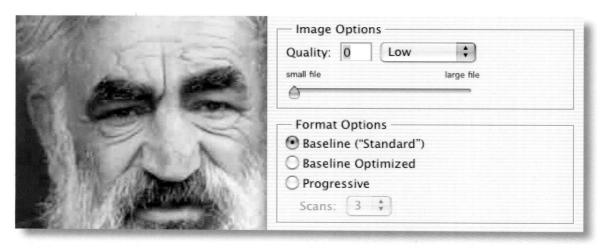

Choose a compression setting that will balance quality with file size (download time). Excessive compression leads to image artifacts, lowering the overall quality of the image.

File preparation overview

- 1. Select an image with full detail.
- 2. Select appropriate 'Color Settings' in the image editing software.
- 3. Acquire the image from the capture device with sufficient pixels for quality printing.
- 4. Adjust the tonality and color to ensure the histogram is optimized for quality output.
- 5. Remove any dust and scratches.
- 6. Apply the Unsharp Mask.
- 7. Save the image as a TIFF or Photoshop file.
- 8. Duplicate the file and resize for uploading to the web.
- 9. Save the file as a JPEG with a suitable compression/quality setting.

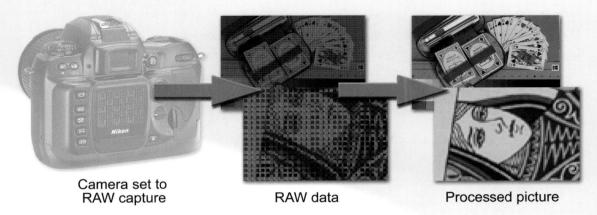

Capturing in RAW

More and more medium to high end cameras are being released with the added feature of being able to capture and save your pictures in RAW format. Selecting the RAW format stops the camera from processing the color separated (primary) data from the sensor, and reducing the image's bit depth and saves the picture in this unprocessed format. This means that the full description of what the camera 'saw' is saved in the image file and is available to you for use in the production of quality pictures. Many photographers call this type of file a 'digital negative'.

Sounds great, doesn't it? All the quality of an information-rich image file to play with, but what is the catch? Well RAW files have to be processed before they can be used in a standard image editing application. To access the full power of these digital negatives you will need to employ a special dedicated RAW editor. Photoshop CS is the first version of the program to have such an editor built into the program. Designed specifically to allow you to take the unprocessed RAW data directly from your camera's sensor and convert it into a usable image file format, the Photoshop RAW editor also provides access to several image characteristics that would otherwise be locked into the file format. Variables such as color space, white balance mode, image sharpness and tonal compensation (contrast and brightness) can all be accessed, edited and enhanced as apart of the conversion process. Performing this type of editing on the full high-bit, RAW data provides a better and higher quality result than attempting these changes after the file has been processed and saved in a non-RAW format such as TIFF or JPEG.

So what is in a RAW file?

To help consolidate these ideas in your mind try thinking of a RAW file as having three distinct parts:

Camera data, usually called the EXIF data. Including things such as camera model, shutter speed and aperture details, most of which cannot be changed.

Image data which, though recorded by the camera, can be changed in a RAW editor and the settings chosen here directly affect how the picture will be processed. Changeable options include color mode, white balance, saturation, distribution of image tones and application of sharpness.

The image itself. This is the data drawn directly from the sensor sites in your camera in a non interpolated form. For most RAW enabled cameras, this data is supplied with a 16-bit color depth providing substantially more colors and tones to play with when editing and enhancing than found in a standard 8-bit camera file.

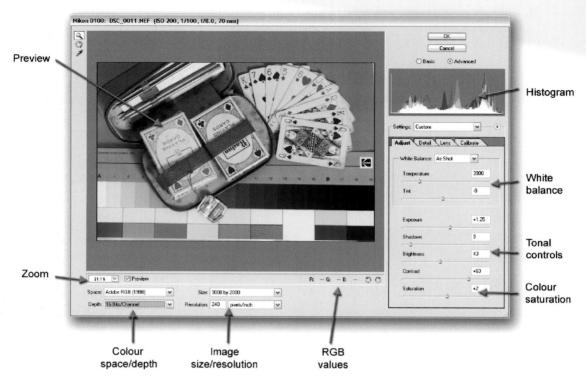

RAW processing in action

When you open a RAW file into Photoshop CS you are presented with a RAW editing dialog containing a full color, interpolated preview of the sensor data. Using a variety of menu options, dialogs and image tools you will be able to interactively adjust image data factors such as tonal distribution and color saturation. Many of these changes can be made with familiar editing tools like levels and curves controls. The results of your editing can be reviewed immediately via the live preview image and associated histogram graphs.

After these general image editing steps have taken place you can apply some enhancement changes such as filtering for sharpness using an Unsharp Mask tool, removing moiré effect and applying some smoothing.

The final phase of the process involves selecting the color space, color depth, pixel dimensions and image resolution with which the processed file will be saved. Clicking the OK button sets the program into action applying your changes to the RAW file, whilst at the same time interpolating the Bayer data to create a full color image and then opening the processed file into the full Photoshop workspace.

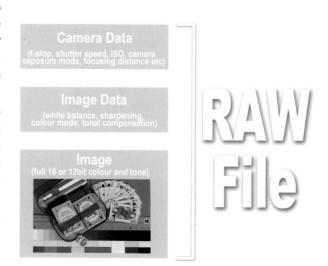

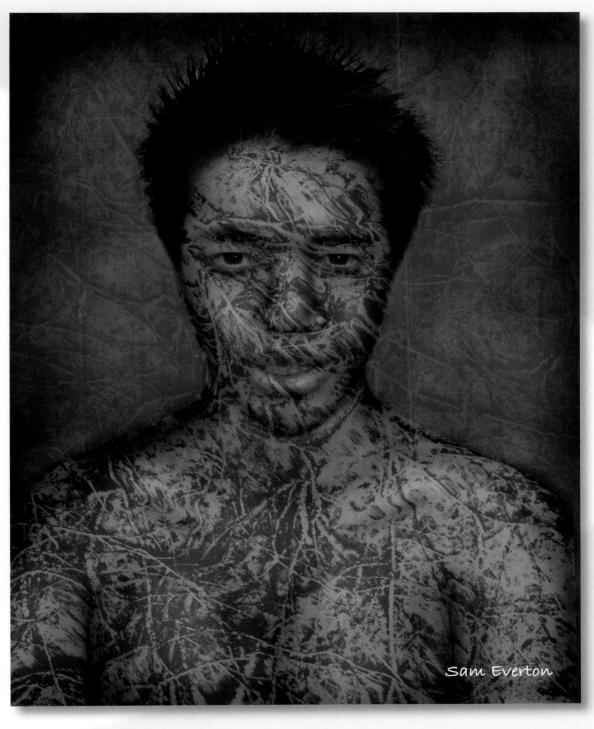

digital printing

photo

essential skills

- ~ Control the color accuracy between monitor preview and print.
- ~ Understand the technical processes and procedures involved with producing a digital print.
- ~ Print a color managed digital image using a desktop inkjet printer.
- ~ Create a strategy to compensate for visual differences between the monitor preview and print.

Printing to an inkjet printer

Creating high quality prints when printing to a desktop inkjet printer can be a mystifying, painful and costly experience. If you are using an inkjet printer you can really only hope to get close to the quality of traditional analog prints from a darkroom if you print on digital 'photo paper' using a '6-ink' inkjet printer (it is, however, possible to achieve reasonable print quality using a '4-ink' inkjet printer and 'photo quality' or 'high-resolution' paper). High quality photo paper/film ensures that images appear sharp, with small ink dots and richly saturated colors. Ink dots from an inkjet printer are most noticeable in the highlights of an image. The addition of light cyan and light magenta inks to the normal 3-ink color cartridge ensures smooth photographic quality highlights. Epson 6-ink printers retail under the 'Epson Stylus Photo' name, whilst Canon's 6-ink models are referred to as 'bubble-jet' printers.

RBG to CMYK

Color on a computer's monitor is created by mixing red, green and blue (RGB) light whilst the reflected light from cyan, magenta, yellow and black inks creates color on the printed page. A perfect match is therefore very difficult, as the range or 'gamut' of colors capable of being reproduced by each of the two display mediums is similar but different. The colors present in a digital image file have to be translated or converted to fit the gamut or 'color space' of each output device or printer.

Profiles

The accuracy of color translation has been helped in recent years by the introduction of 'ICC profiles', e.g. 'sRGB' and 'Adobe RGB (1998)'. These can be tagged onto an image by capture devices and some image editing programmes as a way of recording how the colors in the digital image file actually appear to a specific capture device or when displayed on a particular type of monitor. In order to ensure this new level of visual consistency across all users we must first ensure that our monitor's contrast, brightness and color are within an acceptable range. The process of standardizing the monitor's display characteristics is called 'monitor calibration'.

Monitor calibration and working color space

Reset the 'Target White Point' (sometimes referred to as 'Adjusted White Point') of the monitor to D65 or 6500, which is equivalent to daylight (the same light you will use to view your prints), using 'Adobe Gamma' (from the 'Control Panel/s' in Windows and Mac OS9) or 'Display Calibrator' (from the 'Utilities' folder in Mac OSX).

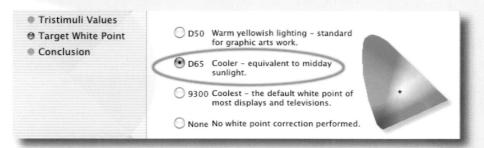

Note > See 'The Digital Darkroom' for extended information on this important subject.

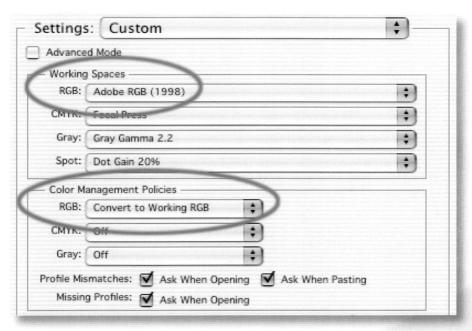

Select an appropriate color setting for the software

To create an on-screen preview of the image that will be eventually output by your printer, it is important to select a 'working space' for Photoshop that is sympathetic to the range of colors that can be achieved by your inkjet printer using good quality 'photo paper'. The most suitable working space currently available is called 'Adobe RGB (1998)'. To implement this working space choose 'Color Settings' in Photoshop and set the workspace to 'Adobe RGB (1998)' from the RGB pull-down menu. In the 'Color Management Policies' section, select 'Convert to Working RGB' from the 'RGB' pull-down menu.

RGB and CMYK

Inkjet printers, although using CMYK (cyan, magenta, yellow and black) inks are designed to print from RGB files. You are therefore only required to set the CMYK color space in the Adobe color settings if you intend to convert your RGB files to CMYK files for output through a 'print service provider' or printing company in the industry. Consult your print service provider for an appropriate CMYK profile for your intended job.

Profiles

Photoshop alerts the user to any possible problems when opening an image when there is no profile (common with many digital cameras or scanning devices), or if the profile does not match your working space.

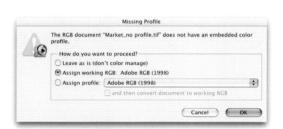

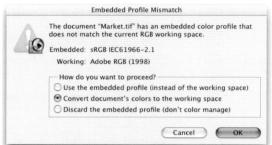

Missing and mismatched profiles

When confronted with the 'Embedded Profile Mismatch' or 'Missing Profile' alert, check the 'Convert document's colors to the working space' or 'Assign working RGB' and then click 'OK'. The most common profile that you will encounter that is not Adobe RGB (1998) is 'sRGB', which is really only suitable for images destined for monitor display, and therefore unsuitable for printing purposes due to its restricted color gamut.

An asterisk denotes a mismatched profile

If the profile of an image open in Photoshop does not match the working space an asterisk appears after 'RGB' in the title bar of the image window. The profile of an image can be changed at any time by going to 'Image > Mode > Convert to Profile'.

Note > When saving images ensure the 'embed profile' box is checked (see 'Capture and Enhance').

Preflight checklist

If color consistency is important, check that your ink cartridges are not about to run out of ink and that you have a plentiful supply of good quality paper (same surface and same make). It is also worth starting to print when there are several hours of daylight left, as window light (without direct sun) is the best light to judge the color accuracy of the prints. If you are restricted to printing in the evening it may be worthwhile checking out 'daylight' globes that offer a more 'neutral' light source than tungsten globes or fluorescent tubes. It is also important to position the computer's monitor so that it is not reflecting any light source in the room (including the window light).

Keeping a record

The settings of the translation process, the choice of paper, the choice of ink and the lighting conditions used to view the print will all have enormous implications for the color that you see on the printed page. The objective when you have achieved a color match is to maintain consistency over the process and materials so that it can be repeated with each successive print. It is therefore important to keep a track of the settings and materials used. There is only one thing more infuriating that not being able to achieve accuracy, and that is achieving it once and not being sure how you did it. Some words of advice...WRITE IT DOWN!

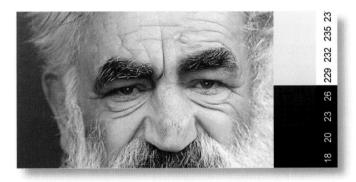

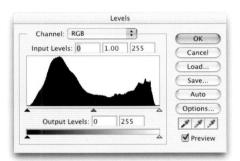

229 232 235 237 240 242 245 247 250 252 255

Quality prints from quality files

As a starting point it is advisable to choose a portrait image with highlight and shadow detail and a good range of saturated and desaturated colors. Check the image's histogram to ensure the image has a full tonal range and make adjustments if required.

Note > You can add a 'grayscale' or 'step wedge' to one side of the image to further aid color and tone assessment. Fill rectangular selections with specific tones/levels of gray. Concentrate on the extreme shadow and highlight values to gain an idea of how your printer handles these tones. Add a desaturated midtone to detect a color cast.

Soft proofing

Although the image that appears on your monitor has been standardized (after the calibration process and the implementation of the Adobe RGB working space), the printed image from this standardized view would appear different if printed through a variety of different inkjet printers onto different paper surfaces or 'media types'. In Photoshop it is possible to further alter the visual appearance of the image on your monitor so that it more closely resembles how it will actually appear when printed by your specific make and model of inkjet printer on a particular paper surface. This process is called 'soft proofing'.

To set up the soft proof view go to View > Proof Setup > Custom. From the Profile menu select the profile of your printer and paper or 'media type'. Choose 'Perceptual' from the 'Intent' menu and check the 'Use Black Point Compensation' and 'Paper White' boxes. Save these settings so they can be accessed guickly the next time you need to soft proof to the same printer and media type.

When you view your image with the soft proof preview the color and tonality will be modified to more closely resemble the output characteristics of your printer and choice of media.

The image should now be edited with the soft proof preview on, to achieve the desired tonality and color that you would like to see in print. It is recommended that you edit in 'Full Screen Mode' to remove distracting colors on your desktop and use adjustment layers to modify and fine tune the image on screen. Avoid using 'Brightness and Contrast' that will result in a loss of highlight or shadow detail (use a 'Curves' adjustment instead).

Start the printing process by selecting 'Print Preview' from the file menu.

- 1. Check the 'Show More Options' box in the corner of the print dialog box and select 'Color Management' from the pull-down menu.
- 2. Select the profile for the printer and media type you are using from the 'Profile' menu. The 'Source Space' indicates the current profile of the image you are about to print.
- 3. Choose 'Perceptual' as the 'Intent' and check the 'Use Black Point Compensation' box. These instructions will guide Adobe to make the required translation from the source to the output color space.
- 4. Click on 'Page Setup' to select the paper size and orientation (horizontal or vertical).
- 5. Deselect the 'Center Image' box to move the print to the corner of the page.

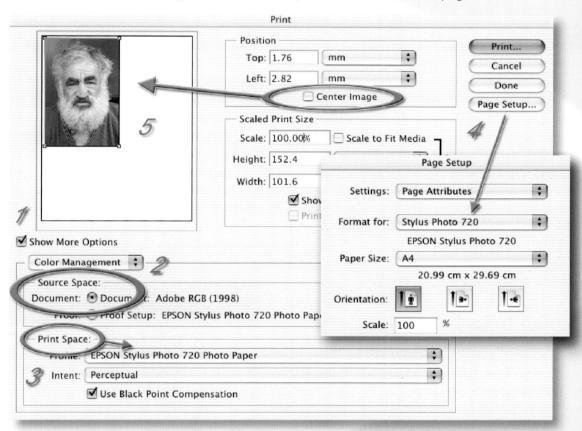

Note > To print just a portion of the image to test the color accuracy make a selection and click on the 'Print Selected Area' option in the Print Preview dialog box. If this is not possible create a rectangular selection around a portion of the image containing important tonal and color information and then copy and paste this selection to its own layer. Switch off the visibility of the background layer and then proceed to select 'Print Preview' as before.

Printer settings

When you click on 'Print' in 'Print Preview' the printer dialog box opens. The 'Automatic' and 'Custom' settings will override Adobe's color management. The secret to success when using Adobe image editing programs is to select the media type and 'No Color Adjustment' from the 'Color Management' controls within the printer software (if using a Canon printer go to 'Color > Color Control > None').

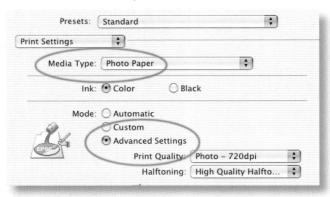

Select the 'Media Type' you are using and then click 'Print'. View the print using soft window light and try to ascertain any differences between the print and the screen image in terms of hue (color), saturation and brightness. Any differences can be attributed to inaccuracies in your initial monitor calibration and/or the profile that was shipped with your printer (sometimes referred to as a 'canned' profile). More accurate profiles of the monitor and printer can be achieved by using profiling software and hardware, which is currently still expensive.

Output levels

Examine the first test strip that is printed to establish the optimum highlight and shadow levels that can be printed with the media you have chosen to use. If the shadow tones between level 10 and level 20 are printing as black then you should establish a levels adjustment layer to resolve the problem. The bottome left-hand slider should be moved to the right to reduce the level of black ink being printed. This should allow dark shadow detail to be visible in the second print. A less common problem is highlight values around 245 not registering on the media. If this is a problem the highlight slider can be moved to the left to encourage the printer to apply more ink.

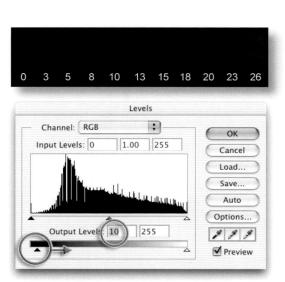

Note > It is important to apply these output level changes to an adjustment layer only, as these specific alterations only apply to the output device you are currently testing.

It is advisable to limit the variables once color consistency has been achieved. When changing an ink cartridge it is recommended that you run a test from the same image used to initiate the color consistency and then modify the preview master adjustment layer accordingly.

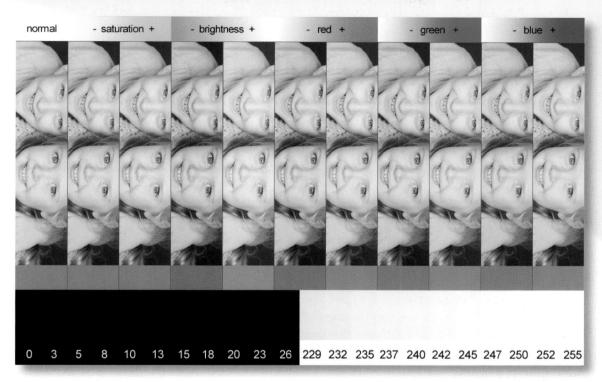

It is possible to set up a 'ringaround' print to monitor variations in print quality. This involves creating a series of adjustment layers that apply variations of hue, brightness and saturation to a test strip sampled from your image. Layer masks can be used to shield all but a small section of the print from the effects of each adjustment layer. Although initially time consuming to set up the adjustment layers can be used on any image you wish to test in the future. If one of the adjustments hits the target drag it to the master image, remove the layer mask of the adjustment layer and proceed to print.

Note > The test file on this page is available from the supporting web site.

>>> PHOTOSHOP

Analysis of the test print

Print the test file available on the web site using the Photoshop color management settings outlined in this chapter.

Note > Make sure the color management is switched off in the printer driver software.

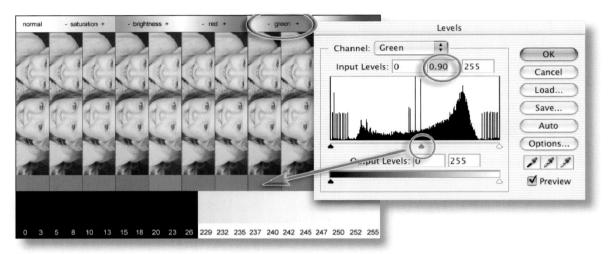

Determining a color cast

- 1. Check that the color swatches at the top of the image are saturated and printing without tracking marks or banding (there should be a gradual transition of color). If there is a problem with either tracking lines or saturation clean the printer heads using the manufacturer's guidelines.
- 2. View the gray tones directly beneath the images to determine if there is a color cast present in the image. The five tones on the extreme left are desaturated in the image file. If these print as gray then no color correction is required. If, however, one of the gray tones to the right (which have color adjustments applied) appears to be gray then a color cast is present in the print.
- Note > Viewing conditions of the test print need to be standardized. Daylight (not direct sunlight) offers a fairly reliable constant.
- 3. Find the tone which appears to be desaturated on top of the test image. Apply this color correction to the next print to remove the color cast being introduced by your color management setup. For example, if the minus green strip appears to print with no color cast then a 0.9 gamma adjustment in the green channel is required for the next test print. If the plus green strip had been neutral then a 1.1 gamma adjustment would have been required.
- Note > Each of the color strips in the test image has the same gamma adjustment applied using the RGB channels. The correction necessary can be made using the levels dialog box by sliding the gamma slider to 0.9 or 1.1 in the corresponding color channel.

76

>>> essential skills >>>

Creating a 'preview master'

Use the following technique to reduce the difference between the screen and printed image:

- 1. Create a new adjustment layer in the layers palette and position it at the top of the layer stack.
- 2. Use this adjustment layer to modify the screen image until it more closely resembles the printed image (view the printed image using daylight).
- 3. Name this adjustment layer as your 'preview master' and leave the visibility ON.
- 4. Create another adjustment layer and modify the color and tone of the image until the image again looks correct.
- 5. Switch the preview master 'OFF' prior to printing a second print.

Note > It is possible to use the preview master for every new image you intend to print that uses the same printer, ink and paper combination. Simply drag this preview master adjustment layer into each new image you wish to edit.

Printing overview

Materials

Start by using the printer manufacturer's recommended ink and paper.

Use premium grade 'Photo Paper' for maximum quality.

Monitor

Position your monitor so that it is clear of reflections.

Select a target white point or color temperature of 6500.

Set contrast, brightness and 'gamma' using 'Adobe Gamma' or 'Monitor Calibrator' software.

Adobe

Set the Color Settings of the Adobe software.

Select printer profile from 'Proof Setup' (View menu).

Select the 'Print Space' (printer profile) from 'Print Preview' prior to printing.

Printer

Use a 6-ink inkjet printer for maximum quality.

Select the 'Media Type' in the printer software dialog box.

Select 'No Color Management'.

Proofing

Use daylight to assess color accuracy of print.

Create a 'preview master' adjustment layer if required.

Printing using a professional laboratory

Professional photographic laboratory services are now expanding into the production of large and very large prints using the latest inkjet and piezo technology. Many are also capable of printing your digital files directly onto color photographic paper. In fact, outputting to color print paper via machines like the Durst Lambda and Fuji Frontier has quickly become the 'norm' for a lot professional photographers. Adjusting of image files that print well on desktop inkjets so that they cater for the idiosyncrasies of these RA4 and large inkjet machines is an additional output skill that is really worth learning.

With improved quality, speed and competition in the area, the big players like Epson, Kodak, Durst, Fuji and Hewlett Packard are manufacturing units that are capable of producing images that are not only visually stunning, but also very, very big. Pictures up to 54 inches wide are can be made

on some of the latest machines, with larger images possible by splicing two or more panels together. A photographer can now walk into a bureau with a CD containing a favorite image and walk out the same day with a spliced polyester poster printed with fade resistant all-weather inks the size of a billboard.

In addition to these dedicated bureau services, some professionals, whose day-to-day business revolves around the production of large prints, are actually investing in their own wide format piezojet or inkjet machines. The increased quality of pigment-based dye systems together with the choice of different media, or substrates as they are referred to in the business, provides them with more imaging and texture choices than are available via the RA4 route.

Before you start

Getting the setup right is even more critical with large format printing than when you are outputting to a desktop machine. A small mistake here can cause serious problems to both your 48×36 inch masterpiece as well as your wallet, so before you even turn on your computer, talk to a few professionals. Most output bureaus are happy to help prospective customers with advice and usually supply a series of guidelines that will help you set up your images to suit their printers. These instructions may be contained in a pack available with a calibration swatch over the counter, or might be downloadable from the company's web site.

Some of the directions will be general and might seem a little obvious, others can be very specific and might require you to change the CMYK settings of your image editing program so that your final files will match the ink and media response of the printer. Some companies will check that your image meets their requirements before printing, others will dump the unopened file directly to the printer's RIP assuming that all is well. So make sure that you are aware of the way the bureau works before making your first print.

General Guidelines

essential skills >>>

The following guidelines have been compiled from the suggestions of several output bureaus. They constitute a good overview but cannot be seen as a substitute for talking to your own lab directly.

- 1. Ensure that the image is orientated correctly. Some printers are set up to work with a portrait or vertical image by default, trying to print a landscape picture on these devices will result in areas of white space above and below the picture and the edges being cropped.
- 2. Make sure the image is the same proportion as the paper stock. This is best achieved by making an image with the canvas the exact size required and then pasting your picture into this space.
- 3. Don't use crop marks. Most printers will automatically mark where the print is to be cropped. Some bureaus will charge to remove your marks before printing.
- 4. Convert text to line or raster before submission. Some imaging and layout programs need the font files to be supplied together with the image at the time of printing. If the font is missing then the printer will automatically substitute a default typeface, which in most cases will not be a close match for the original. To avoid failing to supply a font needed, convert the type to line or raster before sending the image to the bureau.
- 5. Use the resolution suggested by the lab. Most output devices work best with an optimal resolution; large format inkjet printers are no different. The lab technician will be able to give you details of the best resolution to supply your images in. Using a higher or lower setting than this will alter the size that your file prints so stick to what is recommended.
- 6. Keep file sizes under the rip maximum. The bigger the file the longer it takes to print. Most bureaus base their costings on a maximum file size. You will need to pay extra if your image is bigger than this value.
- 7. Use the color management system recommended by the lab. In setting up you should ensure that you use the same color settings as the bureau. This may mean that you need to manually input set values for CMYK or use a ICC profile downloaded from the company's web site.

Set orientation >> lobe Photoshop Image Layer Mode Y 1 3 ₩ Regular Duplicate.. nvas Size. Pixel Aspect Ratio Rotate Canvas 1809 90° CW Trim. Arbitrary. Reveal All In Canvas Vertical

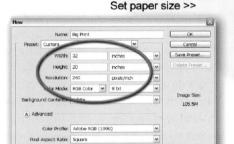

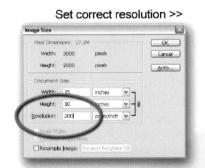

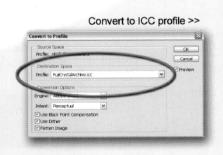

Printing monochromes

To the eyes of experienced darkroom workers the difficulties of printing black and white photographs with a color printer are immediately apparent. Most photo quality inkjets use the five colored inks, as well as black, to produce monochromes. With dot sizes now being so small it is only under the closest scrutiny that the multicolored matrix that lies beneath our black and white prints is revealed. Balancing the different colors so that the final appearance is neutral is a very tricky task. Too many dots of one color and a gray will appear blue, too few and it will contain a yellow hue.

With just this type of situation in mind several of the bigger third party ink manufacturers have produced dedicated monochrome cartridges and ink sets for all popular desktop and wide format inkjet printers. The system is simple – pure black and white can be achieved by removing all color from the print process. The manufacturers produce replacement cartridges containing three levels of gray instead of the usual cyan, yellow and magenta or five levels instead of cyan, lightcyan, magenta, light-magenta and yellow for five color cartridges. All inks are derived from the same pigment base and so prints made with these cartridges contain no strange color casts.

Printing with dedicated monochrome ink sets is the closest thing to making finely crafted fiber-based prints

Yellow/green shadows

CMYK ink set

matte and fine art stock.

After the success of the initial Quad Black system, Lyson produced two more monochrome ink sets Warm Tone affectionately known as 'sepia' and Cool Tone sometimes called 'selenium'. Though the nicknames are familiar don't be confused, there are no toning processes involved here. The whole procedure

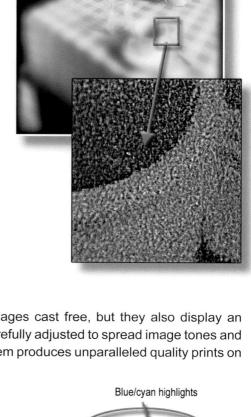

100 95 90 85 80 75 70 65 60 55 50 45 40 35 30 25 20 15 10 5

Dedicated Quad Black Neutral ink set

is still digital and the images are produced with ink on paper. Quad tone sets are available for all the photo quality printers from Cannon and Epson. This includes those models that have chip-based cartridges designed to restrict the user to installing the manufacturer's own inks.

OK, what's the catch?

With such results, and options, you might be forgiven for thinking that all is now 'well with the world' and that 'peace amongst the nations' must be just around the corner, but be warned, it is not recommended that you continually swap between your old CMYK system and the monochrome options. Lyson has no qualms about suggesting

that you dedicate a printer solely for Quad tone output. For most of us the purchase of one such machine is expensive enough, but two might just break the bank. You will also need to keep in mind that the hardware manufacturers don't support the use of non-genuine inks and, in some cases, will not uphold warranty claims made for machines using alternative inking systems.

Making your first Quad Black print

- 1. Download and decompress the Lyson ICC profile for your paper and ink set from www. lyson.com. Drag and drop the profiles into the 'Color' folder in your Mac or Windows system.
- 2. Restart Photoshop. Open a test image.
- Adjust the picture to ensure a good spread of tones. Make sure that even monochrome pictures are stored in RGB mode.
- 4. With the image still open, select File > Page Setup. Select 'Properties'. Select 'Custom' and then 'Advanced'.
- 5. Select 'Photo Quality Gloss Film' as the Media Type, 'Photo-1440dpi' as the Print Quality, 'High Quality Half toning' and 'No Color Adjustment' from the Color Adjustment options. Click 'OK'
- 6. Select File > Print with Preview. Ensure 'Source Space' is set to 'Document' and then select the Lyson printer profile you installed in step 1 in the 'Print Space > Profile' box. Choose 'Perceptual' as the rendering intent. Now click 'Print'.

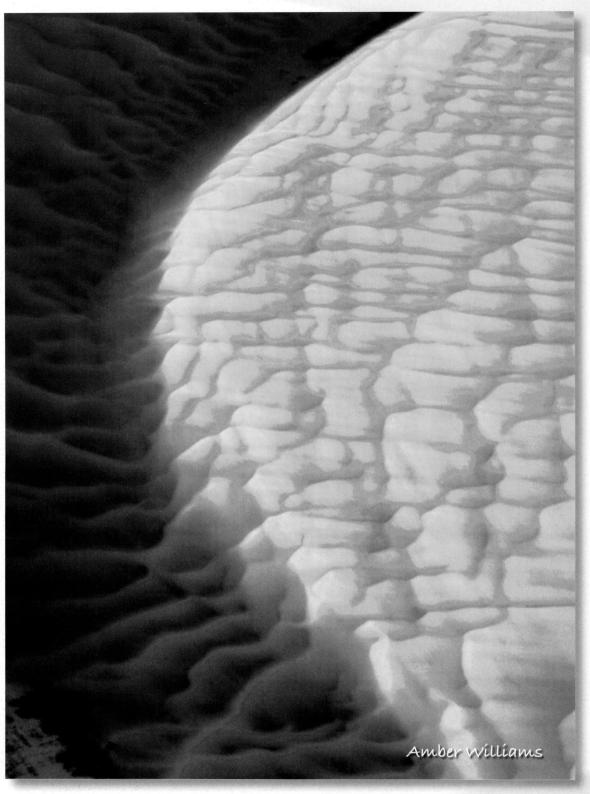

layers and channels photoshop photoshop photoshop photoshop photoshop photoshop photoshop photoshop photoshop photoshop

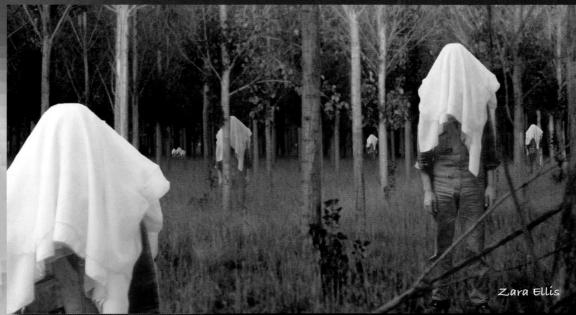

photoshop photoshop photoshop photoshop photos

essential skills

- Learn the creative potential of layers, adjustment layers, channels and layer masks.
- Develop skills and experience in the control and construction of digital montages.

Introduction

The traditional photograph contains all the picture elements in a single plane. Digital images captured by a camera or sourced from a scanner are also flat files. And for a lot of new digital photographers this is how their files remain – flat. All editing and enhancing work is conducted on the original picture but advanced techniques require things to be a little different.

Digital pictures are not always flat

Photoshop contains the ability to use layers with your pictures. This feature releases your images from having to keep all their information in a flat file. Different image parts, added text and certain enhancement tasks can all be kept on separate layers. The layers are kept in a stack and the image you see on screen in the work area composite of all the layers.

Sound confusing? Well try imagining, for example, that each of the image parts of a simple portrait photograph are stored on separate plastic sheets. These are your layers. The background sits at the bottom. The portrait is laid on top of the background and the text is placed on top. When viewed from above the solid part of each layer obscures the picture beneath. Whilst the picture parts are based on separate layers they can be moved, edited or enhanced independently of each other. If they are saved using a file format like Photoshop's PSD file (which is layer friendly) all the layers will be preserved and present next time the file is opened.

Layers and channels confusion

Another picture file feature that new users often confuse with layers is channels. The difference is best described as follows:

- Layers separate the image into picture, text and enhancement parts.
- Channels, on the other hand, separate the image into its primary base colors.

A layers palette will display the layer stack with each part assembled on top of each other, whereas the channels palette will show the photograph broken into its red, green and blue components (if it is an RGB image – but more on this later).

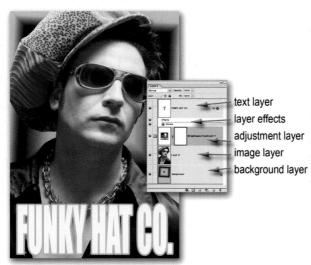

Example image showing the layer components

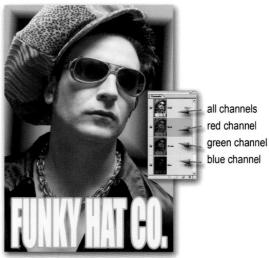

Example image showing the channels

Being able to separate different components of a picture means that these pieces can be moved and edited independently. This is a big advantage compared to flat file editing where the changes are permanently made part of the picture which can't be edited at a later date. A special file type is needed if these edit features are to be maintained after a layered image is saved and reopened. In Photoshop, the PSD format supports all layer types and maintains their editability. It is important to note that other common file formats such as JPEG and TIFF don't generally support these features. They flatten the image layers whilst saving the file, making it impossible to edit individual image parts later.

The layers palette is used to view the content of the different layers that make up a picture

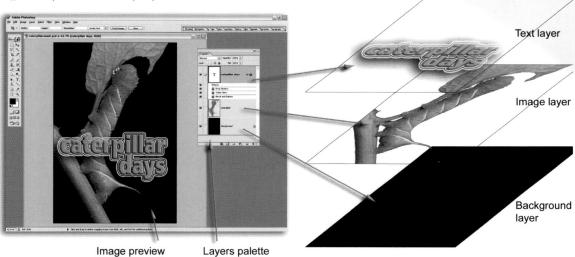

Adding layers

ential skills >>>

When a picture is first downloaded from your digital camera or imported into Photoshop it usually contains a single layer. It is a 'flat file'. By default the program classifies the picture as a background layer. You can add extra 'empty' layers to your picture by clicking the New Layer button at the bottom of the layers dialog or choosing the Layer option from the New menu in the Layer heading (Layer > New > Layer). The new layer is positioned above your currently selected layer.

Some actions such as adding text with the Type tool automatically create a new layer for the content. This is true when adding adjustment and fill layers to your image. When selecting, copying and pasting image parts, Photoshop also creates a new layer for the copied portion of the picture.

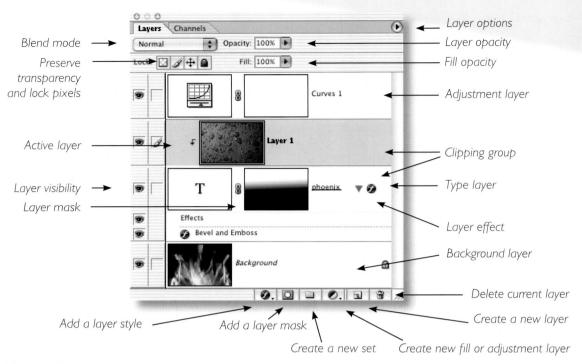

Viewing layers

Photoshop's layers palette displays all your layers and their settings in the one dialog box. If the palette isn't already on screen when opening the program, choose the option from the Window menu (Window > Layers). The individual layers are displayed, one on top of each other, in a 'layer stack'. The image is viewed from the top down through the layers. When looking at the picture on screen we see a preview of how the image looks when all the layers are combined. Each layer is represented by a thumbnail on the left and a name on the right. The size of the thumbnail can be changed, as can the name of the layer. By default each new layer is named sequentially (layer 1, layer 2, layer 3). This is fine when your image contains a few different picture parts, but for more complex illustrations it is helpful to rename the layers with titles that help to remind you of their content (portrait, sky, tree). Layers can be turned off by clicking the eye symbol on the far right of the layer so that it is no longer showing. This action removes the layer from view but not from the stack. You can turn the layer back on again by clicking the eye space.

Working with layers

You can only edit or enhance one layer at a time. To select the layer that you want to change you need to click on the layer. At this point the layer will change to a different color from the rest in the stack. This layer is now the 'selected layer' and can be edited in isolation from the others that make up the picture. It is common for new users to experience the problem of trying to edit pixels on a layer that has not been selected. Always check the correct layer has been selected prior to editing a multi-layered image.

Each layer in the same image must have the same resolution and image mode (a selection that is imported into another image will take on the host image's resolution and image mode). Increasing the size of any selection will lead to 'interpolation' which will degrade its quality.

Manipulating layers

Layers can be moved up and down the layer stack by click-dragging. Moving a layer upwards will mean that its picture content may obscure more of the details in the layers below. Moving downwards progressively positions the layer's details further behind the picture parts of the layers above. You can reposition the content of any layers (except background layers) using the Move tool. Two or more layers can be linked together so that when the content of one layer is moved the other details follow precisely. Simply click on the box on the right of the eye symbol in the layers to link together. The box will be filled with a chain symbol to indicate that this layer is now linked with the selected layer. Unwanted layers can be deleted by dragging them to the dustbin icon at the bottom of the layers palette.

Layer effects and styles

In earlier versions of Photoshop creating a drop shadow edge to a picture was a process that involved many steps, thankfully the latest version of the program includes this as one of the many built-in effects. Including other options such as inner shadow, outer glow, inner glow,

Layer shortcuts

- 1. To display layers palette Choose Windows > Layers.
- 2. To access layers options Click sideways triangle in the upper right-hand corner of the layers palette.
- 3. To change the size of thumbnails Choose Palette options from the Layers Palette menu and select a thumbnail size.
- 4. To make a new layer Choose Layer > New > Layer.
- 5. To create a new adjustment layer Choose Layer > New Adjustment Layer and then select the layer type.
- 6. To create a new layer set Choose Layer > New > Layer Set.
- 7. To add a style to a layer Select the layer and click on the Layer Styles button at the bottom of the palette

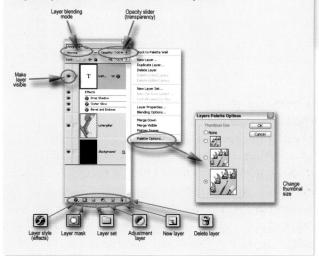

bevel and emboss, satin, color overlay, gradient overlay and pattern overlay these effects can be applied to the contents of any layer.

Users can add effects by clicking on the Layer Style button at the bottom of the layers palette or by choosing Layer Style from the layer menu. The effects added are listed below the layer in the palette. You can turn effects on and off using the eye symbol and even edit effect settings by double-clicking on them in the palette.

Opacity

As well as layer styles, or effects, the opacity (how transparent a layer is) of each layer can be altered by dragging the opacity slider down from 100% to the desired level of translucency. The lower the number the more detail from the layers below will show through. The opacity slider is located at the top of the layers palette and changes the selected layer only.

On the left of the opacity control is a drop-down menu containing a range of blending modes. The default selection is 'normal' which means that the detail in upper layers obscures the layers beneath.

Blending modes

Switching to a different blending mode will alter the way in which the layers interact. Checking the 'preserve transparency' box confines any painting or editing to the areas containing pixels (transparent areas remain unaffected).

Layer sets

Layer sets are groups of layers organized into a single 'folder'. Placing all the layers used to create a single picture part into a set makes these layers easier to manage and organize. Layers can be moved into the set by dragging them onto the set's heading. To create a layer set click on the New Set button at the bottom of the palette or choose Layer > New > Layer Set.

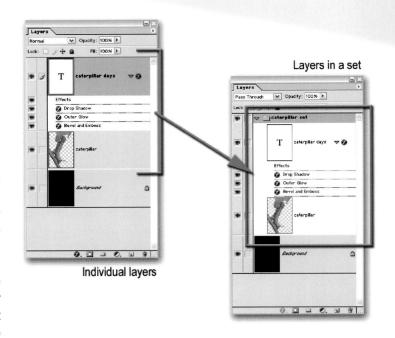

Layer masks

A 'layer mask' is attached to a layer and controls which pixels are concealed or revealed on that layer. Masks provide a way of protecting areas of a picture from enhancement or editing changes. In this way masks are the opposite to selections which restrict the changes to the area selected. Masks are standard grayscale images and because of this they can be painted, edited and erased just like other pictures. Masks are displayed as a separate thumbnail to the right of the main layer thumbnail in the layers palette. The black portion of the mask thumbnail is the protected area and the white section shows the area where the image can be edited and enhanced.

Photoshop provides a variety of ways to create masks but one of the easiest is to use the special

Quick Mask mode.

Quick steps for making a Quick Mask 1. Click the Quick Mask mode button in the toolbox. The foreground and background colors automatically become black and white.

- Select the layer to be masked and using the Brush tool paint a mask on the image. You will notice that the painted mask area is now ruby red. Painting with different levels of gray will create a semi-transparent mask.
- 3. Remove areas of the mask with the Eraser tool.
- 4. Switch back to the selection mode by clicking the Standard Mode button at the bottom of the toolbox. The non-masked area now becomes a selection ready for enhancement.

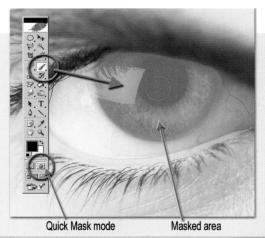

Layer types

Image layers: This is the most basic and common layer type containing any picture parts or image details. Background is a special type of image layer.

Text layers: Designed solely for text, these layers allow the user to edit and enhance the text after the layer has been made. It is possible to create 'editable text' in Photoshop. If the text needs to be modified (font, style, spelling, color, etc.) the user can simply double-click the type layer.

Shape layers: Shape layers are designed to hold the shapes created with Photoshop's drawing tools (Rectangle, Ellipse, Polygon, Line and Custom Shape). Like text layers the content of these layers is 'vector' based and therefore can be scaled upwards or downwards without loss of quality.

Adjustment layers: These layers alter the layers that are arranged below them in the stack, unless a 'clipping group' is created. The thumbnails for the top layers of a clipping group are indented whilst the name of the base layer in the group is underlined. Adjustment layers act as a filter through which the lower layers are viewed. They allow image adjustments to be made without permanently modifying the original pixels (if the adjustment layer is removed the pixels revert to their original value). You can use adjustment layers to perform many of the enhancement tasks that you would normally apply directly to an image layer without changing the image itself.

Background layers: An image can only have one background layer. It is the bottom most layer in the stack. No other layers can be moved beneath this layer. You cannot adjust this layer's opacity or its blending mode. You can convert background layers to standard image layers by double-clicking the layer in the layers palette, setting your desired layer options in the dialog provided and then clicking OK.

Saving an image with layers

ential

The file formats that support layers Photoshop's native Photoshop document (PSD) format, PDF and TIFF. The layers must always be flattened if the file is to be saved as a JPEG. It is recommended that a PSD with its layers is always held as the master copy. It is possible to quickly flatten a multi-layered image and save it as a JPEG or TIFF file by choosing 'Save As' and then selecting the required file format from the pulldown menu or selecting duplicate file from the Image menu and selecting the duplicated merged option in the duplicate dialog box.

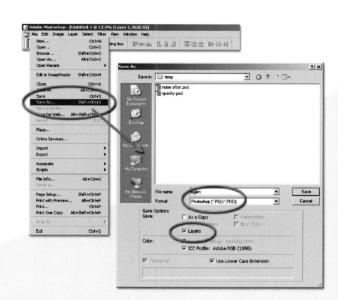

>>> essential skills >>>

Quick Masks, Selections and alpha channels

When first starting to use Photoshop it is easy to think of Selections, Masks and Channels as all being completely separate program features, but in the reality of day-to-day image enhancement each of these tools is inextricably linked. As your skills develop most image-makers will develop their own preferred ways of working. Some use a workflow that is Selection based, others switch easily between Masking and Selections and a third group concentrates all their efforts on creating masks only. No one way of working is right or wrong. In fact many of the techniques advocated by the members of each group often provide a different approach to solving the same problem. Selections isolate parts of a picture.

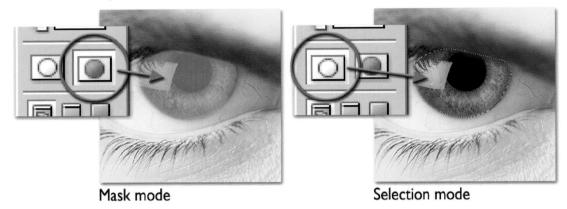

Switching between Mask and Selection modes

You can switch between Mask and Selection (also called 'Standard') modes by clicking on mode buttons positioned at the bottom of the toolbox. Any active selections will be converted to red shaded areas when selecting the Mask mode. Similarly active masks will be outlined with 'marching ants' when switching to Selection mode.

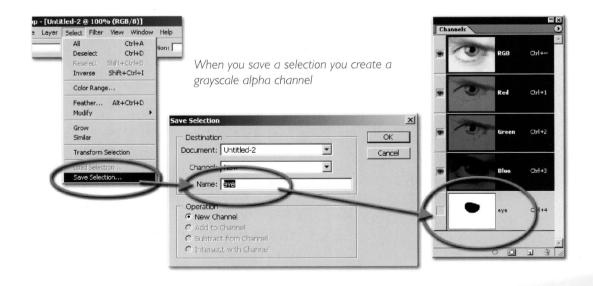

Saving Selections

Photoshop provides users with the option to save their carefully created selections using the Select > Save Selection option. In this way the selection can be reloaded at a later date in the same session via the Select > Load Selection feature, or even after the document has been closed and reopened. Though not immediately obvious to the new user, the selection is actually saved with the picture as a special alpha channel and this is where the primary link between selections and masks occurs. Masks too are stored as alpha channels in your picture documents.

Alpha channels are essentially grayscale pictures where the black section of the image indicates the area where changes can be made, the white portion represents protected areas and gray values allow proportional levels of change.

Alpha channels can be viewed, selected and edited via the channels palette.

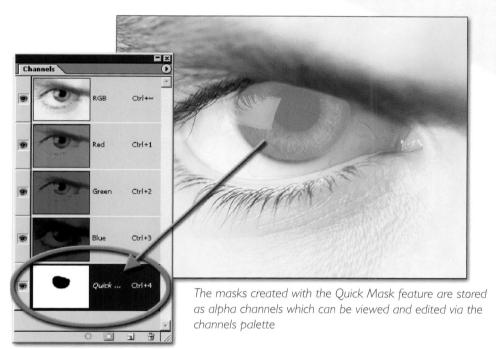

Quick definitions

Selections – A selection is an area of a picture that is isolated so that it can be edited and enhanced independently of the rest of the image. Selections are made with a range of Photoshop tools including the Marquee, Lasso and Magic Wand tools.

Masks – Masks also provide a means of restricting image changes to a section of the picture. Masks are created using standard painting tools whilst in the Quick Mask mode.

Alpha channels – Alpha channels are a special channel type that are separate to those used to define the base color of a picture such as Red, Green and Blue. Selections and masks are stored as alpha channels and can be viewed in the channels palette. You can edit a selected alpha channel using painting and editing tools as well as filters.

Channels

As we have already seen, channels represent the way in which the base color in an image is represented. Most images that are created by digital cameras are made up of Red, Green and Blue (RGB) channels. In contrast, pictures that are destined for printing are created with Cyan, Magenta, Yellow and Black (CMYK) channels to match the printing inks. Sometimes the channels in an image are also referred to as the picture's 'color mode'.

Viewing channels

SO AOHSOTOHA <<<

Many image editing programs contain features designed for managing and viewing the color channels in your image. Photoshop uses a separate channels palette (Window > Channels). Looking a little like the layers palette, hence the source of much confusion, this palette breaks the full color picture into its various color parts.

Changing color mode

Though most editing and enhancement work can be performed on the RGB file sometimes the digital photographer may need to change the color mode of his or her file. There are a range of conversion options located under the Mode menu (Image > Mode) in Photoshop. When one of these options is selected your picture's color will be translated into the new set of channels. Changing the number of channels in an image also impacts on the file size of the picture. Four channel CMYK images are bigger than three channel RGB pictures which in turn are roughly three times larger than single channel grayscale photographs.

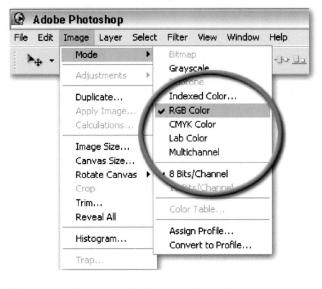

The type and number of color channels used to create the color in your pictures can be changed via the Mode option in the Image menu

When do I need to change channels? For most image editing and enhancement tasks RGB color mode is all you will ever need. Some high quality and printing specific techniques do require changing modes, but this is generally the field of the 'hardened' professional. A question often asked is 'Given that my inkjet printer uses CMYK inks should I change my photograph to CMYK before printing?' Logic says yes, but practically speaking this type of conversion is best handled by your printer's driver software. Most modern desktop printers are optimized for RGB output even if their ink set is CMYK.

Channel types

RGB: This is the most common color mode. Consisting of Red, Green and Blue channels most digital camera and scanner output is supplied in this mode.

CMYK: Designed to replicate the ink sets used to print magazines and newspapers this mode is made from Cyan, Magenta, Yellow and Black (K) channels.

LAB: Consisting of Lightness, A colors (green-red) and B colors (blue-yellow) channels this mode is used by professional photographers when they want to enhance the details of an image without altering the color. By selecting the L channel and then performing their changes only the image details are affected.

Grayscale: Consisting of a single black channel this mode is used for monochrome pictures.

The most used color modes (channel types) are RGB, CMYK, LAB and Grayscale. Unless you are working in the publishing industry, or you want to use advanced image editing techniques, you should keep your picture in RGB mode

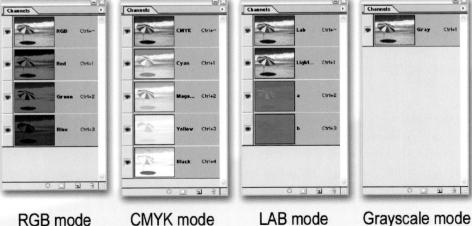

Adjustment layers

Adjustment layers act as filters that modify the hue, saturation and brightness of the pixels on the layer or layers beneath. Using an adjustment layer instead of the 'Adjustments' from the 'Image' menu allows the user to make multiple and consecutive image adjustments without permanently modifying the original pixel values.

Non-destructive image editing

The manipulation of image quality using 'adjustment layers' and 'layer masks' is often termed 'non-destructive'. Using adjustment layers to manipulate images is preferable to working directly and repeatedly on the pixels themselves. Using the 'Adjustments' from the 'Image' menu, or the manipulation tools from the toolbox (Dodge, Burn and Sponge tools), directly on pixel layers can eventually lead to a degradation of image quality. If adjustment layers are used, together with 'layer masks' to limit their effect, the pixel values are physically changed only once when the image is flattened or the layers are merged. Retaining the integrity of your original file is essential for high quality output.

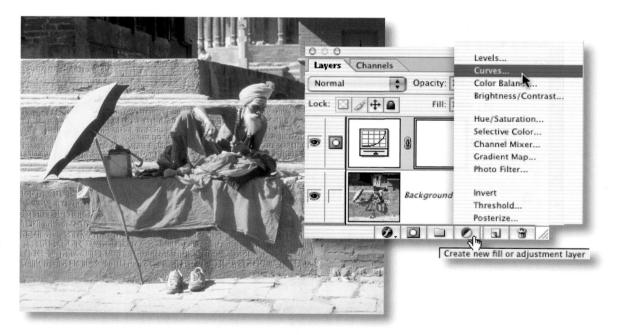

Retaining quality

The evidence of a file that has been degraded can be observed by viewing its histogram. If the resulting histogram displays excessive spikes or missing levels there is a high risk that a smooth transition between tones and color will not be possible in the resulting print. A telltale sign of poor scanning and image editing is the effect of 'banding' that can be clearly observed in the final print. This is where the transition between colors or tones is no longer smooth, but can be observed as a series of steps, or bands, of tone and/or color. To avoid this it is essential that you start with a good scan (a broad histogram without gaps) and limit the number of changes to the original pixel values.

Layer masks

The use of 'layer masks' is an essential skill for professional image retouching. Together with the Selection tools and 'adjustment layers' they form the key to effective and sophisticated image editing. A 'layer mask' can control which pixels are concealed or revealed on any image layer except the background layer. If the layer mask that has been used to conceal pixels is then discarded or switched off (Shift + click the layer mask thumbnail) the original pixels reappear. This non-destructive approach to retouching and photographic montage allows the user to make frequent changes. To attach a layer mask to any layer (except the background layer) simply click on the layer and then click on the 'Add layer mask' icon at the base of the layers palette.

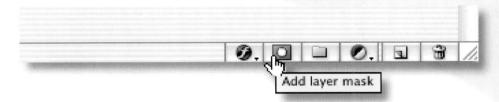

A layer mask is automatically attached to every adjustment layer. The effects of an adjustment layer can be limited to a localized area of the image by simply clicking on the adjustment layer's associated mask thumbnail in the layers palette and then painting out the adjustment selectively using any of the painting tools whilst working in the main image window. The opacity and tone of the foreground color in the toolbox will control whether the adjustment is reduced or eliminated in the localized area of the painting action. Painting with a darker tone will conceal more than when painting with a lighter tone or a dark tone with a reduced opacity.

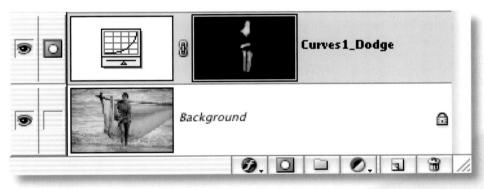

Painting with white will reveal the adjustment in the localized area of the painting action

Painting an adjustment

A layer mask can be filled with black to conceal the effects of the adjustment layer. Painting with white in the layer mask will then reveal the adjustment in the localized area of the painting action.

Working with layers and masks

Using a variety of techniques outlined in the preceding pages it is possible to construct an elaborate montage that demonstrates the creative applications of layers and masks.

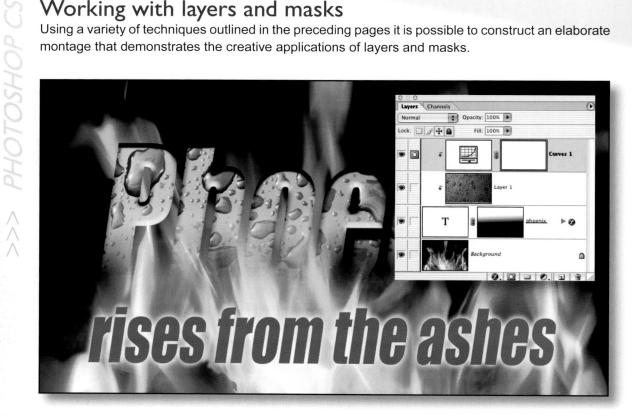

ACTIVITY / www.photoshopessentialskills.com/layers.html

This activity makes use of a layer mask which is filled using the Gradient tool. This graduated layer mask allows the typography to appear gradually as if from the fire. A 'clipping group' is used to assign the texture 'raindrops' to the typographic form (creating a layer mask would have given the same effect). The three-dimensional look of the typography is created by applying a layer effect called 'Bevel and Emboss' to the typographic layer. The finishing touches were created by using an adjustment layer clipped to the texture to increase its contrast.

1. Open the image 'fire.jpg'. Select the Type tool in the tools palette and open the character palette from the Options bar. Specify the font, style and size of the text (with the characters selected typing minus or plus values in the tracking box will move letters closer or further apart).

Note > Color is normally selected by clicking the color swatch. Color is not important for this exercise as the type will be filled with another image. Ensure that anti-alias is selected (crisp, strong or smooth) and then click OK.

2. Stretch or distort the type layer by applying the 'Free Transform' command (Command/Ctrl + T). The type in the example has been stretched vertically by dragging the top-center handle upwards. Press the return/enter key to apply the transformation.

Note > Transform alters the shape and/or size of the subject matter on a single selected layer. Holding the Shift key down whilst dragging a corner handle will constrain the proportions. Holding down the Ctrl/Command key will allow you to skew the text.

3. Apply an effect or 'Layer Style' to this typographic layer, 'Layer > Layer Style > Bevel and Emboss' or choose it from the 'Add a layer style' menu in the layers palette.

Ensure that an 'Inner Bevel' is selected from the Style menu, adjust the look of the bevel and click OK. The effect can be adjusted later by double-clicking on the effects layer.

4. With the type layer still selected add a layer mask by clicking the 'Add a mask' icon at the foot of the layers palette. An empty layer mask will appear in the layers palette beside the typography thumbnail. With this thumbnail selected you can use any of the paint tools to paint a layer mask. A layer mask will conceal information on its own layer. The darker the color that you use to paint with, the more information on this layer will be concealed. If black is selected, the pixels in the location of the mask will be completely concealed. If a middle tone is used the opacity of the information will be reduced.

10 TC

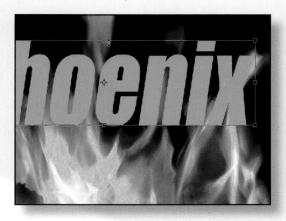

- the 5. Set default foreground background colors in the toolbox (black and white). Click on the layer mask in the layers palette to select it rather than the type. Select the Linear Gradient tool in the tools palette. Select foreground to background or foreground to transparent and 100% opacity. Move the cursor to the bottom of the typography in the main image window. Click and drag the gradient cursor from the base of the letters to the top of the letters. A linear gradient will appear in the layer mask and the typography should be half hidden behind this layer mask. Experiment with dragging shorter and longer gradients.
- 6. The layer mask can be moved by selecting the Move tool and dragging inside the main image window. To move the typography and not the mask you must first click on the typography thumbnail in the layers palette. To move both the layer mask and the typography at the same time you must first click between the layer mask and typography windows in the layers palette. This action creates a link between both elements. The link can be broken by clicking on the icon.
- 7. Select the Type tool again and click beneath the word you have just created. Select a smaller point size and type the additional copy. Highlight the text and adjust the size if necessary. Reposition the copy by dragging the type and then click OK.
- 8. Click the 'Color Swatch' in the type options to open the Color Picker. To choose a color from the image move the cursor onto the image window. The cursor appears as an eyedropper and can sample a color by clicking on it. This color will then be assigned to the typography.

rises from the ashes

1		
1		
Contract		
CITO		
10 //	0 0 mark	
10 //		
10 //	0 0 mark	
10 //	0 0 mark	
10 //	0 0 mark	
10 //	0 0 mark	
10 //	0 0 mark	
10 //	0 0 mark	
	0 0 mark	
10 //	0 0 mark	
10 //	0 0 mark	

- 9		/
- 1		1
	A	
		\
(1)
	3	3
		3
	1	
)
		rigidad.
	de err	
	0739	0.00
1		
1	1	1
π		3
	do	1
		Trans.
(1	3
		3

Layer Style				
Styles	Outer Glow Structure	(ок)		
Blending Options: Custom	Blend Mode: Screen 💠	Cancel		
Drop Shadow	Opacity: 100 %	New Style		
Inner Shadow	Noise: 🔷 0 %	▼ Preview		
☑ Outer Glow	● □ ○ □ □ □ □ □ □ □ □ □ □ □ □ □ □ □ □ □	Preview		
Inner Glow				
Bevel and Emboss	Technique: Softer			
Contour	Spread: 23 1%			
☐ Texture	Size: 32 px			
Satin				
Color Overlay	Quality			
Gradient Overlay	Contour: Anti-aliased			
Pattern Overlay	Range:			
Stroke	Jitter: △ 0 %			

9. Apply an 'Outer Glow' layer style to this typographic layer. Adjust the opacity, spread and size to create the desired effect surrounding the typography. Click the color box to open the Color Picker and choose a yellow color from the image.

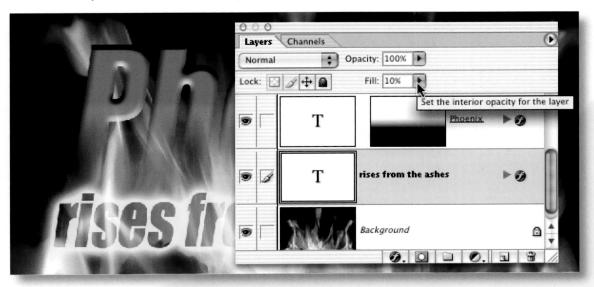

Note > It is possible to control the opacity of the 'fill color' and the layer opacity separately. By reducing the fill color the typography can made transparent whilst the layer style remains at 100% opacity.

- 10. Open the image containing the texture you wish to paste into the typographic form (the image 'texture.jpg' was used in this example). Ensure the image is of a similar size and resolution to that required. The size can be modified later using the 'Free Transform' command but the digital photographer must be careful not to increase the size of any image excessively ('interpolation' will lower the overall quality). Drag the thumbnail of the drops in the layers palette into the image window containing the fire and text. The texture will be placed on a layer above the other layers completely concealing both the typography and the background.
- 11. A clipping group is required in order to fill the typography with the image of the raindrops. Go to 'Layer > Create Clipping Mask' or move the mouse cursor to the line that divides the two layers in the layers palette. By holding down the Option/Alt key the clipping icon should appear (two overlapping circles). Clicking whilst holding down the Option/Alt key will group the layers together. The layer thumbnail is indented and the name of the base layer in the clipping group is underlined. The typography acts as a mask.

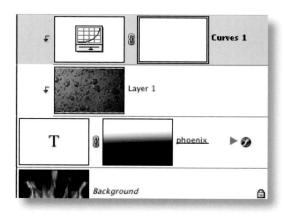

12. Finally an adjustment layer is applied to the top layer. Increase the contrast and/or change the color of the raindrops. It too is clipped to the typography layer to limit its effects to the raindrops only.

Note > Adjustment layers will affect all layers beneath them unless clipped.

ACTIVITY 2 www.photoshopessentialskills.com/layers.html

This activity utilizes the advanced blending via the blending or layer options dialog box and the use of filters to create special effects. The activity also makes use of the 'Transform' commands to modify layer content.

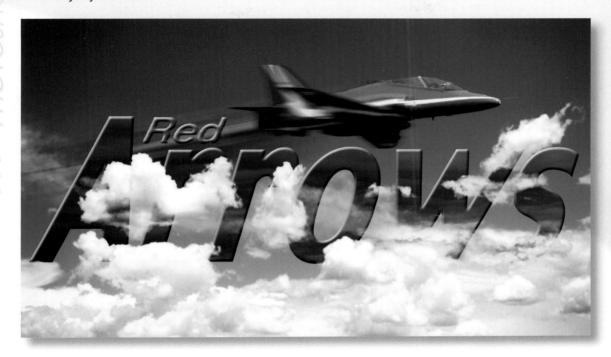

The technique of making the typography disappear amongst the cloud cover is created by a sandwiching technique and a selective blend mode applied to the top layer.

The sky is duplicated and the copy moved to the top of the layers stack. The darker levels (the blue sky) are blended or made transparent whilst the lighter levels (the clouds) are kept opaque. The typography now appears where the sky is darker and is obscured by the lighter clouds.

1. Open the image 'sky.jpg'. Click on the Type tool in the tools palette and create the desired typography. The example uses a Charcoal font, 'Faux Bold' and 'Faux Italic' (a Photoshop feature that allows any font to be made italic or bold). Any bold italic font would be suitable for this activity.

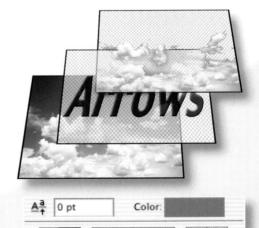

TT Tr T' T,

aa Crisp

English: Faux Italic

- 2. The layer effect 'Bevel and Emboss' is applied to this type layer. Select 'Inner Bevel' from the style menu and select an appropriate 'Angle' that is consistent with the light source in the rest of the image. Choose a blend mode, opacity and color for both the highlights and shadows. In the example both the highlight and shadow were set to 100% and the angle was set to 120°.
- 3. Duplicate the background layer 'Sky' by dragging the layer in the layers palette to the 'New Layers' icon at the base of the layers palette. Move the background copy to the top of the layers stack above the type layer (this action will temporarily obscure the type layer).

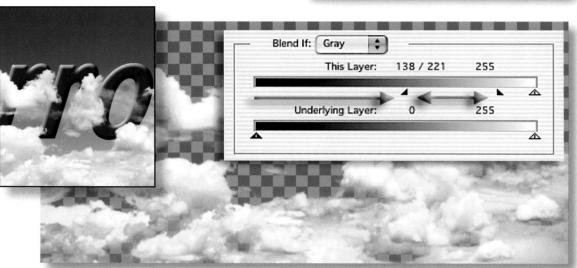

4. Double-click the background copy layer. The 'Blending Options' dialog box will open. This dialog box allows the user to change the opacity and blend mode of the layer. The bottom half of the box allows the user to control the range of levels that may be blended. Dragging the left-hand slider on the top ramp to a position of 150 allows all of the darker tones, or levels, to be made transparent. The typography on the layer below is now visible in all areas where the pixels are 0 to 150. The effect at present is abrupt. The type disappears suddenly into the clouds rather than gradually. A more gradual transition can be achieved by fading the effect over a range of pixels rather than selecting a single layer value at which 100% transparency takes place. By holding down the Option/Alt key and dragging the slider it is possible to split the black slider. Drag the right half of the slider to a value of around 200. This action creates the desired effect of the type fading slowly into the cloud cover.

- 5. Apply a fill to the typography using the technique used in the last activity. The image used to fill the type in this activity is called 'storm_clouds.jpg'. The image is opened and dragged (using the Move tool) or copied and pasted into the sky image. The image is moved to a position directly above the type layer in the layers palette and is 'clipped' to the type layer (see 'Activity 1').
- 6. An adjustment layer is then added and clipped with the storm clouds and typography (see 'Activity 1'). The adjustment layer is used to shift the colors of the storm cloud towards blue. This can be achieved by using either a Color Balance or a Curves adjustment layer.

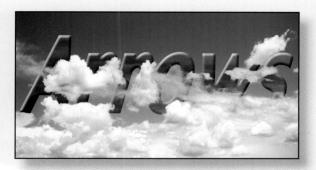

- 7. Open the image '**jet.jpg**'. Drag the layer thumbnail of the jet from the layers palette into the canvas area of the sky image.
- 8. Click on the 'Add layer mask' icon in the layers palette. Set the foreground color to black and select the tools paintbrush tool from the palette. Reduce the opacity slightly in the Options bar and choose a soft edged brush.

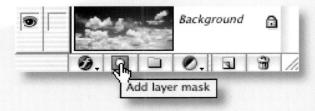

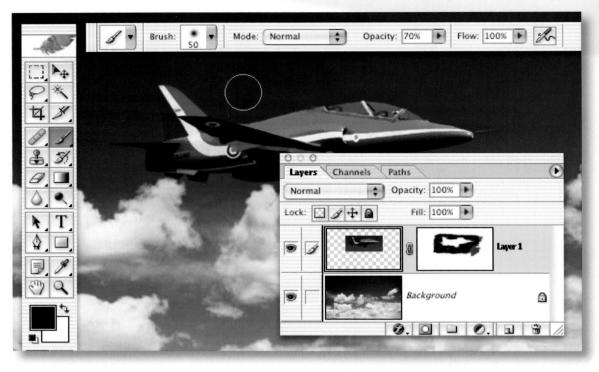

Paint in the layer mask to conceal the edges of the old sky. Move around the outline of the jet several times to blend the jet into the new background. Switch off the visibility of the background layer temporarily to check that you have removed enough of the sky to create a smooth transition.

9. To create the movement effect duplicate the aircraft layer twice (drag the layer to the 'Create new layer' icon). Choose Blur > Motion Blur from the Filters menu to apply a 15 pixel blur to one of the two duplicate layers. Apply a 300 pixel Motion Blur to the second duplicate layer. Ensure that the 'Angle' is appropriate for the direction of travel or movement. If you need to see a preview of the effect drag inside the preview window until part of the aircraft appears.

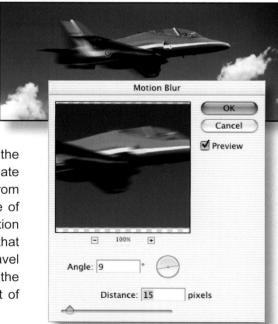

10. Position the 15 pixel blur above and the 300 pixel blur beneath the original. Select the 'Gradient' tool from the tools palette. Select the 'Linear Gradient', 'Foreground to Background' and 'Multiply' mode options in the Options bar. Drag the Gradient tool to conceal the front half of the blurred aircraft. With the 300 pixel blur layer selected choose Transform > Rotate from the Image menu and move the streak into position.

PHOTOSHOP

ssential skills >>>

11. Create an additional type layer to add the word 'Red'. Select a red from the aircraft using the eyedropper tool. This color will be placed in the foreground color swatch in the tools palette and become the default color for the typography. Click and drag the new type layer into position. From the edit menu choose Transform > Skew to increase the angle of lean of the typography. From the Filters menu choose Stylize > Wind and select 'From the Right' to give the appropriate direction of travel.

Note > To apply a filter to a type layer the type must first be rendered (into pixels). If type is rendered it is no longer editable.

Save a PSD version of the image. Choose 'Save a Copy' from the 'Save As' dialog box. Select Photoshop from the pull-down menu.

layer blends nop photoshop photosho

nop photoshop photoshop photoshop photoshop phot

essential skills

- Utilize appropriate layer blend modes for image retouching and creative montage work.
- Create digital montages using the following skills:
 - blend modes
 - layers and channels
 - layer masks.

Introduction

When an image, or part of an image, is placed on a separate layer above the background, creative decisions can be made as to how these layers interact with each other. Reducing the opacity of the top layer allows the underlying information to show through but Photoshop has many other ways of mixing, combining or 'blending' the pixel values on different layers to achieve different visual outcomes. The different methods used by Photoshop to compare and adjust the hue, saturation and brightness of the pixels on the different layers are called 'blend modes'. Blend modes can be assigned to the painting tools from the Options bar but they are more commonly assigned to an entire layer when editing a multi-layered document. The layer blend modes are accessed from the 'blending mode' pull-down menu in the top left-hand corner of the layers palette.

Orien Harvey

The major groupings

The blend modes are arranged in family groups of related effects or variations on a theme. Many users simply sample all the different blend modes until they achieve the effect they are looking for. This, however, can be a time consuming operation and a little more understanding of what is actually happening can ease the task of choosing an appropriate blend mode for the job in hand. A few of the blend modes are commonly used in the routine compositing tasks, whilst others have very limited or specialized uses only. The five main groups of blend modes after Normal and Dissolve that are more commonly used for image editing and montage work are:

- Darken
- Lighten
- Overlay
- Difference
- Hue.

At 100% opacity the pixels on the top layer obscure the pixels underneath. As the opacity is reduced the pixels underneath become visible. The Dissolve blend mode only becomes apparent when the opacity of the layer is reduced. Random pixels are made transparent on the layer rather than reducing the transparency of all the pixels. The effect is very different to the reduced opacity of the 'Normal' blend mode and has commercial applications as a transition for fading one image into another but the effect has very limited commercial applications for compositing and photomontage of stills image work.

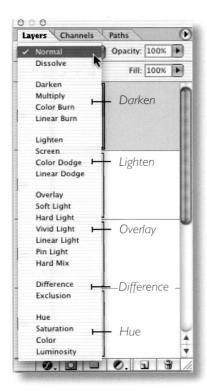

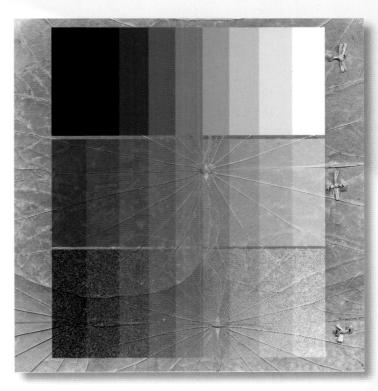

The groups of blend modes are listed using the name of the dominant effect. A step wedge is then used to demonstrate 'Normal' at 100% and 50% opacity and the 'Dissolve' blend mode with the layer set to 50% opacity

The 'Opacity' control for each layer, although not strictly considered as a blend mode, is an important element of any composite work. Some of the blend modes are quite pronounced or 'aggressive' in their resulting effect if applied at 100% opacity and could be overlooked if the user does not experiment with the combined effects of opacity and blend mode together.

NEW FOR PHOTOSHOP CS

The hard mix blend mode is new for Photoshop CS. It has a threshold effect when blending desaturated tones into a desaturated layer and a color posterization effect when blending saturated or desaturated tones with a color layer (see the Overlay Group for examples p.114).

SO TO FOLD V

The 'Darken' group

It's not too hard to figure out what this group of blend modes have in common. Although Darken leads the grouping, Multiply is perhaps the most used blend mode in the group.

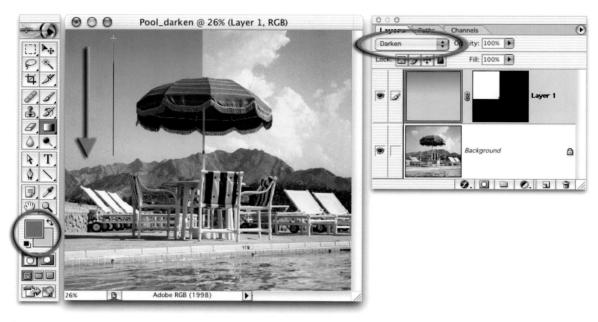

The Darken mode can be used to replace existing highlights whilst ignoring darker tones

Darken

The 'Darken' blend mode chooses pixels from either the blend layer or underlying layers to display at 100% opacity depending on their brightness value. Any underlying tone that is darker than the blend color remains unaffected by the blend mode, and any color that is lighter than the blend color is replaced rather than multiplied with the blend color. This blend mode is usually restricted to pasting a carefully chosen tone into the highlights of an image.

Multiply is a useful blend mode when overall darkening is required

Multiply

The 'Multiply' blend mode belongs to the 'Darken' family grouping. The brightness values of the pixels on the blend layer and underlying layer are multiplied to create darker tones. Only values that are multiplied with white (level 255) stay the same.

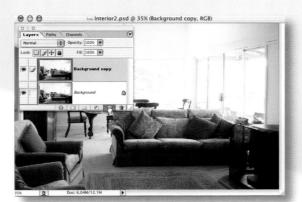

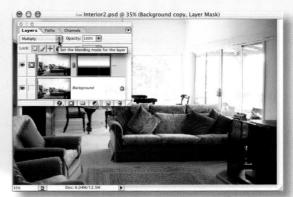

The Multiply blend mode is used to darken the top half of the image

The Multiply blend mode is used to apply a dark edge to the image

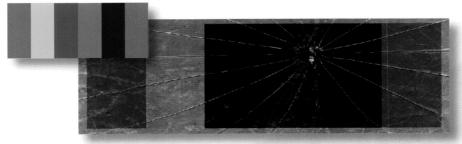

Color Burn

Color Burn and Linear Burn

The image is darkened to reflect the blend color. Color Burn increases the underlying contrast to do this whilst Linear Burn decreases the underlying brightness. This is a difficult blend mode to find a use for at 100% opacity. Saturation can become excessive and overall brightness, now heavily influenced by the underlying color, can 'fill in' (become black).

The 'Lighten' group

Everything that was mentioned with the Darken group is now reversed for this group of blend modes. The 'Screen' blend mode is often considered the firm favorite of this group.

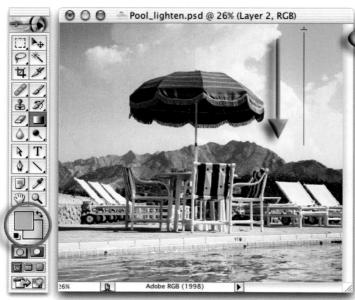

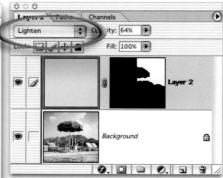

The 'Lighten' mode is used to replace the original dark sky color with a lighter color sampled from the pool. Note how the layer mask is used to protect the umbrella from the blend color.

Lighten

The 'Lighten' blend mode chooses pixels from either the blend layer or underlying layers to display at 100% opacity depending on their brightness value. Any underlying tone that is lighter than the blend color remains unaffected by the blend mode, and any color that is darker than the blend color is replaced rather than multiplied with the blend color. This blend mode is usually restricted to blending a carefully chosen tone into the midtones or shadows of an image. This technique can be useful for replacing dark colored dust and scratches from light areas of continuous tone.

Screen is useful when overall lightening is required

Screen

The 'Screen' blend mode belongs to the 'Lighten' family grouping. The 'inverse' brightness values of the pixels on the blend layer and underlying layers are multiplied to create lighter tones (a brightness value of 80% is multiplied as if it was a value of 20%). Only values that are screened with black (level 0) stay the same.

A background layer is duplicated and a Screen blend mode is applied to lighten all levels

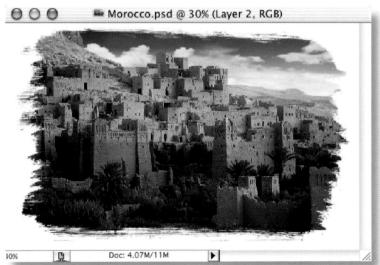

The Screen mode is used to apply a white border around an image

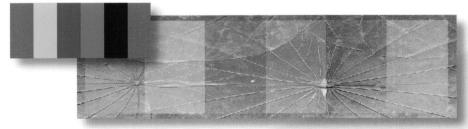

Color Dodge

Color Dodge and Linear Dodge

The image is lightened to reflect the blend color. Color Dodge decreases the underlying contrast to do this whilst Linear Dodge increases the underlying brightness. This again is a difficult blend mode to find a use for at 100% opacity. Saturation can become excessive and overall brightness, heavily influenced by the underlying color, can blow out (become white).

The 'Overlay' group

This is perhaps the most useful group of blend modes for photomontage work.

Applying the blend mode 'Overlay' to a texture or pattern layer will create an image where the form appears to be modeling the texture. Both the highlights and shadows of the underlying form are respected

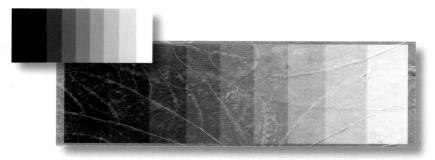

The 'Overlay' blend mode is useful for overlaying textures over 3D form

Overlay

The Overlay blend mode uses a combination of the Multiply and Screen blend modes whilst preserving the highlight and shadow tones of the underlying image. The Overlay mode multiplies or screens the colors, depending on whether the base color is darker or lighter than a midtone. The effect is extremely useful when overlaying a texture or color over a form modeled by light and shade. Excessive increases in saturation may become evident when overlaying white and black. The 'Soft' and 'Hard Light' blend modes produce variations on this overlay theme.

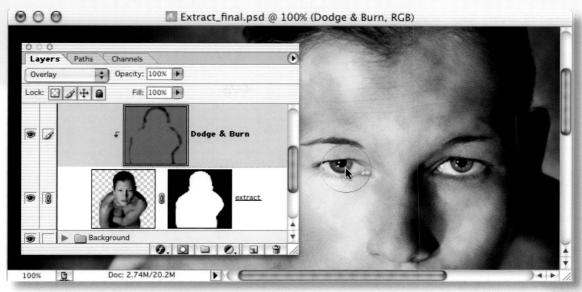

A 50% Gray layer set to Overlay mode is used to dodge and burn the underlying image

Note> A layer filled with 50% Gray is invisible in overlay mode and, as a result, is commonly used as a 'non-destructive' dodging and burning layer.

Soft and Hard Light – variations on a theme

The Soft and Hard Light blend modes are variations on the 'Overlay' theme. Photoshop describes the difference in terms of lighting (diffused or harsh spotlight). If the Overlay blend mode is causing highlights or shadows to become overly bright or dark then the Soft Light blend mode will often resolve the problem. The harsh light on the other hand increases the contrast – but care must be taken when choosing this option as blending dark or light tones can tip the underlying tones to black (level 0) or white (255).

Hard Mix

The Hard Mix blend mode is new for Photoshop CS. It has a threshold effect when blending desaturated tones into a desaturated layer and a color posterization effect when blending saturated or desaturated tones with a color layer.

PHOTOSHOP CS

Blend modes for tinting and toning

The Hue and Color blend modes are predominantly used for toning or tinting images whilst the Saturation blend mode offers more limited applications. Photoshop 8 also offers photo filters.

Hue

The 'Hue' blend mode modifies the image by using the hue value of the blend layer and the saturation value of the underlying layer. As a result the blend layer is invisible if you apply this blend mode to a fully desaturated image. Opacity levels of the blend layer can be explored to achieve the desired outcome.

Color

The 'Color' blend mode is useful for toning desaturated or tinting colored images. The brightness value of the base color is blended with the hue and saturation of the blend color.

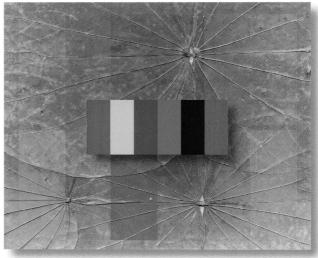

Hue and Color blend modes

Note > Color fills can be used to tint or tone images by setting them to Hue or Color mode. Photoshop's new Photo Filter layers perform a similar task but without the need to set the layer to the Hue or Color mode.

>>> essential skills >>>

Saturation

The brightness or 'luminance' of the underlying pixels is retained but the saturation is replaced with that of the blend layer.

Note > This blend mode has limited uses for traditional toning effects but can be used to locally desaturate colored images. To work with this blend mode try creating a new empty layer. Then either fill a selection with any desaturated tone or paint with black or white at a reduced opacity to gradually remove the color from the underlying image.

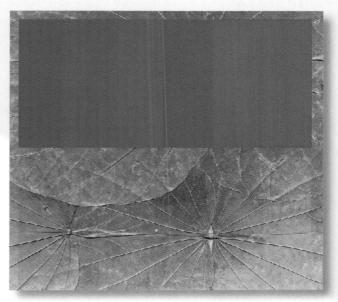

The Saturation blend mode

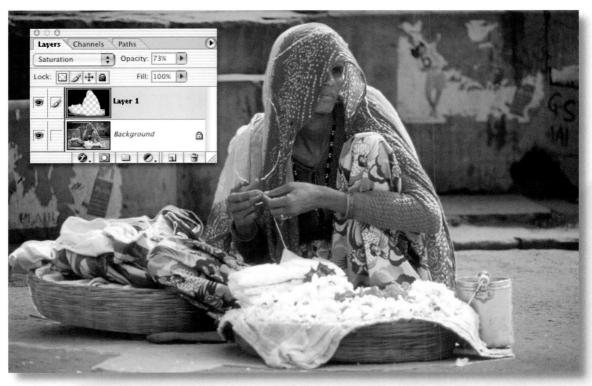

A saturation layer is used to desaturate the undelying image

Luminosity

The 'Luminosity' blend mode creates the same result as the 'Color' mode if the layers are reversed, i.e. the color layer is underneath. The Luminosity blend mode has another very useful application. If the luminosity values are extracted from an RGB image (from the channels palette) and placed on a layer above the colored background image, it is possible to modify the tonality of the image without affecting the hue and saturation of the image. This can also be useful as an advanced technique for applying the 'Unsharp Mask' to a layer.

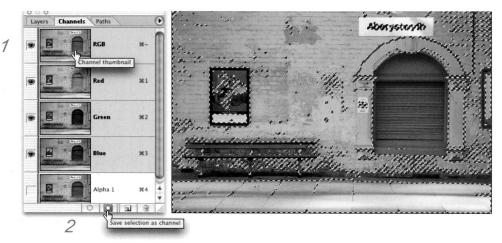

Creating a luminance layer

- 1. Command/Ctrl-click the master RGB channel to select the luminance values.
- 2. Click on the 'Save selection as channel' icon to create an alpha channel.
- 3. Go to Select > Select All.
- 4. Paste the selection as a new layer in the layers palette.
- 5. Set the blend mode of this new layer to 'Luminance'.

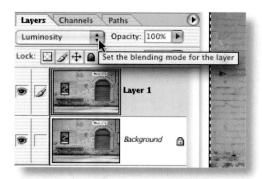

An adjustment layer can be grouped with a luminosity layer to eliminate shifts in saturation when contrast is adjusted. The example to the right demonstrates what happens when contrast is increased using a luminance layer (top left) and normally (botttom right).

Difference and Exclusion

The Difference blend mode subtracts either the underlying color from the blend color or vice versa depending on which has the highest brightness value. A duplicated layer with a Difference blend applied will result in a totally black image. These blend modes can be useful for registering layers with the same content if they are accidentally put out of alignment during image editing (when realigned the layer pixels can be locked). The Exclusion blend modes works in the same way except where the blend color is white. In this instance the underlying color is inverted.

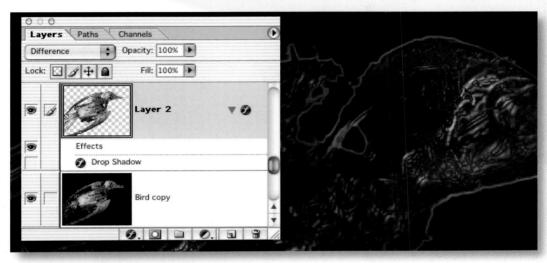

The Difference mode is used to align two images

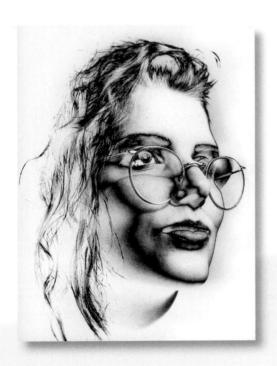

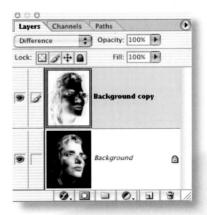

The Difference mode can also be used to create a quick 'sabattier' effect with a grayscale image. To create this effect duplicate the layer and go to Image > Adjustments > Invert. Apply the Difference blend mode to this copy layer.

Creating a simple blend

Blending two images in the computer is similar to creating a double exposure in the camera or sandwiching negatives in the darkroom. Photoshop allows a greater degree of control over the final outcome. This is achieved by controlling the specific blend mode, position and opacity of each layer. The use of 'layer masks' can shield any area of the image that needs to be protected from the blend mode. The blending technique enables the texture or pattern from one image to be modeled by the form of a selected subject in another image.

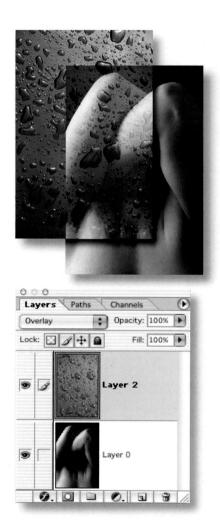

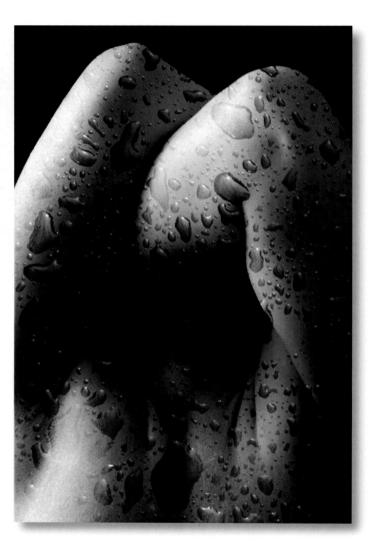

Note > In the montage above the image of the body has been blended with an image of raindrops on a car bonnet. The texture blended takes on the shadows and highlights of the underlying form but does not wrap itself around the contours or shape of the three-dimensional form.

ACTIVITY / www.photoshopessentialskills.com/blends.html

Download the images from the supporting web site or use your own images to complete this simple blend. The secret to success is in the selection of appropriate imagery to complete the task as outlined in the first two steps of the process.

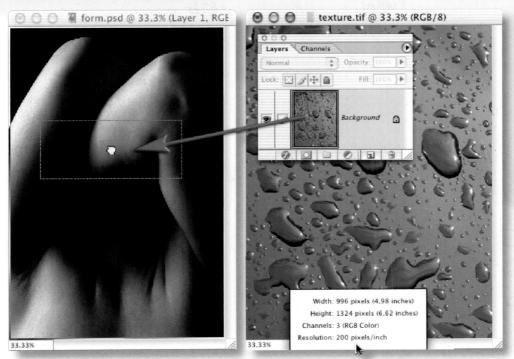

- 1. Select or create one image where a three-dimensional subject is modeled by light. Try photographing a part of the human body using a large or diffused light source at right angles to the camera. The image should ideally contain bright highlights, midtones and dark shadows. Scan the image and save as 'Form'. Alternatively use the image titled 'form.jpg' provided on the web site to support this study guide.
- 2. Select or create another image where the subject has an interesting texture or pattern. Scan the image and save as 'Texture'. Try using a bold texture with an irregular pattern. The texture should ideally have a full tonal range with good contrast. A subtle or low contrast texture may not be obvious when blended. Alternatively use the image provided to support this study guide that is titled 'texture.jpg'.

entia

- 3. Alt/Option click the document sizes in the bottom left-hand corner of each image window to check that the image pixel dimensions (width and height) are similar. It is possible to blend a colored texture with a grayscale image. If the color of the texture is to be retained the grayscale image containing the form must first be converted to RGB by going to 'Image > Mode > RGB'.
- 4. Click and drag the layer thumbnail of the texture image into the form image. Hold down the Shift key as you let go of the texture thumbnail to center the image in the new window. Use the Move tool to reposition the texture if required.

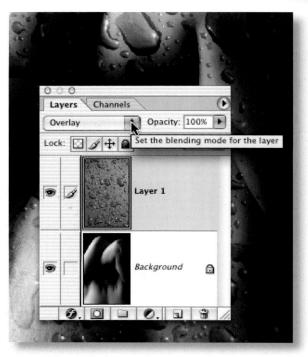

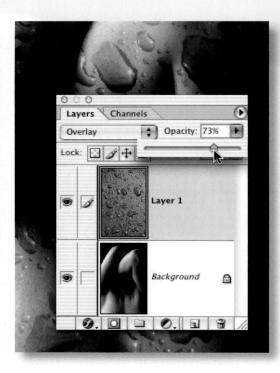

- 5. As the top layer is set at 100% opacity none of the information on the layer below is visible. Experiment with adjusting the opacity of the top layer using the opacity slider in the layers palette. Observe the effects created by allowing the information on the layer below to show through. Set the opacity between 50 and 75%.
- 6. With the top layer active click on the blend mode menu in the layers palette and scroll down to the option 'Multiply'. Observe the changes that take place in the image and pay particular attention to the information that can be seen in the shadows and highlights. Now change the blend mode to 'Screen' and then 'Overlay' to observe the differences that these blend modes have on the interaction between the two layers. Choose the most appropriate one and readjust the opacity of the layer.

7. The blend is now complete. Save a flattened copy (Image > Duplicate > Copy Merged) of the finished image as a TIFF and apply the Unsharp Mask prior to printing. Save a master version as a PSD (Photoshop document) for subsequent editing or manipulation.

Advanced blending techniques

The layer 'blend' modes are an effective, but limited, way of merging or blending a pattern or graphic with a three-dimensional form. By using the blend modes the pattern or graphic can be modified to respect the color and tonality of the 3D form beneath it. The highlights and shadows that give the 3D form its shape can, however, be further utilized to wrap or bend the pattern or graphic so that it obeys the form's perspective and sense of volume. This can be achieved by using the 'Displace' filter in conjunction with a 'displacement map'. The 'map' defines the contours to which the graphic or pattern must conform. The final effect can be likened to 'shrink-wrapping' the graphic or pattern to the 3D form.

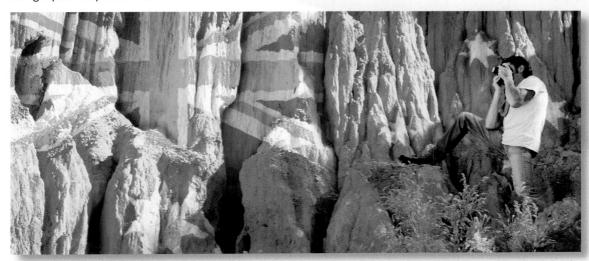

Displacement requires the use of a PSD image file or 'displacement map' created from the layer containing the 3D form. This is used as the contour map to displace pixels of another layer (the pattern or graphic). The brightness level of each pixel in the map directs the filter to shift the corresponding pixel of the selected layer in a horizontal or vertical plane. The principle on which this technique works is that of 'mountains and valleys'. Dark pixels in the map shift the graphic pixels down into the shaded valleys of the 3D form whilst the light pixels of the map raise the graphic pixels onto the illuminated peaks of the 3D form.

Note how the straight lines of the Union Jack are distorted after the Displace filter has been applied. The first image looks as though the flag has been projected onto the rock surface, whilst in the second image it appears as though it has been painted or shrink-wrapped onto the rock surface.

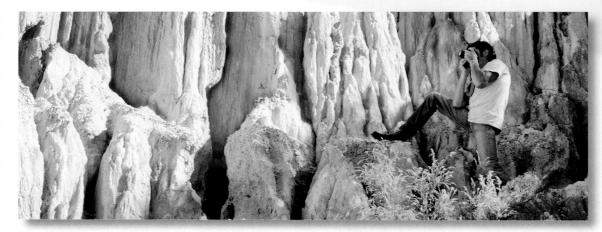

ACTIVITY 2 www.photoshopessentialskills.com/blends.html

The limitation of the displacement technique is that the filter reads dark pixels in the image as being shaded and light pixels as being illuminated. This of course is not always the case. With this in mind the range of images that lend themselves to this technique is limited. A zebra would be a poor choice on which to wrap a flag whilst a nude illuminated with soft directional lighting would be a good choice. The image chosen for this activity lends itself to the displacement technique. Directional light models the rock face. Tonal differences due to hue are limited.

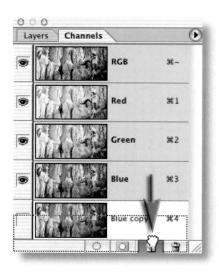

- 1. In order to apply the Displace filter you must first create a grayscale image to become the displacement map. Open the image 'Rockface.jpg'. In the channels palette locate the channel with the best tonal contrast between the shadows and the highlights. Duplicate this channel by dragging it to the New Layer icon at the base of the palette.
- 2. Apply a small amount of 'Gaussian Blur' from the Filters menu and adjust the levels so that the contrast range extends from black to white.

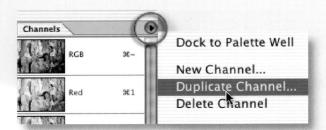

3. Export this channel to become the displacement map by choosing 'Duplicate Channel' from the Channels menu and then 'Document > New' from the Destination menu. Save the exported PSD file. This will be your displacement map.

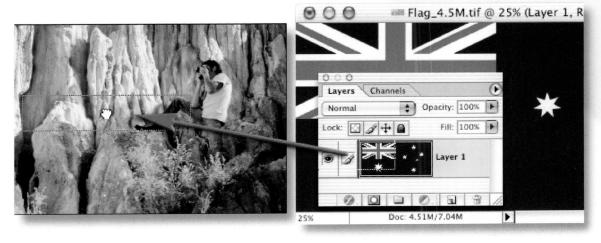

4. A small paper flag was scanned so that it could be used as a flat two-dimensional graphic or pattern (flag.jpg). Drag the flag into the rock ace image. Apply the 'Free Transform' from the Edit menu to obtain a 'good fit' if necessary.

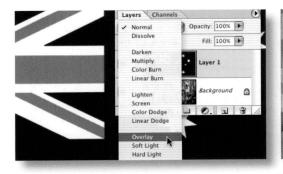

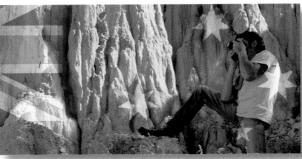

5. From the blend modes choose an appropriate blend mode and layer opacity for the desired effect you would like to achieve. The 'Overlay' or 'Soft Light' blend modes are a good place to start, although 'Color Burn' proved effective in this instance.

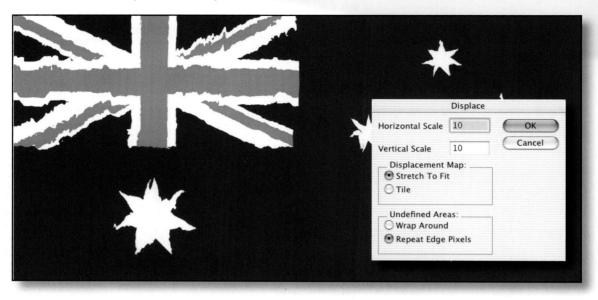

6. Choose 'Filter > Distort > Displace' and enter the amount of the displacement. Select OK and then select the displacement map you created earlier. The distortion is applied to the layer. The Displace filter shifts the pixels on the selected layer using a pixel value from the displacement map. Levels 0 and 255 are the maximum negative and positive shifts whilst level 128 produces no displacement.

Note > If an RGB map is used the red channel controls the horizontal displacement and the green channel controls the vertical displacement.

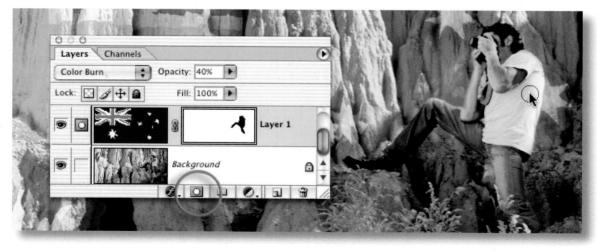

7. To complete the wrap select the map layer in the layers palette and click the 'Add layer mask' icon in the layers palette. Use a soft edged brush and paint into the layer mask using black as the foreground color. This action will shield the man from the blend.

Alternative approach using the 'Liquify' filter

An alternative approach to distorting the graphic using the Displacement filter in 'Activity 2' would be to use the 'Liquify' filter. Instead of using the 'Blue copy' channel to create a displacement map it can be used to 'freeze' an area of the image prior to selectively displacing the unfrozen pixels using the 'Warp tool'. This alternative method of displacing pixels on one layer, to reflect the contours of another layer, is most suited to the improved features to be found in Photoshop 7 and Photoshop CS which allow for the visibility of additional layers.

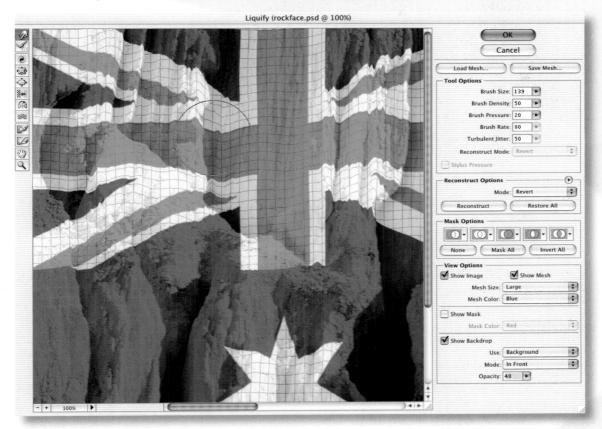

To try this alternative approach complete the first five steps of 'Activity 2', skipping step 3. When you reach step 6, instead of creating a displacement map, click on the graphic layer and go to Filter > Liquify. Check the 'Show Backdrop' option in the dialog box and select 'background layer' from the menu.

To selectively freeze the darker pixels in the image load the 'Blue copy' channel in the 'Mask Options'. Check 'Show Mesh' in the 'View Options'. Select a brush size and pressure and then stroke the graphic upwards whilst observing the contours of the rock wall to displace the lighter pixels. Select 'Invert All' in the 'Mask Options' so that you can displace the darker pixels in the opposite direction.

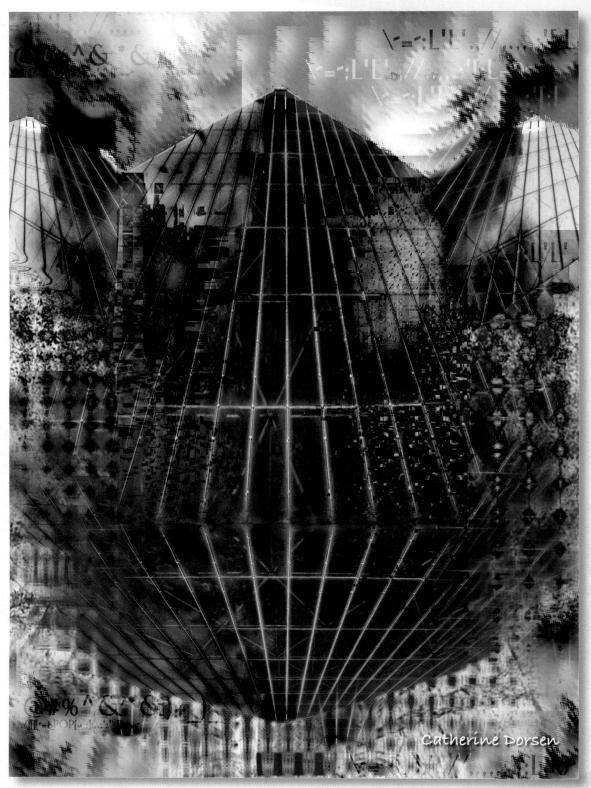

selections

op photoshop photoshop photoshop photoshop photo

op photoshop photoshop photoshop photoshop photoshop photoshop

essential skills

- ~ Develop skills in creating and modifying selections to isolate and mask image content.
- ~ Create digital montages using the following skills:
 - selection tools and techniques
 - layers and channels
 - layer masks.

Introduction

One of the most skilled areas of digital retouching and manipulation is the ability to make accurate selections of pixels for repositioning, modifying or exporting to another image. This skill allows localized retouching and image enhancement. Photoshop provides several different tools that allow the user to select the area to be changed. Called the 'Selection' tools, using these features will fast become a regular part of your editing and retouching process. Photoshop marks the boundaries of a selected area using a flashing dotted line sometimes called 'marching ants'.

Obvious distortions of photographic originals are common in the media but so are images where the retouching and manipulations are subtle and not detectable. Nearly every image in the printed media is retouched to some extent. Selections are made for a number of reasons:

- · Making an adjustment or modification to a localized area, e.g. color, contrast, etc.
- · Defining a subject within the overall image to mask, move or replicate.
- Defining an area where an image or group of pixels will be inserted ('paste into').

Selection tools overview

Photoshop groups the Selection tools based on how they isolate picture parts. These categories are:

- The 'Marquee tools' are used to draw regular-shaped selections such as rectangles or ellipses around an area within the image.
- The 'Lasso tools' use a more freehand drawing approach and are used to draw a selection by defining the edge between a subject and its background.
- The 'Magic Wand' makes selections based on color and tone and is used to isolate groups of pixels by evaluating the similarity of the neighboring pixel values (hue, saturation and brightness) to the pixel that is selected.

Shape-based selections with the Marquee tools

The Marquee tools select by dragging with the mouse over the area required. Holding down the Shift key as you drag the selection will 'constrain' the selection to a square or circle rather than a rectangle or oval. Using the Alt (Windows) or Options (Mac) key will draw the selections from their centers. The Marquee tools are great for isolating objects in your images that are regular in shape, but for less conventional shapes, you will need to use one of the Lasso tools.

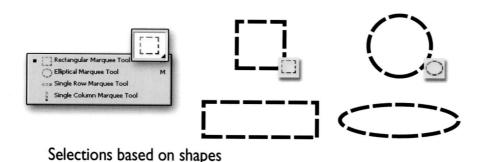

OHOTORYO

Selections based on drawing

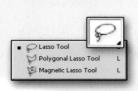

Drawn selections using the Lasso tools

Select by encircling or drawing around the area you wish to select. The standard Lasso tool works like a pencil allowing the user to draw freehand shapes for selections. A large screen and a mouse in good condition (or a graphics tablet) are required to use the Freehand Lasso tool effectively. In contrast, the Polygonal Lasso tool draws straight edge lines between mouse-click points. Either of these features can be used to outline and select irregular-shaped image parts.

A third tool, the Magnetic Lasso, helps with the drawing process by aligning the outline with the edge of objects automatically. It uses contrast in color and tone as a basis for determining the edge of an object. The accuracy of the 'magnetic' features of this tool is determined by three settings in the tool's Options bar. **Edge Contrast** is the value that a pixel has to differ from its neighbor to be considered an edge, **Width** is the number of pixels either side of the pointer that are sampled in the edge determination process and **Frequency** is the distance between fastening points in the outline.

Double-clicking the Polygonal Lasso tool or Magnetic Lasso tool automatically completes the selection using a straight line between the last selected point and the first.

Note > Remember the Magnetic Lasso tool requires a tonal or color difference between the object and its background in order to work effectively.

Selections based on colour and tone

The Magic Wand

Unlike the Lasso and Marquee tools the Magic Wand makes selections based on color and tone. It selects by relative pixel values. When the user clicks on an image with the Magic Wand tool Photoshop searches the picture for pixels that have a similar color and tone. With large images this process can take a little time but the end result is a selection of all similar pixels across the whole picture.

Tolerance

How identical a pixel has to be to the original is determined by the **Tolerance** value in the Options bar. The higher the value, the less alike the two pixels need to be, whereas a lower setting will require a more exact match before a pixel is added to the selection. Turning on the **Contiguous** option will only include the pixels that are similar and adjacent to the original pixel in the selection.

Better with a tablet: Many professionals prefer to work with a stylus and tablet when creating complex selections.

Moving a selection

If the selection is not accurate it is possible to move the selection without moving any pixels. With the Selection tool still active place the cursor inside your selection and drag the selection to reposition it. To move the pixels and the selection, use the Move tool from the tools palette. Press the spacebar to realign a marquee selection before the selection is completed.

To remove a selection

Go to Select > Deselect or use the shortcut 'Command/Ctrl + D' to deselect a selection.

Modifying your selections

Basic selections of standard, or regular-shaped, picture parts can be easily made with one simple step – just click and drag. But you will quickly realize that most selection scenarios are often a little more complex. For this reason the thoughtful people at Adobe have provided several ways of allowing you to modifying your selections. The two most used methods provide the means to 'add to' or 'subtract from' existing selections. This, in conjunction with the range of Selection tools offered by the program, gives the user the power to select even the most complex picture parts. Skillful selecting takes practice and patience as well as the ability to choose which Selection tool will work best for a given task.

Photoshop CS provides two different ways to modify an existing selection.

- 1. The first uses keyboard shortcuts in conjunction with the Selection tools to 'add to' and 'subtract from' the selection. Using this approach is fast and convenient and is the one preferred by most professionals.
- 2. The second uses the mode buttons located in a special portion of the tool's Options bar. This way of working is a great way to start changing your selections. The default mode is 'New Selection' which means that each selection you make replaces the last. Once another option is selected the mode remains active for the duration of the selection session. This is true even when you switch Selection tools.

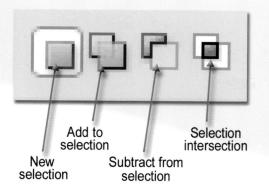

Add to a selection

To add to an existing selection hold down the Shift key whilst selecting a new area. Notice that when the Shift key is held down the Selection tool's cursor changes to include a '+' to indicate that you are in the 'add' mode. This addition mode works for all tools and you can change Selection tools after each new selection is complete.

Subtract from a selection

To remove sections from an existing selection hold down the Alt key (Option – Macintosh) whilst selecting the part of the picture you do not wish to include in the selection. When in the subtract mode the cursor will change to include a '-'.

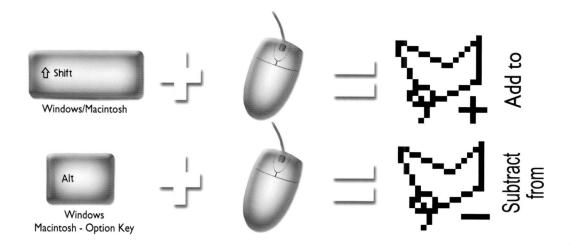

Selection intersection

In Photoshop often the quickest route to selection perfection is not the most direct route. When you are trying to isolate picture parts with complex edges it is sometimes quicker and easier to make two separate selections and then form the final selection based on their intersection. The fourth mode available as a button on the Selection tool's Option bar is the Intersect mode. Though not used often this mode provides you with the ability to define a selection based on the area in common between two different selections.

Inversing a selection

In a related technique, some users find it helpful to select what they don't want in a picture and then instruct Photoshop to select everything but this area. The Select > Inverse command inverts or reverses the current selection and is perfect for this approach. In this way foreground objects can be quickly selected in pictures with a smoothly graduated background of all one color (sky, snow or a wall space) by using the Magic Wand to select the background. Then the act of inversing the selection will isolate the foreground detail.

Professionals who know that the foreground will be extracted from the picture's surrounds often shoot their subjects against an evenly lit background of a consistent color to facilitate the application of this technique.

Saving and loading selections

The selections you make remain active whilst the image is open and until a new selection is made, but what if you want to store all your hardwork to use on another occasion? As we have already seen in the previous chapter Photoshop CS provides the option to save your selections as part of the picture file. Simply select Select > Save Selection and the existing selection will be stored with the picture.

To display a selection saved with a picture, open the file and choose Load Selection from the Select menu. In the Load Selection dialog click on the Channel drop-down menu and choose the selection you wish to reinstate. Choose the mode which the selection will be added to your picture from the Operation section of the dialog. Click OK to finish.

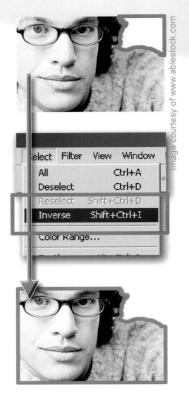

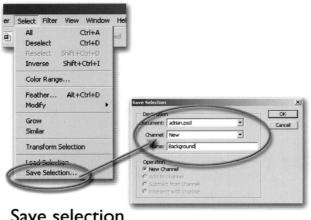

Load selection

Alt+Ctrl+D

nel: Background

Save selection

Feather and anti-alias

The ability to create a composite image or 'photomontage' that looks subtle, realistic and believable rests with whether or not the viewer is able to detect where one image starts and the other finishes. The edges of each selection can be modified so that it appears as if it belongs, or is related, to the surrounding pixels.

Options are available with most image processing software to alter the appearance of the edges of a selection. Edges can appear sharp or soft (a gradual transition between the selection and the background). The options to effect these changes are:

- Feather
- · Anti-aliasing.

Feather

When this option is chosen the pixels at the edges of the selection are blurred. The edges are softer and less harsh. This blurring may either create a more realistic montage or cause loss of detail at the edge of the selection.

You can choose feathering for the Marquee or Lasso tools as you use them by entering a value in the tool options box, or you can add feathering to an existing selection (Select > Feather). The feathering effect only becomes apparent when you move or paste the selection to a new area.

Anti-aliasing

When this option is chosen the jagged edges of a selection are softened. A more gradual transition between the edge pixels and the background pixels is created. Only the edge pixels are changed so no detail is lost. Anti-aliasing must be chosen before the selection is made (it cannot be added afterwards). It is usual to have the anti-alias option selected for most selections. The anti-alias option also needs to be considered when using type in image editing software. The anti-alias option may be deselected to improve the appearance of small type to avoid the appearance of blured text.

Defringe and Matting

When a selection has been made using the anti-alias option some of the pixels surrounding the selection are included. If these surrounding pixels are darker, lighter or a different color to the selection a fringe or halo may be seen. From the Layers menu choose Matting > Defringe to replace the different fringe pixels with pixels of a similar hue, saturation or brightness found within the selection area.

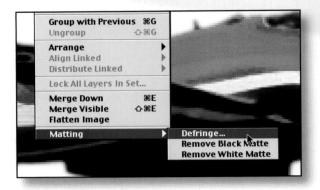

Fringe

Defringe

The user may have to experiment with the most appropriate method of removing a fringe. The alternative options of remove white matte and remove black matte may provide the user with a better result. If a noticeable fringe still persists it is possible to contract the selection prior to moving it using the Modify > Contract option from the Select menu.

Saving a selection as an alpha channel

Selections can be permanently stored as 'alpha channels'. The saved selections can be reloaded and/or modified even after the image has been closed and reopened. To save a selection as an alpha channel simply click the 'Save selection as channel' icon at the base of the channels palette. To load a selection either drag the alpha channel to the 'Load channel as selection' icon in the channels palette or Command/Ctrl-click the alpha channel.

It is possible to edit an alpha channel (and the resulting selection) by using the painting and editing tools. Painting with black will add to the alpha channel whilst painting with white will remove information. Painting with shades of gray will lower or increase the opacity of the alpha channel. The user can selectively soften a channel and resulting selection by applying a Gaussian Blur filter. Choose Blur > Gaussian Blur from the Filters menu.

Note > An image with saved selections cannot be saved as a JPEG.

If you are new to the magic of the wand, enter the default setting of 32 in the tolerance field of the Options bar (raising the value makes the ants increasingly frisky). Make sure the 'Anti-aliased' box is checked as this smoothes the edge of the selection (to stop it looking like the mouth of 'Jaws'). Also check the 'Contiguous' box, as this will make sure your ants respect any boundaries and borders they encounter. Before attempting to make a selection decide which is easier – selecting the background around the object or selecting the object itself (choose the one with fewest colors). You can always 'Inverse' the selection when you are done (Select > Inverse). A careful selection of the background can quickly be turned into a selection of the subject in this way.

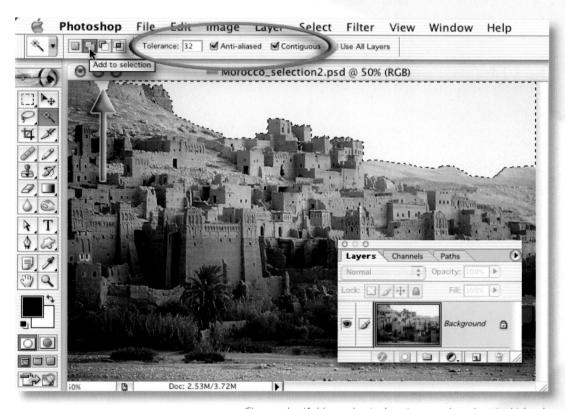

Choose the 'Add to selection' option to select the pixel islands

Unleashing the trained magic ants

Unlike real magic wands you can't wave this one around but have to click on the area you wish to select instead. It is very unlikely that your ants will magically gravitate to the edges of your subject in one hit. These ants have to be trained. You can either click on the 'Add to selection' icon in the Options bar (holding down the Shift key has the same effect) or raise the tolerance of the Magic Wand and try again.

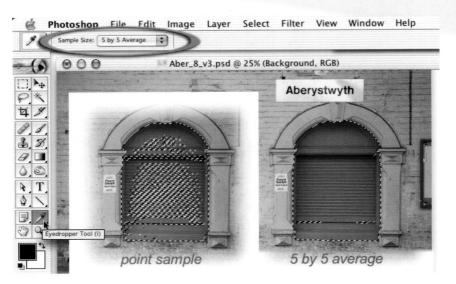

If you raise the tolerance of the wand but the selection is either patchy or excessive go to 'Edit > Undo' and try the following. Raise the setting of the eyedropper tool from 'Point Sample' to '5 by 5 Average'. The wand usually becomes a little more stable and the ants just might be encouraged to make the selection you are looking for.

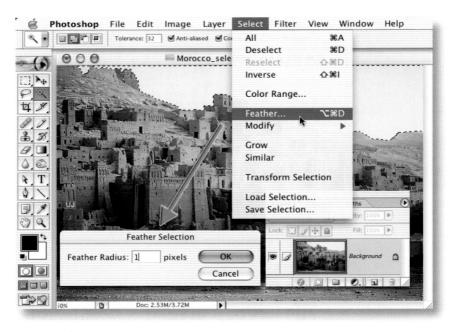

There is no feather option with the Magic Wand tool so this important step is often overlooked. A small amount of feather is nearly always needed – even with seemingly sharp edges. One of the problems with the Magic Wand is that the magic ants have a fear of edges. They prefer to stand back and admire the view from a safe distance.

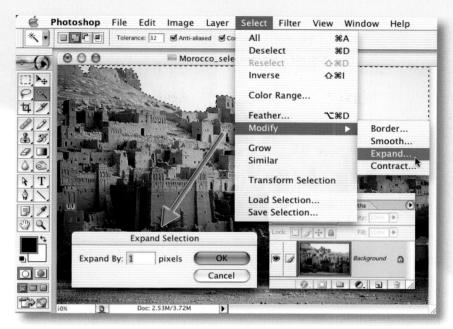

Move the reluctant ants closer to the edge by expanding the selection (Select > Modify > Expand). This will counteract the halo effect that is all too often seen with poor selection work.

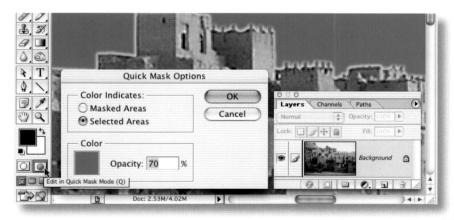

'Quick Mask'

The problem with feathering and modifying selections using the 'Select' menu items is that the ants give very poor feedback about what is actually going on at the edge. Viewing the selection as a 'Mask' in 'Quick Mask Mode' allows you to view the quality and accuracy of your selection. Zoom in on an edge to take a closer look. Double-click the Quick Mask icon to change the mask color, opacity and to switch between 'Masked Areas' and 'Selected Areas'. If the mask is still falling short of the edge, expand the selection again. If the mask is over the edge you can contract the selection (also from the 'Select > Modify' menu). Alternatively give the Select menu the flick and proceed to work on the mask directly. A 'Levels' adjustment in Quick Mask mode provides a 'one-stop shop' for editing the mask giving you the luxury of a preview as you modify the resulting selection.

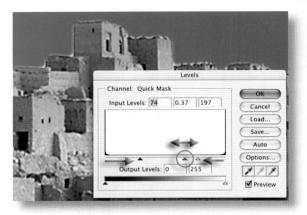

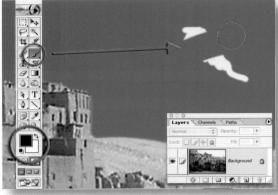

Using a 'Levels' adjustment (Image > Adjustments > Levels) in Quick Mask mode allows you to modify the edge quality if it is too soft and also reposition the edge so that it aligns closely with your subject. Dragging the shadow and highlight sliders in towards the center will reduce the softness of the mask whilst moving the midtone or 'Gamma' slider will move the edge itself.

Note > The selection must have been feathered prior to the application of the levels adjustment for this to be effective.

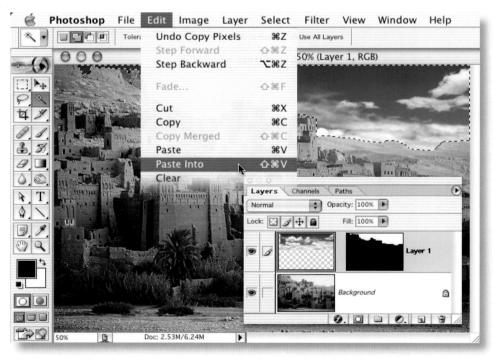

Save the selection as an alpha channel. This will ensure that your work is stored permanently in the file. If the file is closed and reopend the selection can be reloaded. Finish off the job in hand by modifying or replacing the selected pixels. If the Magic Wand is not working for you, you should explore the following alternatives.

Photoshop has many alternative methods for creating selections. The 'Color Range' option from the 'Selection' menu should be considered next. This option is useful for selecting subjects that are defined by a limited color range (sufficiently different from those of the background colors). This option is especially useful when the selection is to be used for a hue adjustment.

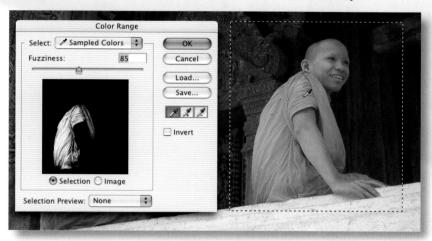

Use a Marquee tool (from the tools palette) to limit the selection area before you start using the Color Range option.

Note > The Color Range option can misbehave sometimes. If the selection does not seem to be restricted to your sampled color press the Alt/Option key and click on the reset option or close the dialog box and re-enter.

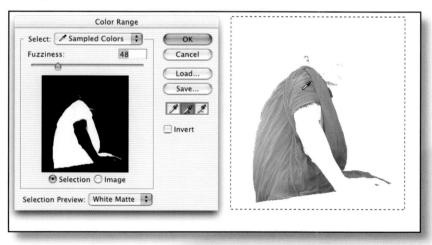

Use the 'Add to sample' eyedropper and drag the eyedropper over the subject area you wish to select. In the later stages you can choose a matte color to help the task of selection. Adjust the fuzziness slider to perfect the selection. Black and white pixels can be left out of the selection if it is to be used for a hue adjustment only.

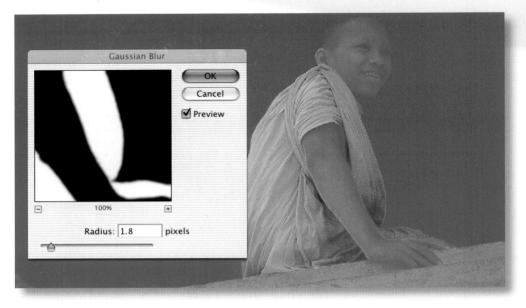

Select OK and view the selection in Quick Mask mode to gain an idea of the selection's suitability for the job in hand. The selection can be feathered from the Select menu (Select > Feather) or a Gaussian Blur filter can be applied to the Quick Mask. The latter option has the advantage of a preview taking the guesswork out of choosing an appropriate feather value.

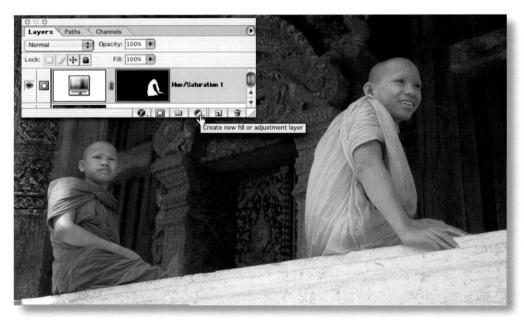

A selection prepared by the 'Color Range' command is ideal for making a hue adjustment. It is also recommended to view the individual channels to see if the subject you are trying to isolate is separated from the surrounding information. If this is the case a duplicate channel can act as a starting point for a selection.

Channel masking

An extremely quick and effective method for selecting a subject with reasonable color contrast to the surrounding pixels is to use the information from one of the channels to create a mask and then to load this mask as a selection.

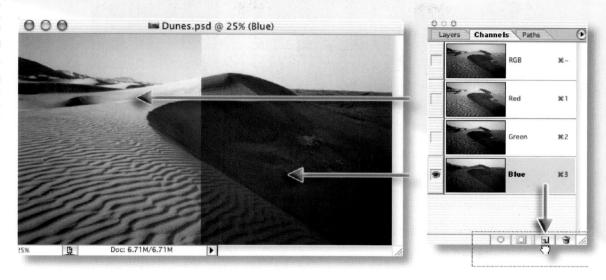

Click on each individual channel to see which channel offers the best contrast and then duplicate this channel by dragging it to the 'New Channel' icon.

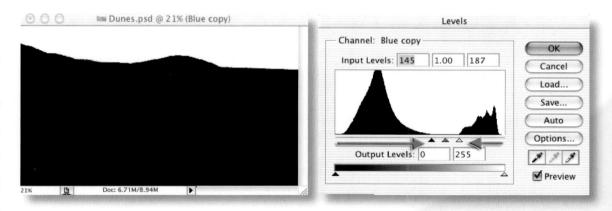

Apply a levels adjustment to the duplicate channel to increase the contrast of the mask. Slide the shadow, midtone and highlight sliders until the required mask is achieved. The mask may still not be perfect but this can be modified using the painting tools.

Select the default settings for the foreground and background colors in the tools palette, choose a paintbrush, set the opacity to 100% in the Options bar and then paint to perfect the mask. Zoom in to make sure there are no holes in the mask before moving on. To soften the edge of the mask, apply a small amount of Gaussian Blur.

Note > Switch on the master channel visibility or Shift-click the RGB master to view the channel copy as a mask together with the RGB image. This will give you a preview so that you can see how much blur to apply.

Click on the active duplicate channel or drag it to the 'Load channel as selection' icon. Click on the RGB master before returning to the layers palette.

Channel masking may at first seem a little complex but it is surprisingly quick when the technique has been used a few times. This technique is very useful for photographers shooting products for catalogs and web sites. A small amount of color contrast between the subject and background is all that is required to make a quick and effective mask.

ssentia

Photoshop's 'Extract filter' can be an indispensable tool for montage work. With a suitable edge the Extract filter works well, e.g. a sharp outline on a contrasting background. If the final montage is to be effective the new background also needs to complement the tone and color of the subject's edge pixels. Many of the problems encountered when trying to achieve effective and sophisticated extractions usually lie with the images chosen and not with the Extract filter itself. As soon as the edge is difficult for the filter to detect the results are often less than convincing. If unsuitable images are chosen a lot of patching, rebuilding or manual removal of the unwanted background pixels may follow.

The filter has difficulty extracting a background where the edge contrast is low

Simple and challenging images for extraction

A studio backdrop that is lit independently of the subject will make extraction easier. You may, however, not have access to a studio where the background illumination and content can be controlled so effectively. When on location the photographer can choose the least busy background and use shallow depth of field (wide aperture on a telephoto lens) to help delineate the edge of the subject clearly to help the Extract filter perform its task.

>>> PHOTOSHOP CS

The Extract filter is about as magic as the wand! It helps if the edge of the subject you are trying to isolate is clearly defined by an edge. The strength of the filter is its ability to select complex outlines with soft edges.

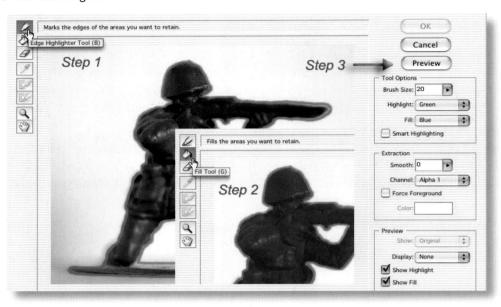

Duplicate the layer you are working before starting the extraction process as the extraction process removes rather than hides the pixels surplus to requirement. To start the process select the layer and go to 'Filter > Extract'. The next step is to use the Edge Highlighter tool to define the edge of transition. The highlighter outline should be wider than the soft edge. The highlighter can extend broadly into the background but must not extend into the subject for any great distance. Smart highlighting adjusts the width as it goes. Alternatively an outline can be loaded from an alpha channel (first create a new channel, then stroke the selection and finally invert the channel).

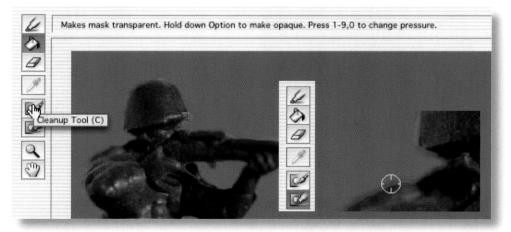

Unless the edge is sharp and clearly defined it is preferable to move to 'Preview' rather than hit 'OK'. From the Preview menu choose a suitable 'matte' color against which to view your extracted subject. The 'Cleanup' and 'Edge Touchup' tools can help to perfect the edges.

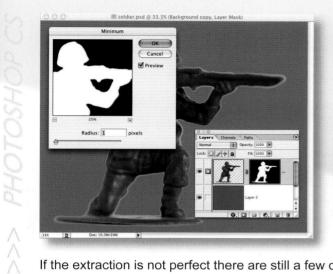

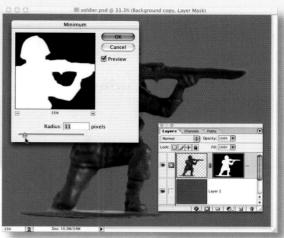

If the extraction is not perfect there are still a few options up Photoshop's sleeve. Command/Ctrlclick the layer thumbnail to load the pixels on the layer as a selection and then click on the 'Add layer mask' icon. The mask can either be softened by applying the Gaussian Blur filter or shrunk using the 'Minimum' filter (Filter > Other > Minimum) to exclude any remaining halo present.

Overview

These selection techniques will never replace the need for the Lasso or Pen tool completely but they do provide an insight into the range of tools that can be used to approach the business of separation. As knowledge of the tools available increases, the choice of background becomes an important issue for photographers who 'create' rather than 'capture' images for digital editing. And if you still can't grow to love the Lasso consider burying the mouse in the garden and invest in a 'graphics tablet'!

Selection shortcuts	
Add to selection	Hold 企 key and select again
Subtract from selection	Hold ℃ /Alt key and select again
Сору	器/Ctrl + C
Cut	器/Ctrl + C
Paste	∺/Ctrl + V
Paste Into	第/Ctrl ☆ + V
Free Transform	器/Ctrl + T
Distort image in free transform	Hold ₩ key + Move handle
Feather	%/Ctrl ℃/Alt + D
Select All	∺/Ctrl + A
Deselect	₩/Ctrl + D
Inverse selection	₩/Ctrl + I
Edit in Quick Mask Mode	Q

SO AOHSOLOHA <<<

ACTIVITY / www.photoshopessentialskills.com/selections.html

A common task in digital image editing is to strip out the subject and place it against a new background – the simplest form of montage. The effectiveness of such a montage is often determined by whether the image looks authentic (not manipulated).

Open the stock images for this tutorial ('sax.jpg' and 'zoom.jpg') from the supporting web site. As with any montage work it is advisable to check that the pixel dimensions of each image are similar and the image modes (RGB or Grayscale) are the same. For a quick check depress the Alt/Option key and click the document size box at the base of the image window.

Note > The resolution and image mode of an image pasted into another image will automatically be adjusted to match the resolution and mode of the new host file. The 'Transform' command can be used to adjust the scale of the imported image using 'Interpolation' but excessive scaling can lower the overall quality of the image. It is better to 'downsample' the larger image (decrease the total number of pixels) rather than sample up the smaller one. Exceptions can be made for background images where there is little fine detail, e.g. water, sky, fire, etc.

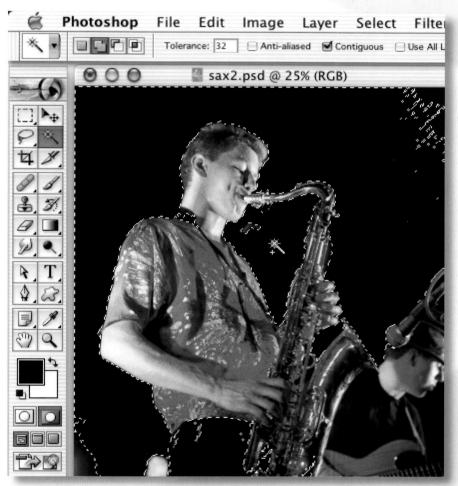

1. Start by selecting the majority of the sax image's background using a combination of the Magic Wand and Lasso tools. Keep the Shift key depressed to build on, or add to, each successive selection. Areas around the saxophone player's trousers will be difficult to select using these tools due to the tonal similarities. Use the 'Quick Mask Mode' to complete the selection work.

ssentia

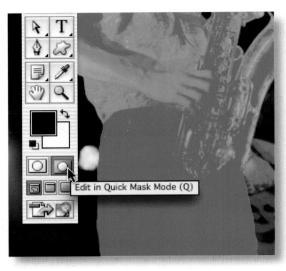

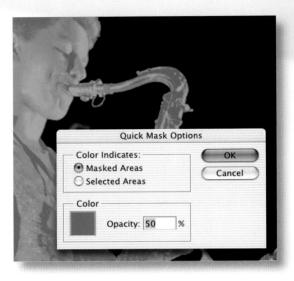

2. Set the foreground and background colors to their default setting in the tools palette and then click on the 'Edit in Quick Mask Mode' icon in the tools palette. Double-clicking the icon will open up the 'Quick Mask Options'. Choose either 'Masked Areas' or 'Selected Areas' depending on your preference. Click the color swatch to open the 'Color Picker' and select a contrasting color to that found in the image you are working on. Set the color to a saturated green with 50% opacity.

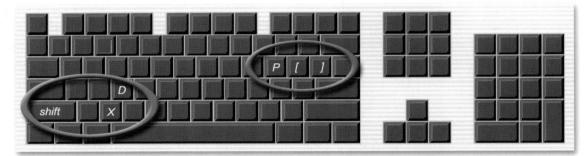

Useful shortcuts for masking work

Brush size and hardness: Using the square bracket keys to the right of the letter P on the keyboard will increase or decrease the size of the brush. Holding down the Shift key whilst depressing these keys will increase or decrease the hardness of the brush.

Foreground and background colors: Pressing the letter D on the keyboard will return the foreground and background colors to their default setting (black and white). Pressing the letter X will switch the foreground and background colors.

Zoom and Hand tools: Use the Command/Ctrl + Spacebar shortcut to access the Zoom tool and the spacebar by itself to drag the image around in its window. The combination of these shortcuts will make shorter work of creating accurate selections.

3. Select the Paintbrush tool from the tools palette and an appropriate hard edged brush from the Options bar. Painting or removing a mask with the brush will result in a modified selection when the edit mode is returned to normal (the icon next to the 'Quick Mask Mode' icon). The foreground and background colors can be switched when painting to subtract or add to the mask. Zoom in on areas of fine detail and reduce the size of the brush when accuracy is called for. Click on 'Edit in Standard Mode' when the painted mask is complete.

Note > If you select the 'Move' tool in the tools palette and drag the saxophone player a short distance you will notice that the selection has a fringe of dark pixels surrounding it (part of the original background image). Selections can be modified by going to the 'Select' menu and choosing either the 'Feather' or 'Modify' options. There are no previews available for these commands so we will modify the edge quality using channels and filters. Undo the move (Command/Ctrl + Z) or go back in the 'Histories' to the point prior to the move.

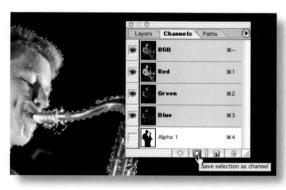

Chta

4. Save the selection as an alpha channel by going to the channels palette and clicking on the 'Save selection as channel' icon. Now that the selection is stored, save your work in progress and go to 'Select' > Deselect'.

Note > Change the name of the original file and save as a TIFF or PSD (the JPEG file format does not support additional channels). The alpha channel contains a record of your selection. This selection can be recalled if the selection is lost or the file is closed and reopened.

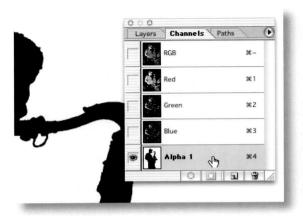

5. Click on the Alpha 1 channel to view the mask by itself or the 'visibility' or 'eye' icon to view the mask and image together. Before returning to the layers palette switch off the alpha channel visibility and select the master RGB channels view at the top of the channels palette.

6. Position the new background image (zoom) alongside the saxophone image. Click on the background layer in the layers palette and drag it to the saxophone image. A border will appear momentarily around the saxophone image to indicate that it will accept the new layer. Depress the Shift key as you let go of the zoom layer to center the zoom image in the canvas area.

7. The image now comprises two individual layers. The background layer is concealed by the zoom layer. Select the top layer (the zoom image) and then go to 'Edit > Free Transform' (Command/Ctrl + T). Drag a corner handle to resize the image to fit the background. Holding down the Shift key whilst you drag will constrain the proportions whilst dragging inside the bounding box will move the image. Press the 'Commit' icon in the options bar or press the return/enter key to apply the transformation.

8. To reload your selection go to the alpha channel in the channels palette. Drag the channel to the 'Load channel as selection' icon at the base of the channels palette or Command/Ctrl-click the alpha channel. Return to the layers palette and with the zoom layer as the active layer click on the 'Add Layer Mask' icon. The layer mask will conceal the portion of the zoom image to reveal the saxophone player. It is important to note that the section of the zoom image that is no longer visible has been masked and not removed permanently.

Note > The 'masked' and 'selected' areas are the reverse of each other. Areas that were not part of the original selection become the masked areas. Holding down the Option key as you select 'Add Layer Mask' reverses the layer mask so that the selection becomes the mask.

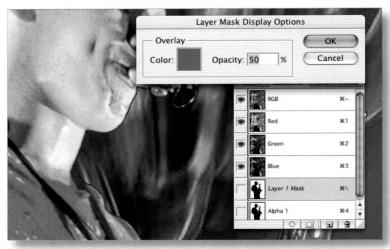

9. The edge of the mask at the moment has a sharp well-defined edge that is not consistent with the edge quality in the original image. This will be modified so that the edge quality does not stand out now that the saxophone player is viewed against a lighter background color. Click on the layer mask to make it active and return to the channels palette. This layer mask is now available as a temporary channel. Double-click the 'Layer 1 Mask' channel to open the 'Display Options'. Select the same options that you used for the 'Quick Mask Mode' earlier.

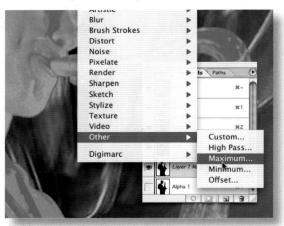

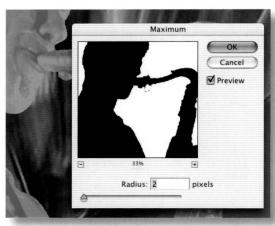

10. Contract the mask by going to 'Filters > Other > Maximum/Minimum'. Increasing the pixel radius will move the edge of the mask to conceal any fringe pixels that are being displayed from the background layer.

Note > As well as moving the edge of the mask 1 pixel at a time the mask also becomes more 'rounded' and this can have a detrimental effect on any fine detail present at the edge of the subject.

ssentia

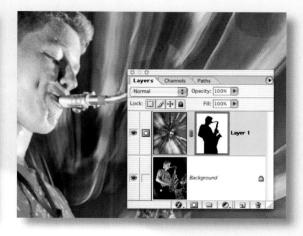

11. With the Layer 1 Mask as the active channel go to 'Filters > Blur > Gaussian Blur'. Soften the edge by increasing the pixel radius in this dialog box. One or two pixels will usually do the trick. Switch off the visibility of the Layer 1 mask channel and review the edge quality of the saxophone player. The Gaussian Blur softens the edge of the mask but may reveal some of the background as a dark halo around the lighter edges. If this occurs return to the Maximum filter once again and shrink the mask by a further pixel.

12. Any imperfections still evident can be corrected by clicking on the mask thumbnail in the layers palette and then painting with black to increase the mask or painting with white to remove sections of the mask. You will need to match brush hardness with the slightly soft edge of the mask if your work is to go unnoticed. You can test the brush quality on a new layer created above the zoom layer before working in the mask itself. Save the completed montage as a PSD image (complete with all layers). Remember to duplicate and flatten the image before applying the Unsharp Mask.

ACTIVITY 2 www.photoshopessentialskills.com/selections.html

The Extract filter can effectively work with a soft or blurred edge, but when this edge is viewed against a very different tone, the edge looks out of place. These 'soft edges' can, however, be 'worked' so that they can be blended into the new background.

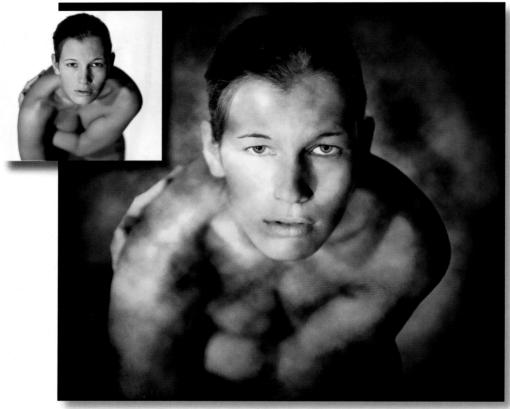

Photography by Benedikt Partenheimer

1. If you are starting with a grayscale image and would like to introduce color you must first convert the image mode to RGB (Image > Mode > RGB). The next step is to import or create a new background. It is possible to create a background using the 'Clouds' filter that resembles the brushed canvas backdrops used by many portrait photographers. To achieve this effect click on the 'New Layer' icon in the layers palette. In the tools palette set the foreground color to black and the background color to a light shade of gray (double-click the color swatch and then choose a color from the 'Color Picker'). To apply the clouds effect go to 'Filter > Render > Clouds'.

2. To create the illusion of an effects light on the backdrop the 'Lighting Effects filter' was used (Filters > Render > Lighting Effects). By clicking and dragging on the handles in the preview box the circle, or spread, of light can be controlled. Select an intensity value that keeps the highlights from 'blowing out' or becoming white and the shadows from 'filling in' or becoming black.

3. Create a curves adjustment layer to color the clouds layer by clicking on the 'Create new fill or adjustment layer' icon. From the pull-down menu in the Curves dialog box select a color channel and create a curve to color the layers beneath.

ssential skill

4. Duplicate the background layer containing the subject to be extracted (Layer > Duplicate Layer) and move it to the top of the layers stack (Layer > Arrange > Bring to Front).

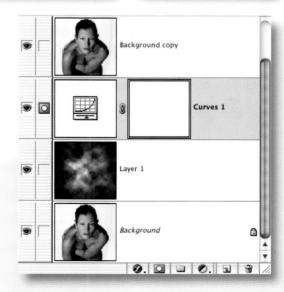

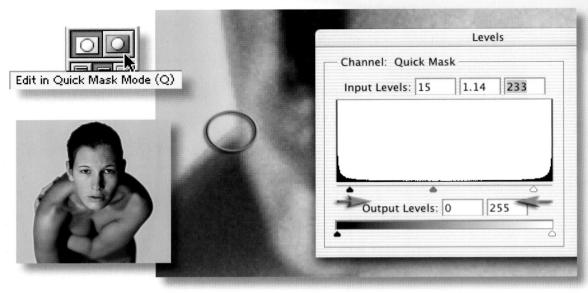

5. The following steps in the process prepare the way for, and speed up the selection process when using, the Extract filter. The 'Magic Wand' is used to make a rough selection of the white background on the background copy layer. This initial selection may fall short of some of the 'soft edges' because of the slow transition between dark and light, which may repel the wand's attempts to make an effective selection. The Magic Wand selection by itself is usually imprecise at selecting a typical background. This can be rectified in a controlled way by first feathering the selection and then using a levels adjustment in 'Quick Mask Mode'. Slide either the highlight slider or the shadow slider to expand or contract the selection so that it falls closer to the edge of the figure. Zoom in on a soft edge to get a clear idea of the effects of moving the sliders. Once the edge of the mask has been modified exit the Quick Mask Mode (press Q) to return to a selection.

Note > It is important to feather the selection (Select > Feather) for this technique to work. The precise amount of feathering is, however, dependent on both the resolution of the image and the edge quality of the subject being extracted.

6. With the selection active click on the 'Create new channel' icon to create a new empty alpha channel (filled with black).

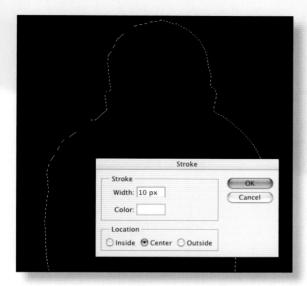

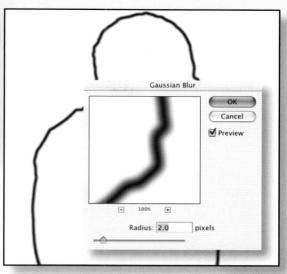

- 7. Stroke the selection (Edit > Stroke). Click on the 'Color' swatch and choose white from the Color Picker. The stroke width you choose should cover the soft edges of the subject you are extracting. Deselect to remove the selection.
- 8. Apply a small amount of Gaussian Blur (Filter > Blur > Gaussian Blur) to the channel and then invert the channel (Image > Adjustments > Invert). Return to the layers palette and ensure the background copy layer is selected.

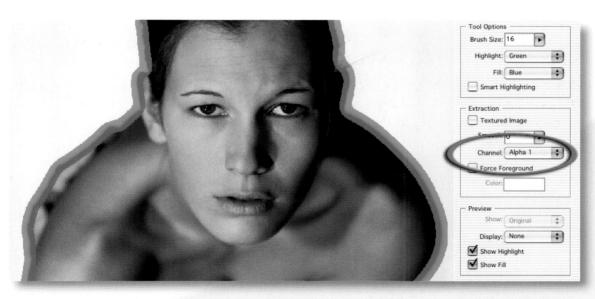

9. Select 'Extract' from the 'Filter' menu and 'Alpha 1' from the Channel pull-down menu. The outline of the subject will be automatically loaded for you, thus saving a lot of painstaking work with the highlighter tool.

SD dOHSOLOHD <<

10. Use the 'Edge Highlighter Tool' to include any areas missed by the alpha channel selection. This may include fine detail that extends from the border or very soft edges that exceed the width of the edge highlight. Zoom in to get a close look at the edge and avoid painting too deeply into the subject itself. Use the spacebar to access the Hand tool so that you can drag the magnified edge through the preview window.

Note > When using the 'Edge Highlighter Tool' you can paint generously into the background but care must be taken not to paint too deeply into the subject as this may result in a loss of subject detail.

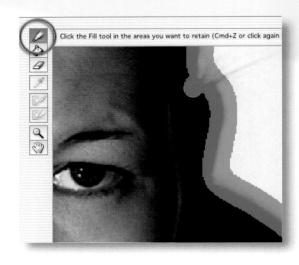

11. Fill the area you wish to retain using the 'Fill Tool' or bucket. The fill color denotes the area to be retained by the extraction process.

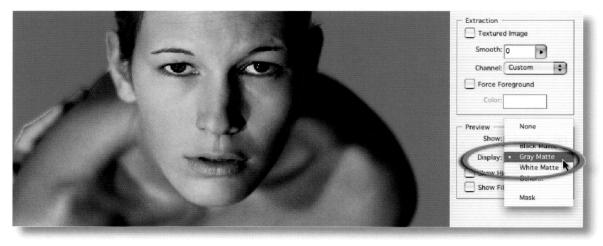

12. Select a 'matte' color from the 'Display' pull-down menu that is closer in tone to the new background. This will help you identify any unwanted edge detail left over from the old background.

>>> essential skills >>>

13. Use the 'Cleanup Tool' to remove any unwanted pixels. Select a low pressure (by pressing a lower number key on your keyboard) to reduce the opacity of the edge pixels gradually. Pressing the Option/Alt key on the keyboard can restore full opacity to the edge pixels. Any ragged edges produced by the extraction process (usually created where edge contrast is low) can be smoothed out or made sharper using the 'Edge Touchup Tool'. Click 'OK' when the edge has been modified to look good against the preview matte.

Note > Many find the 'Edge Touchup Tool' a little unwieldy to use, as it is able to move the location of the edge as well as replace and remove pixels in its attempt to smooth the edge. It takes a lot of practice to use effectively. If your subject/background contrast is sufficient you can often avoid using this tool altogether. A little extra time spent when capturing the image to ensure sufficient contrast will save time during this stage of the process.

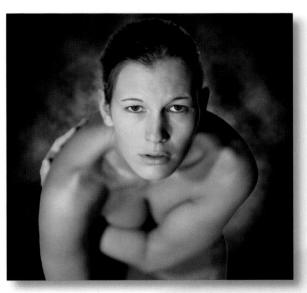

14. The edge pixels that were modified in the last step using the 'Cleanup Tool' were adjusted to look good against a matte color. The edge pixels may not look so good against the exact tone and color of the new background now that the extraction has been performed. If the edge pixels are now too dark or too light, burning or dodging selectively can modify them further.

		N ₁	ew Layer	
Name:	Layer 2			
	Use Previous	Layer to C	reate Clipping Mask	
Color:	None	\$		
Mode:	Overlay	+	Opacity: 100	%
	Fill with Over	rlay-neutra	al color (50% gray)	

15. It is possible to burn or dodge the offending pixels on the background copy layer itself (choose a low brush pressure and set the 'Range' of the Burn and Dodge tools, located in the Options bar, to highlight or shadow to limit the effects). An alternative option is to burn or dodge the pixels on a '50% gray' layer set to 'Overlay' blend mode that has been grouped with the background copy layer. Adjustments made to this layer modify the pixel values on the layer below, whilst areas that are left as 50% gray leave the pixels below unaffected.

Note > The advantage of working on a separate layer is that it offers an extremely flexible way of editing an image. Working on a separate layer allows you to repeatedly change your mind regarding the level of adjustment required. Fifty percent gray overlay layers, together with adjustment layers and layer masks, offer the least destructive method of image editing. Pixel values, rather than being changed repeatedly, are changed only once when the image is flattened prior to printing.

16. Once the pixels have been modified to a more suitable tone for the new background, the edge can be softened further if required. A softer edge can be achieved by using a layer mask. Make a selection by holding down the Command/Ctrl key when clicking the 'Background copy' thumbnail.

Note > The completed layers that form the new background have been placed in a 'Layer Set' to help prevent the layers palette becoming unduly crowded.

- 17. Click on the 'Add layer mask' icon to create a layer mask using the selection.
- 18. Apply a small amount of 'Gaussian Blur' to this mask (Filters > Blur > Gaussian Blur). This will soften any hard edges remaining from the extraction process. The edges should now look very comfortable against the new background.

19. Create a new layer and apply the Clouds filter again. A 'Spotlight' lighting effect is used to reflect the lighting used on the model. Click on the top color swatch to pick an appropriate color for the effect.

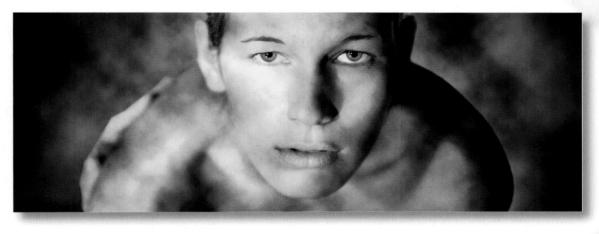

20. Assign an Overlay blend mode to the new layer. Add a layer mask to protect the whites of the eyes from being colored. Finally the layer is grouped with the background copy layer by holding down the 'Option/Alt' key and clicking on the dividing line between this layer and the previous layer (alternatively choose 'Layer > Group with Previous' from the menu). Use adjustment layers with layer masks to color and brighten the eyes (the focal point of the image) and refine the overall image.

advanced retouching photoshop photoshop photoshop photoshop photoshop photoshop photoshop photoshop photoshop photoshop

op photoshop photoshop photoshop photoshop phot

essential skills

- Develop skills using layers, adjustment layers, channels and layer masks.
- Retouch and enhance images using the following techniques and tools:
 - 16-bit/channel mode
 - adjustment layers and layer masks
 - History and healing brushes
 - Dust and scratches and Liquify filters
 - unsharp mask
 - channel mixing
 - luminosity masks and layers.

Introduction

To end up with high quality output you must start with the optimum levels of information that the capture device is capable of providing. The factors that greatly enhance the final quality of the image are:

- A 'subject brightness range' that does not exceed the exposure latitude of the capture medium (the contrast is not too high for the film or image sensor).
- Using a low ISO setting or fine grain film to capture the original image.
- The availability of 16 bits per channel scanning or RAW camera file import.

With a healthy histogram the retouching process can begin. The digital file can then be enhanced or manipulated to create a specific aesthetic objective and be targeted to meet the output characteristics of a specific output device. In this way maximum quality can be achieved and maintained.

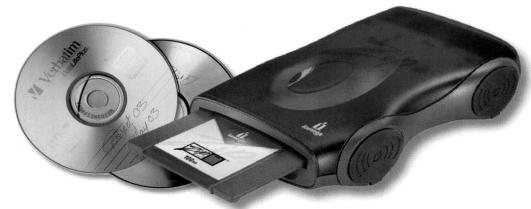

Save, save and save

Before you start to edit your digital image it is well worth acquiring good working habits. Good working habits will prevent the frustration and the heartache that are often associated with inevitable 'crash' (all computers crash or 'freeze' periodically). As you work on an image file you should get into the habit of saving the work in progress and not wait until the image editing is complete. It is recommended that you use the 'Save As' command and continually rename the file as an updated version. Unless computer storage space is an issue the TIFF or PSD file formats should be used and not the JPEG file format for work in progress. Before the computer is closed down the files should be saved to a removable storage device. In short, save often, save different versions and save back-ups.

Stepping back

Digital image editing allows the user to make mistakes. There are several ways of undoing a mistake before resorting to the 'Revert to Saved' command from the File menu or opening a previously saved version. Photoshop allows the user to jump to the previous state via the Edit > Undo command (Command/Ctrl + Z) whilst 'Histories' allows access to any previous state in the histories palette without going through a linear sequence of undos (stepping backward – Command/Ctrl + Option/Alt + Z).

16-bit image editing

In order to produce the best quality digital image, it is essential that we capture, retain and preserve as much information about the tonality and color of the subject as possible. The more we edit the pixel values in 8 bits per channel mode to compensate for poor light quality in the original scene, or poor scanning, the more information/quality we will sacrifice. If the subject is well lit and exposed, and the quality of the scanning or capture is good, minimal editing is usually required. This type of file can be edited in 8-bit mode with no apparent loss in quality. Sixteen-bit editing, however, is invaluable if maximum quality is required from an original image file that requires extensive editing.

The problem with 8-bit editing

As an image file is edited extensively in 8 bits per channel mode (24-bit RGB) the histogram starts to 'breakup', or become weaker. 'Spikes' or 'comb lines' may become evident in the resulting histogram after the file has been flattened.

Note > The least destructive 8-bit editing techniques make use of adjustment layers so that pixel values are altered only once, when the layers are flattened prior to printing.

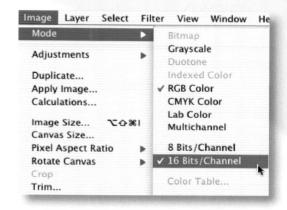

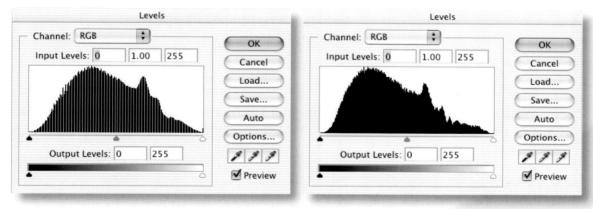

Final histograms after editing the same image in 8 and 16 bits per channel mode

The problem with editing extensively in 8-bit mode is that there are only 256 levels or tones per channel to describe the full color range of the image. This is usually sufficient if the histogram looks healthy (few gaps) when we begin the editing process and the amount of editing required is limited. If many gaps start to appear in the histogram as a result of extensive adjustment of pixel values this can result in 'banding'. The smooth change between dark and light, or one color and another, may no longer be possible with the data supplied from a weak histogram. The result is a transition between color or tone that is visible as a series of steps in the final image.

Advantages and disadvantages of 16-bit editing

When the highest quality images are required there are major advantages to be gained by using 'Adobe Photoshop' to edit an image file in '16 bits per channel' mode. In 16 bits per channel there are trillions, instead of millions, of possible values for each pixel. Spikes or comb lines, which are quick to occur whilst editing in 8 bits per channel, rarely occur when editing in 16 bits per channel mode. Photoshop 8 now has the ability to edit an image in 16 bits per channel mode using layers and all of the editing tools. The disadvantages of editing in 16 bits per channel are:

- · Not all scanning devices are capable of scanning in 16 bits per channel mode.
- The size of file is doubled when compared to an 8 bits per channel image of the same output size and resolution.
- Many filters do not work in 16 bits per channel mode.
- Only a small selection of file formats support the use of 16 bits per channel.

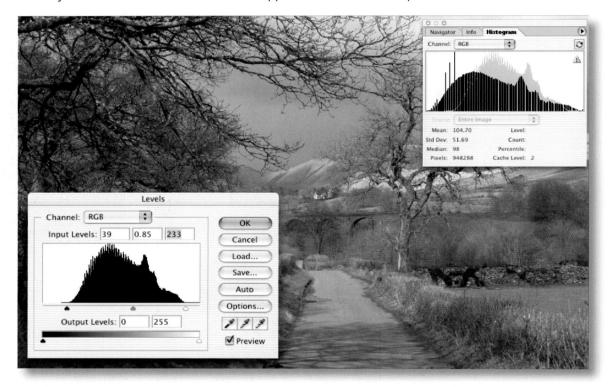

Choosing your bit depth

It is still preferable to make major changes in tonality or color in 16-bit mode before converting the file to 8-bit mode. Images can be converted from 8 bit (Image > Mode > 16 Bit/Channel) or captured in 16 bit (the preferred choice). Most of the better scanners that are now available (flatbed and film) now support 16 bits per channel image capture. Many scanners refer to 16 bits per channel scanning as 48-bit RGB scanning. Some scanners offer 14 bits per channel scanning but deliver a 48-bit image to Photoshop. Remember, you need twice as many megabytes as the equivalent 8-bit image, e.g. if you typically capture 11 megabytes for an A4 image (A4 @ 200ppi) you will require 22 megabytes when scanning in 16 bits per channel.

Target values - using the eyedroppers

To make sure the highlights do not 'blow out' and the shadows do not print too dark it is possible to target, or set specific tonal values, for the highlight and shadow tones within the image using the eyedroppers (found in the levels and curves dialog boxes). The tones that should be targeted are the lightest and darkest areas in the image with detail. The default settings of these eyedroppers are set to 0 (black) and 255 (white). These settings are only useful for targeting the white paper or black film edge. After establishing the darkest and lightest tones that will print using a step wedge (see 'Digital printing' page 67) these target levels can be assigned to the eyedroppers.

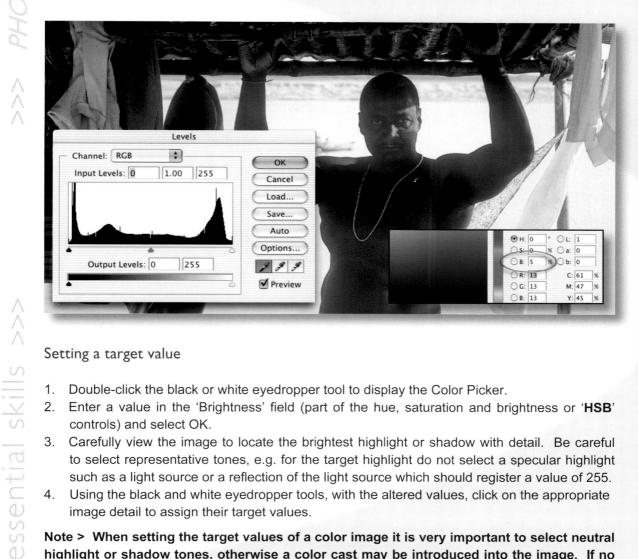

Setting a target value

- Double-click the black or white eyedropper tool to display the Color Picker.
- Enter a value in the 'Brightness' field (part of the hue, saturation and brightness or 'HSB' controls) and select OK.
- Carefully view the image to locate the brightest highlight or shadow with detail. Be careful to select representative tones, e.g. for the target highlight do not select a specular highlight such as a light source or a reflection of the light source which should register a value of 255.
- Using the black and white eyedropper tools, with the altered values, click on the appropriate image detail to assign their target values.

Note > When setting the target values of a color image it is very important to select neutral highlight or shadow tones, otherwise a color cast may be introduced into the image. If no neutral highlight or shadow tones are present it is advised that the tones are targeted by pegging them on an adjustment curve, using the master RGB channel.

Controlling tones using the Shadow/Highlight feature

Both the Curves and Levels features provide a method of altering the brightness and contrast in our pictures. In the hands of skilled Photoshop workers these tools can be used to perform miracles beyond simple contrast and exposure changes. But many users find the relationship between how their picture appears and a curve or histogram graph to be a little obscure. With this in mind, and in conjunction with the release of Photoshop CS, the engineers at Adobe added a new tool to the 'tone-tweakers' arsenal.

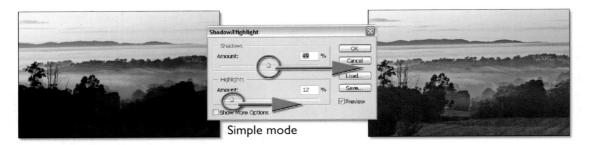

Called the Shadow/Highlight feature it is located in the Image > Adjustments menu. The tool provides a slider-based control of complex tonal correction in the highlights, shadows and to a lesser extent the midtones. When first opened the feature displays two slider controls, one for highlights and the other for shadows. Moving the Shadow control to the right lightens the darker regions of the image without changing midtones or highlights. Adjusting the Highlight slider to the right darkens the lighter parts of the picture or as my old photography lecturer used to say, 'crushes the highlights'. Similarly highlight changes occur independent of other areas of the photograph.

Extra options

Now for most simple tasks this two slider approach gets the job done but for the really problematic photographs finer control is needed. Checking the Show More Options setting reveals several other sliders which provide just such control.

Tonal Width - This setting allows you to adjust how the highlight or setting changes alter the midtone areas of the picture. Low values concentrate the alterations to just highlight or shadows. Higher values spread the changes to other tones in the picture.

Radius - Unlike the Tonal Width setting Radius alters the effect based on the values of neighboring pixels. High Radius settings use more pixels to determine the type of changes and so result in broader effects. Too high a value and the highlight or shadow changes will alter tones across the whole

picture. Low values tend to result in more detailed and local changes.

Color Correction – This option adjusts the saturation or vividness of the colour in altered areas of the picture. Low or negative values result in low saturated or almost monochrome images whereas high settings create vibrant changes.

With monochrome pictures this slider is used to adjust brightness.

Midtone Contrast – The Midtone Contrast slider governs the contrast of the altered areas in your picture. Low values result in low contrast results whereas a high setting will increase the contrast dramatically.

This simple slider provides a level of control that is very difficult to replicate with curves and/or levels controls. With either of these two features lightening the shadows, or darkening the highlights, can result in a low contrast or flat looking picture. This feature allows the user to restore a sense of the original contrast into the changed areas.

Black and White Clip – These two values are used to determine how much of the shadow or highlight tones are converted to pure white (255) or pure black (0). High values result in images with greater contrast but less detail in highlight and shadow areas.

Shadow/Highlight workflow

- 1. Start your Tonal Width and Radius settings about midway along the scale then make a rough adjustment moving the Amount sliders for shadow and then highlight.
- 2. Fine-tune the changes to each of the areas using the Tonal Width and Radius sliders.
- 3. Next adjust the Midtone Contrast setting to ensure that the changed areas are not too flat.
- 4. Finally alter the Color Correction control to increase or decrease the vibrancy of the picture's colors.

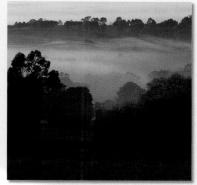

Original

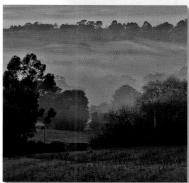

Shadow (50,50,30) Highlights (50,50,30) Adjustments (20,0)

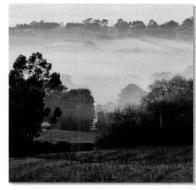

Shadow (65,80,50) Highlights (0,9,30) Adjustments (20,39)

Shadow (100,90,60) Highlights (0,50,20) Adjustments (75,35)

Dust and scratches

Clone Stamp and Healing Brush

The primary tools for localized retouching are the 'Rubber Stamp Tool' and the 'Healing Brush Tool'. The Clone Stamp or Rubber Stamp is able to paint with pixels selected or 'sampled' from another part of the image. The Healing Brush also matches the texture and characteristics of the sampled pixels to those of the pixels surrounding the damage. The Healing Brush tool allows for a more seamless repair where the damage is surrounded by pixels of a similar value. If the damage is close to pixels of a very different hue, saturation or brightness a selection of the damaged area should first be made that excludes the different pixels.

- Choose a brush size from the brushes palette.
- Select a sampling point by Option/Alt-clicking on a color or tone (this sample point is the location from where the pixels are sampled).
- Drag the tool over the area to be modified (a cross hair marks the sampling point).

Note > Deselect 'Aligned' to return to the initial sampling point each time you start to paint. If a large area is to be repaired with the Clone Stamp tool it is advisable to take samples from a number of different points with a reduced opacity brush.

Cloning entire objects With care it is possible to duplicate an entire subject within the image. The image above demonstrates how a landscape composition has been manipulated to fit a portrait format. This has been achieved by cloning the sign and the life-ring and moving them to the right. The original life-ring is then removed.

Dust and Scratches filter

Ideally if the original image and scanning equipment are clean the scanning process introduces only the occasional dust mark or scratch. If on closer inspection of the digital file it appears that the dust and/or scratches cover an extensive area of the image it is often quicker to resort to the Dust & Scratches filter rather than use the Rubber Stamp tool. Choose Filters > Noise > Dust & Scratches. Set the threshold to zero and choose the lowest pixel radius that eliminates the dust and scratches problem. Then increase the threshold gradually for optimum image quality. The drawback to applying the Dust & Scratches filter to the entire digital image is that it also has the effect of blurring the image.

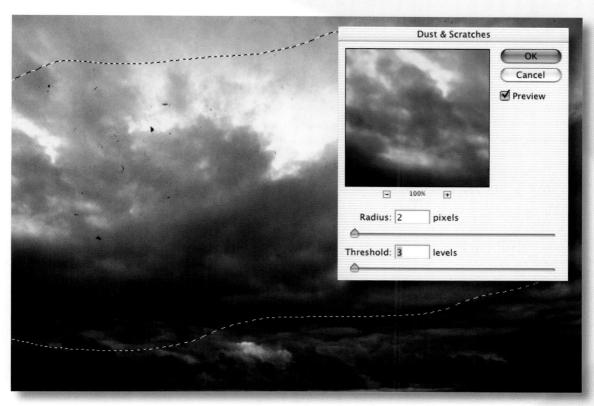

Limitation of effect

It is important to reduce or limit the filter to areas of the image that do not contain fine detail, e.g. areas of featureless or blurred background. This can be achieved by using any of the selection tools. Only those pixels that are part of a selection can be modified or adjusted using global actions such as the Image Adjust or Filter commands. This technique will reduce the amount of manual retouching (using the Rubber Stamp tool) to just those areas containing fine detail.

The History Brush technique

The History Brush can also be used to remove dust and scratches. This technique is especially useful when removing dust and scratches from the more detailed areas of the image. Pixels are painted over the damaged areas from an image state or 'snapshot' that has had the Dust & Scratches filter applied (back from the future).

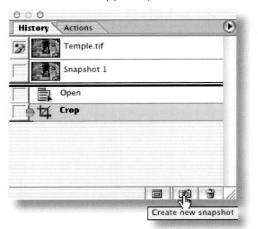

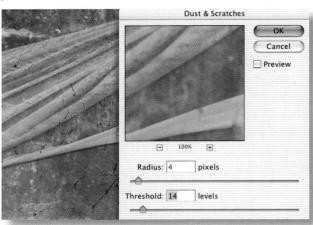

- 1. Set the correct image size and mode before creating a snapshot (ensure that the background layer is selected in the layers palette).
- 2. Apply the Dust & Scratches filter to the entire image and create another new snapshot.

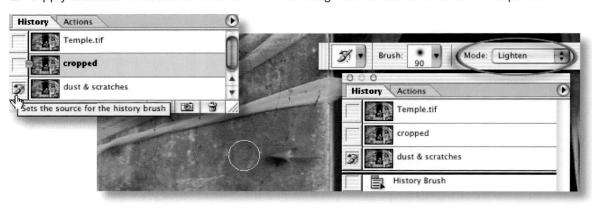

- 3. Click on the previous state or 'snapshot' in the histories palette. This will go back to the point where the dust and scratches are still visible. Set the source for the History Brush as the dust and scratches snapshot (see the illustration above).
- 4. Select the History Brush in the tools palette and select the appropriate blend mode in the Options bar ('Lighten' for dark blemishes and 'Darken' for light blemishes).
- 5. Proceed to paint with the History Brush over the areas to be repaired using an appropriate sized brush selected from the brushes palette.

Note > This technique is used in the second activity of this chapter.

Correcting perspective

You know the story, you're visiting a wonderful city on holiday wanting to capture as much of the local scenes and architecture as possible. You enter the local square and point your camera towards an impressive three-spired building on the other side of the road only to find that you must tilt your camera upwards to get the peaks into the picture. At the time you think nothing of it and you move onto the next location. It is only when you are back at home about to print your photograph that you realize that the innocent 'tilt' has caused the edges of the building to lean inwards.

Now to a certain extent this isn't a problem, even though it is not strictly accurate, we all know that most buildings have parallel walls and the majority of people who look at your picture will take this into account — won't they?

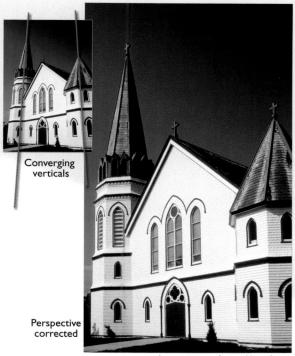

Image courtesy of www.ablestock.com

Apart from a return trip and a reshoot is there anyway to correct these converging verticals? Well, I'm glad you asked. Armed with nothing except Photoshop and the steps detailed here, you can now straighten all those leaning architectural shots without the cost of the return journey.

1. After opening the offending image turn on the display grid (View > Grid). This will place a non-printing grid over the surface of the picture and will act as a guide for your adjustments. In most cases we need to move the two upper corners of the picture further apart to make them parallel. To achieve this we will use the Perspective feature built into the Photoshop Crop tool.

2. Select the Crop tool from the toolbox. Click and drag a rough cropping marquee around the picture. Tick the Perspective option in the tool's Option bar. This option changes the way that the tool functions. It is now possible to use the corner handles of the crop marquee to manipulate the photograph's perspective.

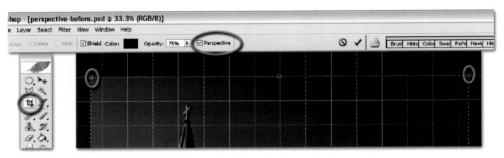

3. In our case we need to select both the top left and right handles and drag them inwards. Continue dragging until the crop marquee edges align with the building sides, or a part of the picture that is meant to be vertical. Double-click on the picture, or select the Tick button in the tool's Option bar, to apply the perspective transformation. Check to see that the building's edges now align with the grid lines. If this isn't the case, undo the perspective change (Edit > Undo Crop) and then reapply the crop with slightly different settings.

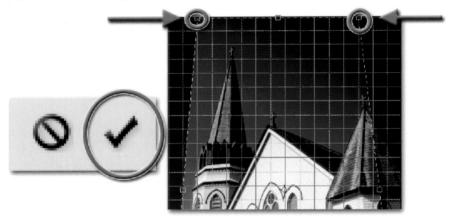

4. To complete the correction we need to make the building a little taller as the tilted camera has artificially shortened the spires. The picture needs to be a layer before we can apply the height transformation so double-click onto the background layer in the layers palette.

5. If we stretch the picture upwards without providing some canvas space for the extra height then the top or bottom of the building will be cropped. So before extending the height we need to increase the vertical size of the canvas. Choose Canvas Size from the Resize menu (Image > Resize > Canvas Size) and input a new value into the height box. Here I have used a value of 130% and anchored the bottom part of the picture so that the extra canvas is added to the top.

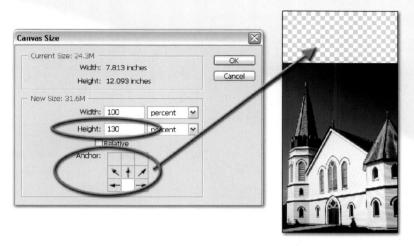

6. Now we can select the Scale feature from the Resize section of the Image menu (Edit > Transform > Scale) and click and drag the top handles to stretch the picture bigger. As a final step use the Crop tool to trim the unused sections of the canvas away from the corrected image.

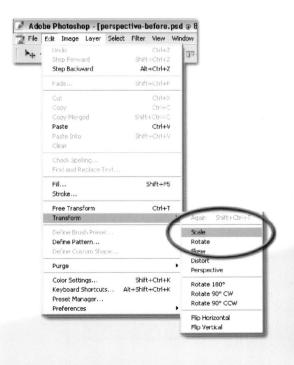

ACTIVITY / www.photoshopessentialskills.com/retouching.html

A localized adjustment can be created using the 'Fill' command. Selecting a layer mask and filling an active selection with either the foreground or background color will create a mask that limits adjustments or visibility in a localized area of the image. This allows the Selection tools to be used in addition to the Paint tools for the creation of masks. The fill shortcuts 'Command/Ctrl + delete' (to fill with the foreground color) and 'Option/Alt + delete' (to fill with the background color) speed up the masking process.

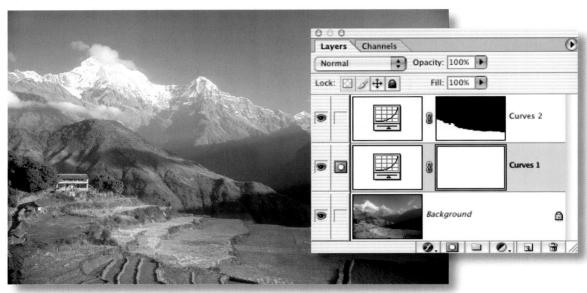

The Himalayas image demonstrates how an adjustment layer can be used to effect global changes to tonality and color whilst a second adjustment layer affects only the foreground due to the presence of a layer mask limiting its effect.

- 1. Open the image file 'Himalayas.jpg'.
- 2. In the layers palette click on the 'New fill or adjustment layer' icon and select a 'Curves' adjustment layer from the fly-out menu.
- 3. From the 'Channel' menu select the 'Red' channel. Click on the line in the center of the curves box. Drag upwards until the line becomes a curve. Observe the changes to the color in the image window. Increase the level of the red in the image until you feel that the overall color has been corrected.

4. Using the 'Lasso Tool' (with a 2-pixel feather entered in the Options bar) select the fields in the foreground of the landscape.

Note > Feather selections to soften the transition between the adjusted and non-adjusted pixels. If you create a mask with a hard edge it can be softened by applying a small amount of 'Gaussian Blur' (Filter > Blur > Gaussian Blur).

- 5. Click on the channels palette (grouped with the layers palette) and then click on the 'Save selection as channel' icon to save the selection as an alpha channel. This will ensure the selection is saved when the file is closed.
- 6. Return to the layers palette. With the selection active create another new adjustment layer. Choose 'Curves' from the menu. The selection automatically limits the adjustment to the selected area by filling the rest of the layer mask with black.
- 7. In the Curves dialog box select the 'Green' channel. Pull the curve down to reduce the level of green in the foreground of the image and click OK to complete the tonal and color adjustments. Double-click the thumbnail on either adjustment layer to reopen the Curves dialog box in order to further modify the color or tonality.
- Note > Drag an adjustment layer to the 'Delete layer' icon (trash can) to discard the adjustment.
- 8. To retain the adjustment layers when saving the image it is important to save the document as a Photoshop file (PSD) or a TIFF file with layers.

In this activity specific highlight, shadow and midtone values are targeted on an adjustment curve. The color cast is corrected using the 'Set Gray Point' eyedropper in the Curves dialog box and the color of the man's turban is selectively altered.

- 1. Open the file 'Market.jpg' and select the 'Eyedropper Tool' in the tools palette. Set the sample size of the eyedropper to a 5 by 5 Average in the Options bar to ensure general tonal values are sampled rather than individual pixel values.
- 2. Create a curves adjustment layer by clicking on the 'Create new fill or adjustment layer' icon at the foot of the layers palette.
- 3. Move the mouse cursor outside of the Curves dialog box into the image window. The cursor will change to an eyedropper tool whatever tool was selected previously. Hold the mouse clicker down as you move around the image and note the 'Input' readout in the Curves dialog box. Move to a bright highlight in the image (a bright section of the shirt).

>>> essential skills >>>

- 4. Select a tone that registers an input level that is approximately 235. Command/Ctrl-click whilst the pointer is over the image area to set an adjustment point on the curve.
- 5. Move the cursor to an object with a dark tone (the rim of the man's spectacles). Select a tone that registers an input level that is approximately 15 to 20. Set an adjustment point as before.
- 6. Move the cursor to a part of the image that you would like to adjust to a midtone (the skin on the back of the man's hand would be ideal). Select a tone that registers an input level that is approximately 95. Set an adjustment point as before.

- 7. In the Curves dialog box drag the highlight adjustment point until the output value reads 245. Select and drag the shadow adjustment point until the output value reads 10. Select and drag the midtone adjustment point until the output value reads 127.
- 8. Select the 'Set Gray Point' eyedropper in the Curves dialog box (between the black and white point eyedroppers). Click on a suitable tone you wish to desaturate in an attempt to remove the color cast present in the image (the metal tray holding produce to the left of the man's shoulder would be ideal). The neutral tone selected to be the 'Gray Point' can be a dark or light tone within the image. If the tone selected is not representative of a neutral tone the color cast cannot be rectified effectively.

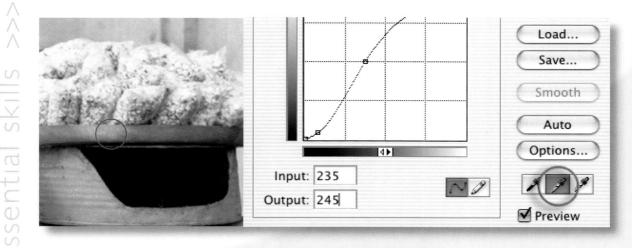

9. Fine-tune any color correction by selecting an individual channel from the pull-down menu in the Curves dialog box. Create an adjustment point or use the adjustment point created by the Gray Point eyedropper to perfect the color adjustment. Select OK to apply the curves adjustment.

10. Create a 'Hue/Saturation' adjustment layer. Move the 'Hue' slider until the man's turban shifts to an orange/red hue. Decrease the saturation slightly.

Note > All colors will be modified towards red as the adjustments are made at this stage.

11. Fill the layer mask that accompanies the Hue/ Saturation adjustment layer with black (Edit > Fill).

Note > If the default colors are set in the tools palette the keyboard shortcuts 'Command/ Ctrl + Delete' and 'Option/Alt + Delete' can be used to fill or clear a layer mask quickly.

12. Select the 'Brush Tool' and make the foreground color white. In the Options bar set the opacity to between 80 and 100%. Select an appropriate brush size and paint the turban in the image to reveal the hue adjustment. If you paint over the edge simply switch the foreground color to black and paint to remove the previous adjustment. Save the image as a PSD file.

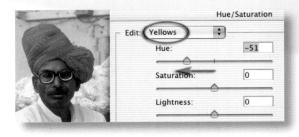

ACTIVITY 3 www.photoshopessentialskills.com/retouching.html

This activity takes you through the complete series of steps required to retouch a digital file of poor quality. It is dirty, crooked and the color and tone are a long way from being correct. The process includes sharpening, which is the last step prior to printing.

- 1. Open the file 'Temple.jpg'.
- 2. Select the 'Measure Tool' from the tools palette (behind the 'Eyedropper Tool'). Click and drag along the edge of the step beneath the man's feet to draw a line parallel with the step.

3. Go to Image > Rotate Canvas > Arbitrary. The angle of rotation required to straighten the image will automatically be entered in the 'Angle' text field. Click OK to rotate the canvas.

4. Set the output dimensions and resolution in the 'Options' bar $(7 \text{in} \times 4.5 \text{in} \otimes 200 \text{ ppi})$. Drag the cropping marquee over the image to select an area that removes the black border and shaded lines at the base of the image.

5. Check the 'Enable perspective cropping' box in the Options bar. Drag the top two corner handles of the bounding box inwards until the edges of the bounding box align with the verticals of the image. Press the tick or 'Commit current crop option' icon in the Options bar to crop the image to the required specifications.

Note > The keyboard shortcuts for cropping are 'return/enter' to commit the crop and 'esc' to cancel the crop.

6. In the history palette create a new 'snapshot' of the cropped image. This snapshot will enable the use of the History Brush in the selective removal of the dust and scratches that cover much of the image.

Note > The 'Dust & Scratches' filter cannot normally be applied globally to the whole image without removing excessive amounts of detail.

7. From the 'Filters' menu apply the 'Dust & Scratches' filter ('Filters > Noise > Dust & Scratches'). Use the smallest 'Radius' and 'Threshold' settings possible to remove the large majority of the damage.

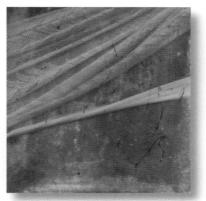

entla

Note > Do not worry if the Dust & Scratches filter removes important detail as well as the dust and scratches. You will revert to a previous 'History State' and use the 'History Brush' for selectively cleaning the image.

8. Create another new snapshot and set the source for the History Brush on this latest snapshot by clicking in the window next to the snapshot thumbnail. Snapshots can be named by double-clicking on the snapshot name and typing in something more memorable than the default name.

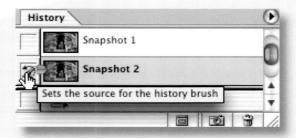

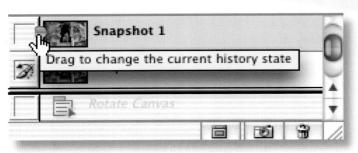

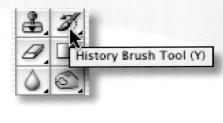

9. Change the current history state to the previous snapshot ('Snapshot 1') by clicking on it.

Note > The History Brush will be used to paint from the future state (minus dust and scratches) to the current state. The filter is limited to a localized adjustment.

10. Select the 'History Brush' from the tools palette. Select the 'Lighten' paint mode in the History Brush options.

Note > Set the paint mode to darken if the marks or blemishes are lighter than the surrounding image.

11. Paint out the damage using an appropriate brush size (just larger than the damage being retouched). Zoom in on the image when required and navigate by pressing the spacebar (to access the Hand tool) and dragging to move the image within the window.

12. Create a new adjustment layer and select 'Curves' from the menu. Use the RGB curve to adjust the tonality of the image. Select a sample highlight from the sunlight striking the stonework to the right of the step and move it to a value of 245. Select a midtone from the shadow side of the man's forehead and move it to a value of 127. Select a dark tone above the man's head and move it to a value below 10. Remove the color caste by moving the curves in the individual Red, Green and Blue channels. Alternatively use the 'Set Gray Point' eyedropper and select the neutral gray from the man's hair.

- 13. Create a 'Hue/Saturation' adjustment layer. Select 'Reds' from the pull-down menu. Increase the saturation by dragging the 'Saturation' slider to the right. As the warm tones in the image are restricted to the red scarves emerging from the temple and the man's skin, the rest of the image remains relatively unaffected. Click OK to apply the adjustment.
- 14. To limit the adjustment to just the scarves, paint into the adjustment layer's layer mask with black (set to 100% opacity) to conceal the increase in saturation to the man's skin. Alternatively fill the mask with black and paint with white to reveal the saturation adjustment to the scarves.

15. Prior to sharpening the image duplicate the file (Image > Duplicate).

16. View image at 100% (View > Actual Pixels). From the 'Filters' menu select 'Sharpen > Unsharp Mask'. Average settings are Amount: 80 to 180, Radius: 1.0, Threshold 3 for a scan destined for a full-page print.

17. Save the duplicate image as a TIFF file for printing. Save the master file with adjustment layers as a Photoshop file (PSD). If minor adjustments are required they should be made to the master file and a new duplicate created before printing a second time.

ACTIVITY 4 www.photoshopessentialskills.com/retouching.html

The glamor portrait offers an excellent opportunity to test the effectiveness of a variety of image editing skills. The portrait is an unforgiving canvas that will show any heavy-handed or poor technique that may be applied. Start with a color portrait that has been captured using a soft diffused light source.

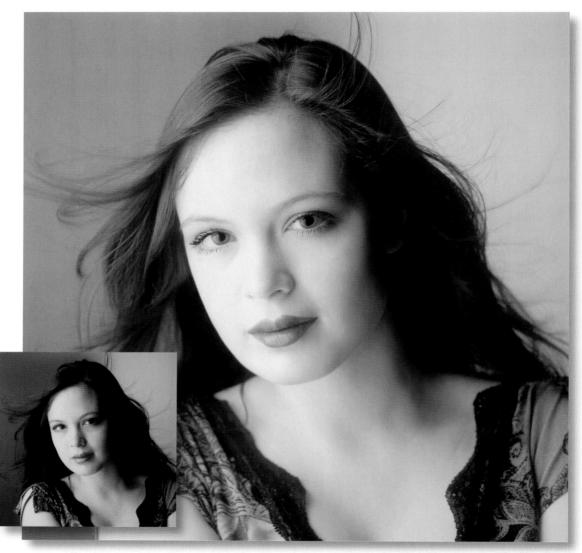

Photography by Michael Wennrich

Start with a 20 megabyte 16 bits per channel image file that has a good histogram and that has been color corrected. The objective of this project is to perfect various characteristics and not to make such changes that the character of the sitter is lost to the technique. Care should be taken not to excessively smooth skin texture and thereby create an artificial or plastic appearance. Fading filters and reducing opacity of brushes will help to smooth imperfections and not totally eliminate them.

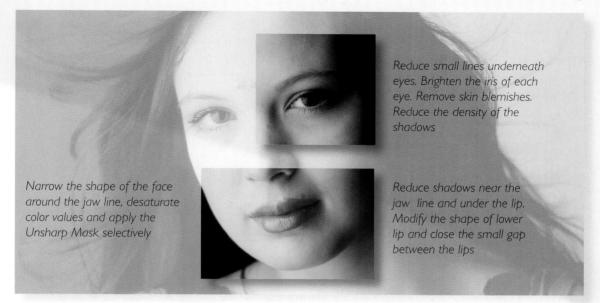

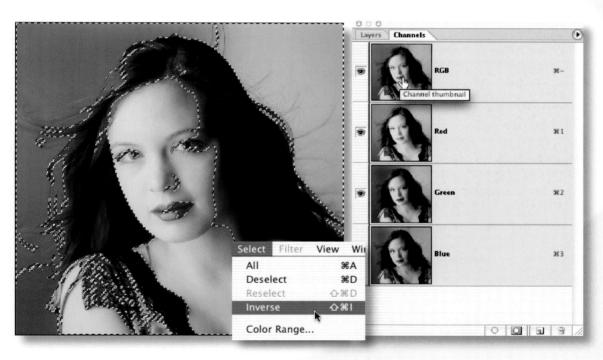

Adjust the tonality

1. To brighten the dark shadows a luminosity mask is created from the channels palette. The luminosity mask will help to isolate the shadows for adjustment and leave the highlights relatively unaffected. To select the luminosity from the channels Command/Ctrl-click the master RGB channel. The resulting selection must be inverted before creating a curves adjustment layer in the layers palette.

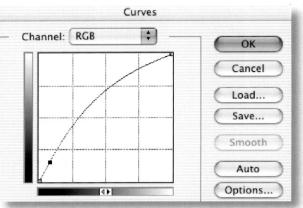

2. With the luminosity selection active create a curves adjustment layer and open the shadows by raising the curve to reveal any detail present. It is not necessary to peg the highlights as these values are being masked. The mask can be further enhanced to limit the adjustment layer's impact on the midtones and shadows by increasing its contrast (click on the layer mask thumbnail and use an adjustment from the 'Image' menu).

Remove blemishes from the skin

3. Always duplicate the background layer before starting to work directly on the pixels. Use the Healing Brush to remove fine lines from underneath the eyes. Care must be taken when selecting the size and hardness of the brush. If an overly large soft edged brush is used it can draw in color values from the eyelashes or eyelids that can contaminate the skin tone (a selection can be made prior to using the Healing Brush to isolate the healing area from different colors or tones). If the brush is too hard the edges of the healing area will be visible. Sometimes it is better to use a smaller brush and make several passes rather than trying to complete the section with a single pass. The Healing Brush, with its protection of surface texture, is a superior alternative to using the Rubber Stamp tool at a reduced opacity.

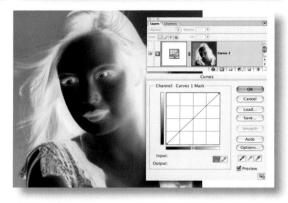

The Healing Brush in some respects behaves like a filter, and as such can be 'faded' from the Edit menu. The ability to fade the Healing Brush in conjunction with the application of a blend mode from the Fade menu can often disguise and blend the edges to create an undetectable patch.

The Patch tool can occasionally be used as a quick-fix solution to repairing a large area where the surrounding tone is similar and large enough to support the patch. The Feather Radius is critical to the success of the patch technique. If 'Source' is selected in the patch options the damaged area must first be selected and then dragged to an area with a similar texture value that is undamaged. Small blemishes can be removed by either spotting with the Healing Brush or using the History Brush technique as described earlier.

Liquify

4. Ensure the 'Background copy' layer is selected before experimenting with the 'Liquify' filter. The Liquify filter can be used to modify the shape or line of various features. The 'Pucker Tool' is used to contract an area of the lip that is asymmetrical whilst the 'Push Left Tool' with the brush pressure set to 10% is used to move the edge of the face inwards. It is important to exercise great restraint when using these tools, as the face can quickly become a cartoon caricature of itself when taken too far. The tools also soften detail which becomes obvious when overdone.

Selective color adjustment

5. The lips have been selected using a Lasso tool and the selection feathered. A curves adjustment layer is then applied to increase the depth of tone on the lighter side of the lips. A gradient mask is then applied (foreground to transparent) to hide the adjustment from the darker side of the lips. This evens out the lip color.

Note > The lips were later retouched again using the Rubber Stamp at a reduced opacity to close the small gap and lighten the lines and irregularities in the lip surface.

Eye highlighter

6. The focal point of any portrait is the eyes and some time can be spent making the most of this important feature. The whites of the eyes can be cleaned using the Healing Brush whilst a new layer filled with 50% gray can be used to dodge the eyes to brighten them. The iris of each eye can be selected using the Ellipse tool. A second ellipse with the 'Subtract from selection' icon selected can be used to remove the pupil from the selection. Create a Hue/Saturation adjustment layer either to adjust the saturation and lightness or to 'Colorize' the eyes with a different color.

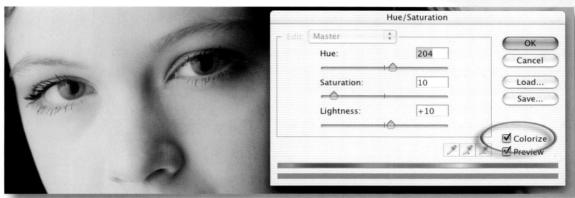

The 'make-over'

7. Make-up can by applied by brushing color onto a new layer set to an appropriate blend mode. Use a soft edged brush set to a reduced opacity and build up the color slowly to obtain a subtle effect. The layer opacity can be reduced if necessary and a small amount of 'Gaussian Blur' can help to soften any edges that are noticeable.

Channel mixing

8. A desaturated layer with a reduced opacity can be used to reduce the overall color saturation of this portrait image to create a different mood. This effect can be created by using the 'Channel Mixer'. The Channel Mixer can be placed on an adjustment layer and can selectively draw its grayscale information in differing amounts from the three channels. Viewing the red channel of a portrait image you will usually find that the skin texture is smoother than in the green or blue channels.

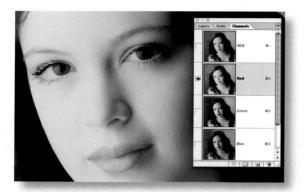

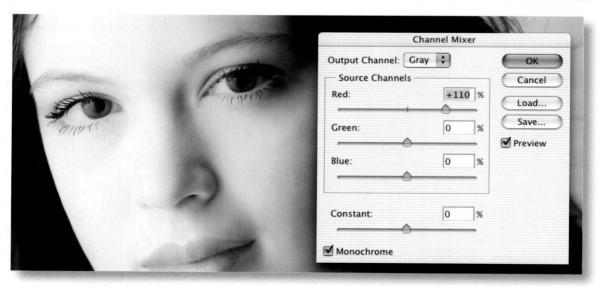

In the 'Channel Mixer' dialog box choose 'Gray' as the output channel and check the 'Monochrome' box. Adjust the red, green and blue channel sliders until you achieve the tonality and contrast you are looking for. Favoring the red channel over the green and blue will usually render a smoother appearance. The total amount in the three fields should add up to approximately 100% if the image is to retain its overall brightness level.

Unsharp Mask

Smooth skin tones can be unduly sensitive to the application of the Unsharp Mask. It is usual to raise the threshold slider sufficiently so that areas of smooth tonal gradation are left unaffected. Film grain, image sensor noise and minor skin defects all come in for the sharpening treatment if the threshold is left too low. If the sharpening process is proving problematic a selective sharpening layer should be considered.

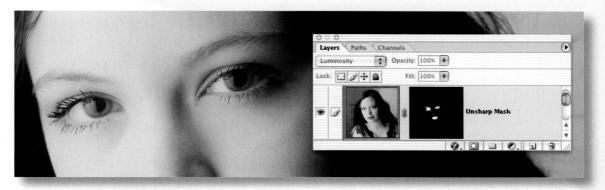

9. Create a Luminosity layer by Command/Ctrl-clicking the master RGB channel. Click on the 'Create new channel from selection' icon in the Channels palette. Select this new alpha channel and go to 'Select > Select All'. Paste this selection as a new layer and apply the Unsharp Mask to this layer. Create a layer mask to shield the skin tones from the effects of the Unsharp Mask.

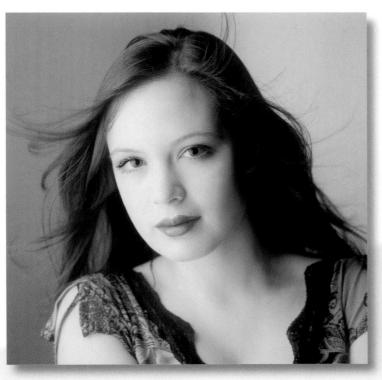

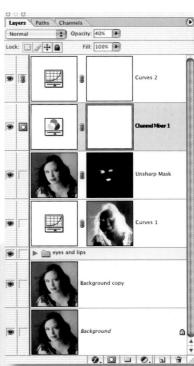

Capturing high contrast scenes

Light is the cornerstone of all great images. Whether you shoot digital, or are still playing with film and chemistry, without light, the pictures we make would only exist in our imaginations. But despite our dependence, too much light is not a good thing. Whilst in the depths of winter we struggle with not enough light, in summer time or when shooting on vacation in sunnier climes we can encounter the problem of too much of the stuff.

It is not that the light is too bright; it is more that there is too much difference between the highlight and shadows in a scene. In photographic terms, this difference is called the 'subject brightness range' and on a sunny day it is possible for the contrast range to exceed the recording abilities of the camera's sensor. If this happens your images will contain:

- Little or no highlight detail
- Large areas of flat white or black and
- A loss of shadow details.

This is not a scenario that is peculiar to digital camera users; film shooters also suffer from the inability to capture all that they can see. In fact, we are so used to this phenomenon that most of us would view it as normal. However, for those who do recognize that some of the image detail has been lost, there is the question of how can I make images in cases of extreme contrast and still retain delicate highlights and shadows.

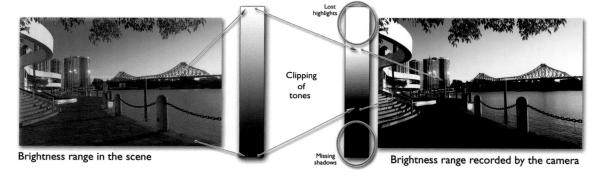

Solving the contrast dilemma

The layer and blending capabilities of Photoshop provide the means to help solve the contrast dilemma. There are several different techniques available for increasing the dynamic range (range of brightness) captured in a picture, all of which revolve around shooting several images of the one scene using different exposures. In the two-shot technique, one exposure is designed to capture highlight and midtone values whilst the other records midtone and shadow areas.

The two pictures are then combined in Photoshop producing an image that contains the highlight detail of one photograph, the shadow information of another and midtones drawn from both exposures.

At first glance the pictures made with this technique appear a little flat and lacking in contrast, but when you look carefully into the image you will be able to see a good spread of tones and detail that extends from the brightest areas through to the shadows. The flat appearance is partly due to this increase in detail and partly because we are not used to seeing images that capture so much contrast.

>>> essential skills >>>

Limitations

The down side of this multi-shot technique is that it can only be used with stationary subjects. Restricting though this is, it still means that you can use the process to record loads more detail in subjects like:

- Architecture
- Still life
- Landscapes (when no wind is around)
- · Macro pictures and
- Interiors.

ACTIVITY 5 www.photoshopessentialskills.com/retouching.html

1. To start the process you need to find a suitable subject. To really test the technique try to locate a scene that contains a huge difference between the brightest and darkest parts of the subject. Set your camera up on a tripod and lock it down. Adjusted the exposure, white balance and focus controls from automatic to manual. Use the camera's built-in meter to make the normal exposure (as a reference) and then shoot two more pictures – one 2 stops over the normal setting and a second 2 stops under. The overexposed image is used to capture the shadow details and the underexposed picture the highlight areas.

Most modern digital cameras have an auto-bracketing system that can be set to automatically shoot all three frames at the various exposures.

2. With the over and under documents open in Photoshop hold down the Shift key whilst you drag the darker picture onto the document containing the overexposed image. Holding down the Shift key will make sure that the new layer is kept in register with the existing background. You should now have the underexposed picture (dark) sitting on top of the overexposed background (light). Save the file as a separate picture.

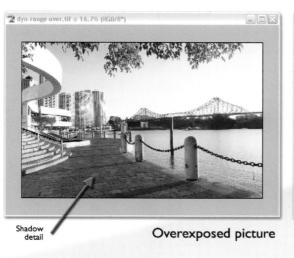

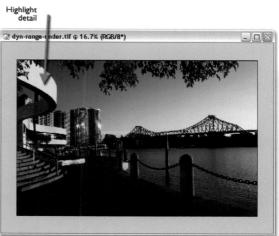

Underexposed picture

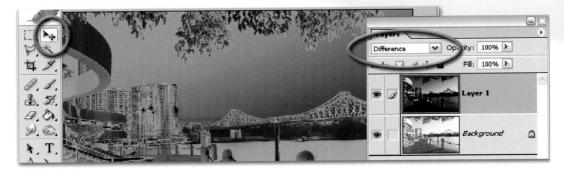

3. To check the alignment of the two pictures, switch the blending mode of the top layer to Difference, select the Move tool and use the arrow keys to make 1-pixel adjustments to the layer until the top picture matches the bottom. Switch back to Normal blending mode.

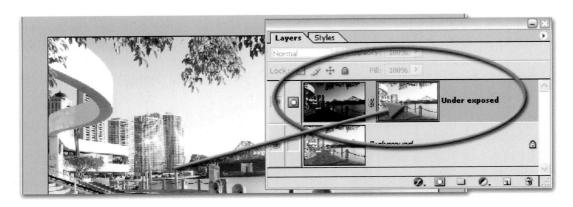

- 4. We will use a layer mask to blend the details of the two layers together. Start by selecting the upper most layer and adding a layer mask (Layer > Add Mask > Reveal All). Notice a mask thumbnail now appears in the upper layer. Select the background layer (underexposed dark) and make a selection of the whole layer (Select > Select All). Next copy the layer (Edit > Copy) and whilst holding down the Alt key (Option Macintosh) click on the layer mask. This selects and displays the layer mask, consequently the document window will turn white. Now paste (Edit > Paste) the copied selection into the mask. Notice the document window now displays a grayscale version of the bottom layer. Turn off the selection 'marching ants' (Select > Deselect).
- 5. In the next couple of steps we will make some adjustments to the grayscale layer mask in order to enhance the blending of the two layers. To see the results of the changes, open a new version of the document (Window > Arrange > New Window) so that you can view the picture without the mask.

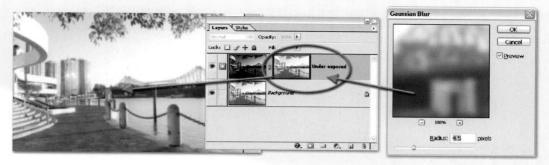

6. With the layer mask still selected, apply the Gaussian Blur filter (Filter > Blur > Gaussian Blur). Select a pixel radius that removes detail and texture from the mask but doesn't form a halo around hard edges or contrasting areas of the composite picture.

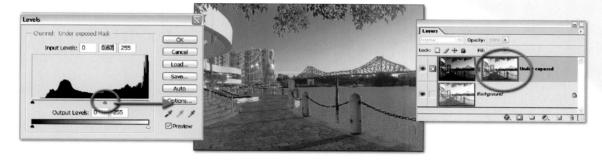

7. The final task is to adjust the contrast and brightness of the mask in order to control the blending of the two exposures. To achieve this you can use either the curves or levels feature. Here I use the Levels control. Make sure that the layer mask is still targeted and then select Image > Adjustments > Levels.

Moving the mod point input slider to the right lightens the shadow area and conversely movements to the left darken these picture parts. After these final adjustments close the new window and click onto the upper layer thumbnail to view the results.

The results

Now if we compare the image taken with a standard exposure with that made from a combination of two separate pictures it is easy to see the additional detail that is now apparent in the shadow and highlight areas.

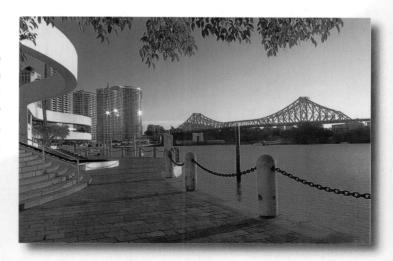

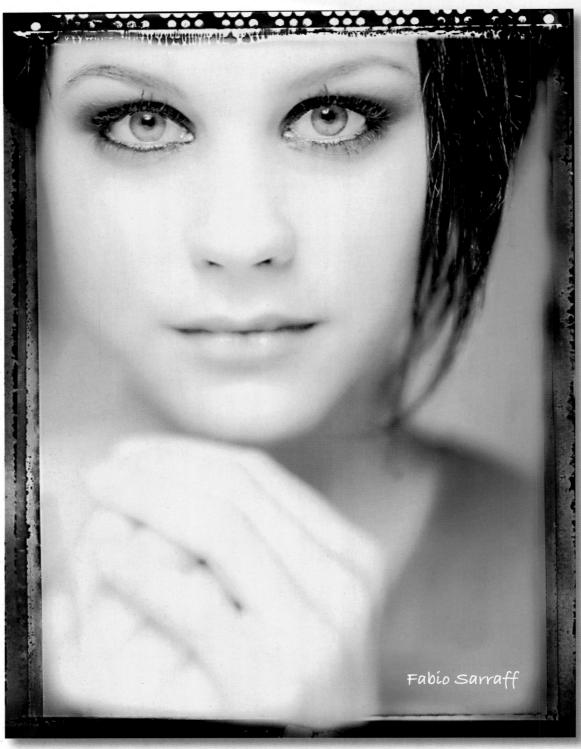

special effects op photoshop photos

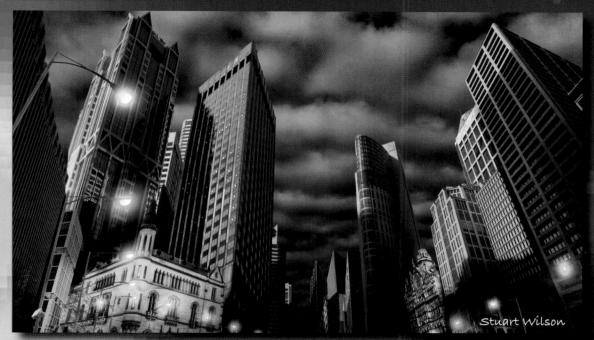

otoshop photoshop photoshop photoshop phot

essential skills

- Create a three-dimensional composite image using layer masks, styles, blend modes and images captured using a flatbed scanner.
- Create a toned image using the 'Gradient Map' tool.
- Create a cast shadow.
- Create a color posterized image using the 'Posterize' and 'Gradient Map' adjustment layers.
- Create a cross-processed effect using 'Curves' and 'Hue/Saturation' adjustment layers.

Layer comps

The flatbed scanner is surprisingly good at capturing objects and artifacts that aren't absolutely flat. Forty-eight bit export scanners are now an affordable reality for most imaging students and enthusiasts. This tutorial will demonstrate how a range of compositing or montage skills can be used to construct artwork from a range of flatly lit source material.

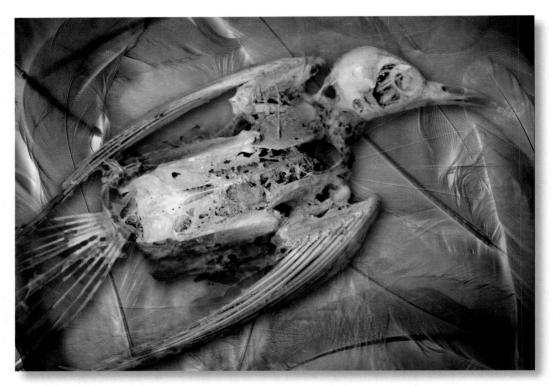

The source material – a mummified bird together with a few feathers and a book cover made from dried leaves

ACTIVITY / www.photoshopessentialskills.com/effects.html

Choose one or two objects and some interesting textures that are visually interesting – watercolor paper, scrunched-up plastic bags, etc. If the outcome is to be a full-page print you should aim to scan around 10 megabytes of pixels per file (double that if you are scanning in 48-bit mode). Ensure the histogram for each component piece is optimized prior to starting the montage.

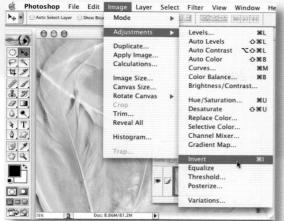

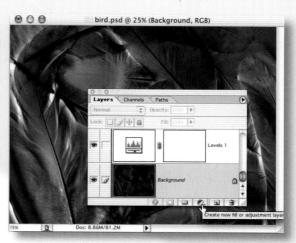

1. Choose the image that will become the background layer. The feathers image in this activity was 'inverted' (Image > Adjustments > Invert') to provide a darker background for the mummified bird. The tonal qualities were optimized using an adjustment layer before importing the second texture layer.

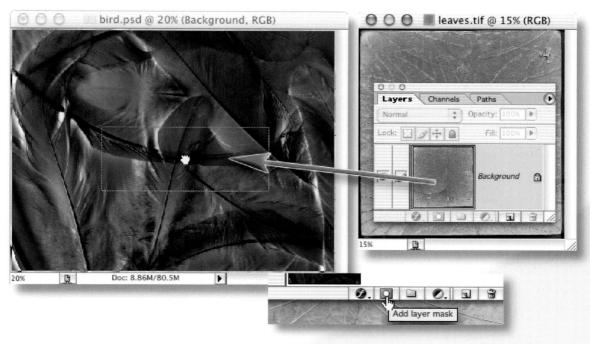

2. Position the second texture image (the leaves) alongside the feathers image. Click on the background layer in the layers palette and drag it into the feathers image window. A border will appear momentarily around the feathers image to indicate that it will accept the new layer. Depress the Shift key as you let go of the leaves layer to center it in the canvas area. Free Transform the image to fit the new canvas ('Edit > Free Transform'). Click on the 'Add layer mask' icon at the base of the layers palette.

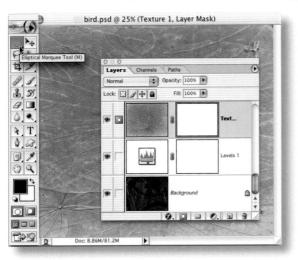

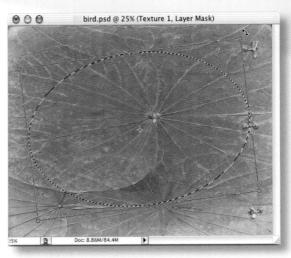

3. With the layer mask active click on the 'Elliptical Marquee Tool' and draw a large ellipse in the canvas area just large enough to accommodate the main subject matter. To angle the selection to suit the angle of the subject matter select 'Free Transform' from the Edit menu. Move to just outside one of the corner handles and position the cursor until a double-headed arrow appears. Drag the selection to rotate it to a new position. Creating the selection in a layer mask rather than the layer itself will allow you to rotate the selection without moving the pixels. When you are happy with the new angle of the ellipse press the return/enter key to commit the transformation.

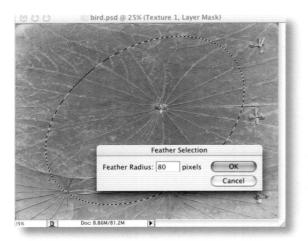

4. From the Select menu choose feather ('Command/Ctrl + Option + D') and select a very generous feather radius (80+ pixels for an A4 image). Go to 'Select > Inverse' and then 'Edit > Fill'. Fill the selection with black. If black is already the foreground color you could use the keyboard shortcut 'Option/Alt + Delete'.

- 5. Lower the opacity of this layer and/or experiment with the blend modes until you get a pleasing balance between the two layers.
- 6. Bring in the third component to this montage and create a selection (using all of your favorite techniques) to separate the bird from its background. When the selection is complete (don't forget to feather it by one or two pixels no pun intended) hit the 'Add layer mask' icon once again.

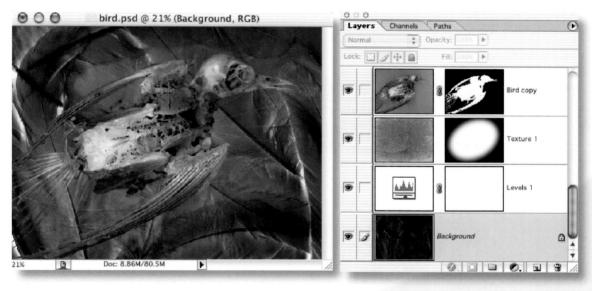

7. With the bird now transplanted to its new background all of the elements are in place but are not 'at one with each other'. What we need are some shadows to give the subject a sense of three-dimensional form that was removed by the flat light of the scanner. This together with the addition of a drop shadow will unite the bird with its new background. Time to save the work in progress and put the kettle on for a cup of tea because we are nearly there.

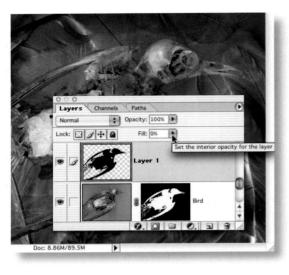

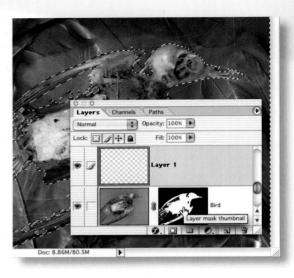

8. Click on the 'New Layer icon' at the base of the layers palette and then hold down the Command/ Ctrl key whilst clicking the layer mask thumbnail on the bird layer to reload your selection. When the selection reappears click on the new layer in the layers palette and fill the selection with black. The next step may seem a bit strange but we are going to hide the black bird (or should that read magpie) by setting the 'Fill' opacity of the layer to 0%. If you are using an older version of the Photoshop you can find the 'Fill opacity slider' in the 'Blending Options' by double-clicking the layer. To this invisible bird we will now add the shadows. Strange but true!

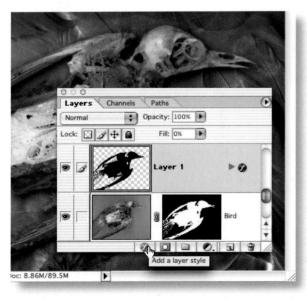

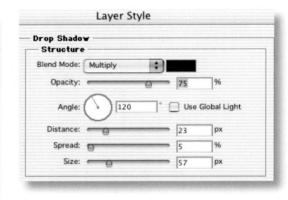

9. From the 'Add a layer style' icon at the base of the layers palette choose 'Drop Shadow'. Choose settings that appear as if the object were now sitting on the background.

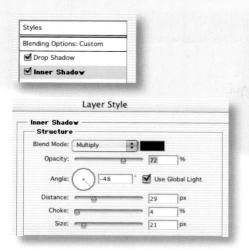

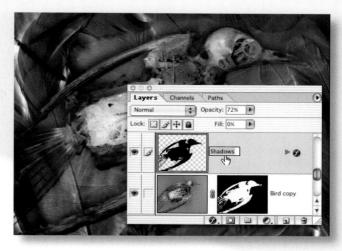

10. From the styles palette choose 'Inner Shadow' and reverse the lighting direction. The mixture of inner shadow and drop shadow should give your subject the depth you may be looking for. Before you start patting yourself on the back and rushing off to get that cup of tea I asked you to make you will need to check the accuracy of your masking skills. Set the screen view to 'Actual pixels' (double-click the magnifying glass in the tools palette or use the keyboard shortcut 'Command/ Ctrl + Zero') and then drag the image around to inspect your handiwork. Any halos or fringes can usually be corrected by working directly on the layer you applied the layer styles to.

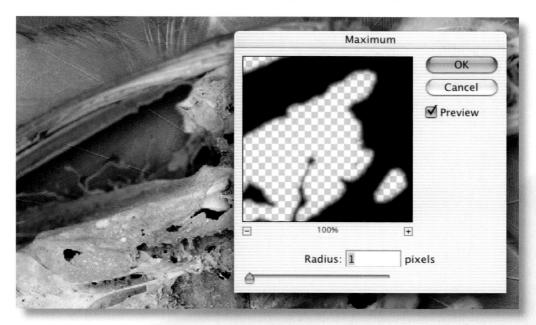

11. To remove any unsightly ghosting or fringes that may appear around your main subject try applying the 'Maximum' or 'Minimum' filter to your layer styles layer. Go to 'Filters > Other > Maximum/Minimum'. This should shrink or expand your mask to conceal those unsightly lines you have been trying to get rid of for years.

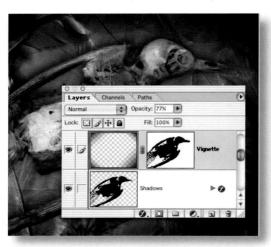

12. The image can be 'tarted up' for good measure with the application of a subtle vignette (Gradient tool with the foreground to transparent option) to further darken the edges and a thin contrasting border color ('Select > Select All' and then 'Edit > Stroke').

Layer Comps

As you move through the infinite number of variables that can be selected for layer visibility, position and layer styles to achieve a visual outcome it is possible to record each variable as a 'Layer Comp'. It is similar in practice to creating a 'snapshot' in the histories palette or using the non-linear histories to explore a variety of compositing options. The advantage to Layer Comps is that unlike histories and snapshots they are saved with the image file and therefore available when the file is reopened.

Gradient maps

Burning, toning, split-grade printing and printing through your mother's silk stockings are just some of the wonderful, weird and positively wacky techniques used by the traditional masters of the darkroom waiting to be exposed (or ripped off) in this tantalizing digital tutorial designed to pump up the mood and ambience of the flat and downright dull.

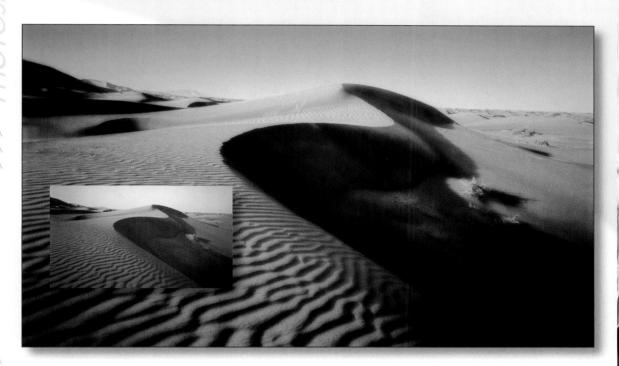

Seeing red and feeling blue

It probably comes as no small surprise that 'color' injects images with mood and emotional impact. Photographers, however, frequently work on images that are devoid of color because of the tonal control they are able to achieve in traditional processing and printing techniques. Toning the resulting 'black and white' images keeps the emphasis on the play of light and shade but lets the introduced colors influence the final mood. With the increased sophistication and control that digital image editing software affords us, we can now explore the 'twilight zone' between color and black and white as never before. The original image has the potential to be more dramatic and carry greater emotional impact through the controlled use of tone and color.

ACTIVITY 2 www.photoshopessentialskills.com/effects.html

The tonality of the tutorial image destined for the toning table will be given a split personality. The shadows will be gently blurred to add depth and character whilst the highlights will be lifted and left with full detail for emphasis and focus. Selected colors will then be mapped to the new tonality to establish the final mood.

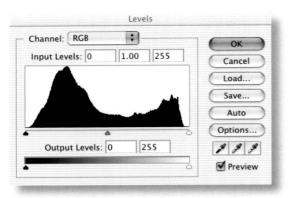

1. For the best results choose an image where the directional lighting (low sunlight or window light) has created interesting highlights and shadows that gently model the three-dimensional form within the image. Adjust the levels if necessary so that the tonal range extends between the shadow and highlight sliders. In the layers palette drag the background layer to the New Layer icon to create a background copy (a safety-net feature).

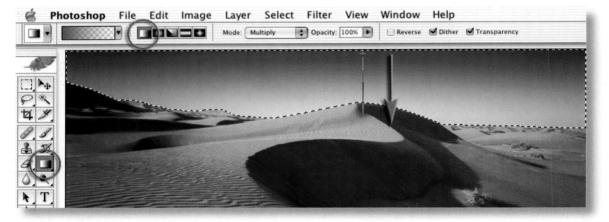

2. Bright areas of tone within the image can be distracting if they are not part of the main subject matter. It is common practice when working in a black and white darkroom to 'burn' the sky darker so that it does not detract the viewer's attention from the main focal point of the image. In the tutorial image the overly bright sky detracts from the beautiful sweep of the dominant sand dune.

To darken the sky start by clicking on the foreground color swatch in the tools palette to open the 'Color Picker'. Select a deep blue and select 'OK'. In the Options bar select the 'Foreground to Transparent', 'Linear Gradient' and 'Multiply' options. Drag a gradient from the top of the image to just below the horizon line to darken the sky. Holding down the Shift key as you drag constrains the gradient keeping it absolutely vertical.

Note > You may need to make an initial selection of the sky if the gradient interferes with any subject matter that is not part of the sky. See 'Selections' page 129 for more detail.

3. Duplicate the 'Background copy' layer and select 'Desaturate' from the 'Image > Adjustments' menu.

4. Use an 'adjustment layer' to adjust the tonality of this layer. 'Group' the adjustment layer with the desaturated layer to limit the adjustments to this layer. Hold down the Alt/Option key on the keyboard and click on the 'Create new fill or adjustment layer' icon. In the 'New Layer' dialog box check the 'Group With Previous Layer' option. Click 'OK' to open the 'Levels' dialog box.

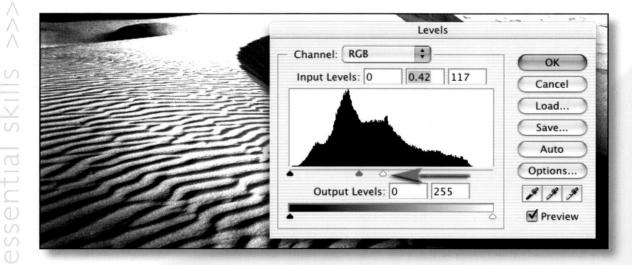

5. Drag the highlight slider to the left until the highlights disappear. Move the 'Gamma' slider (the one in the middle) until you achieve good contrast in the shadows of the image. Select 'OK' to apply the levels adjustment.

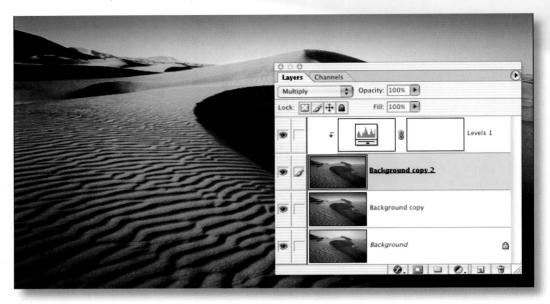

6. In the layers palette switch the 'Mode' of this grayscale layer to 'Multiply' to blend these modified shadow tones back into the color image.

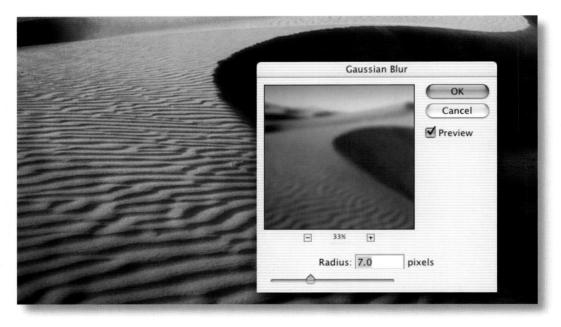

7. Go to 'Filter > Blur > Gaussian Blur' and increase the 'Radius' to spread and soften the shadow tones. With the preview on you will be able to see the effect as you raise the amount of blur. Go to 'View > Zoom In' to take a closer look at the effect you are creating.

Note > This effect emulates the silk-stocking technique when it is applied to only the high contrast part of the split-grade printing technique made famous by Max Ferguson and digitally remastered in his book *Digital Darkroom Masterclass (Focal Press)*.

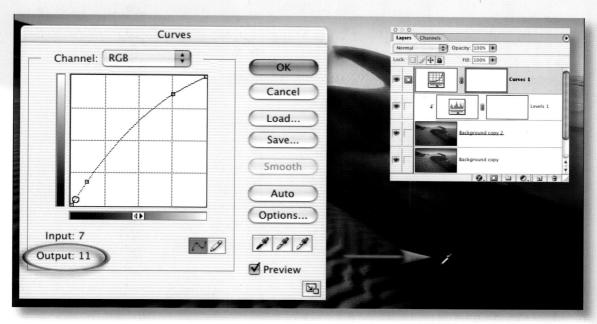

8. Create an additional adjustment layer to modify and fine-tune the tonality that results from this blending exercise. This second adjustment layer should not be grouped with the previous levels adjustment layer.

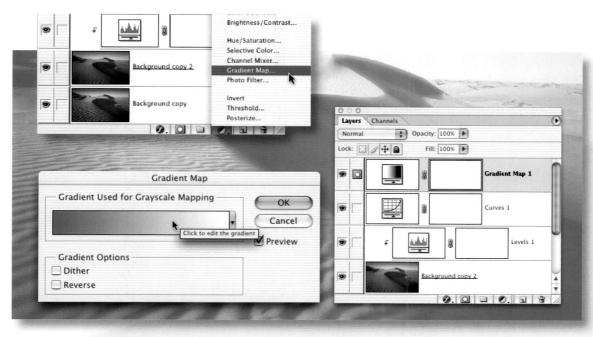

9. Create a 'Gradient Map' by clicking on the Create new fill or adjustment layer icon in the layers palette. Click on the gradient to edit it.

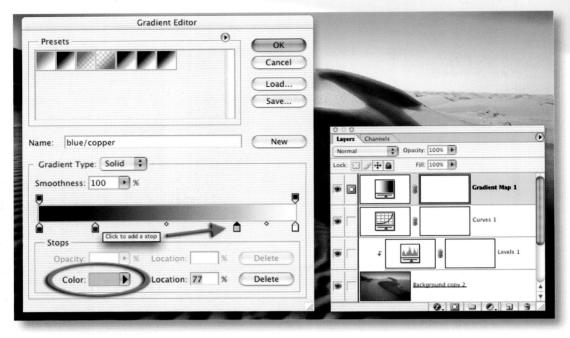

10. The Gradient Editor dialog box allows you to assign colors to shadows, midtones and highlights. Click on the 'Color Stop' underneath the gradient on the left and then click on the 'Color' swatch and choose black from the 'Color Picker'. Click underneath the gradient to create a new color stop. Slide it to a location that reads approximately 25% at the bottom of the dialog box. This time choose a dark color. Cool colors such as blue are often chosen to give character to shadow tones. Create another stop and move it to a location that reads approximately 75%. This time try choosing a bright warm color to contrast with the blue chosen previously. Drag these color sliders and observe the changes that occur in your image. Create bright highlights with detail and deep shadows with detail for maximum tonal impact. Choose desturated colors from the Color Picker (less than 50%) to keep the effects reasonably subtle. Once you have created the perfect gradient you can give it a name and save it by clicking on the 'New' button. This gradient will now appear in the gradient presets for quick access.

Note > The gradient map used in this toning activity can be downloaded from the supporting web site and loaded into the 'presets' by clicking on the load button.

11. To create a merged copy of your work in the existing image file simply go to 'Select > All', then 'Edit > Copy Merged' and finally 'Edit > Paste'. A new layer will appear with all of the information from the visible layers. If this is not on the top of the layer stack it should be dragged there so that it is not adjusted a second time by any of the adjustment layers that appear above.

12. Select all again and then from the 'Edit' menu choose 'Stroke'. Choose a width in pixels and an appropriate color to frame your masterpiece.

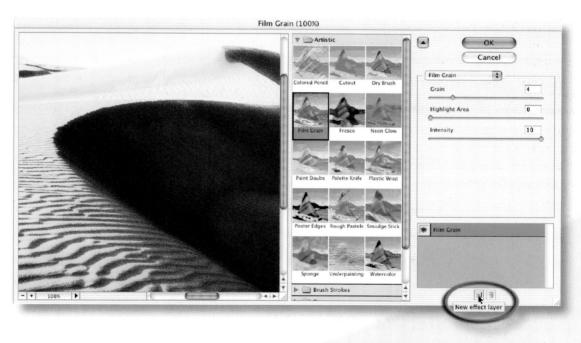

13. If your image has come from a digital camera and has no evidence of any film grain you can go to 'Filter > Artistic > Film Grain' or 'Filter > Noise > Add Noise' to replicate the type of image that would have emerged from a darkroom at the hands of a grand master. Get really gritty by experimenting with the 'Unsharp Mask' from the 'Filter > Sharpen' menu. Now all you need to do is lock yourself in the bathroom for half a day, dip your hands in some really toxic chemicals and you will have the full sensory experience of the good old days.

SSentia

Cast shadows

Cast shadows, instead of drop shadows, are often an essential feature in montage work. In order to create the illusion that an object or subject belongs in the environment the shadow that is cast must respect the source of light, lighting quality and perspective. Shadows can sometimes be extracted from the original image but sometimes the shadows must be created from scratch.

ACTIVITY 3 www.photoshopessentialskills.com/effects.html

1. Use the Ellipse tool to create a sphere in the landscape prepared for the previous activity. Holding down the Shift key as you drag will constrain the ellipse to a circle. Pressing the spacebar whilst drawing the circle will allow you to reposition the graphic.

2. Duplicate this vector layer by dragging the layer to the 'New Layer' icon in the layers palette.

3. Add a layer style to the top shape layer. Select the layer and then click on the layer style in the styles palette or drag the layer style from the palette to the required layer.

Note > You can download the style for this shape from the supporting web site. The style can then be loaded via the 'Preset Manager' from the 'Edit' menu or the styles palette options.

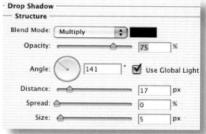

4. Add a drop shadow to the 'Shape 1' layer by clicking on the 'Add a layer style' icon in the layers palette. Set the blend mode to 'Multiply', the opacity to 75% and keep the size and spread values small. Precise settings of the shadow can be modified later.

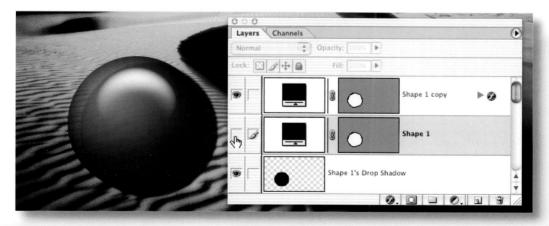

5. Go to 'Layer > Layer Style > Create Layer' to place the Shape 1 drop shadow on its own layer. Switch off the visibility of the 'Shape 1' layer.

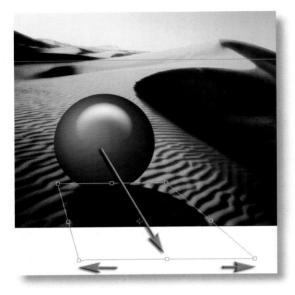

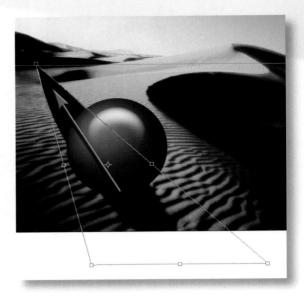

- 6. Use a guide dragged from a ruler or the 'Line Tool' to mark the horizon line within the image.
- 7. Select the 'Shape 1's Drop Shadow' layer and apply the 'Free Transform' command from the 'Edit' menu. Drag the top center handle of the Free Transform bounding box down so that the shadow is cast forwards from the strong backlight present in the image. Press the Ctrl/Command key and reposition each corner handle to create some perspective. The perspective can be checked for accuracy by dragging the top center handle of the Free Transform bounding box to the horizon line if the points meet the perspective is correct.

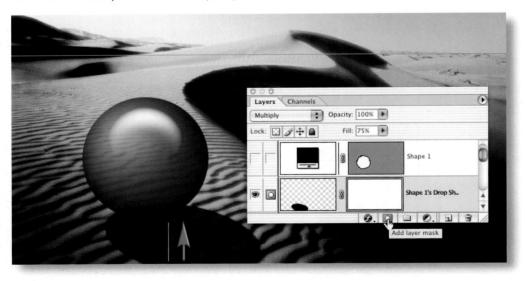

8. Add a layer mask to the shadow layer and use the Gradient tool with a low opacity to fade the shadow as it moves further away from the sphere.

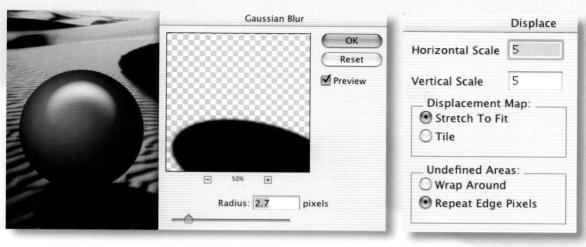

9. The shadow can be softened using the 'Gaussian Blur' filter and by adjusting the opacity of the shadow layer. The shadow can also be made to undulate over an uneven surface by using either the 'Liquify' filter or the 'Displace' filter as described in the 'Layer Blends' chapter.

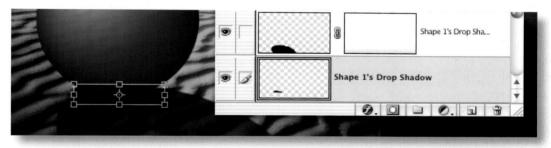

10. A second shadow can be added directly beneath where the object touches the surface. This secondary shadow helps the object appear 'grounded'. The original shadow layer can be duplicated and the Free Transform command used to resize and reposition this smaller shadow.

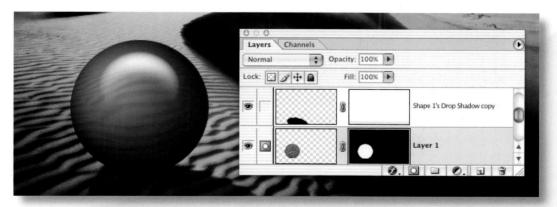

11. To complete the illusion the 'Bloat Tool' in the 'Liquify' filter was used to distort the ripples in the sand visible through the sphere.

Posterization

Sometimes the difference between a good portrait and a great portrait is simply the quality of light used to illuminate the subject. Soft directional light is usually great for creating a flattering or glamorous portrait, but if the light is too flat, the drama or impact of a character portrait can be lost. In this activity the Posterize command comes to the rescue to enhance the character and create a little drama!

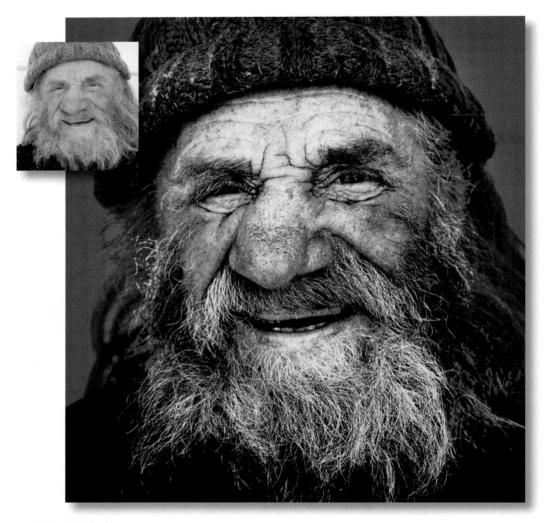

ACTIVITY 4 www.photoshopessentialskills.com/effects.html

Using the Posterize command in Photoshop (Image > Adjustments > Posterize) is as simple as selecting the command and typing in the number of levels required. You will find the Posterize command can be very effective for dividing grayscale images into large flat areas of tone to create a dramatic graphic impact. The effects of posterization, however, are often far less successful if the command is applied directly to an RGB color image. The aim of this activity is to create a successful and dramatic posterized color image.

sentia

1. Open the 'old_man.jpg' portrait image from the supporting web site. Duplicate the background layer by dragging it to the 'New Layer' icon in the layers palette. Although the final image will be color you need to desaturate this background copy layer by choosing 'Image > Adjustments > Desaturate'.

2. From the 'Create new fill or adjustment layer' icon in the layers palette choose Posterize. From the Posterize dialog box select 6 levels (this will give you white, black and four tones of gray). You can experiment with different numbers to see the variations of effect later (ensure the 'Preview' box is checked). The Posterize command, however, offers no control over the exact placement of these tonal values. This control can be achieved by using a gradient map as used in the 'gradient map' activity.

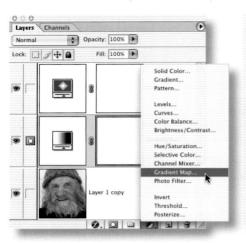

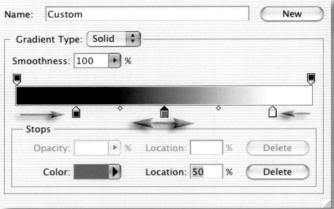

3. Add a Gradient Map adjustment layer and position it between the Posterize adjustment layer and the desaturated image layer in the layers palette. Use a 'black to white' gradient and create an additional stop selecting a midtone gray from the Color Picker. Move the black, white and gray stops until the desired tonality is achieved.

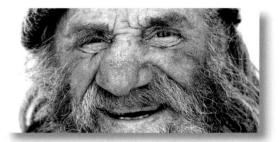

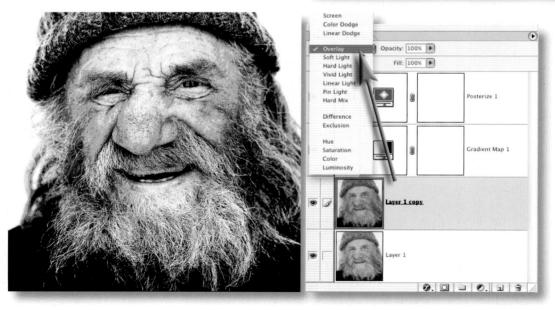

4. To blend the drama of the desaturated layer and the color of the background layer change the blend mode of the posterized grayscale layer to 'Overlay'. To restrict the posterization to the desaturated layer you will need to group the posterize and gradient map layers to the desaturated layer. Experiment with the desaturated layer opacity to modify the result.

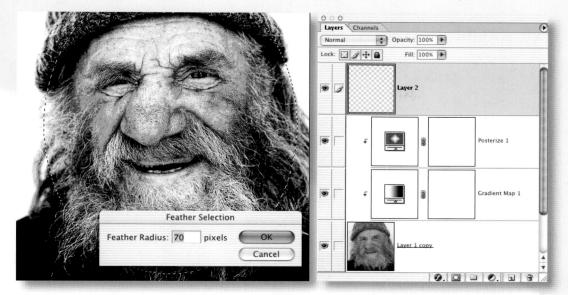

Create a vignette

5. By adding a vignette it is possible to remove the bright distracting background. Click on the 'New Layer' icon to create a new empty layer and then select the Elliptical Marquee from the tools palette. Ensure the new layer is on top of the layers stack. Click in the top left-hand corner of the image and drag to the bottom right-hand corner of the image to create an elliptical selection.

Note > Press the spacebar whilst dragging a selection to reposition the selection.

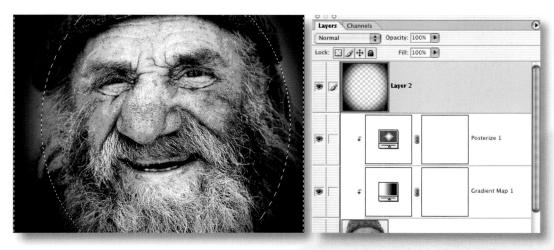

6. From the 'Select' menu choose 'Inverse' and then 'Feather'. In the Feather dialog box enter a 'Feather Radius' value. Choosing a high feather radius will soften the vignette. A feather radius of 50 or 70 pixels may be suitable for a screen resolution but a higher value may be required for a high print resolution image. From the 'Edit' menu choose 'Fill' and select 'Color' from the menu. Choose a dark color from within the image area when the Color Picker opens. Select OK and then lower the opacity of the vignette layer until you have achieved the required effect.

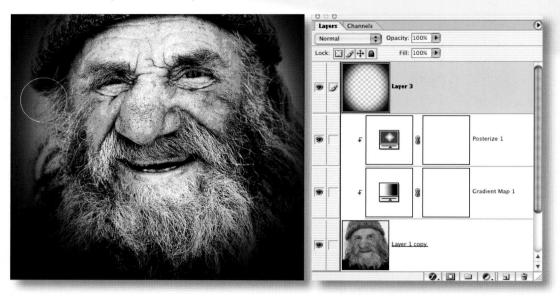

7. Paint into the vignette with a large soft edged brush using a reduced opacity to control any halos that may be present.

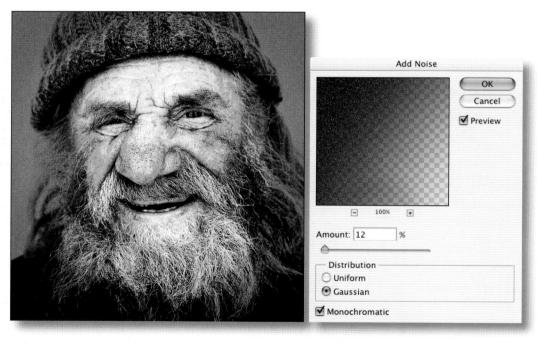

8. Go to Filter > Noise > Add Noise to turn the liquid smooth tone of the vignette to a gritty texture that is consistent with the rest of the image. This activity demonstrates how tonality and color can have a huge impact on the mood and impact of a photographic image and, with a little digital dexterity, how the extraordinary can be released from the ordinary.

Cross process effect

This technique is derived from an effect that was first established by processing color negative film in E-6 chemicals (normally used to process color transparency film). The technique is popular in the fashion photography industry and when applied to film processing is quite destructive to highlight and shadow tones. The same 'look' can be applied to digital files in a non-destructive way using adjustment layers.

Photography by Michael Wennrich

The image top left is a straight scan from a cross-processed piece of film, whilst the enlarged portrait is a digital copy of the effect that has been achieved by using a Curves adjustment layer. The colors present in the film are simulated by shifting the color values and then increasing the color saturation using a Hue/Saturation adjustment layer. The precise color signature of cross-processed film varies depending on the type of film emulsion used but the characteristics are pinky-orange highlights with blue-cyan shadows. Detail is often lost in both shadows and highlights.

ACTIVITY 5 www.photoshopessentialskills.com/effects.html

1. Start with the 'glamor portrait' image from the activity in the 'Advanced Retouching' chapter. Create a 'Curves' adjustment layer and use the channel information above as a starting point to modify and manipulate the color values.

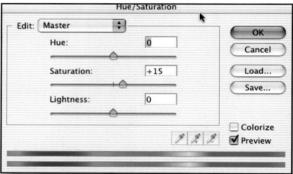

2. With the color values moved modify the tonality using the master 'RGB' channel and then use a Hue/Saturation adjustment layer to increase the saturation to match the cross-processed look. The settings for both of these adjustment layers can be saved for future use by clicking on the 'Save' button in the adjustment layer dialog boxes.

XProcess.acv

Note > The curves setting used in this cross process activity can be downloaded from the supporting web site and loaded into the Curves dialog box by clicking on the Load button.

essential skills >>>

Lith printing - the digital way

There is no doubt that a well-crafted lith print is, to borrow an oft used phrase from my father-in-law, 'a thing of beauty is (therefore) a joy forever'. The trick, for the experienced and occasional darkroom users alike, is the production of such a print. Even with frequent reference to publications penned by lith guru Tim Rudman, I have always had difficulty getting consistency with the production of my prints. Despite this frustration my love affair with the process still continues. There is something quite magical about the quality of images created using this technique and it is this magic that I hanker after. They are distinctly textured and richly colored and their origins are unmistakable.

The process, full of quirky variables like age and strength of developer and the amount of overexposure received by the paper, is unpredictable and almost always unrepeatable. In this regard at least, most printers, myself included, found the whole lith printing process both fascinating and infuriating. This said, it's almost a decade since lith printing started to become more commonplace and there is no sign of people's interest declining.

'Long live lith!' I hear you say, 'but I shoot digital'. Well, good news; the digital worker with basic skills, a copy of Photoshop CS and a reasonable color printer can reproduce the characteristics of lith printing without the smelly hands, or the dank darkroom.

A digitally produced lith print can exhibit similar color and grain characteristics to those typically found in chemically produced originals

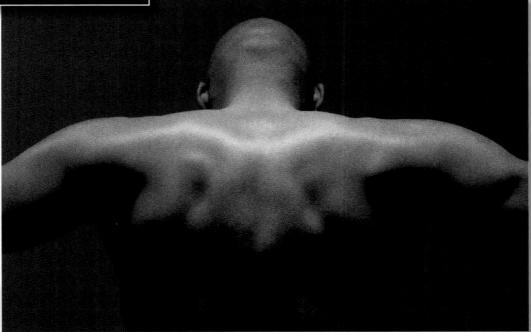

Image courtesy of www.able stock.com

ACTIVITY 6 www.photoshopessentialskills.com/effects.html

1. If you ask most photographers what makes a lith print special the majority will tell you it's the amazing grain and the rich colors. Most prints have strong, distinctive and quite atmospheric grain that is a direct result of the way in which the image is processed. This is coupled with colors that are seldom seen in a black and white print. They range from a deep chocolate, through warm browns, to oranges and sometimes even pink tones. If our digital version is to seem convincing then the final print will need to contain all of these elements. Whether you source your image from a camera or a scanner, make sure that the subject matter is conducive to making a lith type print. The composition should be strong and the image should contain a full range of tones especially in the highlights and shadows. Delicate details may be lost during the manipulation process, so select an image that still works when the fine details are obscured by coarse grain. Good contrast will also help make a more striking print.

2. Now that you have selected a picture with a strong composition, let's add some color. Photoshop provides a couple of options for adding the distinctive lith colors. The simplest approach uses the Hue/Saturation control as a way of changing a full color picture into a tinted monochrome, but keep in mind that the duotone techniques described later in this chapter can also be used for this purpose. If your original is in grayscale mode the first step is to change the file to a mode that is capable of displaying color. For our purposes a switch to RGB color will suffice (Image > Mode > RGB Color).

3. Now open the Hue/Saturation feature (Image > Adjustments > Hue/Saturation). With the Colorize box ticked you can select the color of the tint via the Hue slider. Moving the slider along this scale will gradually change the overall color of the picture whilst retaining the white and black parts of the picture.

4. Now adjust the strength or vividness of the color using the Saturation slider. Low values will produce subtle coloring whereas higher settings create more dramatic results. Selecting a value of 0% produces a picture devoid of any color just containing black, white and gray.

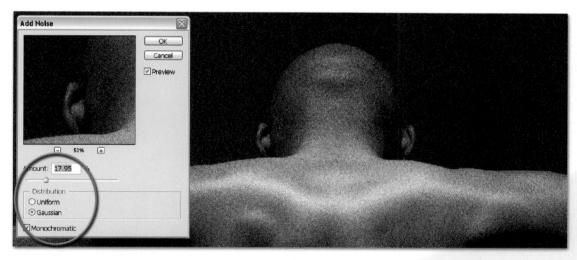

5. To simulate the texture of the lith print, filter the image using either the Grain (Filter > Texture > Grain) or Noise (Filter > Noise > Add Noise) filter. Most of these types of filters have slider controls that adjust the size of the grain, its strength and how it is applied to various parts of the image. The settings you use will depend on the resolution of your picture as well as the amount of detail it contains. The stronger the filter effects the more details will be obscured by the resultant texture. Be sure to preview the filter settings with the image magnification set at 100% so that you can more accurately predict the results. Here I have the used the 'Noise' filter with both the Gaussian and Monochrome options set.

Digital diffusion

Most photographers have an obsession with sharpness. It seems that we are all striving for the ultimate quality in our images. We carefully select good lenses and always double check our focusing before making that final exposure. All this so that we can have sharp, well-focused images that we can be proud of.

It almost seems like a mortal sin then for me to be describing a technique on how to make your images 'blurry', but like it or not, these days the photographic world is full of diffused or blurred imagery. From the color food supplements in our weekend papers to the latest in portraiture or wedding photography, subtle (and sometimes not all that subtle) use of diffusion in contemporary images can be easily found.

Traditionally adding such an effect meant placing a 'mist' or 'fog' filter in front of the camera lens at the time of shooting or positioning diffusion filters below enlarging lenses when printing. The digital version of these techniques allows much more creativity and variation in the process and relies mainly on the use of layers, blending modes and the 'Gaussian Blur' filter.

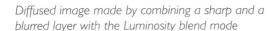

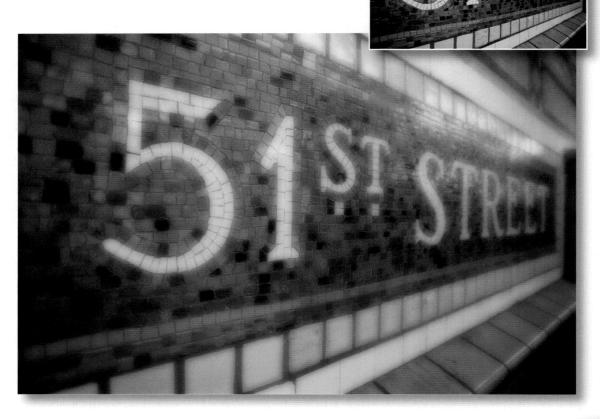

ACTIVITY 7 www.photoshopessentialskills.com/effects.html

The Gaussian Blur filter that can be found in most image editing packages effectively softens the sharp elements of the picture when it is applied. Used by itself, this results in an image that is, as expected, quite blurry, and let's be frank, not that attractive. It is only when this image is carefully combined with the original sharp picture that we can achieve results that contain sharpness and diffusion at the same time and are somewhat more desirable. So essentially we are talking about a technique that contains three distinct steps.

1. First, make a copy of the background layer by selecting Layer > Duplicate. Title the copy 'blur layer' using the Duplicate Layer dialog.

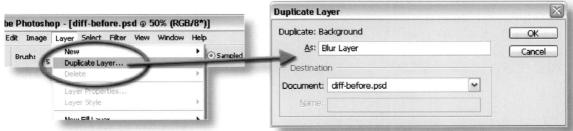

2. With this layer selected, apply the Gaussian Blur filter. You should now have a diffused or blurred layer sitting above the sharp original. If you don't like the look of the Gaussian diffusion then you can choose another effect such as the Diffuse filter instead. This filter is not as controllable as Gaussian Blur but does achieve a different effect.

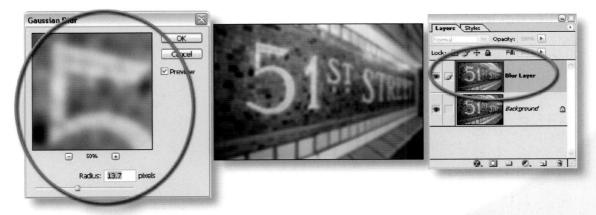

3. Finally change the layer 'blending mode' using the drop-down menu in the top left of the layers palette. As we have already seen Photoshop CS contains many different blending modes that control how any layer interacts with any other. The Normal, Soft Light, Multiply and Luminosity modes all work well for this picture. Of course other modes might work better on your own images so make sure that you experiment. Additionally, you can change the 'opacity' (top right of the dialog) of the blurred layer as well. Adjusting this setting changes the transparency of the blurred layer, which in turn determines how much of the layer below can be seen. More opacity means less of the sharp layer characteristics are obvious. By carefully combining the choice of blending mode and the amount of opacity, the user can create infinite adjustments to the diffusion effect.

sentia

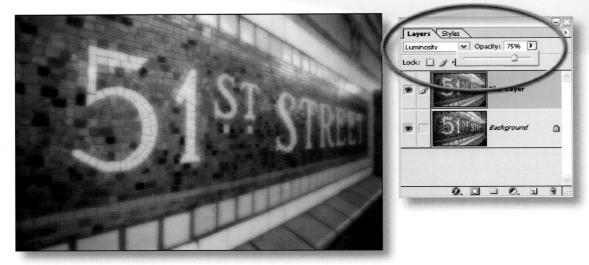

One step further

In some instances it might be preferable to keep one section of the image totally free of blur. This can be achieved by applying the Gaussian filter via a graded selection to your original image. This way some of the picture remains sharp whilst the rest is diffused.

1. Open the base image and make a copy layer of the background using the Layer > Duplicate Layer command. Make sure that the Gradient tool options are set to 'foreground to transparent' and 'radial gradient'. Switch to Quick Mask mode and create a mask from the center of the '51' to the outer right-hand edge of the image.

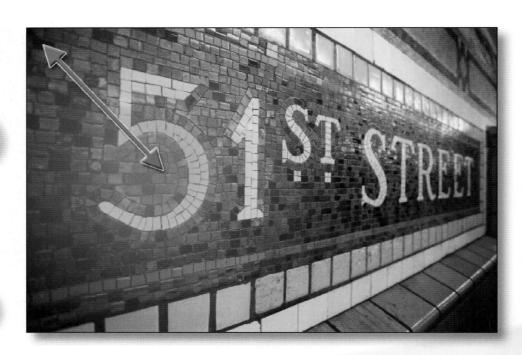

>> PHOTOSHOP C

2. Switch back to the selection mode to reveal the graded circular selection. Depending on the Quick Mask settings, the selection may enclose the parts of the picture that were masked or may isolate the opposite areas in the picture. To change between these two different selections use the Select > Inverse command. Apply the Gaussian Blur filter to the copied layer with the selection still active. By applying this extra step to the duplicate of the original picture (on a separate layer) it is possible to use blending modes and opacity to further refine the strength and character of the diffusion effect.

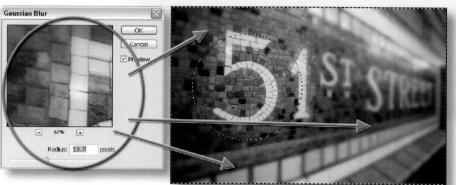

3. To complete the technique and disguise the areas of the picture that have been smoothed with the action of the Gaussian Blur filter you need to try to match the texture of the non-diffused and diffused areas. Do this by adding a very small amount of noise to the picture. The Add Noise filter (Filter > Noise > Add Noise) can be applied to the whole image or via the selection that was used to blur the layer originally. In either case apply only the minimum amount necessary to disguise the changes.

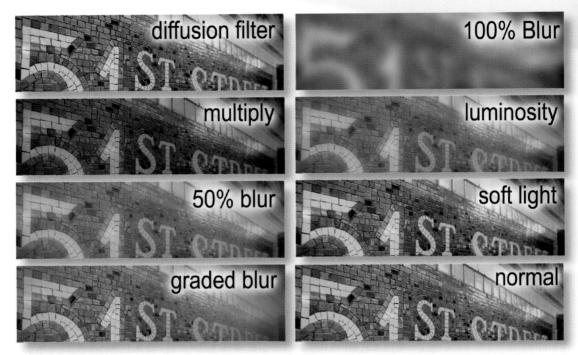

Examples of different diffusion techniques and blending modes

Even more control

You can refine your control over the diffusion process even more by using the Eraser tool to selectively remove sections of the blurred layer.

At its simplest level this will result in areas of blur contrasted against areas of sharpness; however, if you vary the opacity of the eraser then you can carefully feather the transition points.

The addition of the erasing step allows much more control over the resultant image. It is possible to select, and highlight, the focal points of the photograph whilst not losing the overall softness of the image.

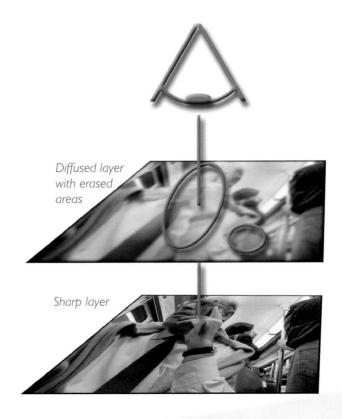

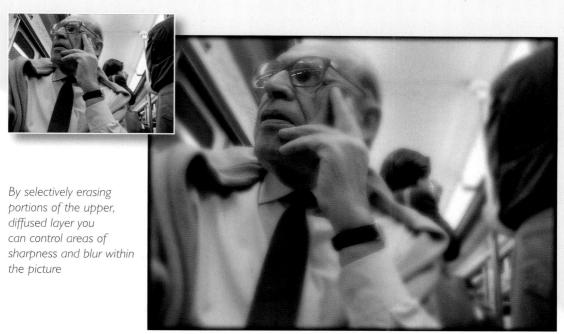

1. Start with a picture that contains the duplicated blurred layer sitting above the sharp original picture. Select the Eraser tool and set it to a soft edged brush with an opacity of 20%.

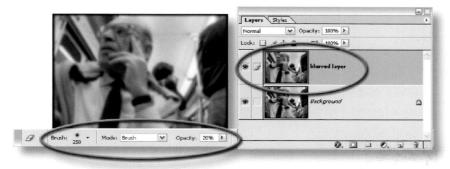

2. With the upper blurred layer selected, start to erase the parts of the blurred layer to reveal the sharpness beneath. Repeat the erasing action for areas that you want sharpest whilst leaving non-essential sections with no changes. It may be easier to think of the erasing action as 'painting back the sharpness' of the picture.

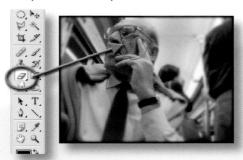

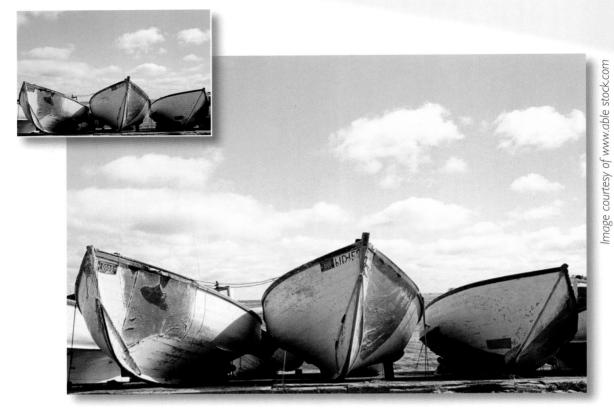

Split toning

Traditional darkroom workers have prided themselves over the years with their ability to produce beautifully toned black and white prints. The famous sepia colored pictures of our past are wonderful examples of toning. Advanced practitioners have even delved into complex two or three toner methods that enabled highlights, midtones and shadows to be colored separately. This technique, which is often called split toning, required the use of several toning and bleaching baths as well as carefully planning the toning sequences if it was to be successful.

As we have already seen in the lith printing technique the digital version of the chemical toning process is not nearly so difficult. Toning a digital black and white print is a comparatively easy process drawing on the Colorize option of the Photoshop's Hue/Saturation command (Image > Adjustments > Hue/Saturation). With straight toning being this easy surely there must be a way to use these ideas to selectively color highlights, midtones and shadows (split toning). Well, Photoshop provides the means with its Color Balance feature (Image > Adjustments > Color Balance) which can selectively tone shadows, midtones and highlights.

Making the Color Balance changes via adjustment layers means that it is possible to introduce a tint, non-destructively, into your black and white images whilst at the same time limiting the color to the tonal range that you have selected.

ACTIVITY 8 www.photoshopessentialskills.com/effects.html

1. If your original is a color image then you will need to 'desaturate' the file first. Create a new Hue/Saturation adjustment layer (Layer > New Adjustment Layer > Hue/Saturation) and drag the Saturation slider all the way to the left. This creates a grayscale image, but in RGB mode. This means that the picture can be colored. If you are using a grayscale picture then convert it to RGB Color first via Image > Mode > RGB Color.

2. Creating a grayscale in this manner often produces flat or low contrast results. Use a Curves or Levels adjustment layer (Layer > New Adjustment Layer > Levels or Curves) to improve any contrast or brightness problems resulting from the conversion.

3. Next, to selectively tint the shadows of the picture we will use a Color Balance adjustment layer (Layer > New Adjustment Layer > Color Balance). Select the Shadows option, move the cyan-red slider to the right and the magenta-green setting to the left. This adds a warm tint to the shadow tones in the picture. Click OK.

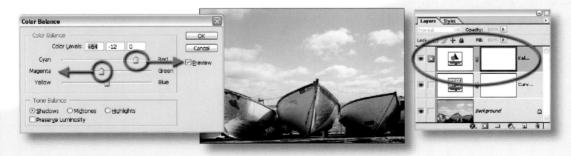

4. To tone the highlights a different color create another Color Balance adjustment layer and select the Highlights option. Move the yellow-blue color slider to the left and the other two settings equally to the right. Click OK. This introduces a yellowing of the highlight tones.

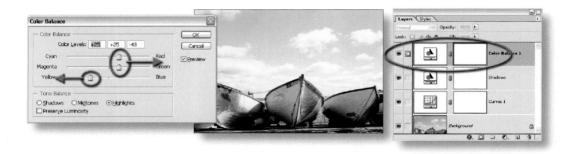

Selective toning

An extension to this technique is to apply your toning methods to a specific area of your image. Using one of the Selection tools available in Photoshop, isolate a portion of your image. With the selection still active tone the area using either the Colorize option with the Hue/Saturation control or the Color Balance feature. For even more dramatic results the selection can then be inversed (Select > Inverse) and a different tint can be applied to the rest of the image.

ACTIVITY 9 www.photoshopessentialskills.com/effects.html

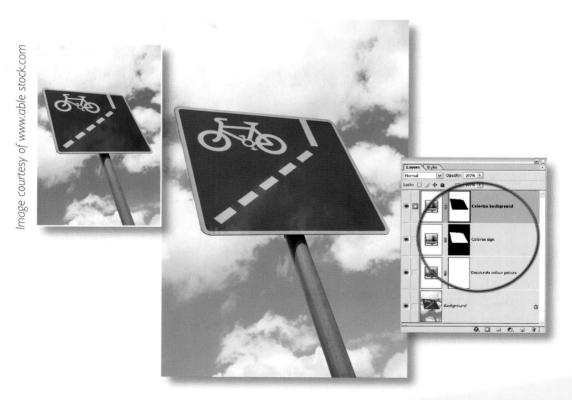

Toning using duo, tri and quadtones

For those readers with a lithographic printing background the idea of toning a black and white image using a duotone process will be quite familiar. To best understand the technique, keep in mind that ink is used to form the image on the printed page. In a straight black and white halftone, the photograph is printed with black ink only. A duotone image, by contrast, is made using two inks instead of one. By controlling which part of the image is printed with which colour it is possible to print images that look like split tone photographic prints.

Photoshop CS has a sophisticated duotone editor that makes it possible for the desktop digital photographer to take advantage of this creative technique. The editor allows the user to select the two colors that will be present in the final image as well as edit which parts of the tonal curve each particular ink will be applied to. Adjusting the shape of the curve can restrict the first color to just the shadow areas letting the second color be used for printing the rest of the picture. Unlike the other techniques we have looked at if you want to try making a duotone you will need to start the process with a grayscale image.

Tri and quadtones extend your creative possibilities even more by adding extra inks into the equation. If this all seems a little too complex then try the duotone presets that come bundled with Photoshop. Here the colors and curve shapes have been designed to provide images with smooth and even transitions between tones and hues. You can usually find these digital toning presets in the goodies folder in your Photoshop directory.

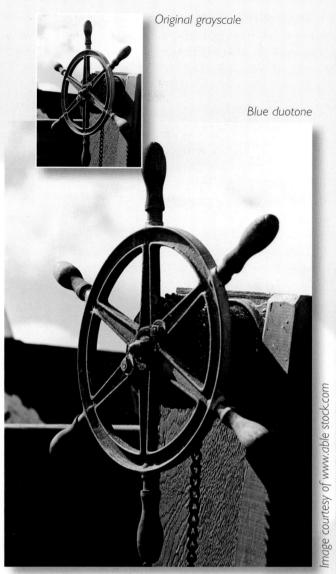

Brown duotone

ACTIVITY 10 www.photoshopessentialskills.com/effects.html

1. Start by converting a color picture to grayscale using Image > Mode > Grayscale function. Apply any contrast and brightness adjustments necessary to redistribute the picture's tones. Switch the picture's mode to Duotone (Image > Mode > Duotone).

2. Once inside the Duotone Options dialog change the Type setting from Monotone to Duotone. This automatically adds the possibility of a second ink color to the document. The Tritone option uses three inks and the Quadtone setting four.

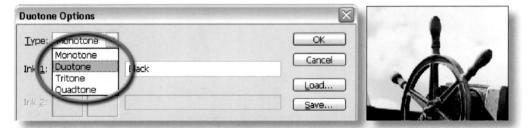

3. To select the second ink color, double click in the Ink 2 color area of the dialog. This will open the color palette, from which you can select the other color to be mixed with black.

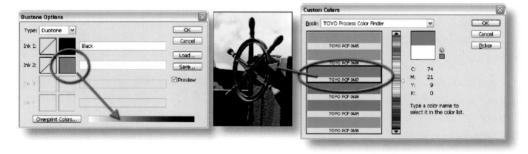

4. By double clicking the Curve thumbnail in the Duotone dialog, you can adjust the prominence of each ink color across the tonal scale.

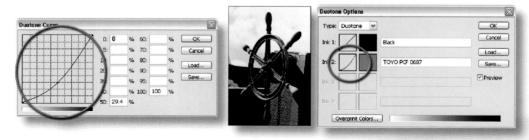

Creating digital depth of field (DOF) effects

Photographers have long considered control over the amount of sharpness in their images as a sign of their skill and expertise. Almost all shooters display their DOF agility on a regular basis. Whether it be when making landscape images that have sharpness from the very foreground objects through to the distant hills, or the selective focus style that is so popular in food and catalog shots today. Everyone from the famed Ansel Adams and his mates in the F64 group to today's top fashion and commercial photographers makes use of changes in 'areas of focus' to add drama and atmosphere to their images.

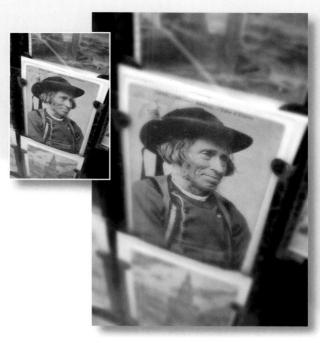

In this digital age the new millennium

photographer can add a new DOF control technique to the traditional camera-based ones. Unlike silver-based imaging, where once the frame is exposed the depth of sharpness present is fixed, pixel-based imaging allows the selection of focused and defocused areas after the shooting stage. In short, a little Photoshop trickery can change an image with sharpness from the foreground to the background to one that displays all the characteristics normally associated with a shallow DOF.

ACTIVITY // www.photoshopessentialskills.com/effects.html

Basic defocusing of the pixels

sentia

1. Choose an image that has a large DOF. This way you will have more choice when selecting which parts of the image to keep sharp and which parts to defocus. The example I have used, in it's original form, has a large DOF and has sharpness throughout. Use one of Photoshop's selection tools to isolate the part of the image that you want to remain sharp. Here I made an oval selection using the Ellipse Marquee tool. Then inverse the selection (Select > Inverse) so that the areas that you want to defocus (make blurry) are now selected.

2. Add some feathering (Select > Feather) to the edge of the selection so that the transition points between focused and defocused picture elements are more gradual. This step can be omitted if you want sharp edged focal points that contrast against a blurry background.

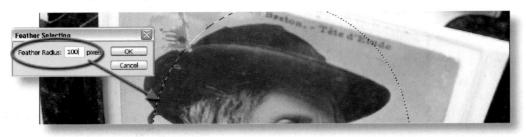

3. Filter the selected area using the Gaussian Blur filter (Filter > Blur > Gaussian Blur) set at a low setting to start with. Make sure the preview option is selected, this way you can get an immediate idea about the strength of the effect. Hide the marching ants (Ctrl + H) that define the selection area so that you can assess the defocusing effect. Re-filter the selection if the effect is not obvious enough. As we have already seen in other techniques that make use of the Gaussian Blur filter a little noise can now be added (Filter > Noise > Add Noise) to the picture to counteract the smoothing effect of the filter.

The new Lens Blur filter

This technique provides a simple infocus and out-of-focus effect. It does mean that our attention is drawn to a single part of the frame and in a basic way this does reflect a camera-based shallow DOF technique. But it would be hard to say that the results are totally convincing. To achieve a DOF effect that is more realistic and believable, the basic idea of this technique needs to be coupled with a new feature in Photoshop CS – the Lens Blur filter.

Photoshop's Lens Blur filter is a dedicated feature designed to create realistic DOF effects in your pictures

SO HOTSOLOH <

If realism is your goal then it is necessary to look a little closer at how camera-based DOF works, and more importantly, how it appears in our images. Imagine an image shot with a long lens using a large aperture. The main subject situated midway into the image is pin sharp. Upon examination it is possible to see that those picture elements closest to the main subject are not as 'unsharp' as those further away. In effect the greater the distance from the point of focus the more blurry the picture elements become.

This fact, simple though it is, is the key to a more realistic digital DOF effect. The application of a simple one step blurring process does not reflect what happens with traditional camera-based techniques. The new Lens Blur filter (Filter > Blur > Lens Blur) in Photoshop CS is designed specifically to help replicate this gradual change in sharpness. The filter uses selections or masks created before entering the feature to determine which parts of the picture will be blurred and which areas will remain sharp. In addition, if you use a mask that contains areas of graduated gray (rather than just black and white) the filter will adjust the degree of sharpness according to the level of gray in the mask.

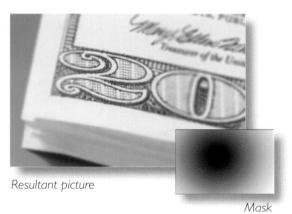

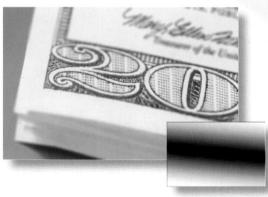

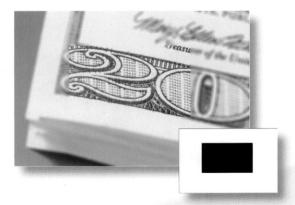

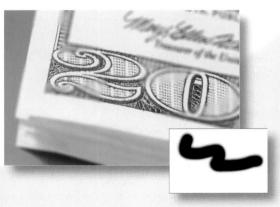

The Lens Blur filter uses a mask or selection to determine which parts of the picture will remain sharp and which areas will be blurred. In addition, the level of sharpness is directly related to the density of the mask. Graduated masks will produce graduated sharpness similar to that found in photographs with camera-based shallow DOF techniques. Image courtesy of www.ablestock.com.

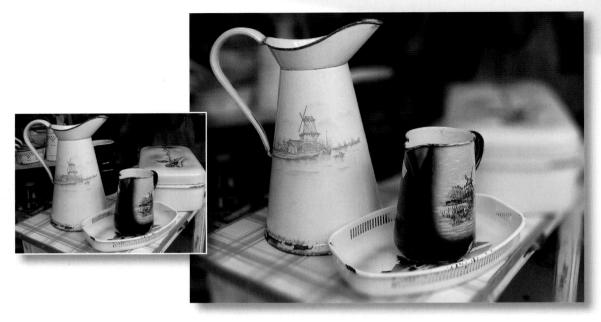

Lens Blur DOF effects

The Lens Blur filter can be used with both sharp edged selections (which equate to sharp edged masks) as well as graded masks. The white area of the mask receives the most blurring, the black parts no defocusing effect and the gray areas proportional filtering. To create a realistic shallow DOF effect you will often need to combine both mask types together. The following tutorial demonstrates a process for achieving just such a combination.

ACTIVITY 12 www.photoshopessentialskills.com/effects.html

1. Start by making a selection of the image parts that are to remain sharp in the picture. Here I selected the two jugs towards the front of the frame. The selection was feathered (Select > Feather) by 1 pixel before being saved (Select > Save Selection) as a new channel (alpha channel mask).

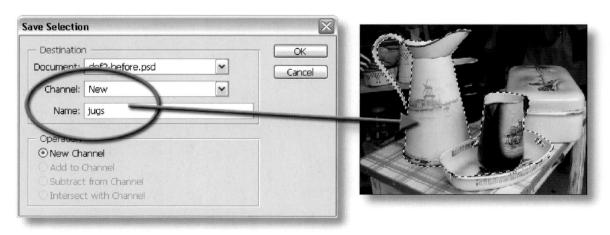

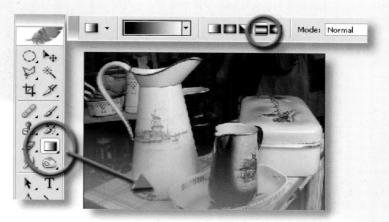

2. Next, switch to the Quick Mask mode and using the Gradient tool set to Reflective Gradient, draw a selection at the base of the table area that equates to the gradual defocusing of the picture moving from the foreground to the background.

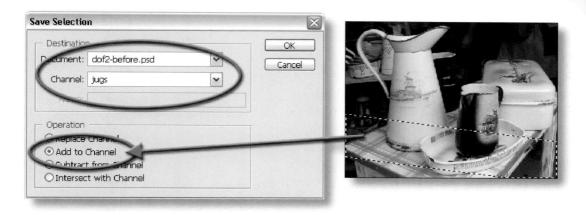

3. Switch back to Selection mode (Standard mode) and save (Select > Save Selection) the graded selection to the same channel ('jugs') as the first selection. This time instead of making a new channel mask choose the Add to Channel option in the Save Selection dialog. This will combine the two selections into one channel mask.

Lens Blur filter options >>

Preview – Faster to generate quicker previews. More accurate to display the final version of the image.

Iris Shape – Determines the way the blur appears. Iris shapes are controlled by the number of blades they contain.

Invert - Select this option to inverse the alpha channel mask or selection.

Gaussian or **Uniform** – Select one of these options to add noise to the picture to disguise the smoothing and loss of picture grain that is a by-product of applying the Lens Blur filter.

Depth Map Source - Select from the drop-down list the mask or selection that you will use for the filter.

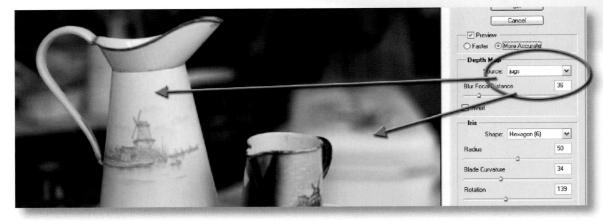

4. Make sure that the RGB combined channel is selected in the channels palette and then open the Lens Blur filter. Choose a preview option. Select the pre-made mask ('jugs') from the Depth Map Source drop-down list. Set a low focus distance and choose an Iris shape from the Shape pop-up. To add specular highlights to the picture drag the Threshold slider to set the brightness cut-off point. Select Gaussian or Uniform to add noise back to the smoothed parts of the picture. Click OK to process the picture.

Digital Polaroid transfer effect

Most readers will probably be familiar with Polaroid instant picture products – you push the button and the print is ejected and develops right before your eyes. For many years professional image-makers have been using the unique features of this technology to create wonderfully textured images. The process involved substituting watercolor paper for the printing surface supplied by Polaroid. As a result the image is transferred onto the roughly surfaced paper and takes on a distinctly different look and feel to a standard Polaroid print.

Much acclaimed for its artistic appeal, the technique was not always predictable and much to the frustration of a lot of photographers, it was often difficult to repeat the success of previous results. There were three main problems – dark areas of an image often didn't transfer to the new surface, colors and image detail would bleed unpredictably and it was difficult to control how dark or light the final print would be. I know these problems intimately as it once took me 16 sheets of expensive instant film to produce a couple of acceptable prints.

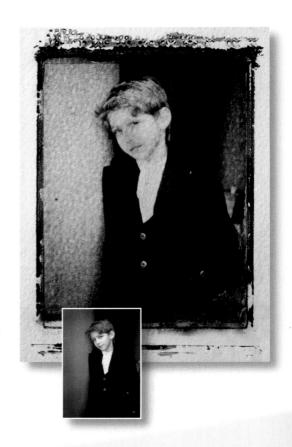

A digital solution

This success ratio is not one that my budget or my temperament can afford. So I started to play with a digital version of the popular technique. I wanted to find a process that was more predictable, controllable and repeatable. My first step was to list the characteristics of the Polaroid transfer print so that I could simulate them digitally. To me it seemed that there were four main elements:

- ~ Desaturated colors
- ~ Mottled ink
- Distinct paper texture and color and
- The Polaroid film frame.

To duplicate these characteristics on the desktop would mean that I could capture the essence of the Polaroid process.

ACTIVITY 13 www.photoshopessentialskills.com/effects.html

1. The Polaroid technique requires the watercolor paper to be slightly wet at the time of transfer. The moisture, whilst helping the image movement from paper to paper, tends to desaturate the colors and cause fine detail to be lost. These characteristics are also the result of the coarse surface of the donor paper.

So the first step of the digital version of the process is to desaturate the color of our example image. In Photoshop this can be achieved by using the Image > Adjustments > Hue/Saturation. With the dialog open carefully move the Saturation slider to the left. This action will decrease the intensity of the colors in your image.

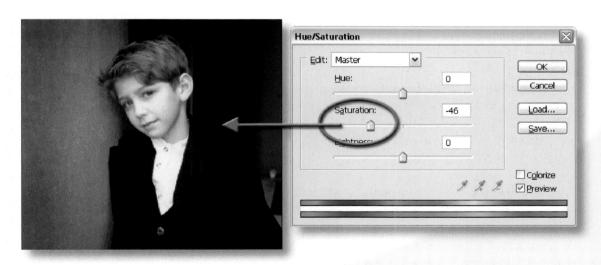

2. The distinct surface and image qualities of Polaroid transfer prints combine both sharpness and image break-up in the one picture. To reproduce this effect digitally, I copied the original image onto a second layer. My idea was to manipulate one version so that it displayed the mottled effect of the transfer print whilst leaving the second version untouched. Then using the blending modes or opacity features of Photoshop's layers I could adjust how much sharpness or mottle was contained in the final result.

In practice, I started by duplicating the image layer. This can be achieved by selecting the layer to be copied and then using the Duplicate Layer command located under the Layers menu. Alternatively you can drag the layer to the New Layer button at the bottom of the layers palette.

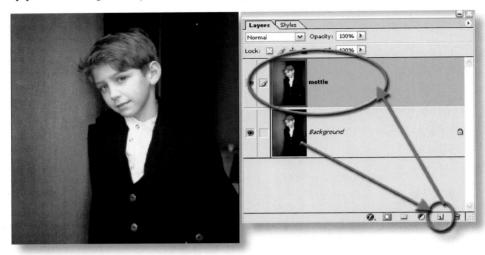

3. With the upper most layer selected, I then needed to find a method to simulate the mottle of the transfer print. Though not exactly right, I found that by combining the effects of the Paint Daubs and Palette Knife filters I could produce reasonable results. When using these filters yourself keep in mind that the settings used will vary with the style and size of your image. Use the ones in the example as a starting point only. This part of the process is not an exact science. Play and experimentation is the name of the game. You might also want to try other options in the Artistic, Sketch or Texture selections of the Filter menu.

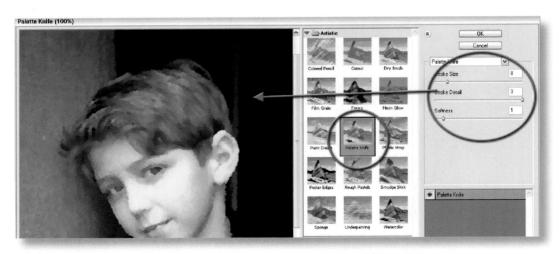

4. The last step in this texture stage is to combine the characteristics of the two layers. This can be achieved by either changing the blending mode of the uppermost layer or by adjusting its opacity, or both. For the example image a simple opacity change was all that was needed, but don't be afraid to try a few different blend/opacity combinations with your own work.

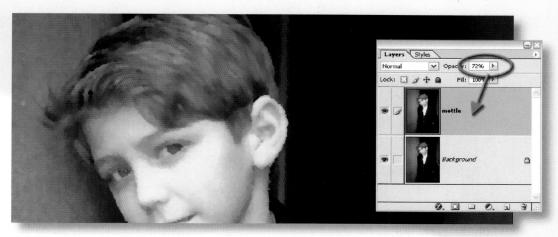

5. The paper color and texture is a critical part of the appeal of the transfer print. These two characteristics extend throughout the image itself and into the area that surrounds the picture. For this to occur in a digital facsimile it is necessary to provide some space around the image using Photoshop's Canvas Size feature (Image > Canvas Size).

Unlike Image Size, this option allows the user to increase the size of the canvas that all image layers (including the background layer) are sitting upon without changing the image itself. In the example the canvas width was increased by 120% and the height by 140%.

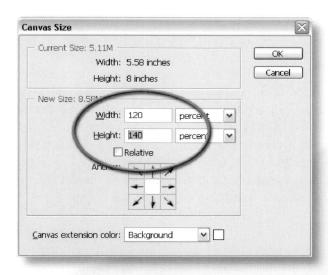

6. To add the texture to both image and surround I flattened (Layer > Flatten Image) the two image layers and the white background into a single layer. Next, I photographed a section of watercolor paper to use as a customized texture with the Texturizer filter (Filter > Texture > Texturizer). You can download and use this very file from the book's web site or pick one of the other options from the Texture pop-up list.

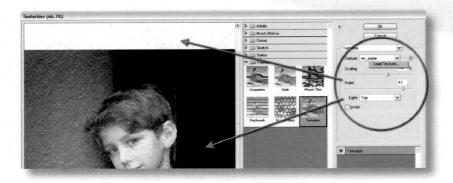

7. With the texture complete, I played with the overall color of the image using the Levels feature (Image > Adjustments > Levels). I altered the blue and red channels independently and concentrated on the lighter tones of the image so that rather than the paper being stark white it took on a creamy appearance.

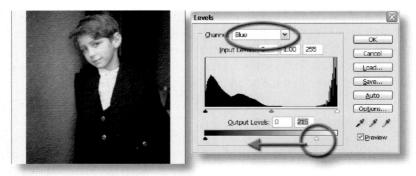

8. The last part of the process involves combining the final image with a scan of a Polaroid film edge. You can make your own by scanning a Polaroid print and then removing the image or you can download the edge I used for the example from the book's web site. Open the edge file as a separate document. Click onto the edge picture and drag it onto your picture. The edge will automatically become a new layer on top of the existing image layer. With the edge layer selected change the layer's blend mode to Multiply. Notice that the white areas of the layer are now transparent allowing the picture beneath to show through. Finally use the Scale command to adjust the size of the edge to fit the image.

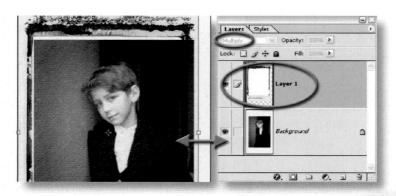

filters

photoshop photoshop photoshop photoshop phot

op photoshop photoshop photoshop photoshop phot

essential skills

- Apply filter effects to a picture.
- Use the Filter Gallery feature to apply several filters cumulatively.
- Using filters with text and shape layers.
- Filtering a section of a picture.
- Painting with a filter effect.
- Installing and using third party filters.

Filtering in Photoshop

Okay, hand's up all of you who have a range of 'Cokin' filters in your camera kit bag. If your arm is raised in timid salute then you are not alone, I too admit to buying a few of these pieces of colored gelatine in an attempt to add drama and interest to my images. Ranging from the multi-image split prism to the keyhole mask for that all important wedding shot, these photographic 'must haves' seem to be less popular now than they were in the eighties.

It's not that these handy 'end of lens add-ons' are essentially bad, it's just that I think that we have all seen too many hideous examples of their use to risk adding our own images to this infamous group. In fairness though, I still would not leave home without a good set of color correction filters, and I am sure that my landscape colleagues would argue strongly for the skillful use graduated filters to add theater to distant vistas.

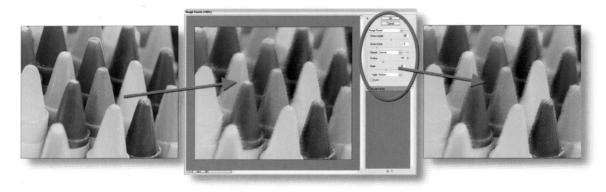

As much as anything the filter's decline can be attributed to changes in visual fashion and just as we thought that 'flares' would never return to the streets, digital effects filters of the seventies have also made a comeback. This time they don't adorn the end of our lenses but are almost hidden from the unsuspecting user, sometimes in their hundreds, underneath the Filter menu of Photoshop.

I think just the association with day's past and images best forgotten has caused most of us to overlook, no let's be honest, run away from, using any of the myriad of filters that are available. These memories coupled with a host of 'garish' and 'look at this effect' type examples in the weekly computing magazines have overshadowed the creative options available to any image-maker with the careful use of the digital filter.

To encourage you to get started I have included a variety of examples from the range that comes free with Photoshop. I have not shown Gaussian Blur or any of the sharpening filters as most people seem to have overcome their filter phobia and made use of these to enhance their imagery, but I have tried to sample a variety that, to date, you might not have considered using.

If you are unimpressed by the results of your first digital filter foray, try changing some of the variables. An effect that might seem outlandish at first glance could become usable after some simple adjustments of the in-built sliders contained in most filter dialog boxes.

New for Photoshop CS – the Filter Gallery

Some Photoshop filters can now be applied using the new Filter Gallery feature. Designed to allow the user to apply several different filters to a single image it can also be used to apply the same filter several times. The dialog consists of a preview area, a collection of filters that can be used with the feature, a settings area with sliders to control the filter's effect and a list of filters that are currently being applied to the image.

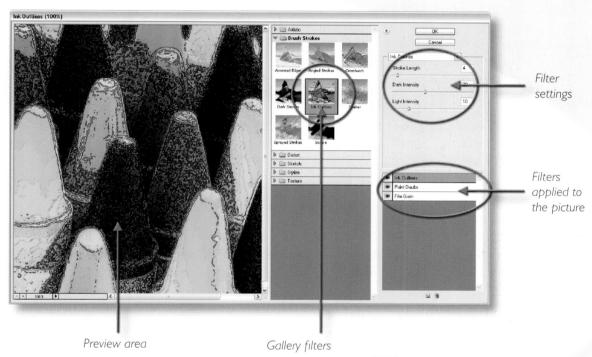

Filters are arranged in the sequence that they are applied. Filters can be moved to a different spot in the sequence by click-dragging up or down the stack. Click the 'eye' icon to hide the effect of the selected filter from preview. Filters can be deleted from the list by dragging them to the dustbin icon at the bottom of the dialog.

Most of the filters that can't be used with the Filter Gallery feature are either applied directly to the picture with no user settings or make use of a filter preview and settings dialog specific to that particular filter.

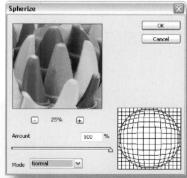

The Spherize filter does not work with the Filter Gallery but has its own preview and settings dialog

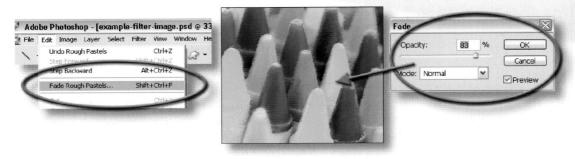

Fade Filter command

The opacity, or strength, of the filter effect can be controlled by selecting the Edit > Fade command when selected directly after the filter is applied. With a value of 0% the filter changes are not applied at all, whereas a setting of 100% will apply the changes fully. As well as controlling opacity the Fade dialog also provides the option to select a different blend mode for the filter changes.

Improving filter performance

A lot of filters make changes to the majority of the pixels in a picture. This level of activity can take considerable time, especially when working with high resolution pictures or underpowered computers. Use the following tips to increase the performance of applying such filters:

- Free up memory by using the Edit > Purge command before filtering.
- Allocate more memory to Photoshop via the Edit > Preferences > Memory and Image
 Cache option before filtering.
- ~ Try out the filter effect on a small selection before applying the filter to the whole picture.
- Apply the filter to individual channels separately rather than the composite image.

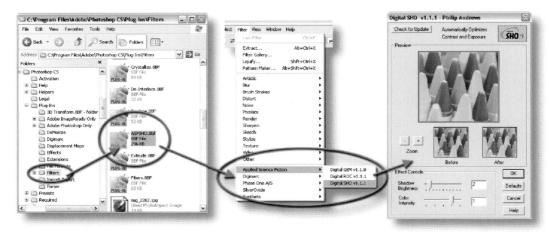

Third party filters are generally installed automatically into the Photoshop Plug-Ins > Filter folder. The program then attaches the extra plug-in to the bottom of the Filter menu the next time Photoshop is opened. Here the Applied Science Fiction Digital SHO filter is installed with other filters from the group's suite of enhancement filters.

Installing and using third party filters

Ever since the early versions of Photoshop Adobe provided the opportunity for third party developers to create small pieces of specialist software that could plug into Photoshop. The modular format of the software means that Adobe and other software manufacturers can easily create extra filters that can be added to the program at any time. In fact, some of the plug-ins that have been released over the years have became so popular that Adobe themselves incorporated their functions into successive versions of Photoshop. This is how the Drop Shadow layer effect came into being. Most plug-ins register themselves as extra options in the Filter menu where they can be accessed just like any other Photoshop feature. The Digital SHO filter from Applied Science Fiction is a great example of plug-in technology. Designed to automatically balance the contrast and enhance the shadow detail in digital photographs, when installed it becomes part of a suite of filters supplied by the company that are attached to the Filter menu.

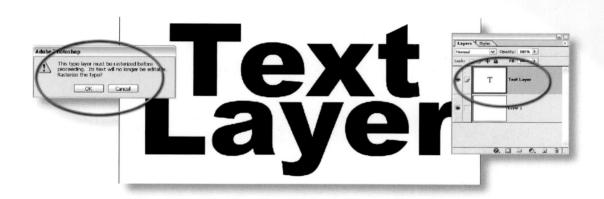

Filtering a shape or text (vector) layer

Filters work with bitmap or pixel-based layers. As text, vector masks and custom shapes are all created with vector graphics and these layers need to be converted to bitmap before a filter effect can be applied to them. Photoshop uses a Rasterize function to make this conversion. Simply select the text or shape layer and then choose the Layer > Rasterize option.

Alternatively if you inadvertently try to filter a vector layer Photoshop will display a warning dialog that notifies you that the layer needs to be converted before filtering and offers to make the conversion before proceeding.

Filters 101

entla

The filter examples are grouped according to the menu heading that they fall under in Photoshop. Each of the filter's effects has been compared using a common 'crayons' image and the associated dialog box for controlling these effects is displayed alongside.

ARTISTIC FILTERS

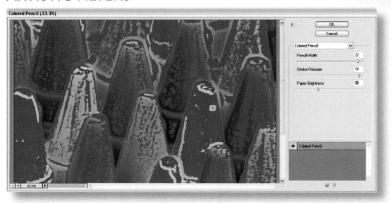

Colored Pencil – Sketchy pencil outlines on a variable paper background. Variables: Pencil Width, Stroke Pressure, Paper Brightness

Cutout – Graded colors reduced to flat areas much like a screen print.Variables: Number of Levels, Edge Simplicity, Edge Fidelity

Fresco – Black edged painterly effect using splotches of color. Variables: Brush Size, Brush Detail, Texture

Paint Dabs – Edges and tones defined with daubs of paint like color. Variables: Brush Size, Sharpness, Brush Type

Plastic Wrap – Plastic-like wrap applied to the surface of the image area.Variables: Highlight Strength, Detail, Smoothness

Rough Pastel – Coarsely applied strokes of pastel-like color. Variables: Stroke Length and Detail, Texture, Scaling, Relief, Light Direction

BRUSH STROKES FILTERS

Accented Edges – Image element edges are highlighted until they appear to glow. Variables: Edge Width, Edge Brightness, Smoothness

Cross Hatch – Colored sharp ended pencil-like cross hatching to indicate edges and tones. Variables: Stroke Length, Sharpness, Strength

Ink Outlines – Black ink outlines and some surface texture laid over the top of the original tone and color. Variables: Stroke Length, Dark Intensity, Light Intensity

Sumi-e – Black outlines with subtle changes to image tone. Variables: Stroke Width, Stroke Pressure, Contrast

DISTORT FILTERS

Pinch – Image is squeezed in or out as if it is being stretched on a rubber surface. Variable: Amount

Shear – Image is distorted in middle in one direction whilst the edges remain fixed. Variable: Undefined Areas

Twirl – Spin and stretch image to look as if it is being sucked down a drain hole Variable: Angle

 Wave – Image is rippled in a wave-like motion. Variables: Number of Generators, Type, Wavelength, Amplitude, Scale, Undefined Areas, Randomize

PIXELATE FILTERS

Color Halftone – Similar to a close-up of a printed color magazine image. Variables: Maximum Radius, Screen Angles for channels 1–4

Mezzotint – Adjustable stroke types used to give tone to the image. Variables: Type

Mosaic – The image is broken into pixel-like blocks of flat color. Variable: Cell Size

Pointillize – Random irregular dot shapes filled with colors drawn from the original image. Variable: Cell Size

RENDER FILTERS

Lens Flare – Creation of a lens flare effect that is then superimposed on the original image. Variables: Brightness, Lens Type

SKETCH FILTERS

Bas Relief – Color reduced image with cross lighting that gives the appearance of a relief sculpture. Variables: Detail, Smoothness, Light direction

Chalk and Charcoal – Black and white version of the original color image made with a charcoal-like texture. Variables: Charcoal Area, Chalk Area, Stroke Pressure

Graphic Pen – Stylish black and white effect made with sharp edged pen strokes. Variables: Stroke Length, Light/Dark balance, Stroke Direction

Stamp – Just broad flat areas of black and white. Variables: Light/Dark Balance, Smoothness

STYLIZE FILTERS

Extrude – The 'building block' filter creating colored and stacked three dimensional blocks out of your original image.

Variables: Type, Size, Depth, Solid Front Faces, Mask Incomplete Blocks

Wind – Parts of the image are blurred in the direction of the prevailing wind. Variables: Method, Direction

TEXTURE FILTERS

Craquelure – Cracks imposed on the surface of the original image.Variable: Crack Spacing, Crack Depth, Crack Brightness

Stained Glass – Image broken up into areas of color which are then bordered by a black line similar to stained glass.

Variables: Cell Size, Border Thickness, Light Intensity

THE TEN COMMANDMENTS FOR FILTER USAGE

- 1. Subtlety is everything. The effect should support your image not overpower it.
- 2. Try one filter at a time. Applying multiple filters to an image can be confusing.
- 3. View at full size. Make sure that you view the effect at full size (100%) when deciding on filter settings.
- 4. Filter a channel. For a change try applying a filter to one channel only Red, Green or Blue.
- 5. Print to check effect. If the image is to be viewed as a print, double check the effect when printed before making final decisions about filter variables.
- 6. Fade strong effects. If the effect is too strong try fading it. Use the 'Fade' selection under the 'Filter' menu.
- 7. Experiment. Try a range of settings before making your final selection.
- 8. *Mask then filter*. Apply a gradient mask to an image and then use the filter. In this way you can control what parts of the image are affected.
- 9. Try different effects on different layers. If you want to combine the effects of different filters try copying the base image to different layers and applying a different filter to each. Combine effects by adjusting the opacity of each layer.
- 10. Did I say that subtlety is everything?

Filter DIY

Can't find exactly what you are looking for in the hundreds of filters that are either supplied with Photoshop or are available for download from the Net? I could say that you're not really trying, but then again some people have a compulsion to 'do it for themselves'. Well, all is not lost. Photoshop provides you the opportunity to create your own filtration effects by using its Filter > Other > Custom option.

By adding a sequence of positive/negative numbers into the 25 variable boxes provided you can construct your own filter effect. Add to this the options of playing with the 'Scale' and 'Offset' of the results and I can guarantee hours of fun. Best of all your labors can be saved to use again when your specialist customized touch is needed.

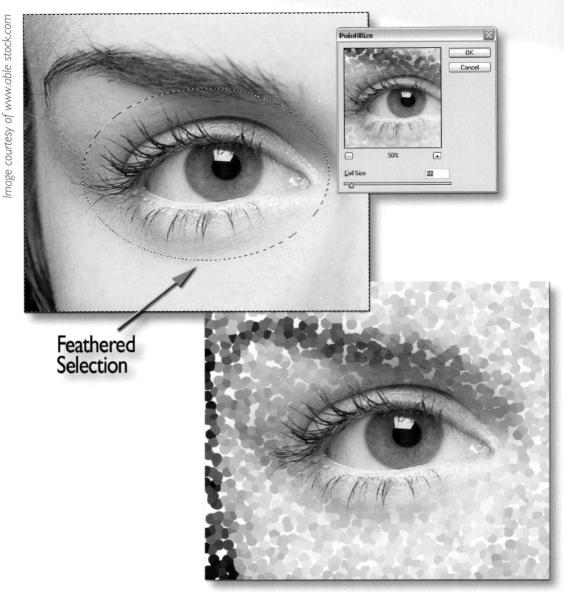

ACTIVITY I www.photoshopessentialskills.com/filters.html

One way of controlling the way that a filter changes your image is to restrict its effect with the use of a selection.

- 1. Before selecting the filter make a selection of the area that you don't want to be altered. In this example the eye was isolated with the Ellipse marquee.
- 2. Next invert the selection (Select > Inverse) so that the rest of the picture is then selected and then add some feathering (Select > Feather) so that there is a gradual change between the filter effect and the unfiltered parts of the picture.
- 3. Now select the filter and apply the effect to the selected area.

ACTIVITY 2 www.photoshopessentialskills.com/filters.html

You can obtain a more painterly approach to applying filter effects with the aid of the History Brush.

1. Start by filtering the picture with the effect you want to apply. Adjust the filter settings to suit the image and click OK. Here the Neon Glow filter is used to provide graphic contrast with the model's skin tone.

2. Next open the history palette (Window > History) and click the step before the filter application. Select the History Brush from the toolbox and click into the box on the left of the filter history state.

A small icon of the History Brush will appear signifying that you are now painting using this state as your source.

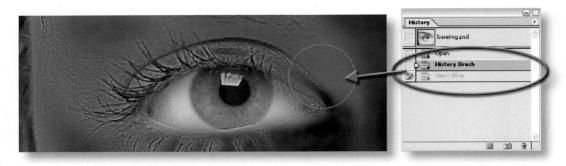

3. Now you can brush over the picture painting the filter effect as you go. Altering the opacity of the brush will change the transparency of the effect.

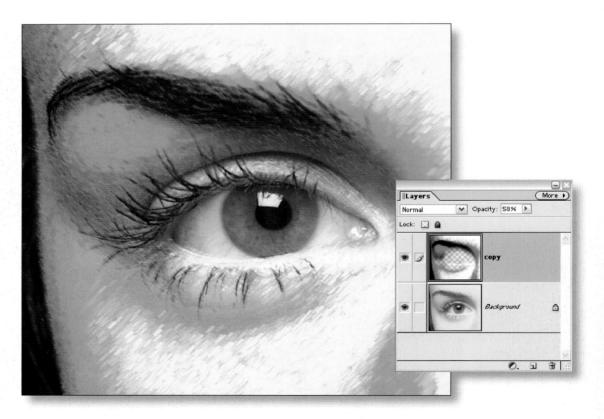

Yet another approach is to apply the filter to a copy of the picture that has been stored on a separate layer above the original. The Eraser tool can then be used to remove sections of the filtered layer to reveal the unaltered picture beneath. In addition the opacity of the filtered layer can be adjusted so that the whole effect becomes semi-transparent

graphics op photoshop pho

op photoshop photoshop photoshop photoshop photoshop

essential skills

- ~ Create a customized text layer using layer styles, adjustment layers, clipping groups and filters.
- ~ Create a vector logo and custom layer style.
- ~ Create an animation for the web using ImageReady.
- Create a 3D background texture and embed the logo using the Displace filter and layer styles.

Introduction

Typography and graphics are essential components of many illustrative assignments. With Photoshop's ability to support text and 'vector' layers there is no reason to look to other software programs to complete the task in hand. A type or vector layer is 'resolution-independent' and can be scaled to any size without becoming pixellated. For the highest quality commercial output using PostScript printers (capable of reading this vector data), it is important to preserve the information by saving files containing vector information using the EPS, PSD, PDF or TIFF file formats. If a multi-layered document containing type or graphic layers is flattened the vector information is lost when the layers are rasterized (the layers are converted to pixel data).

Note > The layer styles and vextor shapes created in this chapter can be downloaded from the supporting web site. See 'Activity 2' for more details.

Working with typography

Typography can manipulated in Photoshop in a variety of ways. The 'character' palette can be opened by clicking on the palette icon in the Options bar when the Type tool has been selected. The dimensions and spacing of the characters can be controlled and there are options for creating font variations even if none exist in the fonts folder, e.g. 'Faux Bold' and 'Faux Italic'. Text can also be transformed and warped and still remain as a vector layer. Various visual effects can be applied to the shape of the text by utilizing layer styles and using the text as a clipping mask. Type layers must, however, be 'rasterized' when filters are required to modify their appearance. The following activity uses these features and attributes in the creation of some stylized typographic design.

ACTIVITY /

1. Create a new document 5 inches wide and 2.5 inches high with a resolution of 300ppi. Select the Text tool and choose the font options in the Options bar. Choose the 'center text' option and proceed to type in the main image window. Hold down the Ctrl/Command key and resize the text using the handles of the bounding box that appears. Alternatively commit the text and use the 'Free Transform' command. Duplicate this text layer by dragging it to the New Layer icon.

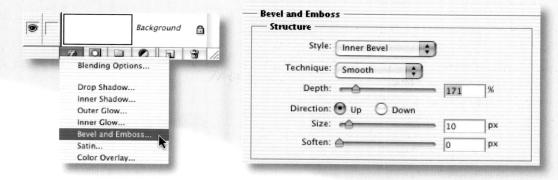

2. Apply a Bevel and Emboss layer style to the top type layer.

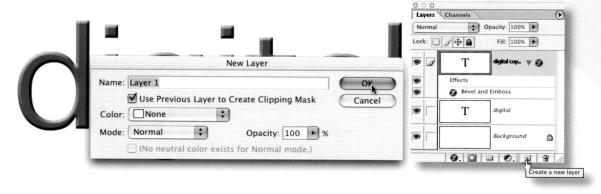

3. With the uppermost type layer as the active layer hold down the Alt/Option key and click on the New Layer icon in the layers palette. Select the 'Use Previous Layer to Create Clipping Mask' option in the New Layer dialog box and select OK.

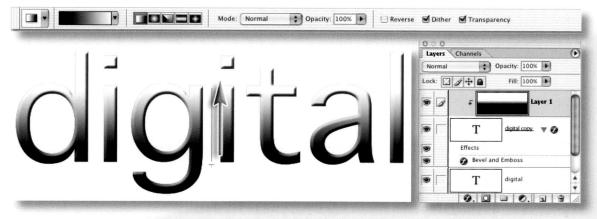

4. Select the 'Gradient Tool' and the 'Black, White', 'Linear', 'Normal' and '100%' options. Hold down the Shift key and drag a gradient from the base of the letters to approximately two-thirds of the way to the top of the characters.

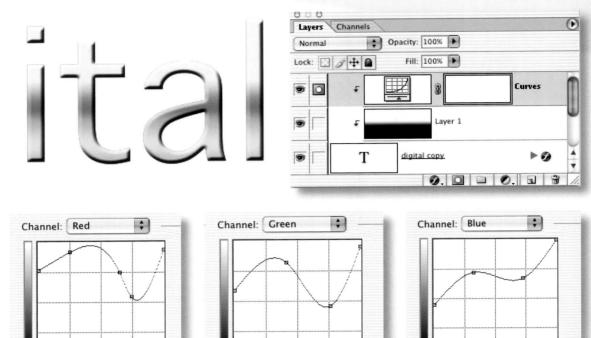

5. Hold down the Alt/Option key and create a 'Curves' adjustment layer that is part of the clipping group created in the previous step. Adjust the Red, Green and Blue channels in the Curves adjustment to 'colorize' the black and white gradient below.

Note > An alternative approach to toning or texturizing the typography would be to group an image with the type layer.

6. Select the original text layer and go to 'Filter > Pixelate > Mosaic'. Select 'OK' when the warning dialog box invites you to Rasterize the type.

Note > Filters cannot be applied to vector layers without first rasterizing them.

7. Choose a cell size to create a mosaic background behind the uppermost text layer.

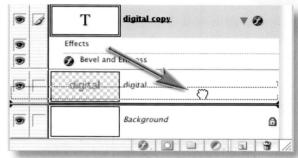

8. Drag the layer effect (Bevel and Emboss) from the top text layer to the bottom text layer to apply the same layer style.

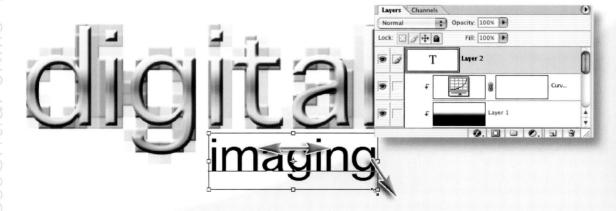

9. Click on the top layer in the layers palette and hold down the Shift key as you click with the Type tool. This will ensure a new type layer is created and the type layer does not become part of the clipping group. Hold down the Ctrl/Command key to position and size the text.

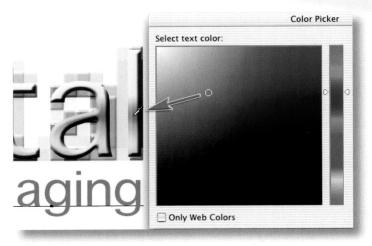

10. Select a colour for the typography. Double-click the type layer to select all of the type and then click on the color swatch in the Options bar. Move the cursor out of the Color Picker dialog box and sample a colour from the image window using the eyedropper. Select OK. Apply a layer style to this type layer as before. If the text requires printing on an inkjet printer the text layers will need to be rasterized or the file flattened and then the Unsharp Mask applied.

PDF Options

Encoding

ZIP

JPEG

Quality: Maximum

mail file large file

Save Transparency
Image Interpolation
Downgrade Color Profile

PDF Security Security Settings...

Include Vector Data

Embed Fonts

11. If the text is to be output via a PostScript printer then the file can be saved as a 'Photoshop PDF' file. The PDF file format allows the user to embed the fonts used to create the text. This allows the print service provider to handle the file with or without the font on their system. Alternatively the text layers can be converted to shape layers (go to Layer > Type > Convert to Shape). The text layer now becomes a vector graphic.

Vector graphics

Vector images are constructed from geographical markers (anchor points) connected by lines or curves, rather than pixels (the basic building blocks of a digital photo). A 'vector' shape is 'resolution-independent' and can be drawn any size without becoming pixellated.

Converting text to vector shapes

A vector shape can be created by using text characters as the starting point. In the example above two characters are stretched out using the Horizontal scale control and then moved closer together using a minus 'kerning' value. A precise alignment of the letter 's' over the letter 'e' is not possible but the shape of each character can be edited further if converted to a vector shape.

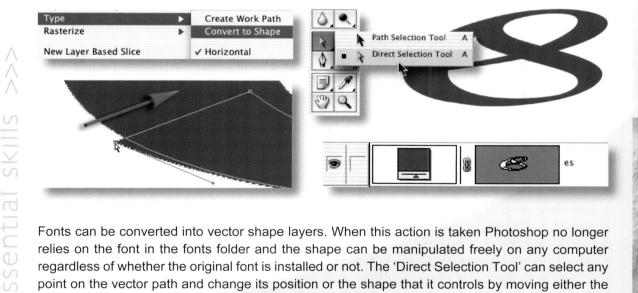

Fonts can be converted into vector shape layers. When this action is taken Photoshop no longer relies on the font in the fonts folder and the shape can be manipulated freely on any computer regardless of whether the original font is installed or not. The 'Direct Selection Tool' can select any point on the vector path and change its position or the shape that it controls by moving either the point itself or the handles that extend from it.

Note > Photoshop is dependent on the font in the fonts folder of the computer in order to render any variation in shape or form. If the file is opened on another computer where the font is missing Photoshop will be unable to render any changes.

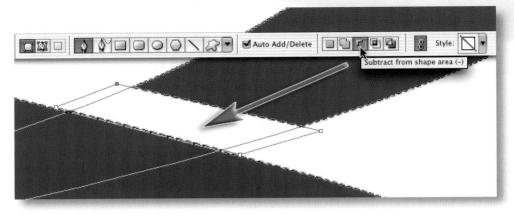

Creating a new vector shape

Use the 'Pen Tool' if you want to create a new path rather than modify an existing one. If you want the new shape to modify an existing shape, select the 'Vector mask thumbnail' in the layers palette and one of the options to the right of the 'Create new shape layer' icon in the Options bar.

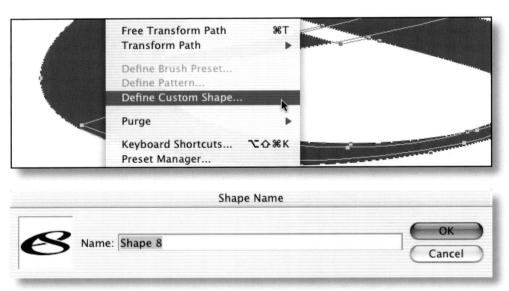

Defining a new custom shape

When a vector shape is completed it can be saved or archived as a 'Custom Shape' for future use. To create a custom shape drag the 'Path Selection Tool' or 'Direct Selection Tool' over the entire vector shape to select all points, and then from the Edit menu select 'Define Custom Shape'.

Creating a simple vector logo

Photographers displaying and distributing images to clients over the Internet are wise to protect their images. By adding a small identifying logo to images or by adding a larger reduced opacity watermark over the entire image it makes the image more difficult to appropriate. The easiest and fastest way to apply either of these identifying graphics is to store the logo in Photoshop itself rather than as a separate image file. Photoshop can store the logo as a 'vector' shape that is 'resolution-independent' (it can be drawn any size without becoming pixellated).

Photoshop is shipped with a small assortment of pre-drawn vector shapes called 'Custom Shapes'. Any vector shape created can be stored as a 'Custom Shape' adding your own shapes to Photoshop's selection – hence the name 'Custom Shapes'.

ACTIVITY 2

essential skills

In this activity you will create a custom shape from a simple combination of vector shapes and a letter. As you become confident with the tools you can begin to get more elaborate – but remember, the logos of the very powerful companies tend to be very simple.

1. Start by going to File > New File to create an empty canvas that is 320 × 320 pixels with a resolution of 160ppi (a precise size and resolution is not important at this stage as a vector logo can be scaled later for the required output device without a problem). The resolution and pixel dimensions suggested create a file output size of 2 × 2 inches. The file can be resized later to create a larger graphic without any risk of pixellating because of the very nature of vector shapes that are 'resolution-independent' (not described by pixels).

2. Draw a series of guides similar to those in the illustration. The guides will help you create a symmetrical and uniform logo. To create guides go to the 'View' menu and select Show Rulers. Check the rulers are set to pixels. If they are not set to pixels you can quickly reset them by going to Edit > Preferences > Units & Rulers.

Click on a vertical or horizontal ruler and drag a guide into the image area using the ruler to guide you. The guides for this activity were placed in the following positions:

- ~ 20, 60 and 85 pixels from each side
- ~ 160 pixel center position
- ~ 40 and 60 pixels from the top
- ~ 60 and 80 pixels from the bottom

3. Select the Type tool and type the letter 'M' in the center of the new canvas (in the illustration the font Arial Bold 72 pt was used).

Note > You can use any letter or letters to personalize the logo.

The background in the illustration was filled with a light gray. The 1-pixel wide white lines were drawn over a grid and then blurred a little using the 'Gaussian Blur' filter. This background does not form part of the logo.

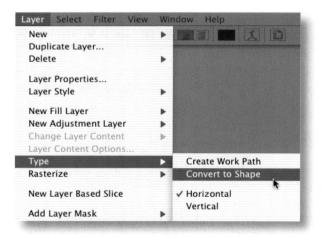

Select the type layer and go to Layer > Type > Convert to Shape.

- 5. From the Edit menu select 'Define Custom Shape'. Name the shape layer. The shape is stored in the 'Custom Shapes' and will be used later in the activity.
- 6. Delete the shape layer (the letter 'M') by dragging the layer to the trash in the layers palette.
- 7. Select the 'Ellipse Tool' (residing behind the 'Rectangle Tool') in the tools palette or on the 'Options bar'.
- 8. Starting in the top left-hand corner (where the guides intersect) click and drag the cross hair to the intersection of the guides in the bottom right-hand corner of the canvas area.

Now select the 'Subtract from shape area' icon in the Options bar and drag a second smaller ellipse that will cut out or subtract from the original ellipse. Use the guides to locate the starting and finishing points.

9. Select the 'Add to shape area' icon and your custom shape from the palette. Move the mouse cursor to your ellipse and add the custom shape (click and drag the mouse). If you need to resize the letter you can use the Free Transform command from the Edit menu. If you need to move the letter select the shape using the 'Path Selection Tool' (black arrow) and then click and drag the letter to a more suitable position.

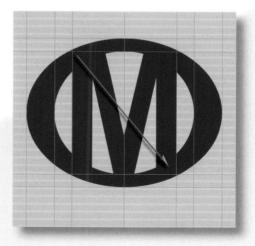

10. The shape layer is now constructed from three separate 'paths' (the individual elements of the shape). The 'Path Selection Tool' (black arrow) can select multiple paths by dragging over one or more of these paths. The Direct Selection Tool (white arrow) can be used to select an individual anchor point on any of the paths to adjust the path's shape.

The 'active' adjustment point will be highlighted when selected and can be moved by dragging the point or using the arrow keys on the keyboard. Adjust the inner ellipse so that the width is even by selecting each of the side anchor points in turn and then tapping the left or right arrow key on your keyboard.

Note > Each anchor point that is selected will display one or two 'direction lines' that end in 'direction points'. These can be moved to change the shape and size of the curve between the two anchor points.

11. When all adjustments to your logo are complete ensure the vector thumbnail is selected and select 'Define Custom Shape' from the Edit menu again to add the combined shape to the custom shapes menu. It is now possible to throw away all the layers then select the custom shape from the custom shapes palette and draw another.

Note > Custom shapes can be saved as a shapes file. The shapes file can be loaded into another copy of Photoshop on a different computer by clicking on 'Load Shapes' and browsing to the shapes file to be uploaded.

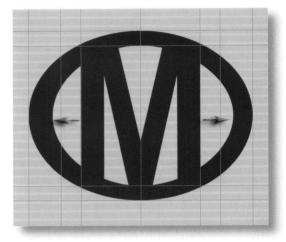

Alternative ways of acquiring a shape

An alternative to creating your shape in Photoshop is to import a vector shape from Adobe Illustrator or by scanning a piece of artwork (a shape that exists on a piece of paper) using a flatbed scanner.

When Adobe Photoshop opens an Adobe Illustrator file it asks for the file to be assigned a size and resolution so that it can be 'rasterized' (converted to pixels). To protect the vector properties of the shape the file should first be opened in Illustrator, the path or paths selected and then copied to the clipboard (Edit > Copy). The vector file can then be pasted (Edit > Paste) as a vector shape in an open Photoshop file.

If a shape has been scanned and opened as a 'bitmap' file (a file constructed from pixels) in Photoshop you must first make a selection of the shape. With the selection active go to the 'paths' palette and from the palette options select 'Make Work Path'. Select this path with the 'Path Selection Tool' and then proceed to the 'Edit' menu to save this active path as your custom shape.

Layer styles

After dragging a logo to suit your needs the custom shape can then be quickly assigned a layer style. A layer style is a series of layer effect settings that has been saved (as a style) and can be a combination of layer effects such as 'Drop Shadow' and 'Bevel and Emboss'. To apply a layer style, click on the shape layer and then click on a style from the 'styles' palette.

12. To create the 'Blue Glass' effect start with the one that comes shipped with Photoshop by clicking on the style with your shape layer selected.

Note > Unlike the vector logo the styles are resolution dependent. The effects are described in pixels, e.g. a 3-pixel bevel, etc. A layer style that is suited to a high-resolution graphic will not be suitable for a low-resolution graphic destined for the Internet. Photoshop offers the option of scaling all of the layer effects at the same time. In this way a layer style that is suited for use with a high-resolution image can be quickly scaled to one suited for an image with a lower resolution.

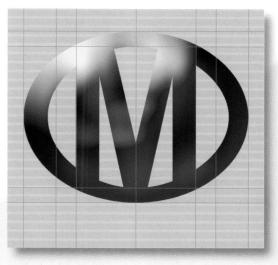

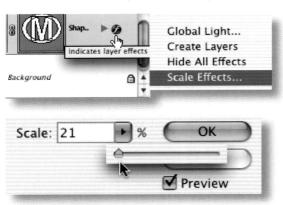

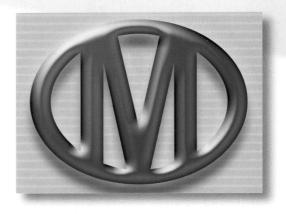

- 13. Scale the layer style by going to Layer > Layer Style > Scale Effects. Alternatively you can select it from the Context menu by right-clicking (PC) or Control-clicking (Mac) the Layer Style icon on the layer.
- 14. You can modify an existing style by adding a couple of your own layer effects. Click on the Effects icon in the layers palette to add a 'Drop Shadow' and then an 'Outer Glow'. The additional effects used in the activity are outlined in the table.

Specifications for the Drop Shadow

Colour		
Hue: 210	Saturation: 80	Brightness: 55
Structure		
Blend: Multiply	Opacity: 70%	Angle: 90°
Distance: 16 px	Spread: 0%	Size: 14 px
Quality		
Contour: Linear	Noise: 0%	

Specifications for the 'Outer Glow'

Colour		
Hue: 195	Saturation: 75	Brightness: 100
Structure		
Blend: Screen	Opacity: 60%	Noise: 0%
Elements		
Technique: Softer	Spread: 0%	Size: 23 px
Quality		
Contour: Linear	Range: 50%	Jitter: 0%

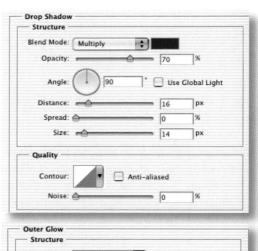

Saving your style

15. With the graphics layer selected click on 'New Style' in the styles palette to add the modified style. You may choose to add the image resolution to the name of the style. Just as with the shape the style can be saved as a styles file.

The logo with personalized style and used at a reduced opacity to act as a watermark

Scaling your logo

essential skills

If the logo is destined for the Internet the file should be scaled using the Image Size dialog box (go to Image > Image Size). Make sure the 'Resample Image' box is checked and drop the resolution until the pixel dimensions required are achieved. Check the Scale Styles to preserve the appearance of the styles used in preparing the graphic.

Note > Once scaled you can 'jump' the file into ImageReady to optimize or animate the file by clicking on the 'Jump' icon at the base of the tools palette.

Pixel Dimei	nsions: 57	.4K (was 732.4	K) —	(ок
Width:	140	pixels	₽ 7®	Cancel
Height:	140	pixels	• 1	Auto
Document	Size:			7
Width:	2	inches	• 7.	
Height:	2	inches	⇒ 7 _®	
tesolution:	70	pixels/inc	ch 🛟	
Scale Sty	les			
Constrain	n Proportio	ns		
Resample	e Image:	Bicubic	•	
			ministration	
			a)	
			B000	

Edit in ImageReady (Shift+

Creating an animated graphic for the web

We can use Adobe ImageReady, the companion software to Photoshop, to animate and optimize images destined for the 'World Wide Web'. If our animation plans include rotating a graphic in space we should first make some different viewpoints in Photoshop before jumping the multi-layered file into ImageReady, as the vector tools are not replicated in ImageReady.

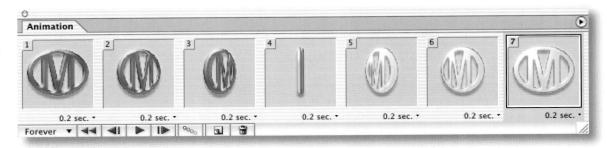

Photoshop is not really designed as a cutting-edge 3D rendering program, but it is quite capable of creating a few alternative viewpoints of an image by using the Transform command. Although capable of rendering a graphic to appear three-dimensional, Photoshop has no way of knowing or understanding the depth of the two-dimensional graphics that are created using the vector tools. The process of rendering alternative viewpoints in Photoshop is only a semi-automated feature, as we must instruct Photoshop how the graphic will look as it is turned in space.

ACTIVITY 3

- 1. Start with the full size graphic created for 'Activity 2'. Add some additional guides to the canvas area, 20 pixels from the top and 40 pixels from the bottom. Drag the layer with the vector logo to the New Layer icon in the layers palette to duplicate the layer.
- 2. Using the command 'Edit > Transform > Perspective' drag the corner handles to increase the height on the left-hand side and reduce the height on the right-hand side. By dragging the side handles of the bounding box, the width of the graphic can be reduced. Press the 'return/enter' key to apply the transformation.

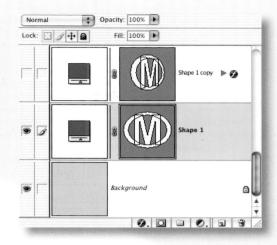

- 3. Modify the appearance of the graphic using the 'Direct Selection Tool'. The leading edge is made wider by clicking on the inner ellipse and then dragging (or by using the arrow keys on the keyboard) the anchor point to a new position.
- 4. Duplicate this modified layer in the layers palette before proceeding to alter the perspective a second time. The existing guides will help you to reposition the bounding box when using the Transform command.

Note > It is important to ensure the top of the ellipse remains in the same position as you create additional views of the logo, if the logo is later to appear to be spinning on the spot (use the intersection point of two guides to help you).

essential

5. It will be necessary to create a new shape layer for the side view rather than modify an existing layer. Use the 'Rounded Rectangle Tool' to draw a bar between the top and bottom guides. Alter the radius in the Options bar to obtain an appropriate end shape to this bar. A radius of 40 pixels was used in the example.

- 6. Apply the 'Blue Glass' layer style to the new shapes layer by dragging the layer effects from an existing layer to the new layer. Open the layer effects on an existing layer with the required style and click and drag the word 'effects' to the new layer. After completing the side view the logo has turned through 90°. Duplicating and 'flipping' your existing layers can create the viewpoints of the remaining 270°.
- 7. To create the additional views to complete the 360° rotation duplicate a pre-existing layer and flip the logo if required.
- Note > To flip a vector shape select all the paths using the Path Selection tool and then go to Edit > Transform Path > Flip Horizontal.
- 8. Your layers palette should look like the one opposite when you have completed a 180° turn.
- Note > As the demonstration graphic is symmetrical there is no need to create additional viewpoints.
- 9. Save the file as a PSD file. Before jumping a Photoshop file with layer effects into ImageReady, scale the image in the 'Image Size' dialog box using the resolution control to alter the pixel dimensions.

Combined use of filters and styles

Vector graphics can be integrated into the image using a variety of skills and techniques. Layer styles can be used together with Displace and Liquify filters to embed a logo into a photographic background. With a little skill and knowledge three dimensional graphics can be created and rendered from scratch in Photoshop without a requirement for any drawing skills.

ACTIVITY 4

1. Create a new RGB file 5 inches square with a resolution of 300ppi.

2. Set the foreground color to black and choose a desaturated color for the background (click on the background color to launch the 'Color Picker').

- 3. From the 'Filter' menu choose 'Render > Clouds'.
- 4. From the channels palette click on the 'Create new channel' icon at the base of the palette. The new channel should appear filled with black.

5. From the 'Filter' menu choose 'Render > Difference Clouds'.

6. Click on the master RGB channel and return to the background layer in the layers palette. From the 'Filter' menu choose 'Render > Lighting Effects'. From the 'Texture Channel' menu choose your 'Alpha 1' channel and move the slider to 'Mountainous'.

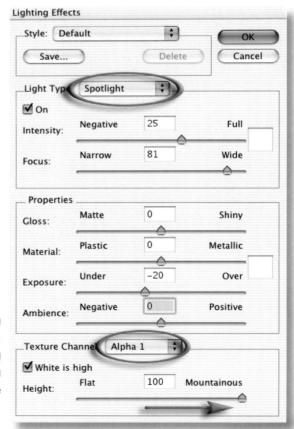

essential skills >>>

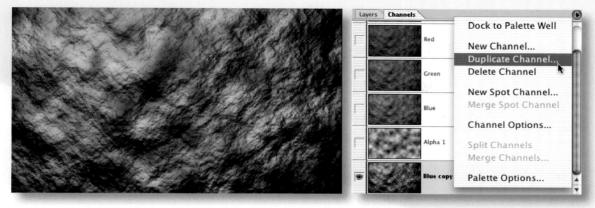

- 7. After creating a three-dimensional background using the Lighting Effects filter create an 'Image Map' for the 'Displace' filter technique. First duplicate the channel with the most amount of contrast by dragging it to the 'Create new channel' icon. Apply a 'Levels' or 'Curves' adjustment if the contrast needs adjusting further and a small amount of Gaussian Blur. Then go to the Channel Options and select Duplicate Channel.
- 8. From the 'Duplicate Channel' dialog box select 'New' from the 'Document' menu and select OK. Save the new file as your image map to your desktop or project folder. This will act as the displacement map to distort the logo to follow the contours of the background.

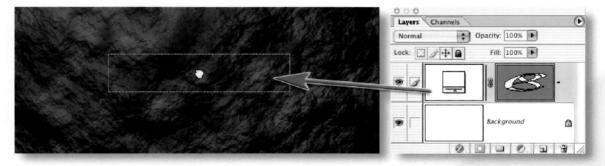

9. Open a vector logo file that you have created for an earlier activity. Drag the vector logo thumbnail over to the background image to create a multi-layered file. Discard any layer styles you may already have.

10. Rasterize the vector logo ('Layer > Rasterize'). Go to 'Filter > Distort > Displace'. Choose the displacement map you created in the last step. Choose horizontal and vertical settings for the required amount of displacement (dependent on the depth of the underlying graphic) and then select 'OK' to distort your graphic. Duplicate the vector layer by dragging it to the New Layer icon.

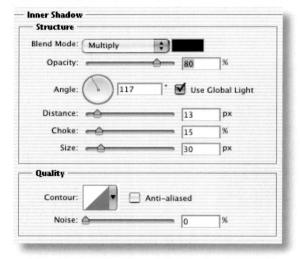

11. Add a Bevel and Emboss, Inner Shadow and Color overlay layer styles to one of the two vector layers. Choose black for the Color Overlay. Choose 'Outer Bevel' and 'Chisel Hard' for the 'Style' and 'Technique' options in the Bevel and Emboss layer style dialog box.

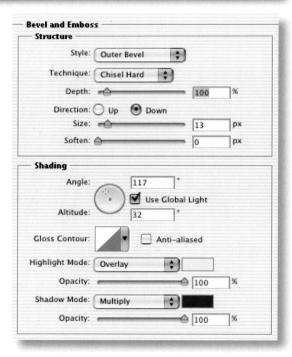

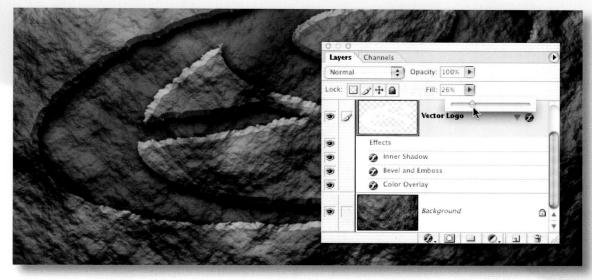

12. Reduce the 'Fill' opacity to reveal the underlying surface. The black 'Color Overlay' will serve to darken the bottom of the trench slightly.

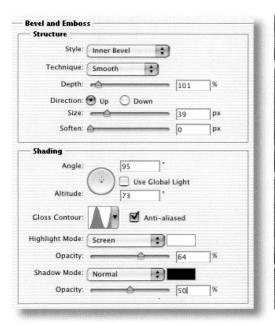

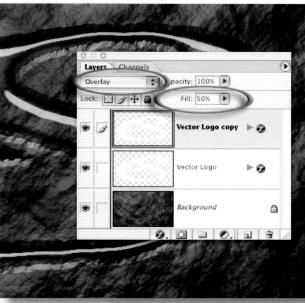

13. Apply an Overlay blend mode to the logo copy layer and reduce the fill opacity to 50%. Apply a Bevel and Emboss layer style to this layer. To create the illusion of water filling the trench select a 'Gloss Contour'. Switch off the 'Global Light' and position the light source just above center. Some fine-tuning will be required to move the reflection over the surface of the water.

Note > Experiment with grouping an image to the top layer at a reduced opacity to create the illusion of a reflected image.

images for the web

photoshop photoshop photoshop photoshop phot

essential skills

- ~ Create an animation for the web using Adobe ImageReady.
- ~ Create a web page using slices, rollovers, links and optimization in Adobe ImageReady.

Introduction

ImageReady was bundled with Photoshop with the release of version 5.5. This move by Adobe was to recognize the growing significance of the Internet as a medium for visual communication using digital images. Adobe continues to retain the two separate interfaces rather than rolling them into one at this present time, so as to reduce the overall complexity and the number of tools visible at any one time. Although many specialized web features are now starting to appear in Photoshop itself (slicing, weighted optimization, etc.), the bulk of the web tools remain in its 'sister' software ImageReady. ImageReady's primary strength is in its ability to 'Slice', 'Animate' and 'Optimize' images. In addition ImageReady is able to create 'Rollovers' and 'Links' (the two primary interactive features on a web page) together with the supporting 'HTML' or web code to enable them to be read by a web browser. Individuals whose primary task is to create sophisticated web sites would normally use the information and images created by ImageReady to load into specialized web-building software such as 'Adobe GoLive' or 'Macromedia Dreamweaver'. Using these software packages web builders are able to fine-tune the HTML, load in additional imagery created by software such as 'Macromedia Flash' or 'Adobe LiveMotion' and exercise a degree of file management not supported by ImageReady.

Working with Photoshop and ImageReady

Photoshop and ImageReady are intelligently interlinked so that a digital file can be 'jumped' from one software to the other, any changes being made to the file in one software package being automatically updated as it becomes active in the other software package. Each software package has its own specialized strengths but the creator of the file can make use of these by 'jumping' the file between the two software packages. An example of this may be an image file that starts life in Photoshop and is then jumped into ImageReady so that it can be modified to become interactive for the web. ImageReady is able to support the pixel, vector and adjustment layers in the file that has been created by Photoshop, but its ability to modify or create these layers is limited. If for instance one of the adjustment layers in a file required extensive modification, the image file would have to be jumped back into Photoshop for this work to be performed before being returned or jumped back into ImageReady.

Creating a personal web site

Photoshop and ImageReady can supply all the features required to prepare the simple homepage linked to web galleries for uploading straight to an 'Internet Service Provider' (ISP). The activities that follow will take you through this process and cover the major features of ImageReady.

ImageReady

The interface of ImageReady is similar to Photoshop. If you 'jump' a file into ImageReady instead of opening a file in ImageReady (File > Open) the file also remains open in Photoshop. Any changes you now make to the file in ImageReady will be copied to the version open in Photoshop when you jump or switch back to Photoshop.

Note > Some of the features available in Photoshop (e.g. adjustment layers and vector tools) are supported but cannot be edited in ImageReady. If at any time you need to access Photoshop's features simply switch or jump between the two.

The interface

If you are new to ImageReady it is worth familiarizing yourself with the interface and tools palette. At the top left corner of the image window there are the preview tabs 'Original', 'Optimized', '2-up' and '4-up'. It is usual to have the 'Show Original Image' displayed when creating an animation or working with type, etc. Prior to saving the image for the web you will need to 'Optimize' the image (choose a file format, compression setting and/or color palette, etc.). The 'Show Optimized Image' view displays a preview of the image as it will appear after saving the image with the settings chosen in the 'optimize' palette.

File quality, format and size

Creating images for the web is a trade-off between quality and speed of download. Choosing high quality over file size will increase the time taken to download the image for display in the web browser. Choosing speed at the expense of quality will lead to poor quality images. The final choice is a subjective one but can be influenced by considering the people most likely to be viewing the images (artist, photographer, general public, etc.), the type of connection they have to the Internet (modem, cable, etc.) and the resolution of the monitor being used to display the images (800 × 600, 1024 × 768, etc.).

Save and Save Optimized

Files created or modified in ImageReady are saved as master PSD files using the 'Save' and 'Save As' options from the 'Edit' menu. Optimized GIF and JPEG files destined for the web are saved using the 'Save Optimized' and 'Save Optimized As' options from the Edit menu. Optimized file sizes and download times are displayed at the bottom of the image window (with the image in the 'Show Optimized' view). The choice of file format selected to save the image for the web is dependent on the type of image you are creating.

JPEG file format

Photographic images requiring 24-bit color quality (millions of colors) are usually saved as JPEG files. When choosing the JPEG file format a compression setting is applied that will balance quality with file size (download time). Excessive compression leads to image artifacts, lowering the overall quality of the image. The JPEG file format, although capable of saving 24-bit color, does not support transparency or animations.

GIF file format

A GIF (graphics interchange format) is an 8-bit format that supports both transparency and animated frames. A 'color palette' determines the 256 possible colors supported by the 8-bit GIF file format. This color palette can be a predetermined color palette such as a 'web palette' or can be weighted towards the dominant colors present in the image being optimized (perceptual, selective and adaptive color palettes).

The file size of a graphic image with a limited color palette may be reduced further by choosing a more restrictive color palette that uses fewer than 256 colors (128, 64, 32, etc.). Using a smaller color palette can help to reduce the final file size but can have detrimental effects on quality, especially if smooth transitions of tone or color are required. If photographic images are required for animation a larger color palette is usually required to avoid the effects of 'banding' (steps in tone or color).

Note > The effects of banding can be minimized by selecting a 'dither algorithm' from the optimize palette (diffusion, noise or pattern). The process of dithering alternates the colors that meet in a pattern to create the perception of an intermediate color.

Image resolution and the web

It is important to note that the pixel dimensions of the image and the resolution setting of the monitor control the size of an image displayed in a web browser. The web browser ignores the resolution and output dimensions (in inches or centimeters) that may have been specified in Photoshop.

Note > The image size dialog box in ImageReady has no options for resolution or output dimensions. The image being edited in ImageReady should normally be displayed at 100% magnification, as this is the size it will be viewed on the Internet by someone using a monitor with a similar resolution. Images will appear smaller when displayed on a higher resolution monitor and larger when displayed on a lower resolution monitor. Scrolling is required to view an image larger than the browser window.

ACTIVITY I

Before you start to animate the logo make a decision as to whether you would like the logo spinning in front of the existing background or whether you would like to see the web page around and behind the cut-outs of the logo (the GIF file format is able to support transparency as well as animated frames). If you decide to opt for transparency, first switch off the visibility of the background in the layers palette (click on the 'eye' icon).

Note > If transparency is required it is advisable to switch off the outer glow and drop shadow components of each layer style as the limited color palette has difficulty rendering gradual transitions of color effectively when using transparency.

1. Scale the multi-layered logo created in the graphics chapter to create a file size 140 pixels wide and 140 pixels high. First make visible the 'Shape 1' layer in the layers palette. This should be the only layer with an 'eye' icon visible. In the animation palette, set a time delay for this frame (0.2 seconds was set for this demonstration).

An animation frame can be constructed from the combined elements from single or multiple type, shape and image layers. To select the contents of each animated frame simply click on the visibility of one or more layers, layer effects or adjustment layers. As you create additional frames alter the visibility, opacity or position of the layers to alter the contents. Each frame can be assigned a 'frame delay time' or a period of time that the frame will be visible for before it is replaced by the next frame in the sequence. Actual timings should be previewed in a web browser.

2. Create a second frame by clicking on the 'Duplicates current frame' icon in the animation palette. This duplicate frame is exactly the same as the first frame until the visibility, position and opacity of the layers are altered. Make visible the 'Shape 1 copy' layer and switch off the visibility of the 'Shape 1' layer.

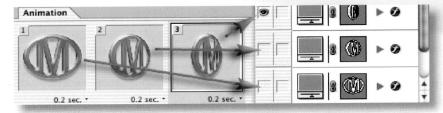

3. Continue to duplicate the last frame in the sequence and make visible the next layer in the stack until you have six frames, each reading from a different layer in the layers palette. Duplicate the first frame and then drag this frame to the end of the frames sequence so that it becomes frame 7.

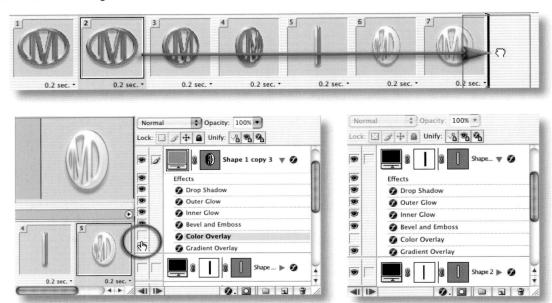

4. In the illustration above the color overlay component of the layer style has been switched off so that the reverse side of the logo appears different from the front surface. The new side view (half white and half blue) was created by first duplicating the side view layer. The color overlay layer effect was then switched off on this duplicate layer. Layer masks were added to conceal a different half of each layer.

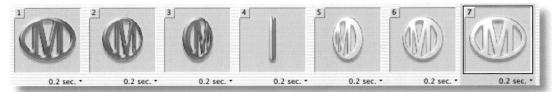

The animation palette should now resemble the one shown in the illustration. The logo will now turn 180°. Because the logo is symmetrical and looks the same when turned 180° there is no need to create any additional frames if the color overlay is left switched on. The following steps, however, introduce a new feature to the animation.

Tweening

If we want the opacity of a layer, layer effect or position of a layer to change gradually then we only need to create the first and last frame in the sequence. ImageReady is able to create the intermediate frames automatically without the need to create additional layers in a process called 'tweening'. ImageReady is not capable of 'tweening' or creating intermediate frames automatically when we wish to change the shape or size of a graphic. If we wish to zoom smoothly into a graphic or rotate the graphic in space we must first create the intermediate steps of the animation as additional layers that the animated frames can draw from.

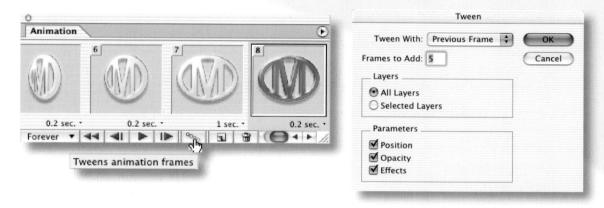

5. Start by duplicating the seventh frame and make visible the color overlay effect that had been previously turned off. With the eighth frame selected click on the 'Tweens animation frames' icon in the animation palette. Select the desired number of intermediate or 'in between' frames required and click OK.

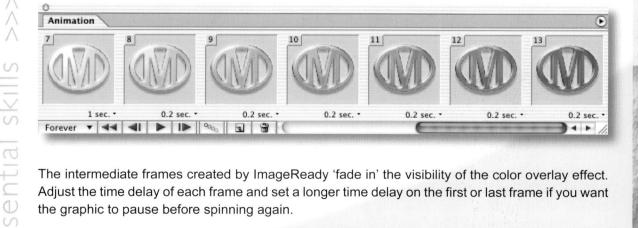

The intermediate frames created by ImageReady 'fade in' the visibility of the color overlay effect. Adjust the time delay of each frame and set a longer time delay on the first or last frame if you want the graphic to pause before spinning again.

Note > In the bottom left-hand corner of the animation palette you can set whether you want the animation to play just once, forever or a specified number of times.

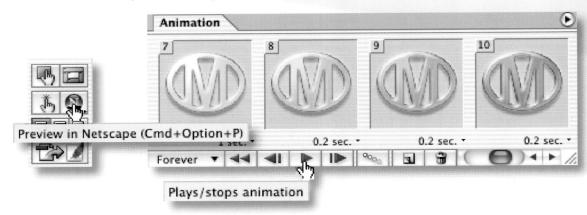

- 6. Play the animation by clicking on the 'Plays/stops animation' icon in the animation palette. Click on the 'Preview in Default Browser' icon to see the animation in 'real time'.
- 7. Click on the optimized view and set the required number of colors and the color palette. Choose whichever color palette gives the best visual result for your graphic. Select a dither algorithm if using only a few colors and check the transparency option if you have clicked off the background in the layers palette to create a logo that spins against the web page background.

8. Save the animation as a master PSD file (File > Save As) and an optimized GIF file (File > Save Optimized As). The optimized GIF file can be launched by opening the accompanying HTML file (if saved) or can simply be dragged into a browser window. The animation may also play if the file is embedded into the body of an email.

Note > If saving an HTML file with your animated GIF first create a new folder so that the GIF and HTML are in the same location. This will ensure the link between the two files is not broken when the files are moved to a different location or uploaded to a server.

The creative possibilities for motion that ImageReady opens up are, of course, limitless. You may like to think about how the use of a motordrive or zoom lens can add to the potential for animation. Think about creating sequential images over an extended period of time. Try mounting the camera on a sturdy tripod to create a professional result when the camera does not need to pan to follow the action.

Web page construction

ssential skills

Photoshop and ImageReady can prepare photographic images, animations and graphics for assembly in 'web authoring' software such as 'Dreamweaver' and 'GoLive'. Everything can, however, be assembled and made interactive in ImageReady itself.

ImageReady has its limitations, but if something relatively simple is required there is no need to go to the expense of acquiring expensive web authoring software.

Photoshop and ImageReady can 'slice' an image canvas and save each slice as a separate image file suitable for use on the Internet. The slices can be saved in different file formats, each with its own optimization setting. Photoshop and ImageReady can also write the supporting 'HTML' file so that a web browser can reassemble the slices. Photoshop and ImageReady can embed 'hyperlinks' in the image so that the user can jump to other web pages in the same web site or other web sites on the 'World Wide Web'. ImageReady can also export slices as GIF animations and create 'Rollovers' so that as the user moves the mouse cursor over a slice, changes will occur within the web page (a new image will be loaded into the same slice or a different slice somewhere else on the web page).

The following activity will guide you through the 'basic' steps in order to create a complete web page. Most of the major features of ImageReady will be introduced as you assemble, slice, optimize and save a web page. This 'index' page, will serve as a 'homepage' to welcome and guide visitors to web galleries that you can create in Photoshop.

ACTIVITY 2

Preparing the images and graphics

1. Prepare the component images with the 'Proof Setup' set to either Macintosh RGB or Windows RGB. This will allow you to see how the images will finally appear in the web browser on a target monitor.

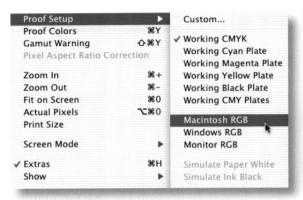

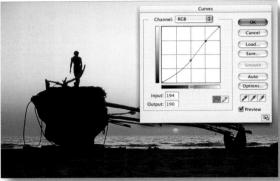

Modify the saturation or brightness of each image until it looks correct in the 'Proof Setup' selected. Size each image until it looks correct on the screen at 100% or Actual Pixels.

Note > Resolution and document size of an image will be ignored by the web browser.

2. Choose a background color by clicking on the background color swatch in the tools palette. Select 'Only Web Colors' in the 'Color Picker' dialog box and choose a web safe color.

Note > Choosing a web safe color will allow you to export graphics using a transparent backgound. The web browser can display this web color without the need to download pixel information.

3. Create a new document (File > New). Select pixel dimensions that will comfortably fit onto a target monitor resolution. A typical monitor's resolution of 1024×768 can comfortably display a page that is 900 by 600 pixels in addition to the browser window.

Preparing the images and graphics

Design a simple layout that includes a banner, some 'buttons' that will act as links to additional pages, and a main image window that will display the images in your web site.

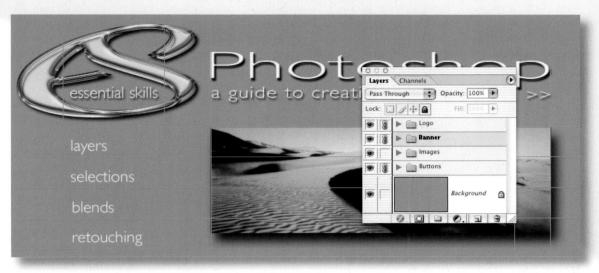

4. Organize the contents of the web site into layer sets using guides to align the individual layers. When the content is all in place lock or link the individual layers to ensure the layers maintain their relative position within the design.

- 5. Create alternative versions of the buttons or text that will act as the links. These can be used by ImageReady as 'Rollovers' (an image that changes when the viewer's mouse moves over the button or text).
- 6. The images in the image window can be triggered or switched on by creating a secondary rollover in ImageReady. Images can be placed one on top of another in alignment, but displayed one at a time only when the viewer rolls over the corresponding button or text. Switch off the visibility of all the images when they have been correctly positioned.

Slice the image canvas

7. When all of the component pieces of the web site design are in place select the 'Slice Tool' and ensure 'Guides' and 'Slices' are selected in the 'Snap To' submenu.

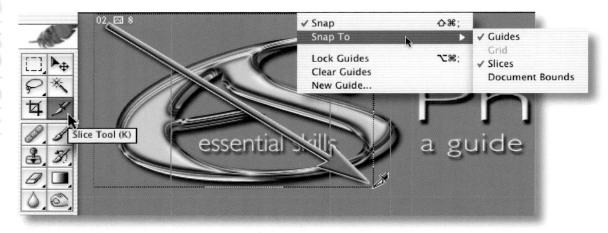

8. Slice the entire canvas area. Each of the component pieces of the web page should be isolated. Photoshop will create auto slices or 'spacers' to complete the table. The 'Snap' will ensure the slices meet with each other and align with the major guides.

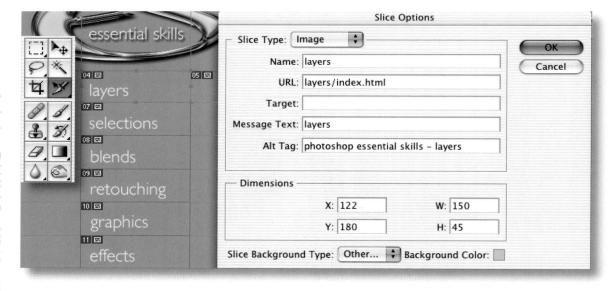

9. Choose the 'Slice Select Tool' (located behind the 'Slice Tool') and select a slice that will act as a link to another web page. Double-click the slice to open the 'Slice Options' dialog box or choose the 'Slice Options' in the 'Options bar'. Name the slice and type in the 'URL' or web address of the page that is linked to this slice.

Note > If the page is part of the same web site there is no need to type in http://www. If the page is in a 'sub-directory' type in the name of the folder followed by a forward slash.

Save for Web Command

10. When the slicing is complete go to 'File > Save for Web'. The purpose of this dialog box is to save the optimum export setting for each of the slices (fastest download time/smallest file with acceptable quality). Images are usually saved as JPEGs whilst graphics can be saved as GIF files. Choose the background color from the color swatch. Click on the 'Optimized' tab at the top of the palette or the '2-Up' option (this allows you to see a before and after optimization). Click on the 'Slice Select Tool' and proceed to select a slice to optimize.

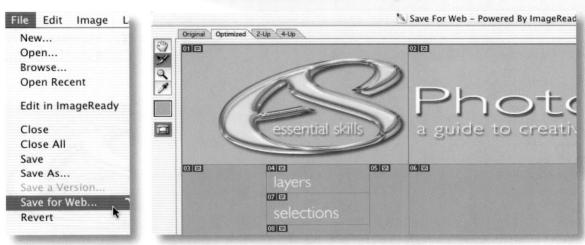

Note > Shift-clicking more than one slice allows you to apply an optimization setting to multiple slices, e.g. the text links can all be selected for a single GIF file setting.

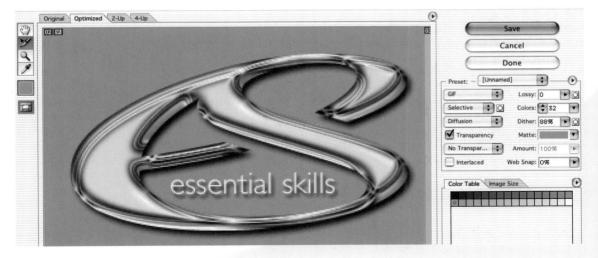

11. Reduce the colors and select a palette option for GIF files. Select 'Transparency' and the background color in the 'Matte' option. Selecting interlaced (GIF) or progressive (JPEG) allows images to gradually appear on the web page as they are in the process of downloading.

Creating the rollovers

12. The web page can be saved directly from the Save for Web dialog box or can be opened in ImageReady to create any rollovers or animations that are required. Click on the 'Edit in ImageReady' button in the bottom corner of the dialog box.

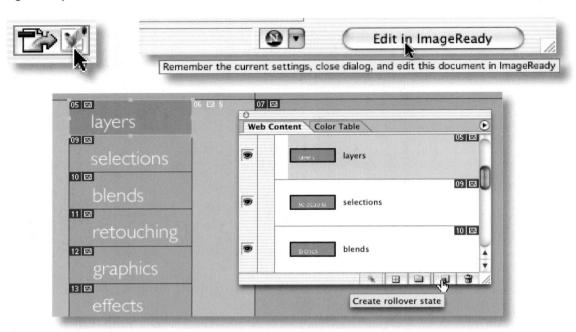

13. Click on a slice with the 'Slice Select Tool' and in the web content palette find the corresponding slice. Click on the 'Create rollover state' icon to create an 'Over' state for this slice.

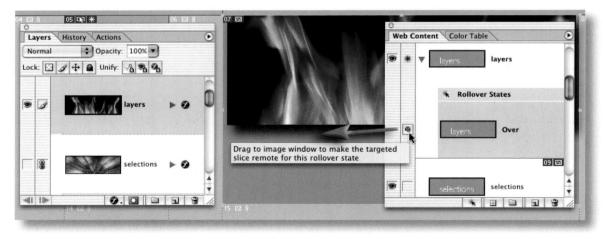

14. With the 'Over' state selected switch on the visibility of the alternative text layer in the layers palette and the preview image corresponding to this link in the images folder. Drag the icon next to the thumbnail to target the window or slice where the image will appear.

Preview and save web pages

15. Return to 'Show Original Image' mode. Click on the 'Preview Document' icon in the tools palette. Move the cursor over the buttons to check the rollovers are working. Then click on the 'Preview in Default Browser' icon to open your file in the web browser. Return to the open file in ImageReady and correct or modify any rollovers, animations or optimization settings if required.

16. Select the background color used in the web page as the foreground or background color swatch (use the 'Eyedropper Tool' or use the Color Picker).

- 17. Go to 'File > Output Settings > Background'. In the 'BG Color' pull-down menu select the background color used in your web site. This will ensure that the color surrounding the table of slices will be the same.
- 18. From the 'File' menu choose 'Save Optimized As'. Create a new folder called 'mywebsite' and save the HTML and images into this folder. Save the ImageReady file as a PSD file in a separate folder.

ential skill

19. Drag any web gallery folders that are linked to your homepage into your 'mywebsite' folder. Launch the 'index.html' file to test the site and then upload to the Internet.

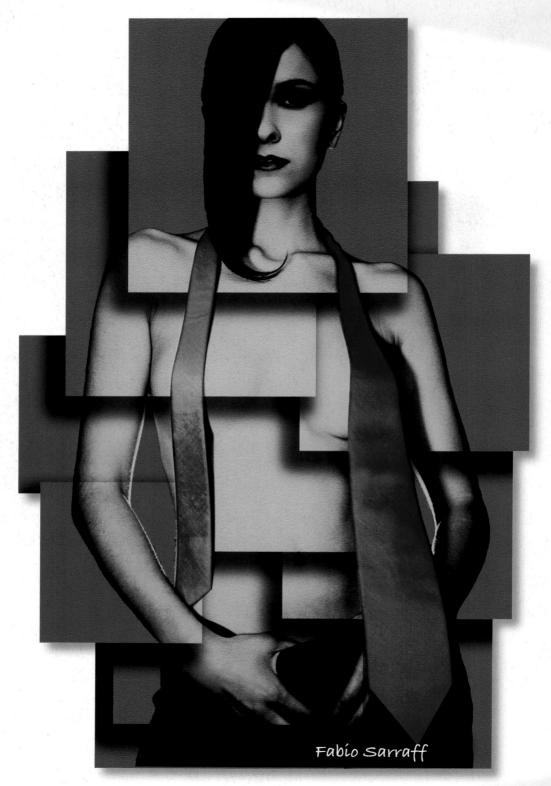

automated features photoshop photoshop photoshop photoshop photoshop photoshop photoshop photoshop photoshop

photoshop photoshop photoshop photoshop photoshop

essential skills

- Create customized keyboard shortcuts and actions.
- ~ Create contact sheets for reference and CD archive covers.
- ~ Create an automated PDF slideshow presentation.
- ~ Create an automated Web Photo Gallery.

Customizing your frequently used commands

As your skill level increases and your understanding develops you will find that many of the tasks that you regularly perform in Photoshop fall into common patterns featuring groups of commands applied in set sequences. For this reason Photoshop provides numerous automated features to increase the speed and ease with which some frequently used commands and actions are applied to either selected images or folders of images.

Keyboard shortcuts

Photoshop users have long incorporated the use of keystroke combinations into their daily operations as a way of speeding up their regularly used commands and functions. Activating a feature involved the pressing of one, two or more keys in combination. On the Windows system the Shift, Ctrl and Alt keys featured in most shortcuts, whereas the Macintosh system made use of the Command, Option and Shift keys. In previous versions of Photoshop the keystroke combinations have been predefined by the Adobe engineers and many were listed along side the feature's menu listing.

In the CS version of the program any single command or action can now be saved as a 'keyboard shortcut'. Existing shortcuts can be modified and commands without shortcuts can be assigned with a shortcut of the user's choosing. The modified set of shortcuts can be named, saved and loaded into Photoshop CS on another computer.

Photoshop CS provides a customizable keyboard for regularly used features and commands

Actions

Photoshop CS, as well as other versions of the package, comes complete with a built-in recorder feature that lets you save a sequence of changes you make to a picture. Called Actions, this feature is easy to use and is great for speeding up all those tasks that you repeatedly perform on your photographs. Once recorded the Action sequence can be applied to a single file or a group of files via the Batch command (File > Automate > Batch).

- 1. To create an action, start by opening the actions palette (Window > Actions). Click the sideways arrow in the top right of the palette to reveal the flyout actions menu. Select New Action from the list.
- 2. In the New Action dialog input an action name, shortcut key to run the action (function key) and choose a color for the action when viewed in button mode. You can also select the action set that you want the new action stored in. If you haven't created a new set the 'Default Actions.atn' set will be set as default. Click Record to start saving your image adjustments.
- 3. With an example picture open, perform the actions that you want to be recorded. In the example I made a simple Hue/Saturation adjustment that turns a full color image blue via the Colorize option. Be sure to perform all changes in the same order that you want them to occur when applied to other pictures.
- 4. Once you have completed all the image enhancements, click the square button at the bottom of the actions palette. This stops the recording process. To see a list of all the steps that have been saved click the sideways facing arrow to the left of the action's name.

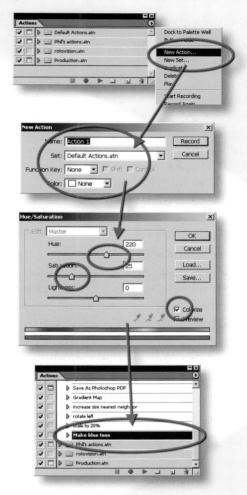

sentia

Now that your action has been recorded you can apply the sequence of correction steps to another image by opening the picture and selecting the action from the actions palette. In button mode clicking the button will start the action. In standard mode the Play button at the bottom of the palette needs to be clicked to commence the enhancement.

> PHOTOSHOP CS

Existing actions can also be accessed and edited from within the actions palette. Open the 'Commands' actions set and double-click on any action to edit its keyboard shortcut. A color or keystroke combination can be assigned to the action sequence and the order of the commands can be rearranged by dragging them to new positions in the palette.

When the actions palette is switched to 'button mode' the commands can be played with a single click of the mouse. By applying different colors to groups of actions those that perform similar editing or enhancement functions can be easily identified from the myriad listed.

Show Navi F10	Show Info F8	Show Actions F9
Cut (selection) F2	Copy (select F3	Paste F4
Flip Horiz & F6	Flip Vertical & F7	Rotate 90 ☆F8
Rotate 180 &F10	Show Color F6	Show Layers F7
Crop (selection)	Purge All & F3	Select Sim ⊕ F4

Downloading actions from the Net

There is a large and active community of Photoshop users who regularly write and share sophisticated 'actions' via the Net. At web sites like www.actionfx.com you can select from many different types of actions. After downloading the action it is installed into the Photoshop CS\Presets\ Photoshop Actions directory. After restarting Photoshop the new action will be attached to the list of actions in the actions palette and be ready to use.

Top tip: Actions are not only a great way to speed up regular tasks, they can also be used to make sure that exactly the same results are obtained when processing a group of files. If I applied the 'Make blue tone' action described in the tutorial to a folder of pictures I could be sure that all the altered photographs would be the same color blue.

Editing an action

ssentia

Photoshop includes some pre-recorded 'actions' that can be applied or edited to suit your own requirements. Additional actions can be loaded from the palette options or created 'from scratch'. The default 'Sepia Toning' action leaves the layers used to create the effect intact but the action can be further edited so that the image is flattened after the effect has been applied.

In the illustration above the Sepia action is edited by first playing the action and then clicking on the record button. When the action is in record mode simply flatten the image from the layers palette options and press the 'Stop' button. Photoshop records the additional command to the existing action. Actions can be renamed, grouped in sets and saved as action files to be shared or used for back-up.

Actions can be applied to a folder of images by using the Batch command which is part of the 'Automate' menu (go to File > Automate > Batch). An action can also be saved and placed as a 'droplet' on the desktop or in a folder of images. An image, or folder of images, can be dragged onto a droplet to apply the same sequence of commands to multiple images.

Actions and Batch commands

A sequence of commands that are commonly applied to a series of images can be recorded as an 'action' in the actions palette. The sequence is recorded when editing the first image and can be played back on any subsequent image that has been opened. The action can also be applied to images that have not yet been opened by selecting them in the file browser or selecting the folder of images from the 'Batch' dialog box (go to 'File > Automate > Batch').

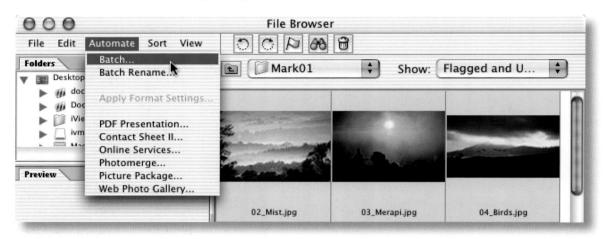

To select multiple images in the 'File Browser' first locate the folder and then either Shift-click to select all images between two selections or Command/Ctrl-click to select specific images.

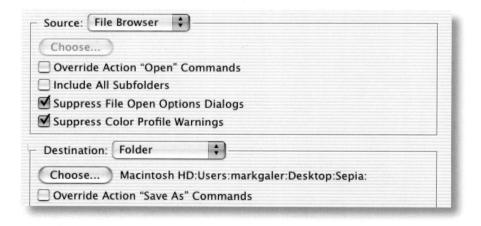

Choosing a 'Destination' folder will ensure the original images are not modified. Various options are available in the Batch dialog box so that the batch processing can suppress commands within the action or suppress warnings that would otherwise interrupt and stop the batch processing procedure. Some actions include dialog boxes that require the user to choose a particular setting before the action can continue. These too can be suppressed.

Contact Sheet

Several labor intensive operations that image-makers frequently find themselves performing are handled quickly and easily by the automated features available in Photoshop. The 'Contact Sheet' automated feature prepares all the images within a folder as thumbnails at either screen resolution or print resolution.

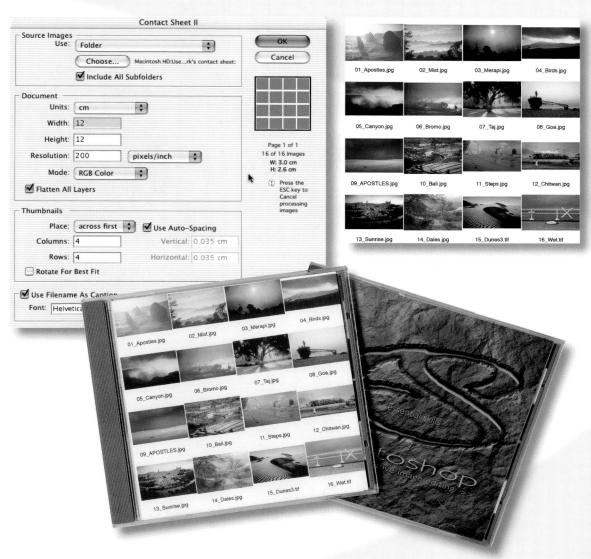

The creation of a CD cover size contact sheet allows the image-maker to create inserts for CDs containing archived images. The option of including 'Subfolders' allows the user to create file sheets for large cataloged image collections that are kept by cataloging software packages such as 'iPhoto'. When the first contact sheet is full Photoshop automatically creates additional pages until all of the images in the folder are represented.

Picture Package

The Photoshop Print Package option provides a great way to lay out multiple images on a single page. Found in the same Automate section of the File menu as the Contact Sheet command, Picture Package allows you to select one of a series of pre-designed, multi-print layouts that have been carefully created to fit many images neatly onto a single sheet of standard paper.

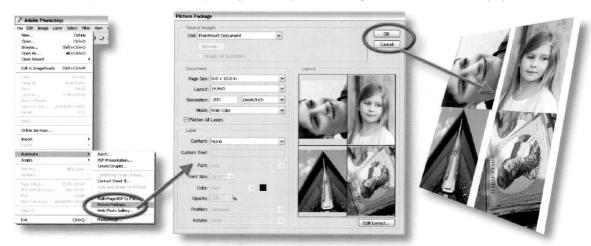

There are designs that place multiples of the same size pictures together and those that surround one or two larger images with many smaller versions. This feature was fully revised for Photoshop CS and now provides a preview of the pictures in the layout thumbnail. You can also choose to repeat the same image throughout the design, or by double-clicking on any print in the layout, select and add different photographs. There is also the ability to add labels to the printed images. The Label dialog provides a variety of text options which are added to the Picture Package when the OK button is pressed.

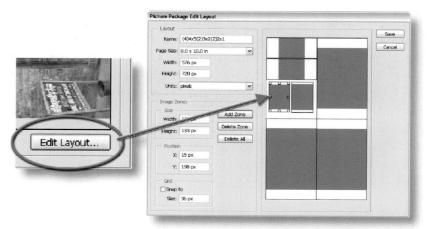

The final CS refinement to the feature involves the inclusion of a Layout Editor feature. Now it is possible to resize, rearrange, add and delete image 'zones' within the Picture Package layout. Using this feature you can customize and save your Picture Package designs.

In recent years shooting multiple pictures of a scene and then stitching them to form a panoramic picture has become a popular activity with digital photographers. This is the first time that Photoshop has shipped with Photomerge. The stitching program that first found its feet in Photoshop Elements has been included as a standard feature in Photoshop. This tool combines a series of photographs into a single picture by ensuring that the edge details of each successive image are matched and blended so that the join is not detectable. Once all the individual photographs have been combined the result is a picture that shows a scene of any angle up to a full 360°.

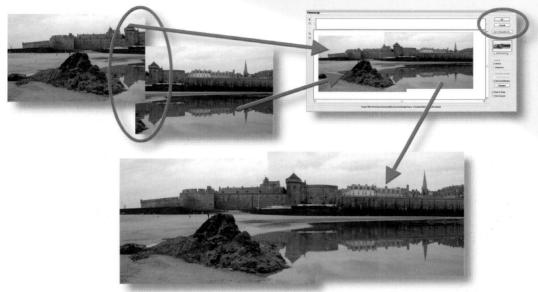

The feature can be started from the File menu (File > Automate > Photomerge) or via the Automate > Photomerge setting in the file browser. The later approach allows the user to select suitable source pictures from within the browser before activating the feature. At this point Photoshop attempts to automatically arrange and match the edge details of successive pictures.

In most circumstances Photomerge will easily position and stitch your pictures but there will be occasions where one or more images will not be stitched. These pictures are stored in the Light box area (top) of the Photomerge dialog where you can click-drag them to the correct position in the composition.

Individual pieces of the panorama can be moved or rotated at any time using the tools from the toolbar on the left-hand side of the dialog. Advanced Blending and Perspective options are set using the controls on the right. Photoshop constructs the panorama when the OK button is clicked.

Ensuring accurate stitching

ssential skills

To ensure accurate stitching successive images need to be shot with a consistent overlap of between 15 and 30%. The camera should be kept level throughout the shooting sequence and should be rotated around the nodal point of the lens wherever possible. The focal length, white balance, exposure and aperture need to remain constant whilst shooting all the source pictures.

D HOMSOLLOHI <<<

PDF presentation

A slide show can be created using the PDF presentation automated feature. In the presentation options it is possible to select the time that each slide will be displayed for and the transition effect between each slide. The slide show can be looped to start again after the last slide has been displayed.

Automatic advance

The slide show will play automatically when the PDF file is launched. After the last slide is displayed the user can exit the slide show by pressing the 'esc' key. The slide show is then visible as a multipaged PDF document. The slide show can be returned to the first page using the Adobe Acrobat page controls and viewed again by using the 'Full Screen View' option from the 'Window' menu.

Manual advance options

If the slide show is created without a time allocated to the 'Advance Every' option the slide show can be navigated by using the page up or page down keys or the arrow keys on the keyboard when in full screen view.

Web Photo Gallery

Photoshop can create a 'Web Photo Gallery' of your images quickly and easily. All the additional software you may need to get your gallery online is available for free from the Internet. Apart from being exposed to a little jargon on the way the procedure is a remarkably painless process.

Photoshop prepares all of your images and generates a homepage called an 'Index' page, on which is displayed a sequence of thumbnails (small versions of your images). These thumbnails are linked to the larger images that are displayed individually on their own pages. When a thumbnail is clicked, the web browser (Explorer, Navigator, etc.) loads the full sized version of the image. Photoshop allows control over the size of the thumbnails, the size of the images, the amount of JPEG compression used and the appearance of the page itself. The resulting web gallery is quick and a very efficient use of valuable time.

Uploading to the web

To place the gallery on the 'World Wide Web' (www) you must either send (upload) the files to your own 'Internet Service Provider' (ISP), or use an Internet Service Provider that offers free hosting of your site, e.g. Netfirms.com or Tripod.com. The activity that follows uses a 'simple' gallery style that does not require the more sophisticated use of 'frames' that partition the page into separate sections.

ACTIVITY 1

1. Place a collection of your own images into a new folder (multiples of 3, 4 or 5 will make a neat arrangement). Photoshop will make copies of these images and resize them for the web gallery. Ensure the images look good with the color management switched off (see 'Images for the Web' > 'Preparing Images and Graphics'). Ensure that the largest dimension of each image is at least 500 pixels. Images prepared by Photoshop for a web gallery will be stripped of their embedded profiles and should therefore be prepared with this in mind. These master images can be in any file format. Photoshop will handle the conversion to JPEG and will sequence the images in the web gallery according to the numerical or alphabetical beginning of the file names. Files starting with numbers are placed before files starting with letters in the sequence. Images should be numbered with a zero preceding the first nine numbers, i.e. 01 to 09 to sequence them in a preferred order in the gallery, e.g. 01.Stone.jpg, 02.Slate.jpg, etc. Image 11 will come after 1 if the zero is not included.

Note > Use short single-word file names with no spaces to avoid linking problems.

- 2. Choose 'File > Automate > Web Photo Gallery'. Choose 'Simple' from the 'Styles' menu and enter your email address if you would like to provide visitors with a useful point of contact.
- 3. From the 'Source Images' section of the dialog box click on the 'Choose' button to select the image directory or folder in which you have placed the images you would like to be featured in your gallery. Click on the 'Destination' button to select the folder the finished gallery will be saved to.

Note > Do not open the image folder – 'choose' it (locate the folder, select it, and then click on the 'Choose' button).

4. From the 'Options' menu select 'Banner'. Enter the gallery details that you would like to appear at the top of your gallery page. This will become your web page banner. You can enter alternative text in these boxes. Select a 'Font' and 'Font Size' to set the appearance of the text.

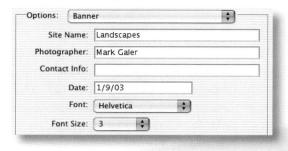

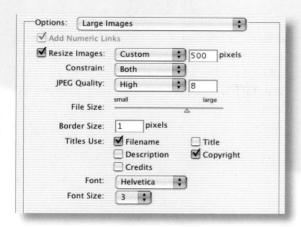

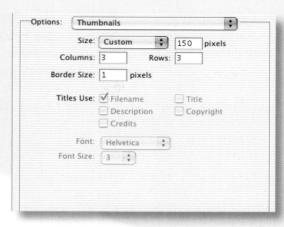

- 5. Select 'Large Images' from the 'Options' menu. Select 'Resize Images' and choose 'Custom' from the menu and enter a size of 500 pixels in the box. Choose 'Constrain: Both' and 'High' from the JPEG quality menu. Choose whether your images will be displayed with or without a border (a 1-pixel border was used in the example) and the source for the image title.
- 6. Choose 'Thumbnails' from the Options menu. If you think most of the people visiting your site will be using a high-resolution monitor (1024 × 768 or greater) you can choose quite large thumbnails, e.g. select 'Custom' from the 'Size' menu and enter 150 in the box. The gallery used in the example uses 3 columns and 3 rows. Avoid creating a gallery which leads to excessive scrolling which many web designers try to avoid. Finally select a border if required. One-pixel borders if selected are enough to separate the images from the background.

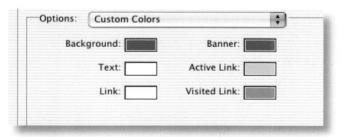

- 7. Choose 'Custom Colors' from the Options menu and click on the color swatches to change the colors. White text was used on a dark gray background. The same color was chosen for the banner to avoid the appearance of a box at the top of the page. As the thumbnails will be links, the link color will also become the border color for the gallery thumbnails. The link colors in the example gallery were selected from a limited palette of grays to avoid the gallery becoming too colorful and distracting from the imagery.
- 8. Click OK to create the web gallery. The web pages and images for the web gallery are placed in the destination folder. Once finished, your web browser is automatically launched and your Web Photo Gallery is displayed. If the browser does not launch, simply open the destination folder and double-click the 'index' file.

Upload your web gallery to the 'World Wide Web'

To upload your files to the World Wide Web you may need to acquire 'FTP' (file transfer protocol) software that can be downloaded for free from the web, e.g. Fetch (http://fetchsoftworks.com) for the Macintosh, and CuteFTP for Windows (http://cuteftp.com).

Using your own 'Internet Service Provider'

If you choose to use your own Internet Service Provider you will need to obtain some information from them in order to gain access to their server on which your files will be placed. You will need the address where your files will be uploaded, your user name and password, which will ensure that you can gain access to this server, and the directory your images will be placed in. You will also require the URL of your account with the ISP as it will be different to the ISP address you

uploaded the site to.

The web gallery should be placed in a folder (called a 'directory' on the web) and so the URL may be as follows: http://www.esp8.netfirms.com/portraits/index.html. The advantage of placing the web gallery in its own directory on the server is that it allows the file name 'index.html' to be used again in a different folder or directory. This will allow you to have multiple galleries or link the gallery you have just created to a 'homepage', or master index.html, that you may create in a future activity.

Make a new	connection to this FTP account:		
Host:	esp8.netfirms.com		
User ID:	esp8		
Password:	•••••		
	Add to Keychain		
▼			
Initial direct	ory: www/		
Non-standa	rd port number:		
	ect times.		

Once you have entered the FTP location (Host), your User ID and Password you will be presented with the option of selecting files and folders to upload. Modern FTP software such as Fetch demands no more than simply to drag your folders and files into the FTP window. If your FTP software seems unhappy with this procedure simply look for the command 'Put folders and files'.

Using a free Internet host

There are many providers offering a free hosting service using advertising as their income revenue. If you pursue this route your gallery will be accompanied with a banner advertising somebody else's site that takes up some of your 'screen real estate'.

Your URL

essential skills >>>

As soon as you upload your files to the service provider the gallery will be 'live' on the Internet. If you want to invite people to view your gallery type your gallery's URL into an email and they should be able to click on this link to be transported to your images. Be careful to type in the exact address. URLs are sometimes 'case sensitive'. Once you have established the correct URL it is often safer to copy and paste the URL when notifying someone of your site address.

Getting found on the Net

To enable people to find your site (if you have not first given them your URL personally), you must first list your site with the 'search engines' (Google, Alta Vista, etc.). Search engines examine listed sites to check for compatibility with the keywords typed into the search field. The search engine then displays the most compatible sites in a 'ranked' order. Most search engines focus their attention on your 'index' or homepage. Additional 'HTML' (hypertext markup language) can be inserted into your index page to increase the chances of being found. You can start with free html editing software such as 'Netscape Composer'. If your page is currently open in Navigator simply go to 'File > Edit Page' (your page will be jumped into Composer). Go to 'Format > Page Title and Properties'. Choose a title and description for your site that uses 'key words' that accurately describe the contents of your site and that may be used by the individual searching.

ACTIVITY 2

1. Select Photomerge from the File menu (File > Automate > Photomerge) to start a new panorama. Click the Browse button in the dialog box. Search through the thumbnails of your files to locate the pictures for your panorama. Click the Open button to add files to the Source files section of the dialog.

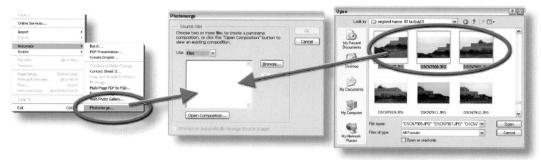

2. Select OK to open the Photomerge dialog box and start to edit the layout of your source images. To change the view of the images use the Move View tool or change the scale and the position of the whole composition with the Navigator. Images can be dragged to and from the light box to the work area with the Select Image tool.

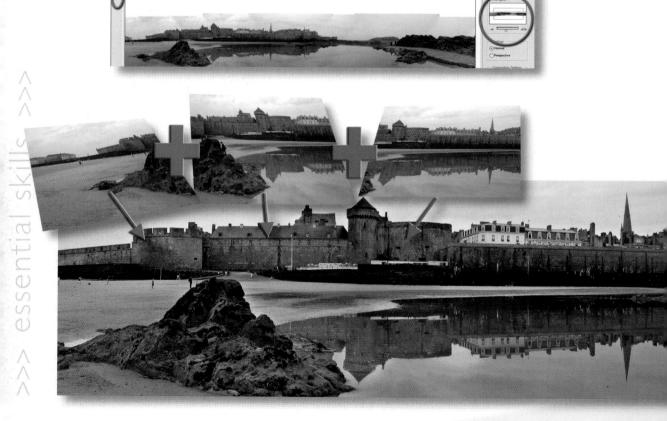

3. With the Snap to Image function turned on, Photomerge will match like details of different images when they are dragged over each other. Ticking the Use Perspective box will instruct Elements to use the first image placed into the layout area as the base for the composition of the whole panorama. Images placed into the composition later will be adjusted to fit the perspective of the base picture.

4. The Cylindrical Mapping option adjusts a perspective corrected image so that it is more rectangular in shape. The Advanced Blending option will try to smooth out uneven exposure or tonal differences between stitched pictures. The effects of Cylindrical Mapping as well as Advanced Blending can be viewed by clicking the Preview button. The final panorama file is produced by clicking the OK button.

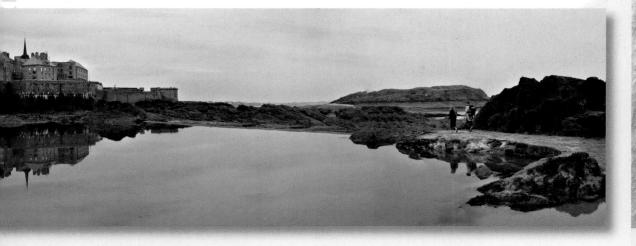

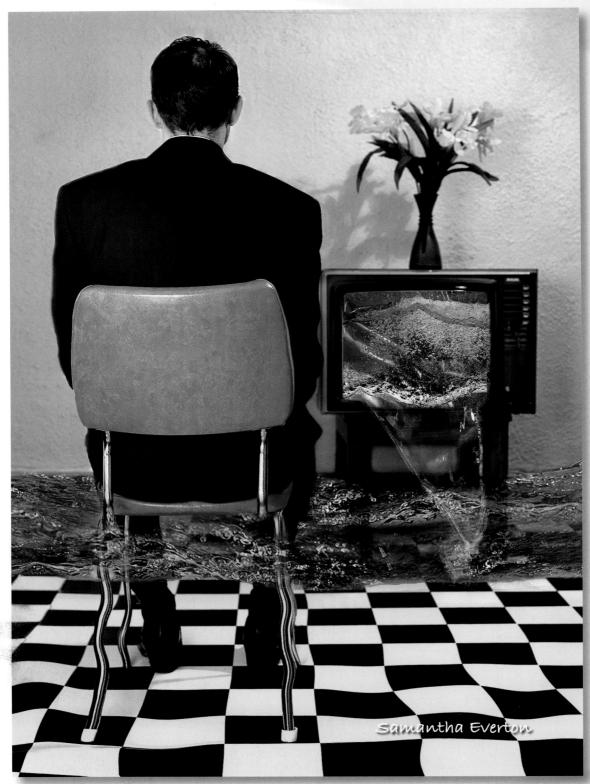

Glossary

Additive color A color system where the primaries of red, green and blue mix

to form the other colors.

Adjustment layers Image adjustment placed on a layer.

Adobe gamma A calibration and profiling utility supplied with Photoshop.

Algorithms A sequence of mathematical operations.

Aliasing The display of a digital image where a curved line appears

jagged due to the square pixels.

Alpha channel Additional channel used for storing masks and selections.

Analyse/Analysis To examine in detail.

Anti-aliasing The process of smoothing the appearance of a curved line in a

digital image.

Aperture A circular opening in the lens that controls light reaching the

film.

Area arrays A rectangular pattern of light sensitive sensors alternately

receptive to red, green or blue light.

Artifacts Pixels that are significantly incorrect in their brightness or color

values.

Aspect ratio The ratio of height to width. Usually in reference to the light

sensitive area or format of the camera.

Bit Short for binary digit, the basic unit of the binary language.

Bit depth Number of bits (memory) assigned to recording color or tonal

information.

Bitmap A one-bit image, i.e. black and white (no shades of gray).

Blend mode The formula used for defining the mixing of a layer with those

beneath it.

Brightness The value assigned to a pixel in the HSB model to define the

relative lightness of a pixel.

Byte Eight bits. The standard unit of binary data storage containing a

value between 0 and 255.

Captured A record of an image.

CCD Charge coupled device. A solid state image pick-up device

used in digital image capture.

Channels The divisions of color data within a digital image. Data is

separated into primary or secondary colors.

Charge coupled device See CCD.

CIS Contact image sensor. A single row of sensors used in scanner

mechanisms.

Clipboard The temporary storage of something that has been cut or

copied.

Clipping group	Two or more layers that have been linked. The base layer acts as a mask limiting the effect or visibility of those layers clipped to it.
Cloning tool	A tool used for replicating pixels in digital photography.
CMOS	Complementary metal oxide semiconductor. A chip used
CIVIOS	
	widely within the computer industry, now also frequently used
	as an image sensor in digital cameras.
CMYK	Cyan, magenta, yellow and black. The inks used in four color
	printing.
Color Picker	Dialog box used for the selection of colors.
ColorSync	System level software developed by Apple, designed to work
	together with hardware devices to facilitate predictable color.
Color fringes	Bands of color on the edges of lines within an image.
Color fringing	See Colour fringes.
Color gamut	The range of colors provided by a hardware device, or a set of pigments.
Color space	An accurately defined set of colors that can be translated for
Color Space	use as a profile.
Complementary metal	See CMOS.
oxide semiconductor	occ owoo.
Composition	The arrangement of shape, tone, line and color within the
Composition	boundaries of the image area.
Compression	A method for reducing the file size of a digital image.
Constrain proportions	Retain the proportional dimensions of an image when changing
Constrain proportions	the image size.
Contact image sensor	See CIS.
Context	The circumstances relevant to something under
	consideration.
Continuous tone	An image containing the illusion of smooth gradations between
	highlights and shadows.
Contrast	The difference in brightness between the darkest and lightest
	areas of the image or subject.
CPU	Central processing unit used to compute exposure.
Crash	The sudden operational failure of a computer.
Crop	Reduce image size to enhance composition or limit
	information.
Curves	Control for adjusting tonality and color in a digital image.
	,
DAT	Digital audio tape. Tape format used to store computer data.
Default	The settings of a device as chosen by the manufacturer.
Defringe	The action of removing the edge pixels of a selection.
3	

Density The measure of opacity of tone on a negative.

subject distance.

Descreen The removal of half-tone lines or patterns during scanning.

Device dependent Dependent on a particular item of hardware. For example,

referring to a color result unique to a particular printer.

Device independent Not dependent on a particular item of hardware. For example,

a color result that can be replicated on any hardware device.

Device An item of computer hardware.

Digital audio tape See DAT.

Digital image A computer-generated photograph co

A computer-generated photograph composed of pixels (picture

elements) rather than film grain.

Download To copy digital files (usually from the Internet).

Dpi Dots per inch. A measurement of resolution.

Dummy file To go through the motions of creating a new file in Photoshop

for the purpose of determining the file size required during the

scanning process.

Dye sublimation print

bye subilifiation print

Dyes

A high quality print created using thermal dyes.

Types of pigment.

Edit Select images from a larger collection to form a sequence or

theme.

Editable text Text that has not been rendered into pixels.

Eight-bit image A single channel image capable of storing 256 different colors

or levels.

Evaluate Assess the value or quality of a piece of work.

Exposure Combined effect of intensity and duration of light on a light

sensitive material or device.

Exposure compensation To increase or decrease the exposure from a meter-indicated

exposure to obtain an appropriate exposure.

Feather The action of softening the edge of a digital selection.

File format The code used to store digital data, e.g. TIFF or JPEG.

File size The memory required to store digital data in a file.

Film grain See Grain.

Film speed A precise number or ISO rating given to a film or device

indicating its degree of light sensitivity.

F-numbers A sequence of numbers given to the relative sizes of aperture

opening. F-numbers are standard on all lenses. The largest number corresponds to the smallest aperture and vice versa.

Format The size of the camera or the orientation/shape of the image.

Frame The act of composing an image. See Composition. Freeze Software that fails to interact with new information.

Grain

FTP software	File	transfer	protocol	software	is	used	for	uploading	and
	dow	nloading	files over	the Intern	et.				

Galleries A managed collection of images displayed in a conveniently accessible form.

Gaussian Blur A filter used for defocusing a digital image.

GIF Graphics Interchange Format. An 8-bit format (256 colours)

that supports animation and partial transparency.

Gigabyte A unit of measurement for digital files, 1024 megabytes.

Tiny particles of silver metal or dye that make up the final image. Fast films give larger grain than slow films. Focus finders are used to magnify the projected image so that the

grain can be seen and an accurate focus obtained.

Grayscale An 8-bit image with a single channel used to describe

monochrome (black and white) images.

Gray card Card that reflects 18% of incident light. The resulting tone is

used by light meters as a standardized midtone.

Half-tone A system of reproducing the continuous tone of a photographic

print by a pattern of dots printed by offset litho.

Hard copy A print

Hard drive Memory facility that is capable of retaining information after the

computer is switched off.

Highlight Area of subject receiving highest exposure value.

Histogram A graphical representation of a digital image indicating the

pixels allocated to each level.

Histories The memory of previous image states in Photoshop.

History Brush A tool in Photoshop with which a previous state or history can

be painted.

HTML Hypertext markup language. The code that is used to describe

the contents and appearance of a web page.

Hue The name of a color, e.g. red, green or blue.

Hyperlink A link that allows the viewer of a page to navigate or 'jump' to

another location on the same page or on a different page.

ICC International Color Consortium. A collection of manufacturers

including Adobe, Microsoft, Agfa, Kodak, SGI, Fogra, Sun and Taligent who came together to create an open, cross platform

standard for color management.

ICM Image Color Management. Windows-based software designed

to work together with hardware devices to facilitate predictable

color.

See ICM. Image Color Management A device used to print CMYK film separations used in the Image setter printing industry. Image size The pixel dimensions, output dimensions and resolution used to define a digital image. Infrared film A film that is sensitive to the wavelengths of light longer than 720nm, which are invisible to the human eye. Instant capture An exposure that is fast enough to result in a relatively sharp image free of significant blur. International Color See ICC. Consortium Interpolated resolution Final resolution of an image arrived at by means of interpolation. Increasing the pixel dimensions of an image by inserting new Interpolation pixels between existing pixels within the image. International Standards Organization. A numerical system for ISO rating the speed or relative light sensitivity of a film or device. Internet Service Provider allows individuals access to a web ISP server. A storage disk capable of storing slightly less than 2GB, Jaz manufactured by lomega. Joint Photographic Experts Group. Popular image compression JPEG (.jpg) file format. To open a file in another application. Jump Placing objects or subjects within a frame to allow comparison. **Juxtapose** 1024 bytes. Kilobyte A device independent color model created in 1931 as an Lab mode

international standard for measuring color.

Selection tool used in digital editing. Lasso tool

An image created by exposure onto light sensitive silver halide Latent image

ions, which until amplified by chemical development is invisible

to the eye.

Ability of the film or device to record the brightness range of Latitude

the subject.

A mask attached to a layer that is used to define the visibility of Layer mask

pixels on that layer.

A feature in digital editing software that allows a composite Lavers digital image where each element is on a separate layer or level. Liquid crystal display. LCD LED Light-emitting diode. Used in the viewfinder to inform the photographer of exposure settings. Lens An optical device usually made from glass that focuses light rays to form an image on a surface. Levels Shades of lightness or brightness assigned to pixels. A pale shade of the subtractive color cyan. Light cyan A pale shade of the subtractive color magenta. Light magenta LiOn Lithium ion. Rechargeable battery type. Lithium Ion See LiOn. LZW compression A lossless form of image compression used in the TIFF format. Magic Wand tool Selection tool used in digital editing. Magnesium Lithium See MnLi. Marching ants A moving broken line indicating a digital selection of pixels. Marquee tool Selection tool used in digital editing. Maximum aperture Largest lens opening. Megabyte A unit of measurement for digital files, 1024 kilobytes. Mega-pixels More than a million pixels. Memory card A removable storage device about the size of a small card. Many technologies available resulting in various sizes and formats. Often found in digital cameras. Metallic silver Metal created during the development of film, giving rise to the appearance of grain. See Grain. Minimum aperture Smallest lens opening. MnLi Magnesium lithium. Rechargeable battery type. Mode (digital image) RGB, CMYK, etc. The mode describes the tonal and color range of the captured or scanned image. Moiré A repetitive pattern usually caused by interference of overlapping symmetrical dots or lines. Motherboard An electronic board containing the main functional elements of a computer upon which other components can be connected. Multiple exposure Several exposures made onto the same frame of film or piece of paper.

Negative

An image on film or paper where the tones are reversed, e.g. dark tones are recorded as light tones and vice versa.

NiCd Nickel cadmium. Rechargeable battery type.

Nickel cadmium See NiCd. Nickel metal hydride See NiMH.

NiMH Nickel metal hydride. Rechargeable battery type.

Noise Electronic interference producing white speckles in the image.

Non-imaging To not assist in the formation of an image. When related to

light it is often known as flare.

Objective A factual and non-subjective analysis of information.

ODR Output device resolution. The number of ink dots per inch of

paper produced by the printer.

Opacity The degree of non-transparency.

Opaque Not transmitting light.

Optimize The process of fine-tuning the file size and display quality of an

image or image slice destined for the web.

Out of gamut Beyond the scope of colors that a particular device can

create.

Output device resolution See ODR.

Path The outline of a vector shape.

PDF Portable Document Format. Data format created using Adobe

software.

Pegging The action of fixing tonal or color values to prevent them from

being altered when using Curves image adjustment.

Photo multiplier tube See PMT.

Piezoelectric Crystal that will accurately change dimension with a change

of applied voltage. Often used in inkjet printers to supply

microscopic dots of ink.

Pixel The smallest square picture element in a digital image.

Pixellated An image where the pixels are visible to the human eye and

curved lines appear jagged or stepped.

PMT Photo multiplier tube. Light sensing device generally used in

drum scanners.

See PDF.

Portable Document

Ortabio Boodi

Format

Pre-press Stage where digital information is translated into output suitable

for the printing process.

Primary colors The three colors of light (red, green and blue) from which all

other colors can be created.

Processor speed The capability of the computer's CPU measured in

megahertz.

esser	ntial skills: photosho	p CS
	Quick Mask mode	Temporary alpha channel used for refining or making selections.
	RAID	Redundant array of independent disks. A type of hard disk assembly that allows data to be simultaneously written.
	RAM	Random access memory. The computer's short-term or working memory.
		See RAID.
	-	A surface used to reflect light in order to fill shadows.
		The change in direction of light as it passes through a transparent surface at an angle.
	Resample	To alter the total number of pixels describing a digital image.
		A measure of the degree of definition, also called sharpness.
	RGB	Red, green and blue. The three primary colours used to display
		images on a colour monitor.
	Rollover	A web effect in which a different image state appears when the
		viewer performs a mouse action.
	Rubber Stamp	A tool used for replicating pixels in digital imaging.
	Sample	To select a color value for analysis or use.
		Intensity or richness of color hue.
	Save a Copy	An option that allows the user to create a digital replica of an image file but without layers or additional channels.
	Save As	An option that allows the user to create a duplicate of a digital
		file but with an alternative name, thereby protecting the original
		document from any changes that have been made since it was
		opened.
		A ratio of size.
		Portion of hard disk allocated to software such as Photoshop to be used as a working space.
	Screen real estate	Area of monitor available for image display that is not taken up by palettes and toolbars.
	Screen redraws	Time taken to render information being depicted on the monitor
		Sample Saturation (color) Save a Copy Save As Scale Scratch disk memory Screen real estate

as changes are being made through the application software.

Secondary colors The colors cyan, magenta and yellow, created when two

primary colours are mixed.

Sharp In focus. Not blurred.

Silver halide Compound of silver often used as a light sensitive speck on

Single lens reflex See SLR camera. Slice Divides an image into rectangular areas for selective optimization or to create functional areas for a web page.

Sliders A sliding control in digital editing software used to adjust color,

tone, opacity, etc.

SLR camera Single lens reflex camera. The image in the viewfinder is

essentially the same image that the film will see. This image, prior to taking the shot, is viewed via a mirror that moves out of

the way when the shutter release is pressed.

Snapshot A record of a history state that is held until the file is closed. Soft proof The depiction of a digital image on a computer monitor used to

check output accuracy.

Software A computer program.

Subjective analysis Personal opinions or views concerning the perceived

communication and aesthetic value of an image.

Subtractive color A color system where the primaries of yellow, magenta and

cyan mix to form all other colors.

System software Computer operating program, e.g. Windows or Mac OS.

Tagging System whereby a profile is included within the image data of

a file for the purpose of helping describe its particular color

characteristics.

Thematic images A set of images with a unifying idea or concept.

TIFF Tagged Image File Format. Popular image file format for

desktop publishing applications.

Tone A tint of color or shade of gray. **Transparent** Allowing light to pass through.

Tri-color A filter taking the hue of either one of the additive primaries,

red, green or blue.

True resolution The resolution of an image file created by the hardware device,

either camera or scanner, without any interpolation.

TTL meter Through-the-lens reflective light meter. This is a convenient

way to measure the brightness of a scene as the meter is

behind the camera lens.

Tweening Derived from the words in betweening – an automated process

of creating additional frames between two existing frames in

an animation.

UCR Under color removal. A method of replacing a portion of the

yellow, magenta and cyan ink, within the shadows and neutral

areas of an image, with black ink.

Under color removal See UCR. **Unsharp Mask**

See USM.

Unsharp Mask filter URL	A filter for increasing apparent sharpness of a digital image. Uniform resource locator. The unique Web address given to every web page.
USM	Unsharp Mask. A process used to sharpen images.
Vector graphic	An resolution-independent image described by its geometric characteristics rather than by pixels.
Video card	A circuit board containing the hardware required to drive the monitor of a computer.
Video memory	Memory required for the monitor to be able to render an image.
Virtual memory Visualize	Hard drive memory allocated to function as RAM. To imagine how something will look once it has been completed.
Workflow	Series of repeatable steps required to achieve a particular result within a digital imaging environment.
Zip	A storage disk manufactured by lomega, available in either 100MB or 250MB capacity.
Zoom tool	A tool used for magnifying a digital image on the monitor.

Keyboard shortcuts ∇ = Option 🌣 = Shift # = Command

Action Keyboard shortcut

Navigate and view

Fit image on screen

Double click Hand tool in palette

View image at 100%

Double click Zoom tool in palette

Full/standard screen mode F

Show/hide rulers #/Ctrl + RShow/hide guides #/Ctrl + ;Hide palettes Tab key

File commands

 Open
 \mathbb{R}/Ctrl + O

 Close
 \mathbb{R}/Ctrl + W

 Save
 \mathbb{R}/Ctrl + S

 Save As
 \frac{\mathbb{R}}{Ctrl} + S

 Undo/Redo
 \mathbb{R}/Ctrl + Z

 Step Backward
 \mathbb{L}/Alt \mathbb{R}/Ctrl + Z

Selections

Add to selection

Hold ❖ key and select again

Subtract from selection

Hold ㆍ Alt key and select again

Copy $\Re/\text{Ctrl} + C$ Cut $\Re/\text{Ctrl} + C$ Paste $\Re/\text{Ctrl} + V$ Paste Into $\Re/\text{Ctrl} + V$ Free Transform $\Re/\text{Ctrl} + T$

Select All #/Ctrl + ADeselect #/Ctrl + DInverse selection #/Ctrl + I

Edit in Quick Mask Mode Q

Painting	
Set default foreground and background colours	D
Switch between foreground and background colour	X
Enlarge brush size (with Paint tool selected)	1
Reduce brush size (with Paint tool selected)	
Change opacity of brush in 10% increments (with Paint tool selected)	Press number keys 0–9
Fill with foreground colour	∵ /Alt ≪
Fill with background colour	%/Ctrl ⊠
Colour adjustments	
Levels	₩/Cnrl + L
Curves	₩/Ctrl + M
Group or clip layer	器/Ctrl + G
Disable/enable layer mask	☆ + Click layer mask thumbnail
Preview layer mask	√Alt + Click layer mask thumbnail
Select next adjustment point in curves	Ctrl + Tab
Layers and channels	
Add new layer	企 第/Ctrl + N
Load selection from alpha channel or layer mask	第/Ctrl + Click thumbnail
Change opacity of active layer in 10% increments	Press number keys 0–9
Add layer mask – Hide All	√Alt + Click 'Add layer mask' icon
Move layer down/up	第/Ctrl + [or]
Crop	
Enter crop	Return key
Cancel crop	Esc key

Hold ☆ key

Hold √/Alt ☆ keys + Drag handle

Constrain proportions of crop marquee

Turn off magnetic guides when cropping

Web links

Resources

Essential Skills http://www.photoshopessentialskills.com

RMIT Photography http://www.rmit.edu.au/adc/photography

Adobe Digital Imaging http://www.adobe.com/digitalimag/main.html

Martin Evening http://www.martinevening.com

Genesis http://www.genesiswebsitedesign.com

ePHOTOzine http://www.ephotozine.com
Digital Dog http://www.digitaldog.net
Epson http://www.epson.com

Computer Darkroom http://www.computer_darkroom.com

Inkjet Mall http://www.inkjetmall.com

Tutorials

Adobe http://www.adobe.com/products/tips/photoshop.html

Phong http://www.phong.com

Russell Brown http://www.russellbrown.com

Think Dan http://www.thinkdan.com/tutorials/photoshop.html

Planet Photoshop http://www.planetphotoshop.com
Ultimate Photoshop http://www.ultimate-photoshop.com

Scan Tips http://www.scantips.com

Photomedia illustrators

Paul Allister obscur@hotpop.com

Catherine Dorsen

Tamas Elliot

Samantha Everton http:saedesign.tripod.com/

Orien Harvey

Anitra Keogh

Benedikt Partenheimer

Raphael Ruz http://endersan.com
Fabio Sarraff sarraff@bigpond.com

Amber Williams

Stuart Wilson swimaging@optusnet.com.au

study imagir Study digital imaging online. 8-week modules from beginners to advanced. Undergraduate equivalent courses supported by interactive online classrooms, experienced lecturers and an Internationally published text. www.rmit.edu.au/adc/photography/online